transnationality, 2, 15, 19, 39, 121, 128, 135, 149, 224, 246
travel, 20, 50, 68, 88, 98, 104, 110, 116, 120, 133–4, 147, 149, 159, 168, 170, 174, 176–7, 180, 224, 226

Um Tiro no Escuro, 21
uncanny, 34, 50, 124
unhomely, 124, 136
United States, 25, 43, 62, 81, 84–7, 91, 94, 162, 175, 179, 182, 203–5, 207–8, 210–11, 215

vagabonds, 133

Vasco Pimentel, 8, 44, 60
victimization, 42, 54, 93, 96
visto, 188, 195

Walter Carvalho, 10, 113–14, 123, 128
Walter Salles, 4, 21, 94, 97, 101–2, 114, 127, 134, 146, 172–3, 181
Word and Utopia, 22
World War II, 12–13, 23, 46, 64, 122, 159–60, 163, 168, 175, 182, 194, 200–2

Yosefa Loshitzky, 2, 100

Index

Peacetime, 11, 189, 194, 197, 221
Pedro Costa, 7, 25–6, 37, 41–5, 47–9, 51–7, 63, 223
place, 1–4, 8, 10, 15, 19, 23, 26, 31, 47, 53, 59–63, 65, 67–75, 77, 79–81, 83–6, 88–90, 92, 95, 102, 110, 116, 119, 122, 126–8, 132–4, 136, 140, 142–3, 147, 155–7, 159, 161–2, 168–70, 172–3, 177, 189, 192–3, 195, 198, 214, 216, 242
Portugal, 1, 4–9, 11, 14–15, 17–20, 22–7, 31–2, 35, 37–46, 48–9, 52–6, 59, 61–4, 68–70, 73–5, 78, 81–4, 86–7, 89, 91–100, 103–12, 127–8, 154, 187, 200, 221, 225, 242
Portuguese Farewell, 39, 43
postcolonial condition, 41–2, 48, 54
postcolonial relations, 48
postcolonialism, 19, 30, 36, 38, 43
postmodern alienation, 100
postnational, 10, 113–14, 116, 120–1, 124–5, 242
poverty, 54, 67, 74, 81, 141, 143, 167, 172–3, 177, 182

race, 50, 61, 63, 71, 74, 106, 128, 151, 202, 224
racial democracy, 187, 189
racial differences, 107
racism, 26, 63, 66, 70, 171, 187
refugees, 132–3, 178
reterritorialization, 5, 9, 77, 79–80, 82, 85–7, 90–1, 244
retomada, 21, 172, 182
returning, 6, 8, 29, 49, 77–8, 115, 133, 145, 151, 161, 215, 244
reverse migration, 10–11, 131, 133, 151, 160, 162
road movie, 10, 131, 133–5, 140–1, 146, 148–9, 167–8, 172, 182–3
Robert Stam, 187

Sandra Kogut, 10, 113–14, 118, 122, 128, 131, 145–6, 149, 189
saudade, 10, 40, 113–20, 122–8, 244
self-discovery, 131
self-investigation, 131
self-reliance, 173, 178, 183
Serge Treffaut, 44
sexuality, 14, 96, 105, 223
slavery, 49, 155, 188
soundtrack, 65, 138, 172
Spain, 1, 6, 14–15, 70, 74, 81, 83, 86, 88, 94, 97–9, 102, 106, 110–11, 187, 200, 223, 225, 245
spatial identities, 77
Stephanie Dennison, 135
stereotypes, 37, 95, 103, 178, 195
Stuart Hall, 43
subjective turn, 131

Taboo, 7, 18, 44, 114, 221, 245
Tarrafal, 45–8
Tempos de paz, 189, 194–6, 221
Teresa Villaverde, 26, 37, 44
Terra Estrangeira, 111, 127
territorialities, 77, 82, 85
territory, 12, 51, 61, 67, 77, 79–90, 114, 118, 139, 144, 159, 163, 226
The Belvedere of the Moon, 24
The Forest, 22
The Island of Love, 43
The Jew, 22, 37
The Motorcycle Diaries, 134
The Mutants, 26, 37, 44
The Year My Parents Went on Vacation, 189
topophilia, 80, 82
totalitarianism, 132, 135
translocal, 65
transnational, 1–2, 4–5, 7, 10, 14–15, 18–20, 22, 24, 70, 74, 94, 113–17, 119–22, 124–8, 131, 133, 135, 137–9, 141, 143–9, 165, 217, 224, 246

Manoel de Oliveira, 22, 35, 39, 43, 225
Marcelo Gomes, 11, 167–9, 176, 183
Margarida Calafate Ribeiro, 19
Margarida Cardoso, 4, 16, 44
marginality, 63
memory, 5, 12–14, 43, 63, 70, 98, 114–16, 120, 132, 137, 139–40, 147–8, 165, 178, 181, 224, 239
Michel Foucault, 188
migration, 1–11, 13–18, 20–1, 24–7, 31, 40, 42–3, 46, 57, 60–6, 72–4, 77–83, 85–90, 93–7, 100–1, 109–12, 114–16, 120, 128, 131–3, 135–6, 139–40, 151–3, 158, 160, 162–5, 167, 170–1, 176–7, 183, 188–9, 192–4, 218, 224–5, 239
Miguel Gomes, 7, 18, 26–9, 32–3, 35, 44, 114
Mikhail Bakhtin, 189
mobility, 14, 79, 83, 86, 88, 100–1, 135, 137, 201, 226
modernity, 59, 70, 74, 92, 115, 117, 135, 170, 174, 182–3
motherland, 12, 143, 157
Mozambique, 4, 6, 16, 23–5, 46, 59, 62, 239
multicultural, 42, 46, 49–52, 128, 159, 185
multiculturalism, 63, 69, 128, 157, 187, 202
multilingual, 132, 142
multinational, 135
Murmuring Coast, 44
Muslims, 61, 72
My Voice, 24, 62, 102
myth, 7, 26, 43, 136, 164, 176, 178, 182, 187, 214, 216, 240

narrative, 43, 47, 51–2, 55, 59, 72, 78, 95, 97, 104, 107, 120–3, 133, 139, 174, 212–13, 215, 217

nation, 1–2, 5, 10, 12–13, 15, 17, 19, 57, 74, 96, 110–11, 113–16, 118, 122, 127–8, 139, 152, 155, 157, 159, 161–2, 170–1, 174, 179, 183, 187–8, 191, 194, 198, 200, 225, 240
national cinema, 4, 10, 15, 20, 25, 37, 43, 185
national stereotypes, 95
nationalism, 62, 113, 128, 135, 139, 152, 163–4, 216, 218
nationality, 5, 45, 78, 85, 87–9, 99, 119, 122, 136, 139, 147, 198, 215, 240
Nelson Pereira dos Santos, 20, 171, 183
Nelson Vieira, 187
new territory, 77, 83
New World Diary, 22
Nha Fala, 24, 62
No, or the Vain Glory of Command, 43
No Quarto de Vanda, 41, 56, 221
nomads, 133
Norma Bengell, 21
nostalgia, 7, 9–10, 15, 19, 34, 36, 38, 104, 115–18, 120, 125–6, 128–9, 173, 224, 240

O Judeu, 22
O Miradouro da Lua, 24
Olga, 13, 189–94, 200–2
Oporto, 8, 64, 88, 241
opposed geography, 82
original territory, 77, 85
Os Mutantes, 26
Other Neighborhoods, 8, 44, 60, 221
otherness, 8, 12, 60, 63, 65–6, 151–3, 155–7, 159, 161–5, 241
Outros Bairros, 8, 60–3, 66, 68, 70–2

PALOP, 7, 9, 17–18, 23–5, 31, 37–8, 59, 62, 66, 241
Paradise Lost, 27, 30–1, 34–5
Paulo Cesar Saraceni, 21
Paulo Nascimento, 22

INDEX

globalization, 14, 24, 94, 113–14, 122, 135
Good Neighbor Policy, 204–5
Guel Arraes, 21
Guinea-Bissau, 4, 23–5, 46, 62, 73

Hamid Naficy, 17, 132
Helena Solberg, 13, 203
Hollywood, 1–2, 13–15, 29–30, 34, 40, 56, 110, 147, 172–3, 206–9, 212, 215, 217, 236
home, 4–5, 9–11, 13, 25, 37, 47, 49, 57, 68, 73, 75, 78, 85, 88, 93, 104, 113–21, 123–4, 127–9, 131, 133–6, 138–9, 143, 145, 147, 149, 156–8, 161, 164–5, 174, 178–9, 187–91, 195, 199, 207, 210, 215–17, 236
home-discovering journey, 11, 139, 145
homeland, 1, 8, 11, 15, 107, 116–17, 131–3, 136–7, 139–45, 147, 153, 156–7, 161, 165, 199, 213, 236
hope, 2, 14, 48, 62, 79, 98, 117, 144, 168–9, 173–4, 183, 199, 236
hostility, 121, 198
human rights, 47, 93, 183
Hungary, 114, 119, 121–6, 129, 132, 135–7, 139, 221
hybrid, 22, 51, 61, 134

imaginaries, 18, 20, 87, 116
immigration, 3–5, 9, 11, 15, 25, 41, 43, 45–6, 54, 59, 62, 69, 93, 96, 100, 105, 108–10, 119, 128, 148, 154–5, 162, 164, 188–90, 196, 199–201, 223, 236
independence war, 47
integration, 9, 24, 26, 37, 72, 75, 77, 93, 96, 102, 105–7, 109–12, 123, 154–5, 157, 161, 179, 199, 237
irregular immigration, 9, 93, 96, 110

Japan, 151–3, 155–64, 180
Japanese, 12, 151–65, 175, 179, 200
Jayme Monjardim, 11, 189–90
Jews, 11, 61, 72, 187–9, 192, 196, 200–1
Jom Tob Azulay, 22
journey, 2, 8, 11, 13, 83, 88–9, 101, 131, 133–7, 139, 143–6, 148, 153, 158, 168–9, 177–8, 182, 238
Judith Butler, 213

Kikongo, 62, 69
Kiluanje Liberdade, 8, 44, 60, 65, 68, 221
Kimbundu, 62
Kriol, 62
Kriolu, 60–4, 66, 68–72, 74

labor, 6, 50, 59, 61, 93, 97, 105, 109, 115, 154–5, 157, 162, 175, 207, 215, 238
Latin America, 94, 132, 135, 142, 151, 162–4, 173, 175, 201–2, 205, 208, 217, 225
Latin American cinema, 127, 129, 144, 146, 224
legal migration, 93–4
Leonel Vieira, 21–2, 26, 44
Lisbon, 7–8, 21, 25, 31–2, 38–42, 44–5, 47–57, 59–61, 63–75, 81, 85, 91, 98–102, 104, 106–7, 112, 146, 225, 238
Lisbonners, 44
loneliness, 31, 36, 53, 106
loss, 2, 5, 10, 19, 27, 30, 44, 48, 68, 77, 80, 82, 90, 104, 114, 204, 210, 216, 238
Lusofonia, 40
Lusophone Africa, 64, 108
Lusophone cinema, 4–5, 36, 96, 140
Lusophony, 5–7, 9, 14–15, 18–19, 21–2, 24, 26–7, 31, 37–8, 63, 69, 73, 111, 239
Luso-tropicalism, 5–7, 18–19, 21, 24, 27, 31, 37–8, 63

contemporary Portuguese cinema, 43, 77
coproductions, 4, 9, 21–3, 37, 94, 109, 231
Cova da Moura Island, 44
CPLP, 14, 17, 25, 36, 63
Creole, 37, 46, 60–2, 64, 72–4
creolization, 61
criminality, 9, 93, 95–7, 99, 101, 103, 105–11, 231
cultural adaptation, 51
cultural differences, 22, 24, 43–4, 95
cultural identity, 19, 41, 43–4, 46, 51, 56, 138, 148, 153

Daniel Filho, 11, 189, 194
Daniela Thomas, 4, 21, 94, 97, 101–2, 114, 127, 129
decolonization, 17, 19, 23, 25, 43, 59, 62
departure, 59, 78–83, 85, 91, 96, 103, 119–20, 131, 137, 140, 204, 214, 216
Desmundo, 22, 37
deterritorialization, 2, 5, 8–9, 50, 77–91, 232 diaspora, 1–3, 5, 7–8, 10–11, 14–15, 39, 41, 43, 57, 73–4, 111, 113, 117, 119, 132–3, 135, 141, 143, 145, 147, 152, 164, 177, 181–3, 232
displacement, 2, 8–10, 14, 16–17, 41–2, 44, 51, 53–4, 61, 63, 65, 110, 115, 119, 132, 135, 139, 147, 199, 215, 217, 223, 232
Djalma Limongi Batista, 22
documentary, 10, 13, 23, 27, 29, 40, 46, 55, 68, 73, 114, 131, 133–48, 175, 189, 194, 203–4, 208, 212–13, 215, 218–19, 232
Double Exile, 8, 78, 221
double occupancy, 50
Down to Earth, 7, 25, 41
dreams, 10, 157, 159, 173, 177, 181, 183, 232
Dribbling Fate, 24, 62

emigration, 4, 6, 11, 62, 78, 81, 83–4, 89, 132–4, 136, 138, 151, 162, 164, 225, 233
emplacement, 2, 8–9, 60–1, 64, 66, 68–70, 72–3, 233
Eric Hobsbawm, 152
Estado Novo, 12–13, 92, 136, 139, 160, 183, 187–9, 191, 193–7, 199–201
European cinema, 1–2, 15, 39, 42, 50, 56, 111, 146
European Community, 6, 25, 48, 82
exile, 1–2, 8–10, 15, 46, 78, 87, 89, 110, 113, 117, 120–1, 132, 144, 147, 152, 192, 212, 218, 221, 233
exodus, 167, 182–3

Fado Blues, 4, 9, 21–2, 37, 94–5, 98, 100, 103, 105, 108, 111, 221
fantasy, 10, 43, 101, 234
Fernando Vendrell, 24–5
film noir, 95, 110
Five Days, Five Nights, 8, 78, 221
Flora Gomes, 24
Fontainhas, 7, 25–6, 37, 42, 49–50, 52–3, 63, 234
Foreign Land, 4, 9, 21–2, 79, 94, 96–7, 100–2, 110, 127, 146, 149, 221
foreigners, 12, 45, 70, 89, 93, 104, 136, 155, 160, 188
foreignness, 50, 207
foster community, 85
fragmentation, 44, 115
Fredric Jameson, 115

Gaijin I, 12, 152–3, 157, 159, 161
Gaijin II, 12, 158–9, 162, 221
Gary Garanian, 10, 132
Germany, 13, 43, 168–9, 179–80, 183, 190–1, 193, 200, 221, 225
ghettoization, 87
Gilberto Freyre, 18, 187
Glauber Rocha, 20, 169, 171, 177

Index

A Drop of Light, 24, 37
A Hungarian Passport, 10, 15, 113, 118, 131, 136–7, 148, 189, 221
A Ilha dos Amores, 43
A Selva, 22
A Shot in the Dark, 21–2, 37
accented cinema, 1, 10, 15, 40, 132–3, 140, 144–5, 149
aesthetic of hunger, 169, 172
Africa, 6, 18–19, 27, 31, 37, 43–4, 46, 56–7, 61–2, 64, 70, 73, 108, 162, 227
Afro-Brazilians, 187
Afro-Portuguese youths, 44
After the Goodbye, 44
Alain Fresnot, 22
alterity, 50, 152, 188, 198, 202
Andalusia, 70
Andrucha Waddington, 172
Angola, 4, 6, 23–5, 40, 46, 59, 62, 108–9, 228
Argentina, 129, 142, 148, 151, 160, 175, 181, 192, 201, 225
Armenian Rhapsody, 10, 132, 221
Artur Ribeiro, 8, 78
Azores, 22, 55, 78, 81, 84–7, 89

Bantu, 62, 69, 123
belonging, 5, 8–9, 13–14, 78, 85–6, 88, 90, 117–18, 121–2, 189, 191–2, 211, 216, 229
Boaventura Sousa Santos, 19
Brazil, 3–4, 6–7, 9, 11–13, 15–17, 20–3, 25, 37, 39, 43, 74, 81, 91, 93–8, 100–1, 103–4, 106–9, 113–15, 119, 121–4, 127, 129, 131–3, 135–9, 142–6, 148–9, 151–7, 159–64, 167–77, 179, 181–5, 187–205, 210–12, 217, 221, 224–5, 229
Budapest, 10, 113, 123, 125–6, 136–8, 146, 229

Cao Hamburger, 189
Cape Verde, 4, 6–7, 23–4, 39, 41, 44–9, 52–5, 59–62, 68–9, 72–4
Carla Camurati, 21
Carlos Diegues, 171, 184
Carmen Miranda: Bananas Is My Business, 13, 203–4, 213
Casa de Lava, 41–2, 49, 53–5
Cassiana Der Haroutiounian, 10, 132, 221
Central do Brasil, 129
Cesar Garanian, 10, 132, 221
Cinco dias, cinco noites, 78, 83–4, 88, 90, 221
Cinema, Aspirinas e Urubus, 11, 181–2, 184, 221
cinematic realism, 42, 49, 51
citizenship, 26, 41, 56, 59, 70, 72–5, 86–7, 119, 122, 136, 198, 225
colonial rule, 44, 46–8, 53–4
colonialism, 18–20, 22–3, 27, 30, 34–6, 38, 46, 56, 61–3
community, 3, 6, 9, 12, 14, 17, 19, 25–6, 42, 48, 53, 63, 67–8, 71, 73, 82, 85–6, 89, 93–4, 99, 106, 110, 132, 138, 140–1, 151–63, 187, 189, 193, 216, 219, 230
consumerist culture, 49
consumption, 51, 95, 175, 190

She is an Assistant Professor in the Department of Geography (University of Coimbra), where she is also Sub-Director of the Degree in Geography—area of prespecialization in Human Geography. She is a Full Member researcher of CEGOT (Centre for Studies in Geography and Spatial Planning), being the main investigation subjects: population, mobility, and territory; territorial dynamics in low density regions; and geography and cinema.

Frans Weiser is Assistant Professor in the Department of Comparative Literature at the University of Georgia. He recently completed his PhD at the University of Massachusetts Amherst and a Postdoctoral Fellowship at the University of Pittsburgh. His book project focuses upon the incorporation of fictional documents in contemporary historical fiction of the Americas, and he has had articles on contemporary Luso-Hispanic and ethnic American historical fiction and film accepted at journals such as *Hispania,* and *Rethinking History.* His research interests include Hemispheric American Studies, literary and cultural studies, travel film, and intellectual history.

Manoel de Oliveira (2008), *Terra em Transe – Ética e estética no cinema português* (2012), *Manoel de Oliveira—Novas Perspectivas sobre a Sua Obra*, and *África—Um Continente no Cinema* (both forthcoming).

Derek Pardue is Assistant Professor of Brazilian Studies at Aarhus University, Denmark. His books include: *Brazilian Hip Hoppers Speak from the Margin* (2011, 2nd ed. Palgrave) and *Ruminations on Violence* (Waveland, 2008). His ethnography, *Creole Citizenship*, concerning Cape Verdean migration in Lisbon, Portugal, is forthcoming with University of Illinois Press.

Ursula Prutsch received her PhD in History in 1993 from the University of Graz, Austria. She has taught Latin American history at the University of Vienna, Austria, and currently holds a position as an Associate Professor for American Studies at the University of Munich, Germany, where she teaches Latin American History and Inter-American Relations. Her previous research focused on Central European emigration to Latin America, on nation-building processes in Brazil and Argentina, as well as on Nelson Rockefeller's Office of Inter-American Affairs. She is the author of *Creating Good Neighbors? Die Kultur- und Wirtschaftspolitik der USA in Lateinamerika, 1940–1946* (Stuttgart: Steiner, 2008) and has edited a volume on *Argentine Film* (Vienna: 2012) together with Daniela Ingruber, among others.

Cacilda Rêgo is Associate Professor at the Department of Languages, Philosophy and Communication Studies at Utah State University, where she teaches Global Communication and Brazilian Cultural Studies. She has published several articles on Brazilian film and television, and is the coeditor (with Carolina Rocha) of *New Trends in Argentine and Brazilian Cinema* (Intellect, 2011).

Carolina Rocha is Associate Professor of Spanish at Southern Illinois University Edwardsville. She specializes in Argentine film and literature. She is the author of *Masculinities in Contemporary Argentine Popular Cinema* (Palgrave, 2012). She has also coedited several volumes: *Argentinean Cultural Production During the Neoliberal Years (1989–2001)* with Hugo Hortiguera, *Violence in Argentine Literature and Film* with Elizabeth Montes Garces, *New Trends in Argentine and Brazilian Cinema* with Cacilda Rêgo, and *Representing History, Gender and Class in Spain and Latin America: Children and Adolescents in Film* with Georgia Seminet.

Fátima Velez de Castro has a degree in Geography (Specialization in Teaching), a Masters in European Studies and a PhD in Geography.

from the Brazilian Northeast: Popular Music in a Culture of Migration (Lang, 2010). In addition, he has authored numerous scholarly articles and book chapters on Brazilian cinema, literature, popular music, and race relations in venues such as the *Latin American Research Review* and the *Journal of Latin American Cultural Studies*. He is currently working on a book project related to representations of *saudade*/nostalgia in twentieth- and twenty-first-century Brazilian cinema.

Regina R. Félix is Associate Professor at the University of North Carolina Wilmington. Her research deals with literature and cinema and focuses on the gender, race, and class underpinnings of power relations in national and transnational contexts. She has published articles in national and international journals and edited volumes and is the author of *Sedução e Heroísmo—Imaginação de Mulher* (Editora Mulheres, 2007) on nineteenth-century women writers. She is coeditor of the volume *Face-à-Face: Cultural, Intellectual, and Political Exchanges between Brazil and France*. She has organized numerous film exhibits at UNCW and is preparing a book on Brazilian women directors.

Nadia Lie is professor of Latin American literature and film at the University of Louvain/KU Leuven. She is the author of *Transición y transacción. La revista cubana 'Casa de las Américas'* (Gaithersburg, Md./Leuven: Hispamérica/Leuven University Press, 1996), and coeditor of several volumes in the field of comparative literature, the most recent of which is *Transnational Memory in the Hispanic World* (Cambridge University Press, 2014). Since 2013, she directs the European project "Transit. The transnational dimension of contemporary Hispanic culture in the XXth and XXIst centuries" (http://projecttransit.eu/). She is currently working on the figure of travel in contemporary Latin American cinema.

Carolin Overhoff Ferreira is professor of contemporary cinema at the Department of Art History, at the Federal University of São Paulo. She has been Assistant Professor at the Portuguese Catholic University, visiting professor at the University of Coimbra, Berlin's Free University, and lecturer at the University for Applied Arts and Design in Hanover. Her books include *Identity and Difference—Postcoloniality and Transnationality in Lusophone Films* (2012), *Diálogos Africanos: um Continente no Cinema* (2012), *New Tendencies in Latin-american Dramaturgy* (1999), and *Cinema Português – Aproximações à Sua História e Indisciplinaridade* (forthcoming), as well as the editor of *O Cinema Português através dos Seus Filmes* (2007), *Dekalog – On*

Contributors

Nuno Barradas Jorge is a PhD researcher at the Department of Culture, Film and Media at the University of Nottingham (UK), studying the work of Portuguese filmmaker Pedro Costa and global trends in contemporary art cinema. He holds an MSc in Multimedia from Nottingham Trent University and an MRes in Film Studies from the University of Nottingham. He has contributed chapters to *Directory of World Cinema: Spain* (ed. Lorenzo J. T. Hortelano, Intellect, 2011) and *El Juego con los Estereotipos* (ed. Nadia Lie et al., Peter Lang, 2012), and served on the editorial board of *Scope: An Online Journal of Film and Television Studies*. His research interests encompass global art cinema, contemporary Iberian cinema, artists' film and video, and the impact of new technologies in contemporary independent filmmaking.

Álvaro Baquero-Pecino obtained a double degree in Hispanic Philology and Literary Theory and Comparative Literature from the University of Granada, Spain. He also earned a MA in Spanish from New Mexico State University, and received his PhD from Georgetown University. His main research interests include crime fiction, psychoanalysis, trauma narratives, immigration, and transatlantic studies. He is currently working as an Assistant Professor at the College of Staten Island of The City University of New York (CUNY), where he teaches Spanish, Literature, and Film Studies.

Marcus Brasileiro is Assistant Professor at the Utah State University. He received his PhD from the University of Minnesota in Luso-Brazilian Literature and Cultures. He has published on the works of João Gilberto Noll, Silviano Santiago, Torquato Neto, Clarice Lispector, Graciliano Ramos, and Mário de Sá Carneiro. His main research area of interest deals with issues of subjectivity, displacement, gender, and sexuality in contemporary Brazilian cultural productions.

Jack A. Draper III is Associate Professor of Portuguese at the University of Missouri. He is the author of *Forró and Redemptive Regionalism*

Filmography

Carvalho, Walter (2009). *Budapeste*. Brazil, Hungary, and Portugal.
Costa, José Fonseca e (1996). *Cinco dias, cinco noites/Five Days, Five Nights*. Portugal.
Costa, Pedro (1997). *Ossos/Bones*. Portugal.
———. (2000). *No quarto de Vanda/ In Vanda's Room*. Portugal.
———. (2006). *Juventude em marcha/Colossal Youth*. Portugal, France, and Switzerland.
Filho, Daniel (2009). *Tempos de Paz/Peacetime*. Brazil.
Garanian, Gary, Cesar Garanian, and Cassiana Der Haroutiounian (2012). *Rapsódia Arménia/Armenian Rhapsody*. Brazil.
Gomes, Marcelo (2005). *Cinema, Aspirinas e Urubus/Cinema, Aspirins and Vultures*. Brazil.
Gomes, Miguel (2012). *Tabu/Taboo*. Portugal, Germany, Brazil, and France.
Kogut, Sandra (2001). *Um passaporte húngaro/A Hungarian Passport*. Brazil, Belgium, Hungary, and France.
Monjardim, Jayme (2004). *Olga*. Brazil.
Pimentel, Vasco, Inês Gonçalves, and Kiluanje Liberdade (1999). *Outros Bairros/Other Neighborhoods*. Portugal.
Ribeiro, Artur (2001). *Duplo Exílio/Double Exile*. Portugal.
Salles, Walter, and Thomas, Daniela (1996). *Terra estranheira/Foreign Land*. Brazil and Portugal.
Solberg, Helena (1995). *Carmen Miranda: Bananas Is My Business*. Brazil.
Teles, Luís Galvão (2004). *Tudo isto é fado/Fado Blues*. Portugal.
Yamasaka, Tisuka (1980). *Gaijin. Caminhos da Liberdade/Gaijin. A Brazilian Odyssey*. Brazil.
———. (2005). *Gaijin II: Ame-me como sou/Gaijin II: Love Me as I Am*. Brazil

Mendible, M. (2007) "Embodying Latinidad—An Overview," in M. Mendible (ed.), *From Bananas to Buttocks: The Latina Body in Popular Film and Culture*. Austin: University of Texas Press, 1–28.

Nichols, B. (2001) *Introduction to Documentary*. Bloomington: Indiana University Press.

O' Neil, B. (2005) "Carmen Miranda: The High Price of Fame and Bananas," in V. L. Ruíz and V. S. Korrol (eds.), *Latina Legacies: Identity, Biography, and Community*. New York: Oxford University Press, 193–208.

Rapport, N., and A. Dawson. (1998) "The Topic and the Book," in N. Rapport and A. Dawson (eds.), *Migrants of Identity*. Oxford: Berg, 3–17.

Roberts, S. (1993) "The Lady in the Tutti-Frutti Hat: Carmen Miranda, A Spectacle of Ethnicity," *Cinema Journal* 32(3): 3–23.

Rubin, G. (1975) "Traffic in Women: Notes on the 'Political Economy' of Sex," in R. R. Reiter (ed.), *Toward an Anthropology of Women*. New York: Monthly Review Press, 157–210.

Shaw, L. (2013) *Carmen Miranda*. London: Palgrave Macmillan.

White, H. (1999) *Figural Realism—Studies in the Mimesis Effect*. Baltimore: The Johns Hopkins University Press.

6. As a working-class female artist in a predominantly male milieu, Miranda was seen as déclassé, a fact that very much chagrined the artist and indeed caused the breakup of her engagement with a wealthy Carioca whose family vetoed her assumed vulgarity.
7. According to Stella Bruzzi's terminology, *Waste Land* (2010, dir. Lucy Walker, João Jardim, and Karen Harley) is the quintessential performative documentary. *City of God* (2002, dir. Fernando Meirelles and Katia Lund) is a docudrama, a label that *Carmen Miranda: Bananas Is My Business* has received by many critics before. Bruzzi explains that a docudrama uses extreme realism, in which, "the role of performance is, paradoxically, to authenticate the fictionalization" (2000:153).
8. In this regard, Bhabha's stereotypical colonized entity that "is almost the same, but not quite" mentioned earlier needs reconsideration. Maria do Carmo's drive to be Carmen Miranda exceeded expectations as she is "all that" and much more: faithfully, even if paradoxically, affirming a Latin American *joie de vivre*, also contradicting O'Neil's opinion aforementioned, as Miranda's fun-seeking, flirtation, and flamboyancy efficiently conveys the carnivalesque South American way subverting the Anglo-Saxon stern countenance.

Works Cited

Anderson, B. (1991) *Imagined Communities: Reflections on the Origin and Spread of Nationalism*. London: Verso.
Barsante, C. E. (1985) *Carmen Miranda*. São Paulo: Europa.
Bhabha, H. K. (1998) *The Location of Culture*, London: Routledge.
Bruzzi, S. (2000) *New Documentary—A Critical Introduction*. New York: Routledge.
Castro, R. (2006) "Entrevista Roda Viva." São Paulo: FAPESP. Available at http://www.rodaviva.fapesp.br/materia/200/entrevistados/ruy_castro_2006.htm (accessed May 22, 2014).
Davis, D. J. (2012) "Racial Parity and National Humor: Carmen Miranda's Samba Performances, 1930–1939," in W. H. Beezley and L. A. Curcio (eds.), *Latin American Popular Culture since Independence: An Introduction*. Lanham: Rowman and Littlefield, 176–192.
Drummond de Andrade, C. (2012) "Confidência do Itabirano." *Sentimento do Mundo*. São Paulo: Companhia das Letras.
Enloe, C. (1989) *Bananas, Beaches and Bases: Making Feminist Sense of International Politics*. Berkeley: University of California Press.
Gil-Montero, M. (1989) *Brazilian Bombshell: The Biography of Carmen Miranda*. New York: Donald I. Fine.
Grinberg, L., and R. Grinberg. (1984) *Psychoanalytic Perspectives on Migration and Exile*. New Haven: Yale University Press.
Koeppel, D. (2008) *Banana—The Fate of the Fruit that Changed the World*. New York: Hudson Street Press.

changeable, and flexible one, which a contemporary transnational perspective allows us, one can see her as the work in progress that her career exhibited. This is in keeping with Rapport and Dawson's liberating suggestion:

> For a world of travelers, of labour migrants, exiles and commuters, home comes to be found in a routine set of practices, a repetition of habitual interactions, in styles of dress and address, in memories and myths, in stories carried around in one's head. People are more at home nowadays, in short, in "words, jokes, opinions, gestures, actions, even the way one wears a hat." (1998: 7)

Indeed, one wishes that Miranda could have dispelled the tests and trials from some of her overbearing family members, friends, and Brazilian fans, each claiming a piece of her. Then her quintessential stylized self-fashioning Tutti Frutti Hat could have been the loftiest of homes in which she could have lived happily ever after.

Notes

1. Cássio Barsante's 1985 biographical tour de force must be recognized as the late twentieth-century pioneering work on Carmen Miranda. Martha Gil-Montero's (1989) biography of Carmen Miranda is the other exceptional initiative to give the star a more accurate configuration. Barsante's testimonial features in Solberg's film, and Gil-Montero's book is acknowledged in the film's credits as the basis for the director's narrative.
2. Carmen Miranda as a personification of Latin America brings to mind Homi Bhabha's (1998) comments on the ambivalence of colonial discourses that demand a recognizable rather than a radical difference. Adorned by exuberant colors and stifled by gigantic fruit salads, Miranda as an Other was made to look innocuous—both affirming her originality and emphasizing her displacement: "colonial mimicry is the desire for a reformed, recognizable Other, as a subject of a difference that is almost the same, but not quite... The success of colonial appropriation depends on a proliferation of inappropriate objects that ensure its strategic failure, so that mimicry is at once resemblance and menace" (122, 123).
3. See Lisa Shaw's (2013) book *Carmen Miranda* for an analysis of ways in which Miranda's star image was commodified (83–104).
4. Gil-Montero points out that as a star, Miranda ranked sixth in Hollywood after Tyrone Power, Sonja Henie, Betty Grable, Jack Benny, and Alice Faye.
5. *Baiano* or *baiana* are those born in the state of Bahia, recognized in Brazil for its African roots. *Baianas* are known as regional characters—with some stereotypical undertones—similar to the southern *gauchos*, rural *caipiras*, and *malandros* from Rio de Janeiro.

behind usually remains as an idyllic background in which all that is good was renounced and discarded. It is in this context that the émigré is also seen as a deserter. To evoke the poetic image of another illustrious migrant, Carlos Drummond de Andrade (2012), in his oft-cited poem *Confidência do Itabirano* (The Itabirano's Confession), we can say that home becomes a photograph on the wall (10); it acquires romanticized contours and proportions larger than life, though at times less in the émigrés' mind than in the minds of those who stayed. The poignancy of these images, perhaps continually reiterated by the latter, lead the émigré to forget the wounds that both pushed for the departure and prevents the wholehearted, honest impetus to return— the quintessential betrayal the émigré inflicts on him/herself, further rubbing salt into the wound.

Those who plead for the émigrés' return try to compel the latter with the belief of a chimeric love of place they themselves do not realize is a construct. In this connection, Rapport and Dawson (1998) rightly question the notion of "socio-cultural 'places'" (4), which is usually found in anthropological discourses, but is rather useful here to give shape to the guilt-stricken psyche of the émigré—possibly the snare in which Miranda was caught. They fittingly comment that "the image [of such place] may never have been more than a useful ideology that served the interests of (some) local people, and a provisional myth that was animated by the practices of (some) [nationalists]" (4–5). In fact, this agrees with the ideological creed of nationalism of the Vargas era in which Miranda, her family, and friends were immersed. It is well known that at the cultural level there was an overt attempt in this period to produce and reproduce artifacts to convey a sense of a Brazilian community—songs that Miranda herself sang in the 1930s were part of this national project. With their understanding of the role of the anthropologist's authority creating autonomous totalities in the anthropological fieldwork, Rapport and Dawson open another dimension with regard to Benedict Anderson's (1991) insight into the ideological underpinnings of his concept of "imagined community." Not only do individuals in a given society enter into this somewhat unavoidable, imagined sharing of character traits and rituals of belonging, but individuals identified with them will treat the émigré as a pariah. And this is how Solberg's report of a national loss in the event of Miranda's departure implies a previous ownership, typical of sociocultural beliefs like those promoted in the nationalistic Vargas era.

Carmen Miranda's trajectory demonstrates that she was beyond these fixities. She was a traveler identified with a suitcase full of *Baiana* costumes. With the view of Miranda's life as an adaptable,

however was a Miranda who Solberg seems to keep as an indentured fruit seller, unable to buy her autonomy, coming back from the United States looking for her bowl of soup and freedom to sing—an innocuous Miranda. This is what her narrative reveals: the figuration of Miranda to whom she, on behalf of her upper-class counterparts, is able to apologize.

But Miranda's friend Joanne Allen nails it in her testimony in *Carmen Miranda: Bananas Is My Business* when she states that Miranda indeed attracted a lot of suitors but never gave too much attention to them since, in her perception, "she didn't want to be domesticated." In the same segment of the film, Allen says that business-driven Miranda, instead, had studio executive Darryl Zanuck wrapped around her finger and used her powerful charisma to attain the position of "mistress of 20th Century Fox." And to conclude this segment, as the ultimate recognition of Miranda's capabilities beyond that of a fruit vendor, the documentary exhibits some organ of the press at that time admitting her acumen: "Somewhat to its astonishment Hollywood has found out that Carmen Miranda is not just the latest in a long line of South American passion flowers [*sic*]. Under that basket of fruit and vegetables, a well-oiled little brain is ticking away—now she's the highest paid gal [*sic*] in the U.S." Thus it is all the more interesting to hear Solberg insisting on Miranda's heavenly desire for a bowl of soup.[8] As regards Miranda's probable desire in relation to her nationality, suffice to say that Miranda was denied a Brazilian passport until two years before her death (Davis 2012: 241). Although her success was proof of her resilience—as she possessed a gentle and pliable appearance, Miranda often concealed her problems behind her smile—it is fair to deduce that she endured a great deal of stress. Perhaps her dislocation was rather due to not being able to enjoy the fruits of her labor without the ability to "go home." Experienced by those who migrate, the psychological pain of such an inexorable displacement Grinberg and Grinberg (1984:185) call the "wound of return":

> For voluntary émigrés or former exiles, the dilemma of whether or not to return is not easy to resolve. Even for those who ardently desire it with every fiber of their being, for those who have been homesick and cherish the vivid images of their people, their country, for those who dreamed day and night of being reunited with everything they left behind—the decision is bound to be difficult. (184)

The concept of returning implies, furthermore, a stationary, fixed home: not only inert but a fantasized one—the country that was left

the Rubicon, as the saying goes, she chose paths of irreversible consequences and no return. Miranda's fate was not determined by the fact that she brought back the image of the indigenous American as the fruit bearer imagined by the European colonizer, as Solberg mentions. Fruit vendors carrying a basket full of produce on their heads was a domestic reality since the servitude times when enslaved Africans were allowed by their masters to make some money by selling goods on their own as *escravos de ganho* (slaves who took to the streets to earn money for their masters as sellers of goods). With this arrangement these slaves were allowed to keep part of their daily fare and eventually buy their freedom—Miranda's *baiana* costumes portray them. If there is such a thing as a manifest destiny, and to play along with this myth, the manifest destiny for Miranda was rather due to her own superior talents, ability to refashion herself, and her good fortune too, to be in the right place at the right time. Hermes Pan, renowned choreographer of names such as Fred Astaire and Ginger Rogers, thought Miranda had no real dancing or singing gifts if compared to the rather over-the-top style of American singers and dancers. But he devoted himself to emphasize her inimitable flair because he endorsed her absolute originality (Gil-Montero 1989: 132).

Miranda was an overachiever admired by her American peers for her resilience, self-discipline, stamina, and not least for her love of making money. In his *Roda Viva* interview, Ruy Castro (2006) reveals that her business acumen was noticeable from the time she negotiated her contracts with Joaquim Rolla, owner of Cassino da Urca. Castro retells what she proposed to Rolla: "I will sing at your Cassino two times a night during thirty days and will not repeat a single dress. Women will come to see me and my dresses and will bring their husbands who will gamble on the roulette." Castro also informs us that Miranda was a 1930s fashion icon in both Rio de Janeiro and Buenos Aires who created her own outfits; ahead of her time, she dared to wear suits with a masculine touch—this is not much later than the time when Coco Chanel was creating her legendary suits for women.

Tellingly, Solberg's film ends with Synval Silva's 1940 song "Adeus Batucada" (Farewell Batucada), which he created upon the request of his close friend Miranda. The song laments the separation from the samba rhythm as the most painful. In the tradition of samba, the song exalts the sambista lifestyle but also evokes one of the core figurations around which Solberg built her film. This figuration is found in the phrase "Jóia que se perde no mar / Só se encontra no fundo" (Jewel that is lost in the ocean / is found only in the depths). The national treasure that was lost with the departure of the Pequena Notável

a documentary requires opting for a certain version of the facts. The notion that facts are arranged in a self-referential, relational connection is an example of reflexivity, in the sense that some narrative effects implicate their cause. In other words, they are posed similarly to the ordinary notion of a self-fulfilling prophecy: one starts with a belief that unfolds into adjusted events.

About the process of historical construction in which *Carmen Miranda: Bananas Is My Business* partakes as a construction of a past event, Hayden White (1999) notes how history unfolds by presupposing a figure ultimately fulfilled by the resulting narrative whose outcome is a mimetic truth. He says: "A given historical event can be viewed as the fulfillment of an earlier and apparently utterly unconnected event when the agents responsible for the occurrence of the later event link it 'genealogically' to the earlier one" (89). The fulfilling narrative is the consummation of the unfolding of a figure supposed in advance. This view of historical discourse to which documentaries are linked agrees with the description Stella Bruzzi (2000) offers of performative documentaries. Using the performative notions of Judith Butler's work, who bases her concepts on J. L. Austin's speech act theories, Bruzzi asserts that performative documentaries "function as utterances that simultaneously both describe and perform an action" (154).[7] In this regard, Solberg's film is performative. As Bruzzi adds in her own explanation, this is so because Solberg's film "is given meaning by the interaction between performance and reality" (idem). In *Carmen Miranda: Bananas Is My Business* this contact between performance and reality occurs in the final revelation of the harmonizing of Solberg's mother with Miranda. Through the voice of her mother, Solberg produces a long-due and historical apology from the upper-class Brazilians who wronged the working-class Carmen Miranda. Even if at some points Solberg casts a patronizing gaze on Miranda, even if her timid feminist voice could not understand Miranda in her own currency—that is, as a foreign actress who became an icon of the stature of other foreign performers such as Greta Garbo, Ingrid Bergman, and Marlene Dietrich, not to mention all the other *Latinas*—her film performs this important historical regret. And thus *Carmen Miranda: Bananas Is My Business* ends by informing that Solberg's mother is reconciled with the Queen of Samba.

Migrant Subjectivity

Once Carmen Miranda left Rio de Janeiro for Broadway, unbeknownst to her, as it happens to all those who leave their homeland, she crossed

could I ever be Americanized? / I was born with Samba / I spend nights singing old songs / Hanging out with hustlers."

Miranda's mission to prove her point, value, and buoyancy were accomplished in her final Urca show. (Incidentally, that value and buoyancy lasted for years to come.) Then, Miranda left for greener pastures in a self-chosen exile in Hollywood. With the proposal of a highly paid contract to make several films with 20th Century Fox, she left Brazil for more than a decade. Solberg does not show her honeymoon with Hollywood. But Gil-Montero captures her delight with her new life and shows the scope of Miranda's ambition in this response to an interview: "In Hollywood, I present myself to the world for the first time. Of course I have been on the air and in the theatre, but then I present myself only to the few. In Hollywood, it is to all the whole world.... Dios, I have die[d] and gone to Paradise!" (1989: 126, 129).

Carmen Miranda:Bananas Is My Business could have presented the manifold reasons for Maria do Carmo's downfall, besides her *saudades*, which was truly unshakable. "It was not exploitation that killed Carmen Miranda... She was better when she was working than when she was not working," says Aloysio de Oliveira (quoted in Gil-Montero: 202–203). Solberg accurately shows that it was Miranda's dependence on stimulants and sedatives and the electroshocks she underwent that put her life at risk. But in the film, we see a rather Manichean view that does not discuss, for instance, Miranda's own addiction to working and thirst for making money; her unyielding hypochondria, her withdrawn personality preventing her to open up to those who were close to her, her increasing stage fright, her overbearing family watching her every step and scrutinizing her marriage, and finally her mother's abandoning her and leaving for Brazil right when she was about to have her serious mental collapse. The film implies that David Sebastian is the villain who maneuvered his way into her life to take advantage of her, which several friends who surrounded the couple denied (Gil-Montero: 197, 242). And indeed her sister Aurora and friend Aloysio attest to the fact that Miranda often complained about an anxiety that she herself could never understand or come to terms with (Gil-Montero: 231).

Of course, there is a limit to what can be included in any narrative piece. And the director of *Carmen Miranda: Banana Is My Business* may have refrained from adding certain details, understandably, in respect to Miranda's heirs—ultimately, truth is an enhanced, vacillating reality. My intention in collating versions of Miranda's life, however, is to demonstrate that a second documentary could emerge in the course of the analysis of one documentary, so to say, as assembling

again reiterates her status as a member of the ruling class.[6] Mentioned in the film, Solberg's mother was a good example of the conceited bourgeoisie that despised the samba bas-fond, which was Miranda's milieu. In an effort to flatter, Solberg even expresses her envy of the ease with which Miranda successfully circulated in the male-dominated, competitive world of the samba music business. As she lived in the same environment with *sambistas* (samba musicians), Miranda had effortless access to their creations; being white and thus able to circulate in the middle class phonographic world, she worked as a skillful conduit between these two worlds (Davis 2012: 177).

It is this early in her career that Miranda revealed her knack for business and exhibited her drive to shine as an artist. Gil-Montero rightly supposes that it may have been impossible for the patronizing elite to fathom the concept that Carmen Miranda "was an enterprising young woman who had grown rich legitimately" (1989: 222–223). This disbelief seems to underlie also Solberg's assumptions as she apparently cannot get around the fact that Miranda's desire and ambition went beyond the craving that the director repeats was for a "bowl of soup and the freedom to sing." The replication of this motto in the film blinds Solberg to the complex set of circumstances responsible for the star's eventual downfall. By doing so, Solberg almost annuls furthering her ingenious insight, namely the grasping of the fact that Miranda belonged to the working class and the provincial and greedy Brazilian high society present at Cassino da Urca in that fatidic night denied her a deserved welcome and feeling of belonging.

Carmen Miranda did get extremely offended and depressed with the episode at Urca and was not at all casual about the derision she experienced: "Money was not enough; she wanted love, and glory, and the thrill of manipulating her audience" (Gil-Montero: 107). And so she deliberately prepared a retort by asking her friends to compose new songs for her. She then scheduled a week-long new show for Cassino da Urca before going back to the United States. The repertoire included famous songs that responded to criticism leveled at her, such as "Disso é que eu gosto" (This is what I like), "Diz que tem" (She says she has it), and "Voltei p'ro morro" (I'm back to the hills) with Vicente Paiva's lyrics, all of which presented themes reaffirming Miranda's love for and belonging to Brazil. The most representative song that spelled out all that she needed to get off her chest though was "Disseram que eu voltei americanizada" (They said that I came back Americanized), also a Paiva composition, which was the highlight of the show and the talk of town. It directly addressed the press' negative campaign, which she only barely tolerated in this manner: "How

to prove different, Solberg herself is part of the ruling class that ultimately despised everything associated with the populace, including samba. That is, by origin, Solberg partakes in the socialite audience who deemed embarrassing Miranda's performances in the United States: how could she have dared to represent them (the Brazilian upper class) as a goodwill ambassador? Solberg includes journalist Caribé Rocha's telling of the inhospitable reception Miranda experienced when she visited Rio de Janeiro in 1940, one year after she had left for Broadway, an event that the film construes as an additional setback contributing to Miranda's heartbreak. At first, Rocha explains, the press attacked the official welcome the government prepared for a mere samba singer. In addition, Rocha also characterizes the climate as filled with confusion and therefore absolutely unfavorable for the homecoming of the star: "As good Brazilians, we thought that Miranda had not been successful despite the fact that all telegraphic agencies had registered her exceptional triumph. But nobody accepted this—and this was mainly because at the time in Rio de Janeiro and in Brazil samba was a black thing, a favela thing."

In Solberg's film, besides the humiliation that Miranda endured when her Cassino da Urca presentation dissolved into heckles, Rocha adds that as the mouthpiece of the upper class, the press legendarily criticized her Americanized ways. As he points out, subsequently and more paradoxically, the press also lamented the loss of "our Carmen." Solberg does not analyze this point; she utters a cagey comment and rather eschews it: "Miranda will never understand what really happened; the contradictory critics, the severe judgment, maybe jealousy." Gil-Montero, though, is right on target with her comment on this episode, pointing out the unequivocal forces at work:

> Indeed, that night in Urca, some envious Brazilians chastised the singer for her unbelievably fast rise to popularity at home and abroad. The most prominent members of Brazilian society rejected the Portuguese immigrant because she was a fake Bahiana and a fake Carioca. The wealthy and the cultured showered their elegant disdain upon the daughter of a humble barber. (1989: 222–223)[5]

The high society who turned their back on Miranda that night could not cope with their inability to embrace Miranda's conquest of the mecca that is stardom.

In her narration, however, Solberg poses as a mediator between generations to connect the 1995 audience of her film and those who deemed Carmen Miranda of inferior social status—a stance that once

my natural color...they bleach you in Hollywood...and don't forget, people: I make my money with bananas...So, very glad to bleach you." The 1950 Ray Gilbert and Aloysio de Oliveira's song "I Make My Money with Bananas" also adds to this point. With light sarcasm, and despite Miranda's awareness and considerable power as a first rank-star, the song confirms the studio executives' upper hand, and this part of the song shows[4]: "I'd love to play a scene with Clark Gable / With candle lights and wine upon the table / But my producer tells me I'm not able / 'Cause I make my money with bananas."

But Roberts also convincingly defends the idea that the mise-en-scène that became the mandatory mask imposed on Miranda was handled by the artist herself, who was fully in control of her persona. Roberts suggests that Miranda-the-actress staged herself as the iconic-Carmen-Miranda, and in Roberts' analysis, Miranda employs the feminist concept of masquerade to overcome the idea of both an essential femininity and ethnicity:

> Studies on masquerade attack the idea that an essential feminine exists prior to the concept of "woman" as constituted in any age. Masquerade mimics a socially constructed identity in order to conceal, but at the same time to indicate, the absence that exists behind the mask and ultimately to discover the lack of any natural gender identity. Similarly, ethnic masquerade works to undermine the concept of ethnic essence. (1993: 15)

And this observation is corroborated by what Aloysio de Oliveira, Miranda's intimate friend and partner in the band *Bando da Lua*, perceived of his costar's persona. According to de Oliveira, "[Maria do Carmo] never went out without putting on something that suggested Carmen Miranda's personality; everywhere she went she was careful to project that image. She was one hundred and fifty percent professional; no detail escaped her" (quoted in Gil-Montero 1989: 221). It may not be the case, then, as Solberg contends that inside Miranda a truer core could be found, a different and more humane Maria do Carmo Miranda da Cunha, once one penetrated the Carmen Miranda Technicolor image.

Solberg's Voice: Confessions of an Upper-Class Girl

From the outset, Solberg sets the tone of her film, describing the gap that separates her upper-class upbringing from Miranda's working-class origins and ultimately exposes the fact that, although wanting

presented served to cover sociopolitical differences not only between the United States and Latin America but also within the United States (1993: 9). With this context in mind, Roberts notes the racial and cultural issues raised in Miranda's time:

> The popular press described Miranda in terms of the physical, of the body-as-wild, savage, and primitive, like an exotic animal, "enveloped in beads, swaying and wriggling..., skewering the audience with a merry, mischievous eye"...Certain elements of Miranda's star text were emphasized and repeated in her films and extra-filmic publicity material, and the same elements were noted (with pleasure) by fans and reviewers. These elements centered on her look, especially her bright, multi-textured outfits, and on her voice..., as pure sound as opposed to any message she communicated. (9)

In her impressive archival work, Roberts uncovers these critics' difficulty in putting the singer's unusual cheerfulness into words. More often than not, they opted for depicting her "as overwhelmingly sexy and sexual" (1993: 10). What Roberts notices in these critics' impressions and dialogues within a *Bananas Is My Business*' standpoint but in a different direction is confusion: "In trying to peek 'inside' Miranda..., critic[s] cannot imagine a subjectivity behind her ethnic, feminine mask, except for this stereotype of raw, yet consumer-oriented, primal drives" (11). With her film, Solberg tries to fill out the empty container left by the stereotyping action. Nevertheless, Roberts explains that, it is true that Miranda's "star appeal" eventually was manipulated to fulfill the Good Neighbor's propaganda; that the energy of Miranda's Broadway period had to be reshaped when she moved on to Hollywood in order to help the American public deal with a foreign brunette as a sex symbol; this role was typically reserved for the American blondes, as brunettes usually portrayed the Eastern European political enemies (12).

In her film, however, Solberg also shows Miranda's cleverness regarding her star status by threatening to lose her accent when negotiating contracts with 20th Century Fox's executive Darryl F. Zanuck, or when the *Carmen Miranda: Bananas Is My Business*'s director demonstrates Miranda's astute perception of her part in the Hollywood puzzle in two significant phrases with which she ended an interview. The footage included in the documentary exhibits the image management that actors have always undergone in Hollywood, especially the well-known whitening process that "ethnic" actors needed to endure. After having confirmed to her interviewer that she did have hair under her turban, Miranda showed her shiny mane and said: "But this is not

modern incarnation of this image, thereby implying with this analogy in her movie that yet another conquest and usurpation happened that compares to the occupation of America by the European. Only, in this second round, Miranda as the bearer of nature was seized and relocated to the United States. Today, we are left with a less glamorous Chiquita featuring in American kitchens. More importantly though, Miranda also signifies the complexity of the banana commodity chain, which involved the United States banana production oligopoly (Chiquita, Dole, and Del Monte) that seized land and forced labor in the tellingly named Banana Republics. Undeniably, Miranda stands for all labor migrants who toil as fruit pickers in the United States today. In other words, by comparing Miranda to the mythical bearer of nature, Solberg does allow us to see this side of the Pequena Notável, that is, as a twentieth-century stylized personification of both unfinished goods and corporeal strength. This certainly goes along with the reality of those who themselves are overworked to exhaustion in agriculture—Solberg implies that overwork too caused Miranda's death. Thus, reading Miranda's life against the glory she attained in Hollywood, as if able to pinpoint Miranda's innermost yearning, the director quotes the artist several times, in voiceover, as wanting merely "a bowl of soup and freedom to sing." And so, in her well-documented film, Solberg tirelessly tries to rescue the manifold actuality that would have remained intact beyond Miranda's glitzy image and searches for something like a soul, culture, and home that sustained the more genuine individual named Maria do Carmo Miranda da Cunha at birth. To her credit, Solberg finds that this is an impossible task.

Behind the Masquerade

As an expatriate in the United States whose stylized tropicality purportedly aimed at turning foreignness palatable, Miranda, in fact, reveals a facet that is more complex. Her downfall certainly stands for the immigrants who worked (and still work) to the point of absolute fatigue as Solberg's film shows. But her renown also calls to mind the immigrants who made (and still make) the system work for them to assert their own agency. In her seminal and thoroughly outstanding 1993 analysis of the Carmen Miranda star text, Shari Roberts also considers the elements of Miranda's persona that negotiated with the abused inner self that we see in Solberg's film. Of course, Roberts analyzes the "spectacle of ethnicity" that Miranda's appearance portrayed in the wartime musicals and how the homogeneity that these musicals

Hawaii, the Philippines, Puerto Rico, the Dominican Republic, Cuba, and Nicaragua" (124). Another noteworthy analysis of the Miranda phenomenon akin to Solberg's viewpoints is Brian O'Neil's (2005) opinion that the performance of the Lady in the Tutti Frutti Hat standing for Latin Americans "could hardly be characterized as respectful or nuanced"; her portrayals, he says, presents "Latinos as perpetual fun-seekers, flirts, and flamboyant dancers" (203). These assessments, as is noticeable, represent Miranda as defenselessly manipulated by the American entertainment industry in complicity with the government's needs. I contend that these Latin American readings of Miranda comply with the main thesis of Solberg, which poses one of the top artists of her time as a victim on many levels. As is often the case with such historical reconstructions though, there are angles to this story suggesting a view of Miranda that goes beyond the reluctantly exploited and unprivileged Latina caught short.

In fact, Miranda went along with the situation offered to her and indeed made money with bananas. Lots of it! Despite the facile play with words, Miranda's Hollywood numbers became as much a monoculture as the banana fields growing in Central America in which the film industry consciously or subconsciously based its ornamental tropical paradises. The executives behind the creation of these wartime musicals, filled with lavish Technicolor choreographies—for which Carmen Miranda became a poster girl—often times had nothing in mind but offering sheer escapism. Their films were designed to offer an outlet for the general public to take their "minds off the atrocities of war and stimulate the will to survive and enjoy life" (Gil-Montero 1989: 116). The Brazilian Bombshell also became the poster girl for a host of other fashionable items—beyond the bananas—which added large sums to her already hefty salary (125).[3] Dan Koeppel (2008) indeed chronicles the rise of bananas to prominence on the American table at this time, and highlights the brand Chiquita designed after Carmen Miranda behind the United Fruit Company's further pursuit of the multimillion banana business in Central America (75, 116–117).

Solberg presents Miranda in her film as recognizing with self-deprecating humor that she merely made her money with bananas. In this regard, the director makes an ingenious observation when she associates the Lady in the Tutti Frutti Hat with the view that European travelers used to characterize the natives of America. Since the sixteenth century, a host of images circulated in Europe that showed versions of an eroticized woman as the keeper of nature. In this segment of the film, Solberg mentions that destiny made Carmen Miranda the

A Gendered Ethnic Spectacle

In her film, Solberg puts together a great deal of significant visuals and testimonials of those close to Miranda, and shows the Pequena Notável primarily as the seal placed on the Good Neighbor Policy. In this regard, Solberg's insight is in line with Gayle Rubin's (1975) precise explanation of the social structures at work that make women the trafficked object of men. As this anthropologist notes, there is "a systematic social apparatus which takes up females as raw materials and fashions domesticated women as products" (158). To follow Rubin's fitting observation in relation to the crafting of Miranda as a product in the American film industry, critic Cynthia Enloe (1989) echoes Solberg's observation, adding that "propaganda and censorship agencies urged the entertainment industry to promote Latin actors and popularize Latin music" (127). By the way, that was also true with entertainers who divulged national themes in the Brazilian entertainment industry during the Vargas era; Miranda was one of them. Within this main framework, Solberg chronicles Miranda's trajectory as a disintegration due to the lack of a vital substance missing for her, mostly owing to her uprooting from Brazil and dislocation to the United States.

Although reductive in view of the ultimate position of this essay, Solberg's perspective had an impact on the scholars of Latin American Studies, who have long considered Miranda as a gender and ethnic paradigm. For example, when Myra Mendible (2007) cites Pablo Neruda's irony in relation to the banana business that enslaved workers in Central America, she also remarks his gendering allusion to a woman's body. When Neruda says "The most succulent item of all/ The United Fruit Company Incorporated /reserved to itself...the delectable waist of America," Mendible finds in the reference to the fertile section of the American continent an allusion to the exposed mid-section of Miranda's body (7–8). In her article, Mendible thus points out the notion of a gendered territoriality that can be seen as the Latina's body standing for an occupied ground. In Miranda's case, this meant typecasting her as a standardized figuration of Latin America, and so the performer's liveliness and enthusiasm were perceived as intended to create the idea of a harmless and eager-to-please Central and South Americas.[2] Mendible also notes that this was a very useful public relations move at the time due to the criticism directed against the United States' aggressive pursuit of raw materials in various tropical regions of the world. In this regard, Enloe observes also that "[b]etween 1880 and 1930, the United States colonized or invaded

the tragedy of a national loss for Brazil. The film attempts to express the sentiments of the Brazilians who were left behind and deeply felt Miranda's absence. Somewhat still under the spell of the nationalist ideology that was pervasive in Brazil in the Vargas era (1930–1945), in Solberg's documentary, Miranda is sorrowed for as if she had been conquered by the *Yankees*.

In this chapter, I question a few claims presented in *Carmen Miranda: Bananas Is My Business*. First, I focus on the ambiguous gender and ethnic texts embedded in the spectacle that the phenomenon Carmen Miranda conveyed, and which, in her film, Solberg intimately connects to the Good Neighbor Policy (1933–1945) between Getúlio Vargas and Franklin Roosevelt's (1933–1945) administrations, which established a closer cooperation within the Americas. With a careful examination of the original footage of Miranda's appearances, and to a great extent, guided by issues found in Martha Gil-Montero's (1989) *Brazilian Bombshell: The Biography of Carmen Miranda*, the director concentrates on the political use that was made of Miranda—one of the causes of her downfall—and sets the goal to reclaim the real, vulnerable person behind the character.

Second, I probe beyond this view of Miranda as a victim to emphasize her agency in creating her own artistic persona. Next, this chapter examines Solberg's stance as an upper-class narrator who recognizes the disdain with which Miranda was treated in her 1940 presentation at Cassino da Urca—the director contends that this was another of the key blows adding to Miranda's demise. I see Solberg's attempt to restore Miranda's reputation in her film as a reduction of the Pequena Notável's international celebrity to a humble local product, so to say, yearning to return to her native environment. When compared to the image of the successful "Brazilian Bombshell" that Gil-Montero offers, Solberg's rendition surfaces as a denial of Miranda's dignity and splendor.

I look beyond Solberg's Brazil/United States dispute over Miranda's legacy and consider the performer's position from a contemporary, more fluid perspective. Miranda is indeed an integral part of both the Brazilian radio and American musical eras, but what is more, she occupies a chief position alongside a cast of celebrities who shaped the view of Latin Americans in the United States. Instead of grieving Miranda's departure as the loss of a Brazilian key cultural ingredient for the American culture, I suggest that we look at her as an émigré whose life is an illustration of what I term a migrant subjectivity—someone whose transience does not allow for an anchored identification.

11

THE MIGRANT IN HELENA SOLBERG'S *CARMEN MIRANDA: BANANAS IS MY BUSINESS*

Regina R. Félix

When engaged in reconstructing wronged historical characters or obscured events, a documentary constitutes a powerful tool in the remaking of history. In his introductory treatment of the documentary genre, Bill Nichols (2001) detects what sounds like a truism but should never be overstated. That is, in this historicizing task, despite their objective appearance, documentaries present a specific stance: they "seek to persuade or convince" (43). Nichols also observes that usually documentaries focus on topics "about which we as a society remain divided" (74). These claims fit the case of Helena Solberg's 1995 documentary *Carmen Miranda: Bananas Is My Business*. In her outstanding film, Solberg's rendition of Carmen Miranda, torn between Brazil and the United States, is one of the first serious attempts at probing deeper into the sensational international name that Miranda became.[1] The film does a great job reshaping the understanding of present-day Brazilians about the *Pequena Notável* (Little Wonder) who has been for decades incongruently missed by Brazilians, even though she was also deemed a deserter by them.

Carmen Miranda: Bananas Is My Business recasts the rags-to-riches trope in its more commonly watched version in the media: the rise and fall of a celebrity, from the humble beginnings of a uniquely talented young woman, followed by a hasty and inconsequential rise to stardom, unequipped management of fame, and finally a decline and death by medical drug abuse. If in the callous milieu of American celebrities the eventual collapse of stars is part of the high-end game, Solberg suggests that in Miranda's case, instead, what occurred was

Lesser, J. (1998) "Jews are Turks who Sell on Credit: Elite Images of Arabs and Jews in Brazil," in I. Klich and J. Lesser (eds.), *Arab and Jewish Immigrants in Latin America: Images and Realities*. London & Portland: Frank Cass, 38–56.

—— (1995) *Welcoming the Undesirables: Brazil and the Jewish Question*. Berkeley: University of California Press.

Lima Soares, R. de. (2006) "Paisagens urbanas, paisagens midiáticas: identidades e alteridades contemporâneas." Online. Available at http://www.eca.usp.br/caligrama/n_5/RosanaSoares.pdf (accessed December 16, 2013).

Martins Pereira, M. L. (2011) "Sobre a hospitalidade e a hostilidade: uma discussão do conflito frente ao imigrante," *Contextos clínicos* 4(1): 9–17.

Rêgo, C. (2005) "Brazilian Cinema: Its Fall, Rise and Renew (1990–2003)," *New Cinemas: Journal of Contemporary Film* 3: 85–100.

Rocha, C. (2010) "Jewish Cinematic Self-Representations in Contemporary Argentine and Brazilian Films," *Journal of Modern Jewish Studies* 9(1): 37–48.

Shaw, M. (2009) "Fernando Morais's *Olga* Translated for the Screen: A Revolutionary in Rio?," *Ipotesi* 13(1): 153–167.

Skidmore, T. (1990) "Racial Ideas and Social Policy in Brazil, 1870–1940," in R. Graham (ed.), *The Idea of Race in Latin America, 1870–1940*. Austin: University of Texas Press, 37–70.

Stam, R. (1997) *Tropical Multiculturalism: A Comparative History of Race in Brazilian Cinema and Culture*. Durham: Duke University Press.

Tal, T. (2012) "Olga Benario Prestes: The Cinematic Martyrdom of a Revolutionary Jewish Woman and the Reconstruction of National Identity in Luiz Inácio 'Lula' da Silva's Brazil," *Women in Judaism: A Multidisciplinary Journal* 9(2). Online. Available at http://wjudaism.library.utoronto.ca/index.php/wjudaism (accessed December 18, 2013).

Tota, A. P. (2009) *The Seduction of Brazil: The Americanization of Brazil during World War II*. Translated by L. B. Ellis. Austin: University of Texas Press.

Tucci Carneiro, M. L. (1988) *O anti-semitismo na era Vargas. Fantasmas de uma geração (1930–1945)*. São Paulo: Editora Brasiliense.

Vieira, N. (1995) *Jewish Voices in Brazilian Literature: A Prophetic Discourse of Alterity*. Gainesville: University of Florida Press.

Ynduráin, D. (2012) "La vida es sueño: doctrina y mito," *Biblioteca Virtual Cervantes*. Online. Available at http://1.www.cervantesvirtual.com/obra-visor/la-vida-es-sueno-doctrina-y-mito/html/81f176bc-a102-11e1-b1fb-00163ebf5e63_7.html (accessed December 19, 2013).

8. In *Global Diasporas*, Robin Cohen notes that Russian Jews, especially workers and intellectuals, joined the Communist and Socialist parties (1997: 17).
9. Shaw quotes Morais, mentioning that Olga and Prestes communicated in French (2009: 159).
10. Shaw analyzes the ways in which this part of the film shows Olga in a more feminine light (161–163).
11. Roberto Elísio dos Santos and João Batista Freitas Cardoso (2011) see it as an example of Globo Filmes' diversified aesthetic.
12. The Brazilian newspaper held by one character reads that American and Russian troops will arrive in Berlin as well as that final arrangements for the remains of President Roosevelt, who had died on April 12, 1945, have been set.
13. Afrânio de Melo Franco (1870–1943), a politician from the state of Minas Gerais, supported the immigration of Europeans, saying in 1892, "O futuro de Minas só depende do aumento da população e de braços para o trabalho; e para a aquisição de braços é que é preciso favorecer a introdução de colonos de raça europeia" (The future of Minas depends solely on the increase of population and arms to work; and to obtain arms, it is necessary to encourage the colonization of Europeans). (Fontana n/p)
14. Before and during World War II, Jewish-Europeans needed visas and sponsorships to migrate.

Works Cited

Bingham, D. (2010) *Whose Lives Are They Anyway?: The Biopic as Contemporary Film Genre*. New Jersey and London: Rutgers UP.

Bletz, M. (2010) *Immigration and Acculturation in Brazil and Argentina (1890–1929)*. New York: Palgrave McMillan.

Cheung, R., and D. H. Fleming. (2009) *Cinemas, Identities and Beyond*. Newcastle: Cambridge Scholars Press.

Cohen, R. (1997) *Global Diasporas: An Introduction*. Seattle: University of Washington Press.

Davidson, J. D. (2012) *Brazil is the New America: How Brazil Offers Upward Mobility in a Collapsing World*. New Jersey: John Wiley & Sons.

dos Santos, R. E., and J. B. Freitas Cardoso. (2011) "Globo Filmes e o cinema de mercado: padronização e diversidade," *Revista Famecos. Midia, Cultura e Tecnologia* 18(1). Online. Available at http://revistaseletronicas.pucrs.br/ojs/index.php/revistafamecos/article/view/8798/6162 (accessed December 16, 2013)

Fontana, L. (n.d.) "História da inmigração italiana." Online. Available at http://www.ouropreto.mg.gov.br/luizfontana/index/index.php?pag=1&&id=9 (accessed December 15, 2013).

Guimarães, A. (2002) *Classes, raças e democracia*. São Paulo, Editora 34.

Europeans, particularly from Central and Eastern Europe, fleeing the war zone, to anti-Semitic policies. *Olga* and *Tempos de paz* depict the implementation of these restrictive immigration laws. Both films present the main characters, who are Central and Eastern Europeans, as conspiring against or presenting values that are different from the notion of *brasilidade* (Brazilianess) promoted by Vargas. By focusing on the plight of these immigrants, *Olga* and *Tempos de paz* shed new light on the immigration process to Brazil in the 1930s and 1940s: in *Olga*, a Jewish-German Communist militant results in her deportation to her native country and eventual death at a concentration camp. In *Tempos de paz*, a Polish World War II survivor, who migrates to Brazil, has to face the arbitrary and unexpected scrutiny of a bureaucrat to gain access to Brazil. Taken together, these films nuance the idea of Brazil as a nation that has always welcomed immigrants. These historical films—one a biopic and another one a fictional film—thus, provide a rare cinematic representation of the immigration policies during the Estado Novo. More importantly, by focusing on immigrant characters, they rescue and represent forgotten voices that constitute the Brazilian socialcultural experience, calling the attention of viewers to Central and Eastern European immigrants.

Notes

1. For more on this, see Antônio Sérgio Alfredo Guimarães' *Classes, raças e democracia* (2002: 109–149).
2. For more on this, see Skidmore (1990: 26–27) and Tucci Carneiro (1988: 83–154).
3. Stam refers to Euro-Brazilians as those who descend from Europeans, particularly those from Portugal. European immigrants, on the other hand, refers to those Europeans who migrated at the end of the nineteenth century and early decades of the twentieth century, from Spain, Italy, and Germany.
4. Lesser holds that "the most hotly debated groups, Japanese, Arabs and Jews, entered primarily between 1900 and 1945, making up about fifteen per cent of all entering immigrants in that period" (1995: 39).
5. For more on this, see Jeffrey Lesser's "Jews are Turks who Sell on Credit" (1995: 39).
6. See Pedro Antônio Tota's *The Seduction of Brazil: The Americanization of Brazil during World War II*, 6–13, for a discussion of the ways in which Brazil veered to the Germanic axis as a means to assert itself away from the foreign demands of American and British foreign policy.
7. Tzvi Tal (2012) argues that Olga has been transformed in Monjardim's rendition into a Christian figure mother.

wealth could also benefit from classical works of art. Ultimately, what makes Clausewitz who he is is his capacity to move others with his performance skills—a talent that contradicts one of Segismundo's statements about immigrants when he tells them, "Vocês não têm nada" (You do not have anything). By accepting his *métier* (profession) and identity, Clausewitz can effectively contribute to his new host society on his own terms. As dos Santos and Freitas Cardoso (2011) state, in its final part, the film "retorna, com delicadeza, à esperança—quando os personagens se reencontram e reconhecem, no teatro, seus defeitos e fraquezas" (returns, carefully, to hope—when the characters get together and recognize, in the theater, their defects and weaknesses) (78). The improvised theater and its audience provide a glimpse of Brazilian society in the middle of the twentieth century: varguistas, their political opponents, and newcomers to the country, all functioning together despite their stark differences.

Clausewitz's admittance into the country seems to put an end to a period of discrimination against European immigrants—mostly Jewish—who sought refuge and a new home in Brazil.[14] Despite Segismundo's attempt to obtain a bribe from Clausewitz and deny him entry, the film's ending highlights the existence of a microcosm in which diversity prevails. Side by side, Brazilians—both varguistas and their political adversaries—and immigrants enjoy Clausewitz's performance. Art acts as the force that can both unify a deeply divided society and ensure the integration of the newcomers. As the final credit rolls, several pictures present European immigrants to Brazil who arrived before, during, and immediately after War World II. Their short bios appear in a still background of the paradisiacal view of the Brazilian coastline, emphasizing the heaven-like features of their new homeland. The immigrants were make-up artists, painters, essayists, and literary critics, while others were mathematicians and scientists, cuing that there was not a policy that restricted access to the Brazilian residency based on profession. While numerous, however, the immigrants' photos and vignettes represent only a small fraction of the mass displacement produced by the war.

Conclusion

Vargas' rise to power, which followed the 1929 crisis, opened up a new period in Brazilian history. Many of the changes that his administration implemented revised the immigration laws that Brazil had held since the nineteenth century. The new immigration laws during the Estado Novo ranged from a quota system that affected those

or affection of those in whom he trusted. It is at this juncture that by listening to Clausewitz's monologue, Segismundo intuitively realizes that in the political machinery of his country, he has become an expendable piece with a dark past. If Clausewitz's hands are devoid of calluses, his are figuratively stained with the blood of the torture he performed and through which he denied the humanity of his party's opponents. After listening to the monologue, he not only opens himself to another subjectivity—Clausewitz's—but also accepts the alterity that the immigrant embodies as different and also as partly incomprehensible, even though his speech was recited in Portuguese. With Segismundo's acceptance of that alterity which Clausewitz personifies, Segismundo grants Clausewitz permission to legally enter Brazil. In that action, hostility and hatred give way to tolerance.

Nonetheless, an issue that escapes the meticulous and practical Segismundo is the potentially subversive message of Clausewitz's monologue. Discussing de la Barca's play, Domingo Ynduráin (2012) holds that "se trata, en definitiva, del tema del poder, de su adquisición, ejercicio y límites" (it deals, in short, with the topic of power, its acquisition, exercise, and limits) (n/p). That is to say, who has the right to decide about the lives of other human beings? Or, does Segismundo, now acting without clear orders, have the right to deny Clausewitz the stamp he needs to enter into Brazil? If, as Martins Pereira affirms, "o imigrante representava o que se desejava como nação, ou seja, aquilo que faltava ao Brasil: ordem, progresso e pureza" (the immigrant represented what was desired as a nation: order, progress, and purity) (11), do not Clausewitz's innocence and his performance underline what is missing in Segismundo's life? These characters complement each other: Segismundo's pragmatism and street-wise ways contrast with Clausewitz's intellectual knowledge of Portuguese and Brazilian poetry, also challenging the idea of cultural citizenship—Clausewitz know more about Brazilian culture than Brazilian-born Segismundo—and nationality. Their different personalities are shown with weaknesses and strengths that make the other a valuable asset.

The performance of the monologue is equally significant for Clausewitz. He has convinced himself that since Brazil needs laborers, he can become one just by stating it on paper. He also believed that the performing arts have no place in a world set on producing and consuming and that becoming an immigrant necessarily entails being a blank slate. His monologue, however, makes him face his difference: in a country looking for laborers, there is also room for artistic performers, and a forward-looking society set on obtaining material

German-Prussian soldier and military theorist who is famous for his motto "War is the continuation of politics by other means." For his part, Segismundo is the name of the main character in Pedro Calderón de la Barca's play *Life is a Dream*. In the play, Segismundo was imprisoned at birth by order of his father, the king of Poland, after it was predicted that the son would kill the father. *Tempos de paz* empties the meaning behind the names of these characters: it is Segismundo who continues battling, now with the "suspicious" Polish immigrant, posing new hurdles to the immigrant's access to Brazil. Clausewitz is now the Polish citizen who, in the eyes of the customs officer, may become a threat to the status quo and recites Segismundo's monologue from *Life is a Dream*. Clausewitz's stellar rendition moves the customs officer, who finally stamps the immigrant's passport, sealing his fate as an accepted immigrant and potential good Brazilian citizen.

Clausewitz's performance and Segismundo's reaction to it have crucial implications for the way in which citizen and immigrant are represented in *Tempos de paz*. Brazilian psychologist Maria Liliana Martins Pereira (2011) states that

> o confronto com o imigrante, que encarna uma diferença radical, aciona conteúdos inconscientes da fundação do sujeito, em relação à forma hospitaleira e hostil com que foi recebido o bebê humano pelo casal parental.
>
> [the confrontation with the immigrant, who incarnates radical difference, triggers unconscious contents related to the origin of the subject in relation to the hospitable or hostile way in which the human baby was received by the parental couple]. (10)

This quotation is useful to further explore Segismundo's personality and his surprising display of emotion triggered by Clausewitz's monologue. Used to giving and receiving orders, in his encounter with Clausewitz, Segismundo is forced to step out of his comfort zone while he awaits the new directions of peacetime. In his exchange with the immigrant and despite the imbalance of power, he is more respectful and open to the Polish immigrant than he has been with his fellow Brazilians whom he has tortured. Not only does Segismundo attentively listen, but more importantly he tells Clausewitz intimate details of his life. Viewers learn that he was brought up in a Lutheran orphanage and that his only talent was the use of violence, which he later put to the service of his *padrinho*, whom, as seen in the scene of the phone call, he strove to please. Neither his sadistic violence nor his willingness to do what he was told, however, earns him the gratitude

the country "precisa de braços para a lavoura" (needs arms to till the lands), a motto that is repeated several times, pointing to the ideological success of Brazil's promotion of European immigration at the end of the nineteenth century[13]—leads him to present himself as a farmer even though he has never worked in a farm before. For Clausewitz, surviving the war and arriving in Brazil gives him the opportunity to start anew, to reinvent himself in a new country.

Clausewitz's optimism and naiveté contrast with Segismundo's cynical and authoritarian approach. As a self-taught survivor of the carnage of War World II, the Polish immigrant is confident that he can easily switch professions. Tackling a new line of work in a fresh land will surely provide him the opportunity to forget the horrors that he has witnessed. For his part, public employee and politically appointed Segismundo is aware of the approaching demise of the government for which he has loyally worked. Older and perhaps less intellectual than Clausewitz, Segismundo does not look forward to having a new profession and a new identity. On the contrary, he feels betrayed by the politicians he has faithfully served. As he admits, "O Brasil precisa de nós, noutra hora o Brasil não precisa de nós" (Brazil needs us now, but later Brazil does not need us anymore). If Clausewitz's life seems to be turning for the better, Segismundo's future definitely appears bleak. Witnessing his country's triumph as part of the Allied forces, he is confused by Brazil's different political positions throughout the armed conflict: first persecuting Jews, then suspecting immigrants of being Nazis. The film's most paradoxical moment is when Segismundo believes Clausewitz to be a Nazi when he appears as a victim of Nazism.

In *Tempos de paz*, Segismundo and Clausewitz are literally caught in a no man's land. As Segismundo's world falls apart, he is left without directions to obey. The mise-en-scène highlights the feelings of despondency of both characters. Brazilian scholars Roberto Elísio dos Santos and João Batista Freitas Cardoso (2011) hold that "predominam os tons ocres, que geram uma sensação de abandono e tristeza" (ochre hues prevail, generating a feeling of abandonment and sadness) (78). Left without clear directions, Segismundo is forced to solve Clausewitz's dilemma by himself. He proposes that the immigrant make him cry to gain the stamp that would allow him to enter the country. At first, Clausewitz reluctantly accepts the challenge and he starts telling about the brutality that he watched during the war, but his memories fail to move a hardened Segismundo, who was a sadistic torturer of the Estado Novo's political opponents. Here, it is important to pause briefly to analyze the significance of these characters' names: Clausewitz bears the name of Carl van Clausewitz (1780–1831), a

the Brazilian coastline, however, the dramatic landscape of green hills and pristine beaches inspires collective awe toward the magnificent land that is displayed in front of these travellers. Undoubtedly, the sun-drenched tropical scenery generates admiration and excitement, as Brazil will be the new home country for many of the immigrants onboard.

Tempos de paz also presents the perspective of those on land, awaiting the arrival of the passenger ship. Of special importance is Segismundo who, while awaiting the boat's arrival, receives a phone call from his political *padrinho* (boss) that prompts him to order the destruction of official documents. The fictional events of *Tempos de paz* take place on April 18, 1945, when President Vargas, in anticipation of his birthday the following day, announces an amnesty of political prisoners. The amnesty signals that "os tempos mudaram" (times have changed). As a frustrated Segismundo explains to his bodyguard, now "são tempos de paz" (they are times of peace), an enigmatic assertion that may refer to both Brazil's regaining internal stability, and to the end of War World II, in which the Brazilian Expeditionary Force fought against the Axis.[12]

Tempos de paz chronicles the multitudinous stages that European immigrants had to face upon their arrival in Brazil. First, passports are checked and passengers with the proper documentation are allowed entry into the country while those deemed too old are denied entrance. Then, customs officers interview immigrants. It is at this moment that Clausewitz's elation at being in Brazil becomes evident: he starts reciting poetry by Carlos Drummond de Andrade (1902–1987). His knowledge of Portuguese and Brazilian poetry is incongruous with his declared profession of farmer. Raising suspicions about his identity, he is taken to be interrogated by Segismundo. This meeting constitutes the central part of the film and pits a Brazilian citizen against a Polish newcomer. At first, Segismundo as a representative of the state appears to be jealously implementing the laws of the land when he states, "Não se pode dar o visto ao primeiro que aparece" (A visa cannot be given to the first person to come). As the dialogue between him and Clausewitz progresses, the latter learns that his stereotypes of Brazil and its inhabitants are not completely accurate. For instance, he describes his country of origin as Catholic and compares it to Brazil, but Segismundo is Lutheran. Clausewitz also learns that even though he is in Brazil, he lacks the stamp that would allow him to be a legal resident, and for that stamp of which Segismundo is in charge, he needs to provide additional explanations about his life and profession. Clausewitz's bookish information about Brazil—and the fact that

the union of a Brazilian and a German-Jew... not, from the point of the view of the Estado Novo, hail an ald... Brazilian society, nor resolve the country's sociopolitical contive... Hence, Olga, a non-Brazilian citizen and female Communions... itant, is expelled from the body politic. The dichotomy between.../bad Brazilian citizens and good/bad immigrants also form the¹... ·ral axis of the film *Tempos de paz*,

TEMPOS DE PAZ

Tempos de paz is the cinematic rendition of playwright Bosco Brasil's *Novas Diretrizes em Tempos de paz* (*New Directions in Peacetime*). The play, written in 2001 and first staged in 2002, soon garnered critical attention and two prizes: the Golden Shell Award and one by the Paulista Association of Art Critics (Associação Paulista dos Críticos de Artes). Actors Dan Stulbach (Clausewitz) and Tony Ramos (Segismundo) played the starring roles, which was later adapted by Daniel Filho and shot with the same principle actors in ten days. Unlike *Olga*, *Tempos de paz* was well-received by critics.[11]

The film opens up with black-and-white documentary footage of unidentified bombed European cities. The fall of a Swastika symbol provides clues that the destroyed cities are either German or German-occupied territories during World War II. These scenes are followed by the transatlantic trip of several immigrants, shot in different shades of blue. Among the travelers, a Polish man named Clausewitz, who knows Portuguese, stands out. His knowledge of Portuguese demonstrates that his migration to Brazil has been planned for a while, despite being a citizen not only of an occupied country, but also of a nation that has been at war since September 1939. Thus, viewers are left to infer how this apparently happy man who concentrates on the correct Portuguese pronunciation of the word "*não*" (no) could have survived, seemingly unscathed, the ravages of a six-year war. As a healthy-looking Pole, he raises suspicions: Why is he migrating if he is not a Jew? And if he is a Jew, how could he be migrating when the majority of the Polish Jewry had, by 1945, perished? These questions are left unanswered in the film. The casting of Stulbach—himself the son of Jewish-Polish immigrants—as Clausewitz further stresses the ambiguous ethnicity of the main character. Just as his presence on the passenger liner elicits questions, so does the identity and origin of the other passengers. Well-fed and well-clothed children are seen playing on the decks as adults are also shown without the haggard looks of those who have been exposed to years of war. As the boat approaches

dialogue between Olga and her friend Sabo who admits that she could live happily in Brazil while the Communist militant rejects that utopia and renews her commitment to the revolution (161). Her clandestine life also gives her the opportunity to strengthen her relationship with Prestes, this development—which implies prioritizing her feeling—disconcerts her and she asks the Communist Party to send her back to Russia. This request does not entail rejecting Brazil. On the contrary, she is shown enjoying watching carnival, a gesture that stresses her admiration of and receptivity to a different culture. That very scene, however, also shows her looking at the celebrations from a window, that is, separated from the joyous crowd and confined while she and Prestes are hiding from the Brazilian authorities.

Indeed, Olga is never fully adapted into Brazilian culture. There are scenes in which she appears suffering from the warm weather. Her no-frills professional clothes in different shades of grey stress her difference from the colorfully dressed Brazilian women. In the final months of her temporary migration to Rio, as the police close in on her and Prestes, the couple is shown almost in isolation in their hiding place. Once they are both apprehended, Olga's stay in Brazil is punctuated by her discovery of her pregnancy and also her lack of contact with her now husband. The film briefly shows her integrated into a micro Brazilian community, one made up by jailed Brazilian women.[10] Nonetheless, as she is denied basic rights, she admits with frustration that "Nunca vou entender este país" (I will never understand this country), a statement that emphasizes her alienation and the narrow scope of her interest in Brazil: fighting for a Communist revolution.

If Olga is irritated by Brazil, the Brazilian authorities perceive her as a traitor. As a Communist, she is "foreign" even though, as the film makes clear, many Brazilians also sympathized with Socialism—an imperialist ideology that challenged the national coalition built by President Vargas. At a time when few women were active in politics—and even less supported Communism—, Olga's participation in politics by instigating revolts against President Vargas constituted a terrible transgression for an immigrant. Moreover, her romantic association with Prestes—Vargas' main political rival—clearly mark her as an enemy of the Brazilian state. Therefore, her migration to Brazil ends when her subversive status as a female foreign Communist is seen as a threat to the tenets of the Estado Novo. The authorities' intransigence leads them to deport her to Nazi Germany, ignoring the fact that as the "esposa de um brasileiro" (wife of a Brazilian), she could be judged and tried in Brazil. Despite Prestes' and Olga's real-life romance, their love story could not become foundational, for

of the local elite. In addition, it is Prestes' heroic deed of marching through Brazil in an oppositional movement known as *Coluna Prestes* (Prestes' Formation) between 1925 and 1927 that first catches Olga's attention. Believing that the country is ready for a rebellion, Olga asks her comrades to imagine "Se nós pudéssemos estar lá lutando" (If we could be there fighting). Her mission to migrate to Brazil is, however, determined by the Communist Party, which chooses her to protect Prestes, who is blacklisted from his native country and therefore has to evade the authorities. In one of the first exchanges between Olga and Prestes, the native Brazilian characterizes his country as a land where liberties are curtailed: he has been exiled first to Argentina and then to Russia. His status as an exile also affects Olga. Like him, she will have to conceal her identity so as to carry out her revolutionary duties.

Olga's migration, which divides the film, closing the first part, is unusual as it is prompted by neither socioeconomic motivations nor safety reasons. Unlike many European Jews who traveled in uncomfortable conditions in order to flee pogroms, thanks to the Communist Party, Olga enjoys the financial resources to play the role of well-off Mrs. Vilar, wife of a businessman. She now uses makeup, wears furs, and dons expensive cocktail dresses and *tailleurs* (tailored suits) in pastel colors that not only enhance her femininity, but also, and more importantly, define her as belonging to a privileged social class. As a tourist or a well-off immigrant, she is seen dancing and interacting with the captain of the passenger liner as well as an affluent Nazi German passenger. The pleasures that Olga enjoys, however, conspire against her agency and individualism. Her first-person narration that has guided the film thus far gives way to a conventional third-person account in which she becomes the target of Prestes' admiring gaze. This technique highlights Prestes' status as the subject while Olga appears as the object of the masculine look. The change in her external appearance runs parallel to her inner transformation: she slowly starts warming up to both Prestes and his political project. When he urges her to see his country from the window of an airplane, her impression that "Parece um paraíso" (It seems like a paradise) alludes to her openness to a new environment. Here, it is important to point out that Olga is only briefly seen speaking German during a manifestation and Russian at a speech; thus, the film does not problematize her acquisition of Portuguese. The complex dialogues that take place diegetically may not have been an accurate depiction of her linguistic skills in Portuguese.[9]

The film presents Olga's stay in Brazil as both pleasurable and painful. While the preparations for a revolution take place, Olga enjoys swimming in her free time. Miranda Shaw (2009) calls attention to a

individual. Even though she was not a Brazilian citizen, Olga was the victim of a Brazilian state aligned, at the time of her capture, with Fascism and Nazism. As a biopic, *Olga* has the characteristics identified by Dennis Bingham:

> [I]n contrast to the Great Man films, however, female biopics overall found conflict and tragedy in a woman's success. A victim, whatever her profession, made a better subject than a survivor with a durable career and a non-traumatic personal life. (2010: 217)

From the outset, the film emphasizes the highly unusual life of its protagonist as well as her tragic demise. Here, it should be noted that Olga's Jewish ethnicity is never mentioned in the film.[7] Rather, the film stresses her exceptionality as a determined woman who participated in politics.[8] The opening scene presents Olga as a child looking at a bonfire; when her father warns her with a "Careful," the child takes it as a challenge with which to prove herself.

The first part of the film shows Olga (Camila Morgado) both at home and as a nomad. She leaves her family home at a very young age, a crucial moment that marks her liberation from an imposed bourgeois lifestyle. As the protagonist remembers her family home in Germany, the film adopts her point of view, highlighting the dark and confining environment from which she longs to flee. As Olga goes through several rooms, she feels suffocated by the oppressive layout of her home. In addition to not belonging to the comfortable domestic world of her parents, Olga also faces the criticism of her mother, who tells her, "Você não parece mulher" (You do not look like a woman). Her physical appearance as a working-class person brings shame to her traditional, upper-class family. Giving up her bourgeois life, she leaves home one rainy night. A dissolve creates a transition as she contemplates another rainy night, stating, "Eu não vou voltar para trás" (I will not go back) while on her way to the Soviet Union where she spends several years training for an armed revolution. Her dedication to Communism makes her the ideal person to accompany Luiz Carlos Prestes (Caco Ciocler) to Brazil in disguise and on a mission that radically changes her personal history and takes her from Russia to South America.

Olga presents the protagonist's initial relation to Brazil as ambivalent. First, her knowledge of the country is restricted to the nation's potential for a Communist revolution. This idea does not take into consideration the local features of Brazil, but rather is a generalization that could pertain to any country in need of liberation from the power

good citizen whilst concomitantly projecting the perils of being ideologically-subversive. (5)

As I explore the immigration of a German Jewess and a Polish national to Brazil, I pay special attention to the ways in which these films present these immigrants. Namely, I ask what kind of immigrants were they? How were home country and host society depicted? In which ways are these characters idealized and/or stereotyped? I also briefly point out these films' features as mainstream/marginal according to their production and consumption.

OLGA

Olga chronicles the life of Olga Benário (1908–1942), a German Jewess who in the 1920s and 1930s held important roles in the Communist Party. Her determination and commitment to the Communist Party contributed to her being assigned to pass as the wife of Brazilian Communist leader Luiz Carlos Prestes (1898–1990). After training at the party's headquarters, Benário was selected to make Prestes' false identity believable and allow him to enter Brazil undetected by the authorities. The couple arrived in Brazil and worked to instigate a Communist revolution, but in 1935, Prestes' efforts were harshly repressed by the government of President Vargas. Benário was apprehended, and, considered a subversive, deported to Germany in 1936 even though she was pregnant. Because she was listed as a criminal for having freed Communist Otto Braun in 1925, she was apprehended by Nazi authorities upon her arrival in Germany. Imprisoned, she gave birth to a daughter who was later taken from her and handed over to her paternal grandmother. Olga died in 1942 in a concentration camp in Germany.

With a script by Rita Buzzar based on Fernando Morais' homonymous novel published in 1985, *Olga* was directed by Jayme Monjardim. The film was produced by Lumière and Globo Filmes, a company founded in the late 1990s that, as Cacilda Rêgo (2005) has pointed out, uses the knowhow of its soap operas to attract massive local audiences. As predicted, *Olga* became a huge box-office success with more than 3 million viewers. Rosana de Lima Soares (2006) explains that the film was a mainstream filmic product, given its massive reception (3), but that it also became marginal from the assessment of the critics who stressed the film's reliance on close-ups and melodramatic features. The mainstream/marginal dichotomy is also relevant for the film's plot and genre: the biography of an exemplary

that was detrimental for many fleeing Europe during those turbulent decades.

The cinematic representation of Jewish Brazilians is a recent development that shows other hues beyond the traditional cultural matrix of Brazilian society, that is, indigenous peoples, Europeans, and Afro-Brazilians (Rocha 2010). A case in point is Sandra Kogut's documentary *Um passaporte húngaro/A Hungarian Passport* (2001), discussed in chapters 6 and 7, which traces her grandparents' migration to Brazil in the late 1930s. *O ano em que meus pais saíram de férias/The Year My Parents Went on Vacation* (2006, dir. Cao Hamburger) was the first blockbuster with a Jewish Brazilian character, Mauro (Michel Joelsas), yet the immigration of European Jews to Brazil remains largely unrepresented. Two recent films, *Olga* (2004, dir. Jayme Monjardim) and *Tempos de paz/Peacetime* (2009, dir. Daniel Filho), illustrate—albeit to different degrees—the migration of two Europeans to Brazil in the mid-1930s and 1940s, respectively. Deemed dangerous to Brazilian identity and values, these immigrants—whether Jewish or suspected of being Jewish—faced persecution and discrimination. In this essay, I do a close textual analysis of these films, arguing that they provide a cinematic take on the nationalist policies of the Estado Novo that closed the country off to displaced Jewish and Eastern European immigrants in the late 1930s to mid-1940s. By debunking the notion of Brazil as a melting pot of racial democracy, these films not only bring to the fore the exclusionary mechanisms that influenced Brazilian policies during the Estado Novo, but also challenge Brazilians to reassess definitions of home and belonging vis-à-vis discursive constructions of nationhood. As they do so, *Olga* and *Tempos de paz* allow the expression of voices that have been silenced from the national community, thus, to put it in the words of Roberto Stam (1997) who relies on Mikhail Bakhtin, providing a more heteroglossic depiction of Brazilian identity (364).

Olga and *Tempos de paz* represent the immigration of Central and Eastern Europeans at two different moments of the Estado Novo. *Olga* provides an inside glimpse into Brazilian politics of the 1930s, while *Tempos de paz* takes place in the last months of Vargas' administration in 1945. Moreover, *Olga* is a biopic, a film based on a true story, and *Tempos de paz* is a fictional film. My analysis of these two films is guided by Ruby Cheung and D. H. Fleming's views about the way in which cinema represents, either by stereotyping or idealizing, the Other. More specifically, Cheung and Fleming (2009) state that

> the manner in which certain identities and subjectivities perform within narratives help[*sic*] to reproduce and reassert the rewards of being a

enjoyed so much political and religious freedom that they have steadily assimilated into the larger society" (3). However, assimilation does not necessarily guarantee acceptance, nor does it signify that Brazil always welcomed Eastern and Central European Jewish immigrants. Vieira notes that "even though Jews have found a hospitable home in Brazil, the Brazilian cultural ethos continues to regard them as other" (3). While during the First Republic (1889–1930) and as result of the abolition of slavery (1888), Brazil boasted policies that welcomed immigrants, the discourse of alterity mentioned by Vieira has been particularly detrimental to those Europeans and European Jews who chose Brazil as a migration destination in the 1930s and 1940s.

Jewish European immigrants to Brazil faced important challenges in the early decades of the twentieth century.[4] Historian Jeffrey Lesser (1998) has persuasively demonstrated that in the first half of the twentieth century, for Jewish immigrants, Brazil was *"o país do futuro* [the country of the future], but for many powerful Brazilians, Jews were imagined to be one of the least desirable of all immigrant groups" (8). Jews were stereotyped by the Estado Novo (1930–1945), the government of President Getúlio Vargas (1882–1954), as supporters of Communist ideologies that were opposed to the Brazilian nationalist project. Here, it is important to consider Michel Foucault's view that the modern state requires enemies to justify its production of discipline (Bletz 2010: 7). In his role as enforcer of order on behalf of the interests of the nation, Vargas created a new alliance among the different socioeconomic actors of Brazilian political life, emphasizing the power of the federal government and implementing immigration quotas, as foreigners were perceived to be taking jobs away from Brazilians.[5] This protectionism influenced foreign policy and changed views on the importance of immigrants. For historian Maria Luiza Tucci Carneiro (1988), discrimination and anti-Semitic policies culminated with the passing of Secret Circular 1,127. This law of 1937 specified that *"fica recusado visto* no passaporte a toda pessoa de que se saiba ou por declaração própria (folha de identidade), ou qualquer meio de informação segura, que é de *origem étnica semítica*" (the following will be rejected: the visa in the passport of any person who lets it be known through his/her own declaration [identity card] or any other means of credible information that he/she is of Semitic origin) (Tucci Carneiro: 168). Whether this law was issued by a pro-Germanic foreign policy or as a result of racist ideologies, its secret character spoke of a duplicity that makes it even today one of the most embarrassing pieces of Brazilian legislation.[6] By blocking the arrival of persecuted European Jews, Brazil implemented an anti-Semitic policy

10

European Immigrants and the Estado Novo in Contemporary Brazilian Cinema

Carolina Rocha

In addition to carnival, soccer, and samba, two long-standing myths have contributed to the unification of Brazil's heterogeneous population. The first revolves around the idea of racial democracy, that is to say, that all races are equally considered in a democratic nation. First associated with the work of sociologist Gilberto Freyre (1900–1987), the term "racial democracy" later became a core pillar of the Brazilian state.[1] Closely related to the first myth, the second is the notion of Brazil as a country that has successfully integrated people of different ethnicities and nationalities, a view recently voiced by American investor James Dale Davidson (2012), who writes, "Brazil is a true melting pot of many cultures from different races and backgrounds" (259). Nonetheless, historians of Brazilian culture have called attention to the ideologies that supported racism in Brazil from the last decades of the nineteenth century to the 1940s.[2] Scholarship on Brazilian cinema and culture has investigated the representation of the country's racial dynamic. For instance, Robert Stam's seminal (1997) *Tropical Multiculturalism* is devoted to examining the ways in which Euro- and Afro-Brazilians and indigenous people have been represented throughout Brazilian film history (20).

Euro- and Afro-Brazilians, along with indigenous peoples, are the major racial and ethnic groups. Brazil is also home to many European immigrants—particularly from Portugal, Spain, and Italy—and to the ninth largest Jewish community in the world.[3] In his introduction to *Jewish Voices in Brazilian Literature,* Nelson Vieira (1995) highlights the assimilation of this ethnic community, saying that in Brazil "Jews

Rêgo, C. (2011) "The Fall and Rise of Brazilian Cinema," in C. Rêgo and C. Rocha (eds.), *New Trends in Argentine and Brazilian Cinema*. Bristol and Chicago: Intellect, 35–49.

Shaw, L., and S. Dennison. (2007) *Brazilian National Cinema*. London, New York: Routledge.

Signorelli Heise, T. (2012) *Remaking Brazil. Contested National Identities in Contemporary Brazilian Cinema*. Cardiff: University of Wales Press.

Silva Rolim, M., and M. Romero Sá. (2013) "A politica de difusão do germanismo por intermédio dos periódicos de Bayer: a Revista Terapêutica e O Farmacêutico Brasileiro," *História Ciências Saúde. Manguinhos* 20(1):159–179.

Stam, R. (2008) "Tropicalia, Transe-Brechtianismo and the Multicultural Theme," in P. Birle, S. Costa, and H. Nitschak (eds.), *Brazil and the Americas. Convergences and Perspective*. Madrid, Frankfurt a.M.: Vervuert, Iberoamericana, 223–237.

Grande Cidade/The Big City (1966) by Carlos Diegues. This tradition was readmitted in 1994, starting with Paulo Lins' 1997 novel *Cidade de Deus* (*City of God*), filmed in 2002 by Fernando Meirelles and Katia Lund, followed by *Tropa de Elite/Elite Squad* by José Padilha in 2007. Specifically *Cidade de Deus* represents the antithesis of *Cinema Novo*. This new discourse on urban violence was internationally received and thus influenced Brazilian domestic politics.
2. Getúlio Vargas had come to power in 1930 through a "revolution from above" and forced his continuance in office by a coup d'etat he organized in November 1937. The constitution was suspended, a sham parliament founded, and freedom of the press abolished. His regime, that of a positivist Gaúcho of Southern Brazil's state of Rio Grande do Sul, found support in the industrial working class, as it wooed workers with comprehensive social welfare programs into state-regimented unions. Vargas ruled the country as dictator until October 1945. His politics shaped Brazil's history until the end of the twentieth century.
3. *Cinema, Aspirinas e Urubus*. Available at http://www.adorocinema.com/filmes/filme-60606/curiosidades (accessed January 11, 2014)
4. *Cinema, Aspirinas e Urubus*. Available at http://www.adorocinema.com/filmes/filme-60606/curiosidades (accessed January 11, 2014)

Works Cited

Bartelt, D. D. (2003) *Nation gegen Hinterland. Der Krieg von Canudos in Brasilien: ein diskursives Ereignis*. Stuttgart: Franz Steiner Verlag.

Bentes, I. (2013) "Global Periphery: Aesthetic and Cultural Margins in Brazilian Audivisual Forms," in J. Andermann and A. F. Bravo (eds.), *New Argentine and Brazilian Cinema. Reality Effects*. New York: Palgrave Macmillan, 103–117.

Cinema, Aspirinas e Urubus. Available at http://www.adorocinema.com/filmes/filme-60606/curiosidades (accessed January 11, 2014).

Dargis, M. (2006) "This Could Be the Beginning of a Brazilian Friendship." Available at http://www.nytimes.com/2006/02/09/movies/09vult.html?_r=0 (accessed January 11, 2014).

Fausto, B. (2006) *Getúlio Vargas*. São Paulo: Companhia das Letras.

Franco Saavedra, R. (2009) "Marimbondos: política e estado no Brasil do séculoXIX," *ANPUH – XXV Simpósio Nacional de História*—Fortaleza. Available at http://anpuh.org/anais/wp-content/uploads/mp/pdf/ANPUH.S25.0230.pdf. (accessed January 7, 2014).

Lübken, U. (2004) *Bedrohliche Nähe. Die USA und die nationalsozioalistische Herausforderung in Lateinamerika, 1937–1945*. Stuttgart: Franz Steiner Verlag.

Prutsch, U. (2007) *Creating Good Neighbors? Die Wirtschafts- und Kulturpolitik der USA im Zweiten Weltkriegs, 1940–1946*. Stuttgart: Franz Steiner Verlag.

there is more than a gradual difference between the totalitarian National Socialist (NS) regime and its politics of genocide and that of Vargas' authoritarian Estado Novo. Nevertheless, both were dictatorships that based their legitimation on the creation of enemies and the exclusion of groups. In spite of being geopolitical adversaries in this war between barbarism and civilization (that is, freedom and human rights), between Germany and Brazil, the global conflict united both protagonists: Ranulpho felt menaced by a careless Brazilian government, which promised the New Mankind through technocrats and social benefits, but exempted the common people in the rural hinterland from its ambitious nation-building-project.

That Ranulpho, like all Brazilians, would also be menaced by aggressive Nazi-Germany, was spread through the radio, as the Brazilian war propaganda (not mentioned in the movie) made people believe that Germany was going to include Brazil in its growing empire of evil. Johann's enemies were the same. Germany made him a traitor; Brazil made him a political enemy. While Ranulpho's future was connected to the urban metropolis, ironically through vending a drug, Johann's was an existence in a deeply rural environment. He moved—in the classic dichotomy of barbarism and civilization, of city and hinterland, that shaped Brazil's and Latin America's ideas of progress and national unity so much—"backward" to save himself in "wilderness," while Ranulpho saved himself by getting a truck and driving to the urbanized south. The film ends before Johann reaches the rubber producing area of the Amazon, Henry Ford's Fordlândia and Belterra, both modernist utopias, made to create a better mankind through progress and discipline.

Thus, *Cinema, Aspirinas e Urubus* let the protagonists develop in times of a geopolitical crisis by showing its audience the double-faceted meaning of modernity. Especially in war, modernity offers its dark side. In the mind of the downtrodden it still offers the fulfillment of many dreams. Modernity is characterized through movement. The movements and the reasons for it are multiple in the film: they cover transatlantic exodus, domestic migration, business trips, as well as traveling thoughts through virtual escapism. Its vehicles are the ship, the truck, the train, and the telescope. Marcelo Gomes' road movie offers a kind of happy end, a relief. Mutual help and friendship turn the diaspora of both heroes into travels of self-reliance and hope.

Notes

1. See *Rio, 40 graus/Rio, 40 Degrees* (1955), and *Rio Zona Norte/Rio, Northern Zone* (1957), both made by Nelson Pereira dos Santos; see *A*

where no other solution is offered than that of migrating to another world. Its protagonists who had begun to develop a wonderful friendship had clear goals.

The sertão of the cinematic retomada is set within a globalized context. Gomes moves even a step further on. He shows that the sertão was already globalized before. Slaves from African descent had settled there; German canons were brought to this spot to be used in a "War at the End of the World," as Mario Vargas Llosa titled his novel about Canudos. The World War II in *Cinema, Aspirinas e Urubus* offers an exemplary paradigm of globalism that touches even distant and seemingly forgotten lands. The sertão of the war years can no longer offer refuge to displaced people or leave people unchanged.

Conclusion

Cinema, Aspirinas e Urubus is a road movie that implies the development of the protagonists. Gomes' hero is Ranulpho, who was a reliable companion to Johann and therefore was rewarded the truck, now purified from its Aspirins-advertising letters. With this precious gift, Ranulpho's diaspora, his refuge from drought and poverty, turns into a promising and perhaps lifelong trip of a self-reliant life. The new enemy alien Johann has to live a second insecure existence, this time as a rubber soldier, a life completely unfamiliar to him and other migrants from the northeast.

Like his Brazilian fellows from the northeast Johann would start this new journey as a migrant. But unlike them he had to throw away his papers, the only "treasure" he had secured. Johann was forced to free himself from his old European identity to avoid prison. But his new exodus is not that of a draft refugee anymore. He uses the train, a remaining strong symbol of modernity in the 1940s that leads to new horizons and connects different and distant worlds. Being a rubber soldier, Johann would neither be the enemy nor the displaced person anymore. He would belong to an "army" of allied rubber workers and therefore fight on the right side, as Brazil was the United States' most powerful brother in arms on the South American continent.

Both Ranulpho and Johann save themselves through friendship, a friendship that overcomes ethnical, political, and economic gaps, although their journeys ultimately lead to opposite directions: while Johann travels north, to the myth-loaded Amazon, Ranulpho heads toward the south, the urban metropolis of Rio de Janeiro, with its historic monuments and rich culture. Their friendship symbolizes a counterdraft against dangerous political utopias and regimes. Clearly,

jumps on a train heading north. Earlier, he had handed over the keys of his truck to the Brazilian. While Johann's diaspora repeats itself in another form, Ranulpho possesses all the tools he needs to fulfill his dreams. He is not a migrant anymore, but a salesman. And he knows what his chances are. He smiles.

In an interview, Gomes explained that the screenplay started from a story told by his great-uncle Ranulpho who used to sell Aspirin in the 1940s. Born in Recife, Pernambuco, Gomes wanted to paint a picture of what "I had registered in my own memory as a child—a desert where the luminosity of daylight 'blinds' you and nights are as dark as tar" (Discussion guide 2006: 3). Film critics and the public both appreciated Gomes' first feature film, the screenplay that he wrote together with film directors Karim Aïnouz and Paulo Caldas. Gomes received several nominations and prizes: the movie was awarded Best Film at the São Paulo Film Festival in 2005 and at the Cinema Brazil Grand Prize two years later. It earned the Special Jury Prize at the Festival do Rio in 2005 and was chosen as Best Film at the Mar del Plata Film Festival in Argentina. The judges of the Lima Latin American Film Festival awarded him with the Best First Work prize. Gomes also won the Cinema Prize of the French National Education System at the Film Festival in Cannes in 2005[3] and was a finalist at the Sundance Institute screenplay competition.

Variety appreciated Gomes' "impressive if sober feature helming debut...Film's pared-down look has a stylish simplicity that should make it a contender for arthouse pickup, though aud[ience]s will need to get into its minimalist rhythm." The *New York Times* critic Manohla Dargis (2006) pointed out: "For much of the film you wait for these men to turn on each other, to circle like vultures. Instead, they talk, they drive, they get along. What more could you want."[4]

"Johann and Ranulpho represent our own dreams of happiness and the desire to find a road for our own lives. And what moves this film are the characters' desires," said Gomes in an interview (Discussion Guide 2006: 3). His film is full of historical allusions and symbols. Its slowness and long cuts are uncommon compared to the velocity of contemporary films, and many other road movies are shaped by Jack Keruac's autobiographic novel *On the Road* (1957) and filmed in 2012 by the Brazilian director Walter Salles. Here, speedy cars or motorcycles are characteristic elements, as the protagonists of the postwar generation escape from boredom and at the same time crave to catch the meaning of life. Many road movies are dramatic escapes from sins and crimes. *Cinema, Aspirinas e Urubus* is a subtle social criticism about the shape, the status, and stagnation of the backland,

When German submarines began to sink Brazilian merchant vessels carrying civilian passengers, mobs united throughout the country, smashed windows of German shops, and destroyed homes. When the German attacks multiplied in the summer months of 1942, the Brazilian government decided to declare war on Germany and Italy (although not Japan) on August 31, 1942.

That day, Johann picks up a letter at a local post office. He hands it over to Ranulpho, who falteringly deciphers the document that would change Johann's life once again. The paper explains that the German medicine Aspirin was put under federal jurisdiction and Johann Hohenfels was offered either to return to Germany immediately, or to surrender to a concentration camp in the interior of São Paulo. The German works out a radical solution. He gets rid of the most precious objects that he has held until this precise moment: his identity papers and some pictorial symbols of his former life. He has always feared losing them, but now he disposes of the bag under a stone in the *caatinga* and is suddenly threatened by a snake, the complex symbol for life, death, destruction, and falseness, but also for cure and resurrection, as an animal that molts. Ranulpho paints over the Aspirin ad on the truck and neutralizes the car.

Drunk, the friends—who are war enemies now—play war at night, symbolically attacking themselves with imagined arms. Probably, their war game is an allusion to the mythical war of Canudos in 1896–1897, the war of the backland, where German arms and canons made by Krupp were aimed at the outlaws. Johann uses a virtual rifle and bombs while Ranulpho uses a virtual knife, the classical weapon of the bandits. The next morning Johann has defined his destiny. The only solution to hide and avoid war and internment camp is to migrate to the north and be hired as a rubber soldier. As such, he stays loyal to the right side without having to carry weapons. Ranulpho thinks of being his assistant again. When both march to the train station in the middle of nowhere, a vulture, an emblematic animal of the desert, wheels in the sky. Like the snake, he is a contradictory symbol of evanescence and purification. The symbol had appeared earlier in the film, when Johann made shadow vultures with his hands in front of the projector light to please the village children. Another vulture sits on the fence post close to the railroad track as they step over the rails. Ranulpho, instead of continuing his role as an assistant, decides to control his own destiny; he decides to travel in the opposite direction, to Rio de Janeiro.

The stateless German has left the road, mingles with the crowd, hides from the police officers and, disguised as a blind passenger,

affairs and well into the war years. The relations between Brazil and Germany had been good and solid, as Brazil had been a recipient country for German goods as well as German-speaking immigrants from the early nineteenth century onward. Whereas some ministers and military officers under Vargas sympathized with the fascist regimes in Europe, others were decided Americanophiles, most notably Oswaldo Aranha, who served as Brazil's ambassador in Washington DC.

At first it had been part of Brazil's melting-pot program to integrate immigrants into a seemingly harmonic society. The regime initiated an integration project with decrees that nationalized the school system in 1938. It prohibited the use of German and Italian languages in schools. The regime's concern to turn immigrants into Brazilians came into open conflict, particularly with Nazi Germany, who had started to bombard German communities abroad with propaganda materials and literature on the Führer and the Fatherland. Considerable segments of Brazil's German population, concentrated in the southern states, sympathized with the new order at home. The United States exerted pressure on Brazil to eliminate fascist thought and Nazi spies as well. The flourishing commerce with Germany also came to an abrupt halt in 1939, when the British maritime blockade upset Brazil's trade with the European continent (Lübken 2004).

First, Brazil declared its neutrality, but continued to trade with Germany. In late 1941 Vargas ended his geopolitical double game between the German Reich and the United States and finally broke off relations with the Axis powers in January 1942. At the same time the US State Department began to suggest to Brazil (and other Latin American countries) that it should police its axis nationals and arrest the suspicious ones, as well as those who were managers or directors of axis companies. The politics of liquidating specifically Italian, Japanese, and German possessions through blacklisting them began at the same time. Chemical industries, food companies, and airlines were nationalized through compensation; schools and other institutions were closed and bank accounts frozen. These measures simultaneously increased the opportunities for US investors.

German Aspirin from Bayer was among those products that were eliminated from the market and slowly substituted by the US company Sterling Products, whose Aspirin were called Melhoral. American firms used the same vending strategy by traveling around with moveable projectors and propaganda films (Prutsch 2007). Those enemy aliens considered dangerous to the nation were transported to internment camps that were and are still called *campos de concentração* in Brazil.

that he was afraid of dying in war and escaped on a ship, working as a waiter. Ranulpho begins to tell "his story," the only story he knows to tell. He reveals about his birthplace, Bonança (which means "favorable winds on sea"), a hamlet of five houses with a cross in its center exposed to a burning sun. Ranulpho pondered an exit strategy and one day he felt that the time had come to hitchhike from the miserable sun-bleached spot.

Johann and Ranulpho fled from what they each conceived as their hell. Ranulpho's former home was a purgatory and he feared of dying from hunger. "It was a bloody hard journey," he professes (as he has never been to Rio before), "but I finally got to Rio, the capital. But when hunger took hold of me, I ran straight back home." Ranulpho benefits from Johann's delirium. Now he dares to speak about his own fears of coming to naught in Rio one day. Both companions are refugees, one of drought and economic hopelessness, and the other of war. Ranulpho continues to tell his story about the stereotypes he faced in Rio, about knife-carrying northeastern outlaws who ate lizards. With these comments he refers to the old myth of (social) bandits, who are still present in the collective memory, but says to himself that "this time" he would have more self-esteem.

Suddenly we see him mounting the film short carefully on the reels and catching the moving image of Rio's sugar loaf in his hand. The other world of self-reliance and chance that he hopes to achieve is just metaphorically to be grasped. It is one of the strongest moments in the movie Ranulpho's technical skills show the viewer what kind of capacities, curiosity, and creativity the people of the backland have, despite that they have never had the chance to develop their talents. The main character of Ranulpho offers a sertanejo different from the heroes in Rocha's films, the oppressed and suffering victims of exploitation, whose exit strategies are made up of heroic war and aggression.

On the road again, through reprising landscapes, accompanied by the lyrics of sambas, the radio voice suddenly informs about the survivors of the German submarine attacks on merchant vessels in the nearby state of Sergipe. The war theater is approaching with a threatening speed. The first Germans, suspected of sending messages about Brazilian shipping positions, are caught. Houses are searched for Swastikas and Nazi propaganda. Johann decides to take his savings and invites Ranulpho to blow all of it in a brothel. As they were having the time of their lives, the Brazilian commented later, the world began to fall to pieces.

The Vargas government strove from the beginning for a peculiar balance of power, not just in its domestic politics, but also in foreign

of many sertanejos. That the harmonious companionship between the male protagonists is tested by her presence and her beauty is obvious, due to Gomes' well-composed medium shots and close-ups of the three passengers, and the talent of the actors. Ranulpho's multifaceted facial expressions, his roguish look and smile that contrast with his sharp comments sometimes give him a kind of burlesque personality that characterizes the popular (catholic) theater tradition, also common in Brazil. The two men compete in seducing Jovelina and show their movie treasure. But films make her sad; they make people think about life. "Life should be like searching for nothing else but happiness. But every time we look for happiness something always goes wrong," she comments.

The motives of reading the constellation of stars reappear when Ranulpho and Johann are invited to the house of a local boss with an aristocratic name: Cláudio José Pereira Carneiro de Assis. His French-educated wife Adelina virtually flees from her boring and superficial life by observing the depths of the nocturnal sky with her telescope. She possesses an expensive technical object, but nevertheless looks upward, to a universe beyond reach, while her egomaniac husband seeks to buy Johann's entire stock of Aspirin. The German would bring the future to his place, he called out, while German submarines already began to attack Brazilian merchant vessels. Ranulpho verbally attacks the self-declared *empresário* (businessman). The poor northeasterner sees no difference between a businessman and a feudal lord, whom he holds responsible for the poverty and misanthropy around him. This short dialogue, the only aggressive dialogue in the movie, ties in with Glauber Rocha's filmic social criticism of the 1960s. And indeed, Ranulpho is the only Brazilian character in this film who prefers to act pragmatically and speak blatantly instead of nourishing himself with virtual worlds. Only when Johann lies down in a fever delirium after being bitten by a snake does Ranulpho dare to speak about his migration, his dreams, and fears.

The Journey Turns into a Diaspora

While resting at a farmhouse Johann is again bitten, this time heavily and on his leg. The companions are now packed tighter together, as Ranulpho still does not know how to drive. The travel has turned into a trip full of danger, from nature and from the outside world. The journey of a salesman has almost cost him his life. The poison makes Johann fall into a fever delirium that lasts for two days and nights. Both travelers cautiously reveal other details of their former lives, and they specify the reasons for their migration. Johann tells

abandoned plantations of Fordlândia and Belterra at the shores of the Tapajós River, created in the late 1920s and early 1930s and representative of his utopian dream of a progressive and happy society, were reactivated for martial needs. The Vargas government paid for the migration of the northeasterners to this green and abundant counterworld. "Once there, you have to work producing rubber, so that the Americans can use it in the war," explains Ranulpho to Johann.

Not only the Aspirin salesman, but also the radio, Getúlio Vargas' most powerful propaganda instrument, promised a utopian future, a secure existence for these victims of natural disasters, who, as protagonists in the war effort, would be transformed into dynamic soldiers and help to reestablish peace. But the sertanejos in the movie don't seem to be convinced by the offer. An owner of the restaurant, where both travel companions eat, explains what he thinks of the Amazon basin. He calls it, "too dangerous [and] full of savage beasts." His imaginary of the myth-loaded Amazon as the exotic other, a "green hell," did not differ much from that of Europeans. The war had not yet reached Brazil, but the topic of the rubber soldiers makes Johann talk to Ranulpho about the reason for his migration to South America. He ran away from the danger of war by "traveling" on a ship and decided to stay in Brazil.

Reality versus Escapism

Despite the radio news about the war effort and Brazil's engagement in it, director Marcelo Gomes did not want to accelerate the speed of the movie; rather, he wanted to use the continuing slowness as an element of tension between the turbulent outside world and the stagnant world of the sertão, as if this space of timelessness still seems to be Johann's best refuge. Johann likes his nomadic life, still trusts the nature, and prefers to spend the nights outside in the fresh air protected by the nocturnal star-spangled sky, while Ranulpho sleeps inside the metallic microcosm that he would later learn to drive. The sertão is dry and poor, says Johann once, it opens up the mind, "but at least there are no bombs falling from the sky."

On their way to Triunfo they pick up a sad young woman, Jovelina (Hermila Guedes), who is traveling to Flores (Flowers), a town with another contradictory name for this environment. To calm her, they turn on the radio, so that she could listen to dance music. She believes in astrology and wants to know from the male passengers what sign they belong to. Jovelina's small talk is another symbol of the strong discrepancy between reality and escapism, which characterizes the life

commented on in the film and it is not clear at this point what kind of danger will arrive, but Johann would later have to get rid of his personal documents.

On the road again, the radio voice speaks of the "Soldados da borracha" (Rubber Soldiers), who helped Brazil "to march." Although the development of the Amazon is often described as a political goal of the Brazilian military dictators (1964–1985), it was the Vargas regime that—helped by the United States—had called for a "march to the west" and sought to wake the sleeping beauty of Amazonia through the prince of progress. The Walt Disney Company produced an educational documentary in 1944, titled *The Amazon Awakens*. The film was commissioned by the Office of Inter-American Affairs (headed by Nelson A. Rockefeller) and the Brazilian government. Getúlio Vargas dreamed of exploiting Amazonia's potential resources by settling landless peasants along new roads.

The wartime needs of the United States directly affected various regions of the largest South American country, a seemingly inexhaustible source of raw material and foodstuffs, an important experimental field for healthcare and technology, as well as a huge potential market for mass consumption. In no other country of Latin America did US institutions—war related or not—carry out so many and such diverse activities than in Brazil during World War II. The movie does not mention that the Vargas regime had granted the United States the right to establish military bases along the North Brazilian Atlantic coast. The Vargas government was well aware of Brazil's strategic and economic importance to the US war effort and knew how to exploit its bargaining position. It did so to the best possible advantage. Lend-lease weaponry and technology transfers from the United States helped Brazil to become the leading military power in the region and thus contributed to a marked shift in the balance of power vis-à-vis Argentina (Prutsch 2007).

First, the US demand for rubber led to a vast increase of economic activity in the huge Amazon basin. Once the Malayan plantations had fallen into Japanese hands, US import requirements had to be met largely by Brazil. Boosting Brazil's rubber production required shifting a large labor force into a sparsely populated Amazonian basin, and the Vargas Government pursued the idea of hiring 50,000 drought-suffering northeasterners from the arid areas of the Brazilian Northeast to serve as *seringueiros* (rubber collectors). Approximately 13,000 rubber collectors were actually transported to the Amazon region. In Brazilian propaganda they were called "rubber soldiers," as they produced a weapon with which the Allies could win. Even Henry Ford's

network of waterways appears, followed by rivers and cascades in the midst of tropical woods. Then a sea of houses composes on screen; it is called São Paulo by the film narrator and described as "unequivocal product of extraordinary human virtuosity" because it is "a group of people designated to fulfill an extraordinary mission to civilize the world!"

These formulas of order and progress are characteristic of the propaganda discourse of the government of Getúlio Vargas (1930–1945/1950–1954), Brazil's smiling and energetic president dictator, who promised to transform the gigantic and heterogeneous agricultural country into a homogeneous modern industrialized nation, with the help of skilled technocrats (Fausto 2006).[2] Although his powerful propaganda apparatus called him "the father of the poor," his social politics had yet to reach the poor northeast (and never would). Instead it was the blond-haired German, who suddenly appeared in the village as a twentieth century Antônio Conselheiro, a magical aid worker of modernity, who had confronted the village dwellers with a dream world. Through Aspirin they could see new and different worlds within their own home country and perhaps search for them. The educational short was a mixture of product advertisement and propaganda from the Vargas regime. It even showed some images of Rio's carnival, the short-lived inverted world of downtime filled with happiness and alcohol, where social distinctions were diluted for a while. But Aspirin helped not only to overcome a headache, but also to master the gap between reality and illusion, and even more, to create lucid thoughts of hope and progress. After the show the village residents stand in line for Aspirin. Ranulpho remarks appreciatively: "Wow! With this you could sell bibles to the devil!"

THE EVIL ARRIVES—BRAZIL AT WAR

Then, an animal bites Johann on his arm. Ranulpho calls it a *marimbondo*, a hornet. It signals to the viewer that the peaceful travel narrative of the start of a cross-cultural understanding will slowly move toward a different direction. *Marimbondo* is not merely an insect. It was given its name by the Guerra de Marimbondos (The Marimbondos War), a local revolt that happened in Pernambuco in 1852 when a group of rebels reacted to decrees that would establish the formal and civil register of the Brazilian population. The marimbondos led themselves by the rumor that the decrees would be a subterfuge: the government's objective would be to enslave the poor and free men (Franco Saavedra 2009: 1). The historical meaning of the maribondos is not specifically

ordinary people without political allegiances. The actor who plays the northeasterner Ranulpho convincingly characterizes a person from this region. Also aesthetically, Gomes, who studied film in Great Britain, tried to find his own language, one that was far away from Hollywood-style action films that shock, please, or overexpose the depth of landscapes. He also avoids the filmic language used by Walter Salles in *Central do Brasil*, which plays with the distance of people and their environment. Gomes did not intend to reproduce dreams of a beautiful and dignified poverty or to rescue the sertão through spectacle or nostalgia. Even the binary tension between city and countryside functions more symbolically. Glamorous Rio is one metaphor for hope and self-reliance; it is Ranulpho's declared destination, but there are other places. Gomes' sertanejos dream about opportunities, about the potential to develop. These wishes could be realized by leaving a damned place of scarcity or by waiting for missionaries of progress to come. Johann's truck bears the auspicious label *Aspirina. O fim de todos os males* (Aspirin, the End of All Evil).

THE WONDER DRUG

Aspirin, produced by the German pharmaceutical company Bayer (whose name never appears in the movie), had become very known in urban areas of Latin America in the late 1930s. Aspirin ads appeared in newspapers and women's magazines, on billboards, and as neon signs on the roofs of Brazil's mushrooming cities. Often middle-class women, obviously suffering from a headache, were depicted being supported by their maids. But Aspirin would relieve their pain and make life easier. The German-Iberoamerican Academy in Berlin also propagated the pill and sponsored its own medical magazine in Brazil to compete with French and US chemical products on the local market (Silva Rolim and Romero Sá 2013: 159–179).

In *Cinema, Aspirinas e Urubus* the village residents are fascinated with the film projector, a technical apparatus they have never seen before, that Ranulpho and Johann set up on the street right before their eyes. At night, the pair projects a propaganda film about the wonders of Aspirin on a wall. The short was cleverly made; rather than mentioning the pills first, it presented magical landscapes to the villagers instead. When the projector begins to roister, when the sentence "O Brasil Maravilhoso" (The Wonders of Brazil) and the first pictures glimmer on the screen, elderly people and children begin to giggle anxiously. They watch regions of their own country (however in black and white) that they never imagined before. A map of Brazil with its

film historians particularly focused on films about urban poverty, the filmic retomada of the sertão faded slightly into the background, with the exception of globalized directors such as Walter Salles. His road movie *Central do Brasil/Central Station* (1998) epitomizes the rediscovery of Brazil and was celebrated internationally as a landmark of the Brazilian film revival. The movie poses again a clear opposition between rural and urban worlds, but reverses the classical dichotomies of the early twentieth century. While Rio is a metropolis with dirty chaotic places and impersonal relations, the emblematic sertão is depicted as a place with strong religious faith and mutual collaboration. The road trip of the two protagonists, an elderly solitary woman and an orphan boy, offers a possibility of change and redemption.

While the *Cinema Novo* "rejected the technical excellence and production values of Hollywood cinema in favor of a more artisan form of production consistent with the realities of a developing country" (Signorelli Heise 2012: 62), the films of the retomada aesthetically reflect a new period in Brazil's history, a period in which Brazil has left behind its reputation as a "Third World" country and become an emerging power. Brazil's foreign political ambitions and its new self-confidence influence cinema and its aesthetic language. Many films show high production values, glossy visual styles, and an emphasis on entertaining plots. Thus, in Walter Salles' *Central do Brasil* and Sérgio Rezende's *Guerra de Canudos/The Battle of Canudos* (1997), the backland is a grand cinematic showcase, made for a global audience. Ivana Bentes called this visual transformation of very deprived places into exotic spectacles "cosmetics of hunger," an ironic variation of Rocha's "an aesthetic of hunger" manifesto (Signorelli Heise: 66).

Andrucha Waddington offers a stunning cinematography of the sertão and its popular culture with *Eu, tu, eles/Me, You, Them* (2000). The film benefits from a commercially appealing soundtrack. *Abril despedaçado/Behind the Sun* (2002), another sertão movie directed by Walter Salles, tells the story of two feuding families in the early twentieth century. Their permanent conflict over land results in brutal violence and death for various members of each family. Salles shot the film a hundred kilometers away from the nearest hotel and obliged the central actors to live the life of the protagonists, but the good-looking TV actors were not convincing in a context of scarcity (Shaw and Dennison 2007: 112). The sertão is not romanticized in these movies, but it is not a "shit hole" that has to be left by its inhabitants either, as Ranulpho called it in *Cinema, Aspirinas e Urubus*.

There is no drama, murder, skirmish, or war in *Cinema, Aspirinas e Urubus*; it is neither heroic nor destructive. The protagonists are

national literary canon. In his book *Grande sertão: veredas* (1956), João Guimarães Rosa transforms the sertão into a holistic metaphor of Brazil and, beyond that, of the world. For him, the sertão was as large as the world.

The binary tension between the urban and the countryside has also been a constant concern of Brazilian cinema since its inception. Influenced by Italian neorealism of the 1950s, Brazilian directors Nelson Pereira dos Santos and Carlos Diegues presented another urban reality, far from classicist buildings, lantern-fringed boulevards, and gleaming skyscrapers. They put an end to the studio system and the comedies of the *chanchada*. Their protagonists were the *favelados*, the dwellers of the shantytowns (Bentes 2013: 103–117).[1] Nelson Pereira dos Santos, who is considered by many to be the godfather of the *Cinema Novo* movement of the 1960s, filmed Graciliano Ramos's neorealist novel *Vidas Secas* (1963) about the plight of a northeastern family in the sertão. Migration is connected to the backland and motivated by the search for a better life. Pereira dos Santos' film was appreciated not only for its innovative qualities and power but also for its capacity to "turn scarcity into a signifier" (Shaw and Dennison 2007: 83).

The sertão enters in the limelight of Glauber Rocha's lens. In Rocha's interpretation of the backland there is a "discernible tendency for filmmakers to seek to locate the nation and map its inherent contradictions, representing both urban and rural life from the perspective of disenfranchised, marginalized fringes of society" (Shaw and Dennison: 101). Rocha, a figurehead of the *Cinema Novo* who was born in the state of Bahia, gave the backland dignity, and its dwellers, a sense of optimism. His films *Deus e o diabo na terra do sol/Black God, White Devil* (1964), and *O Dragão da Maldade contra o Santo Guerreiro/Antônio das Mortes* (1968), are set in the sertão of Bahia. This vast space, in some ways comparable to the US West, was a land without barbed wire, inhabited by sertanejos and *cangaceiros* (bandits), who, in the neo-Marxist discourse of the 1960s, were considered Robin Hoods. They stole in order to help the poor. Rocha's films are a kind of Brechtian lesson (Stam 2008). Through his overtly stylized and visually dazzling films, he aimed for middle-class moviegoers to reflect on their racism against the people of the hinterland, who had begun to pour into urban shantytowns.

The film revival of the mid-1990s (called *retomada*, when two fiscal incentive laws introduced by the government started to yield results) brought back inaugural myths of national formation and ideas of utopian thought, but in another global context (Rêgo 2011). As

The Rediscovery of the Sertão

The sertão occupies a special place in the national imaginary. It is a constituent in Brazil's history and identity that exists only in context with its counterpart, the urbanized coast. The dichotomy between center and periphery—later a dichotomy of modernity and backwardness, and by the late nineteenth century one between barbarianism and civilization—influenced and still influences literature and film. This dichotomy got its first prominent voice through Euclides da Cunha, who reported a cruel civil war between the sertanejos led by the messianic Catholic Antônio Conselheiro, a religious leader who refused to pay new and high taxes to the state government, and the troops of the newly founded Federal Republic. A place in the state of Bahia, covered with shanty huts and called Canudos, was wiped out between the years of 1896 and 1897 by military expeditionary forces; its inhabitants of about 15,000 mulattos and mestizos were killed; several children were given to the soldiers as a present. Da Cunha's 1902 report-turned-book *Os Sertões* (*Rebellion in the Backlands*) became one of the first literary bibles of the nation. He belonged to the intellectual urban elite, but was among the very few to physically travel to this other world of "degenerated" backward people. Da Cunha was deeply shocked by the sadistic war cruelties committed in the name of progress and with the help of modern war machinery; further he was very impressed by the resistance and perseverance of the sertanejos, who had defended themselves bravely with sickles, knifes, and machetes (Bartelt 2003).

His opus magnum, which still belongs to the national literary canon, was the first to connect the two Brazils: the urban coastal one with the rural poor. Although he continued to be an evolutionist, influenced by the Social Darwinism of the time, Da Cunha had transformed his feelings of contempt into respect. With his literature he made the downtrodden a subject of the Brazilian nation-building project and thus, initiated a literary genre that sought to create an integral understanding of Brazil. The title of Rachel de Queiroz' novel *Quinze* (1930) refers to the dramatic drought of 1915 in Ceará. João Cabral de Melo Neto's long poem *Morte e Vida Severina* (*Death and Life of Severino*), written in 1955, tells the story of a poor sertanejo and his migration to the coastal Zona da Mata. Ariano Suassuna's comedy about two antiheroes who struggle to survive, *Auto da Compadecida* (*A Dog's Will*), written in the same year, combines popular literature with trickster tales. Graciliano Ramos' novel *Vidas Secas* (*Barren Lives*), a vivid portrait of an exploited migrant family, is part of the

A part of his identity is revealed when a Brazilian hitchhiker suddenly sits in the truck, once the driver has bought gasoline at a wooden country store, and curiously studies the extraordinary interior. The first dialogue between the travelers makes clear that Gomes did not intend to reproduce or continue the filmic tradition of an "aesthetic of hunger": a tradition, shaped by the Brazilian film director Glauber Rocha in the 1960s, of revolutionary spirit in the sertão—one of originality, telluric energy, and hope. Gomes' sertão turns out to be a forgotten place in a huge republic, whose framers once allowed the stitching of "Order and Progress" on its flag. The sertão of the movie is a forgotten place that lacks not only water and electricity, but also education, social care, and perspective.

"Where do you come from?" the new passenger asks the driver.

"I am from Germany."

"No. I didn't mean where you're from originally. I meant where did you start your journey from on this truck."

"I began in Rio de Janeiro."

"That's where I'm heading."

"Rio?"

"To try my luck down there. I'm fed up of this place; this place is a shit hole."

The driver, Johann (Peter Ketnath), tells his passenger, that he has been on the road for three months. "It's like Brazil goes on forever... That's what good-for-nothing places are like," Ranulpho (João Miguel) answers barrenly. Johann, whose name Ranulpho tries to spell correctly, appreciates the sharp tongue of his new companion and calls him "*ácido*" (sour). At first, they seem worlds apart. When Ranulpho learns that the German sells medicine, he responds: if medicine helps to cure the hunger, Johann will make a fortune.

When they reach a village and pass through its main street, where emaciated people sit in the shadow of the afternoon sun, waiting for something to happen, Ranulpho comments prosaically, "These people are tight-fisted, mean, suspicious, and backward." With his pejorative words Ranulpho reproduces the racist attitude of the Brazilian south toward the people of the backlands he had belonged to before getting into Johann's truck. Ranulpho doubted that the sertanejos would ever buy anything from Johann. It is obvious that Marcelo Gomes sought to find a new way of describing the sertão, which had become a genre in the rich Brazilian production of literature, feature films, and documentaries.

flight from boredom to other spheres. Movements are made by ship, truck, train, and the telescope. The article also focuses on the global historical background of the 1940s, precisely the period of World War II, in which the plot is set. Although Brazil was not a central actor in the global war theater, it was well involved in the global conflict, so that it forced one of the main protagonists to a double escape.

Dried-out river courses, stony paths, stark hills, and endless landscapes of the *sertão* (the Brazilian hinterland) pass by the eyes of the driver and the audience, as Marcelo Gomes places the camera in the interior of the truck, while a radio plays an old samba of the late 1930s, "Serra da Boa Esperança" (Mountain Range of Good Hope, 1937), composed by Lamartine Babo. The truck seems to be his mobile apartment, his microcosm, well designed and pragmatically equipped with objects of survival: a radio, a map of Brazil, a bed, and water containers. Always filmed in dark colors, this cocoon is a contrast to the sun-bleached outside world. The landscape is frequently overexposed to intensify the feeling of heat on a dusty road.

Later, the audience will discover that the truck is a store as well. Its driver is a salesman, whose dark spots on his shirt reveal how he must suffer from the heat. The very few people he talks to during this journey stand suddenly at the curb of the road. One man with a rifle is given a short ride. He vanishes in the caatinga as quickly as he arrived, shooting at something along the way. His sudden appearance, which is not the only camera snapshot in the movie, may allude to mysticism and unreality, which the sertão is known for creating through the challenges and extreme nature that it offers to its inhabitants (*sertanejos*), who seem to be people that keep to themselves. When the driver asks another sertanejo for directions to a place named Triunfo (Triumph), he cannot give an answer. The world that the sertanejos live in is small—a contradiction to the wide landscape; their knowledge about global politics and travel experience seems to be limited as well.

The first sequences reveal to viewers that they are watching a road movie, whose quality lies in a certain anachronism, in slowness, straight dialogues, and tones of early Technicolor films. The growing feeling of timelessness in such a landscape soon comes to an end, when the scratchy radio voice of the news speaker begins to talk about European battlefields and mentions a date: August 18, 1942. Although this date marks a crucial period in Brazil's history (its government would declare war on Germany and Italy a couple of days later) the cigarette-smoking driver quickly turns off the radio. Apparently he is not interested in politics, but at this moment the audience may have wondered where the blue-eyed, blond-haired, barbed driver comes from.

9

CINEMA, ASPIRINS, AND VULTURES: A DOUBLE ESCAPE FROM A GLOBAL CONFLICT

Ursula Prutsch

The film opens with a washed-out screen covered in blazing white light, broken only by the dark frame of a side mirror reflecting the face of a driver. Shapes of bushes appear on the screen. Their contours slowly begin to sharpen until they offer a view of the brown- and ocher-colored landscape of the Brazilian Northeast.

The state of Pernambuco, where film director Marcelo Gomes was born, still belongs to those regions of Brazil where lobbies of wealthy landowners dominate the local parliaments, while subsistence peasants, herders, and traders remain in poverty. Pernambuco is known for its long history of a slave-based sugar economy, and for Palmares, its maroon "kingdom" of escaped slaves. It is also known for its unsuccessful war of independence against the royal power of the Portuguese Bragança family and for its *caatinga*, the semi-arid backlands covered with thornbushes, light-green hassocks and cactuses, and a shallow and stony soil. The film *Cinema, Aspirinas e Urubus/Cinema, Aspirins, and Vultures* (2005) was shot in similar places in the state of Paraíba. What the protagonists of this Brazilian road movie have in common is their escape from their previous lives. Why they decided to flee, under what circumstances, and how, will be described in this article. The plot of the film offers a variety of movements, which will be taken into account. They include business trips, adventure, domestic migration from the backland to the cities, and transatlantic exodus; even virtual voyages will play a role. The migration motives are diverse as well. They range from economic and political reasons to the virtual

Stock, F. (2010) "Home and Memory," in K. Knott and S. McLoughlin (eds.), *Diasporas: Concepts, Intersections, Identities*. London: Zed Book, 24–28.

Tsuda, T. (2003) *Strangers in the Ethnic Homeland: Japanese Brazilian Return Migration in Transnational Perspective*. New York: Columbia University Press.

Deveny, T. G. (2012) *Migration in Contemporary Hispanic Cinema*. Lanham: Scarecrow.
Dulles, J. W. F. (2002) *Sobral Pinto. "The Conscience of Brazil." Leading the Attack against Vargas (1930–1945)*. Austin: University of Texas Press.
Endoh, T. (2009) *Exporting Japan: Politics of Emigration toward Latin America*. Urbana: University of Illinois Press.
Gellner, E. (1983) *Nations and Nationalism*. Ithaca: Cornell University Press.
Hobsbawm, E. J. (1990) *Nations and Nationalism since 1780: Programme, Myth, Reality*. Cambridge : Cambridge University Press.
King, R. (2010) *The Atlas of Human Migration: Global Patterns of People on the Move*. London: Earthscan.
Knott, K., and S. McLoughlin. (2010) *Diasporas: Concepts, Intersections, Identities*. London: Zed Books.
Lesser, J. (1999) *Negotiating National Identity: Immigrants, Minorities, and the Struggle for Ethnicity in Brazil*. Durham: Duke University Press.
———. (2003) *Searching for Home Abroad: Japanese Brazilians and Transnationalism*. Durham: Duke University Press.
———. (2007) *A Discontented Diaspora. Japanese Brazilians and the Meanings of Ethnic Militancy, 1960–1980*. Durham: Duke University Press.
———. (2010) "How the Japanese Diaspora in Brazil became the Brazilian Diaspora in Japan," in K. Knott and S. McLoughlin (eds.), *Diasporas: Concepts, Intersections, Identities*. London: Zed Book, 198–203.
———. (2013) *Immigration, Ethnicity, and National Identity in Brazil, 1808 to the Present*. Cambridge: Cambridge University Press.
Marsh, L. L. (2012) *Brazilian Women's Filmmaking: From Dictatorship to Democracy*. Urbana: University of Illinois Press.
Masterson, D. M., and S. Funada-Classen. (2004) *The Japanese in Latin America*. Urbana: University of Illinois Press.
Meade, T. A. (2010) *A History of Modern Latin America: 1800 to the Present*. Oxford: Wiley-Blackwell.
Morais, F. (2000) *Corações Sujos: A História Da Shindo Renmei*. São Paulo: Companhia das Letras.
Nishida, M. (2002) "The Japanese in Brazil: From Immigration to Dekassegui," *Historically Speaking* 3 (5): 11–12.
Sadlier, D. J. (2008) *Brazil Imagined: 1500 to the Present*. Austin: University of Texas Press.
Singer, P. (2009) "Economic Evolution and the International Connection," in I. Sachs, J. Wilheim, and P. S. M. S. Pinheiro (eds.), *Brazil. A Century of Change*. Chapel Hill: University of North Carolina Press, 55–100.
Simões, I. F. (2004) *Tizuka Yamasaki: A Vida Invade O Cinema*. Brasília: M. Farani Editora.
Staszak, J-F. (2009) "Other/Otherness," in R. Kitchin and N. Thrift (eds.), *International Encyclopedia of Human Geography*. vol 8. Amsterdam: Elsevier Science, 43–47.

6. The hierarchies at the Fazenda Santa Rosa clearly reflect and symbolize the social dynamics in the country. The different levels are represented by Heitor (the owner of the plantation), followed by Chico Santos, the overseer of the plantation, and after him, Tonho, the accountant. Behind them, the immigrants. Within the immigrants there are two groups: the internal migrants from Brazil and the immigrants. They don't compete with each other; instead they try to help each other, as represented in the dance scene. The Japanese are therefore included in a larger community, the immigrants, and migration creates a sense of community within the group.
7. The terminology to label the different generations is controversial. The term *Nikkei* is widely adopted to refer to the Japanese overseas and the people of "Japanese Heritage." However, Daniel Masterson and Sayaka Funada-Classen (2004: xi) use the term *Issei*, to refer to the first generation that emigrated to Latin America before World War II and did not plan to stay. For them, that first generation became later on the true Nikkei, when they needed to stay overseas permanently. Also, the term *Nikkei-jin* is used to globally categorize the second, third, and fourth generations of *Nikkeis* also known as *Niseis*, *Sanseis*, and *Yonseis* respectively.
8. During the trip, the viewer sees the only images of the indigenous population present in the whole movie. They hide, watching the newcomers pass through their territory and scaring the Germans. Despite the above-mentioned statements of inclusion of ethnic groups and minorities, the indigenous, along with black Brazilians, are underrepresented in both movies.
9. This is symbolized by the friendship established between Veronika Müller, a young German woman, and Titoe. Veronika is the first person that Titoe assists in giving birth.
10. Additionally, the scenes showing the construction of houses in the new town recall the foundational myths of the expansion of the United Stated reinforced in many Westerns.
11. They represent "Shindo-Renmei,", an organization that refused to believe in Japan's surrender in World War II. Some of its most fanatical members used violence against those who acknowledged the surrender. The movie *Corações Sujos/Dirty Hearts* (2011, dir. Vicente Amorim), a cinematic transposition of Fernando Morais's (2000) book of the same name is based on the story of this group that was very active in the 1940s.

Works Cited

Anderson, B. (1991) *Imagined Communities: Reflections on the Origin and Spread of Nationalism*. London: Verso.

Coelho Prado, M. L. (2001) "Gaijin. Os caminhos da liberdade: tempo e história," in M. C. Soares and J. Ferreira (eds.), *A História Vai Ao Cinema: Vinte Filmes Brasileiros Comentados Por Historiadores*. Rio de Janeiro: Record, 99–109.

course of decades, and is also connected to international political and economic changes. In contrast with *Gaijin I*, *Gaijin II* reinforces a positive perception of the country and shows the connection to the land and agricultural life as an intrinsic part of both the Japanese community in Brazil, and of the Brazilian nation itself. The inclusion of a reverse migration exposes the differences between several generations of Japanese-Brazilians and their problematic connection with both Japan and Brazil, although the issue of class is also closely connected with their return to Japan. Compared to *Gaijin I*, nationhood and otherness are portrayed as more complex, unstable categories as a result of the internal transformation of the Japanese community in a global economy and the changes that took place in Brazil over several decades.

Notes

1. As explained by Daniel M. Masterson and Sayaka Funada-Classen (2004: 24–43), despite the fact that the Brazilian Constitution of 1890 banished immigration from Africa and Asia in order to lead a "whitening" process of the society, there were many attempts to bring Japanese to Brazil from 1894 on. However, the lack of established commercial relationships between both countries, the low coffee prices, and the mistrust of Japanese diplomats who were aware of the harsh labor conditions suffered by other groups of immigrants in Brazil (such as the Italians) prevented those endeavors to succeed until 1908.
2. As many authors have described, during the course of the twentieth century, Latin America shifted from being a region of immigration to being one of emigration. In the period from 1950 to 2000, approximately 15 million more people left than arrived to the region (King 2010: 48).
3. The first movie, *Gaijin.Caminhos da Liberdade*, is also known as *Gaijin. A Brazilian Odyssey*. In this essay it is referred to as *Gaijin I*. *Gaijin. Ama-me Como Sou (Gaijin 2: Love Me As I Am)* is referred to as *Gaijin II*.
4. This represents an important difference from other types of migrant movements. As Darlene J. Sadlier (2008: 262) stated: "Unlike the 'fractured' migration of many Brazilians who have come to the United States, Titoe and her family and other Japanese workers remain together and hold fast to their language and their traditions."
5. Outside the building, there is a group of immigrants speaking in Italian and Spanish. The image of the Spaniards is anachronic and stereotypical, and one of them speaks with an Argentinean accent. The place resembles other iconic immigration landmarks such as Ellis Island in New York City, one of the biggest ports of immigrants to the US at the time, and one depicted in many films, including the beginning of *The Godfather. Part II* (1994, dir. Francis Ford Coppola).

therefore, perceived as a foreigner. She summarizes her thoughts as follows: "I am neither a *nissei* nor a *sansei*. Only now I discovered that I belong to a fourth generation: *não-sei* or *cansei* (I don't know or I am tired). I speak what I think. I am *gaijin*." It is noticeable that, rather than emphasizing a community experience, the members of the family experience distinct but mixed feelings on their trips to Japan.

Despite all their struggles in Japan, they decide to buy a plane ticket for Batyan so that she can fulfil her promise of returning to the homeland she has dreamed of. This trip ends the movie, resolving the family feuds on both sides, in both Japan and Brazil. The search for an identity seems to come to an end as summarized by the off-screen voice the viewer hears while a plane passes over the rain forest: "And when she thanked the Gods for their protection, Batyan clearly understood that our land is where our home is, and that our home is the place for our soul." The fact that this statement is made up in the air, technically neither in Brazil nor in Japan, reinforces the message of a sublimation of the hyphenated identities and the embrace of a global identity in which otherness and nationhood have been put into perspective and, therefore, transformed.

Conclusions

In conclusion, both movies depict the Japanese migratory experience in Brazil in different ways. *Gaijin I* focuses exclusively on the first generation of Japanese migrants in Brazil at the beginning of the twentieth century. The use of mechanisms such as flashback highlight the presence of Japan as a dreamed, distant homeland, reinforcing the otherness of the Japanese community in both the way they are perceived and the way they perceive others. Those memories must be displaced in order to become part of the new country. The film depicts the city as a space of change and integration representative of the modern Brazilian nation, and is more focused on the process of realization of class struggle on the part of the Japanese community in Brazil (in which their relationship with the Italian immigrants played a crucial role). The film also highlights the prevalence of hierarchical structures in the creation of a national identity in Brazil during the early twentieth century as related to a more traditional concept of nation.

In *Gaijin II*, the story of the Japanese employs a more linear conception of history in which the Japanese were destined to be a part of Brazil and vice-versa. The Japanese migratory experience is linked more strongly to the development of a Brazilian identity over the

Through this event, the film reflects the repression of Japanese and Germans by the Estado Novo, which intended to promote a Brazilian national identity, focusing on the period beginning in 1938 with the April 18th Decree Number 383, which prohibited foreigners' participation in public affairs (Dulles 2002: 113). The scene in which the police show up to inspect the Japanese school is significant, since all communications in Japanese were forbidden—only bilingual publications could be authorized. Another outcome of World War II was the internal tensions within the Japanese community in Brazil (caused by a group within the Japanese community denying the defeat of the Japanese[11]). In the movie, this is represented in the conflict between Kobayasahi and the *sensei* that ends with the death of the latter, and the accident that leaves his son Kazumi (the narrator of the film) handicapped for the rest of his life.

As mentioned above, the third generation of Japanese in Brazil is represented by Maria, and as the narrator says: "Of Japan, she has retained her physical appearance and her grandma's kimono." This third generation is related by marriage to a different generation of immigrants: the family of the Spaniard Gabriel Bravo Salinas and his Italian wife Sofia Damaso, whose son, Gabriel Damaso Bravo Salinas, marries Maria. The conflict between the second generation and the third is symbolized by Shinobu's reluctance to accept a foreigner as part of her family, despite the fact that, as Maria claims, they don't speak in Japanese anymore among themselves. On top of this, the family is exposed to the problems of national politics. There is no mention of the military dictatorship in Brazil in the film; however, the economic crisis of the early 1990s under Fernando Collor de Mello's administration (1990–1992) becomes a crucial event that destabilizes the whole family, forcing Shinobu to go back to Japan where Gabriel will later join her.

After Shinobu returns, Maria and Yoko also decide to go to Japan in search of Gabriel, who disappeared after an earthquake. The trip to Japan represents the Dekassegui phenomenon, a reverse migration that began in the 1980s in which South American Japanese (not only from Brazil but also from other countries such as Peru or Argentina) returned to work in Japan (Nishida 2002). The moment in which both Maria and Yoko enter the wrong line at the airport upon their arrival to Japan is significant; it is there that they begin to realize that they are no longer Japanese. Japan is depicted as a modern, developed country where immigrants have a hard time adapting, although Maria seems to do so more easily than her daughter. Yoko struggles at school as she refuses to embrace all the new rules and costumes, and she is,

travel as part of the construction of the Brazilian nation and suggesting that its roots are in the trip itself, all of which set the film apart from *Gaijin I*.

Moreover, the subsequent trip to the interior is quite pleasant compared to the traumatic train ride to the interior of São Paulo in *Gaijin I*.[8] Instead of going to São Paulo, the immigrants are headed to Londrina, in the state of Paraná. There is a jump in the film after the arrival of the first generation (around 1908), and the story resumes in 1930. Essentially, the experiences of Titoe's arrival and her struggles as a first-generation of Japanese in Brazil are not present in *Gaijin II*. Londrina is a second stage, a space in which this next generation can develop their dreams.

Both movies share a depiction of the sense of community among the immigrants. This time, however, rather than living with Italians, the Japanese are traveling with Germans.[9] Londrina in 1930 is described as a place in which immigrants from 33 different countries arrived, and serves as a symbol of a new multicultural nation that follows foreign patterns, even taking its name from the idea that it is a "little *Londres*" (London).[10]

Rather than inhabiting an abandoned old house on a coffee plantation and suffering exploitation, as in *Gaijin I*, the Japanese in *Gaijin II* are portrayed as an active, essential part of the construction of this utopian nation called Brazil. They are hardworking, disciplined, and business oriented. The construction of their own houses is an essential part of their search for an identity, since the house will serve as the center of the family for multiple generations, connecting them to the land. Also, the creation of a Japanese school is a crucial space for the preservation of traditions, language, and culture for an eventual return to Japan. There is a certain element of romanticism in the depiction of the Japanese; the community is shown as a peaceful group, to a certain extent absent, independent, and even disconnected from national politics. However, as Jeffrey Lesser (2013) highlights, this was a crucial historical period in the construction of the Japanese-Brazilian identity:

> Between 1933 and 1950 the immigrant stream from Japan to Brazil would slow, but the discussion of the social place of Japanese and their descendants remained national topics. Immigrants and nikkei alike began to play an aggressive role in constructing a multifaceted Japanese-Brazilian identity, one that would be constituted and contested in many ways. (115)

An international event, World War II, brought external tensions, causing them to be perceived as enemies within the Brazilian territory.

not homogeneous. It is tied to the process of industrialization, and on a personal level, to Titoe's maturity and coming of age.

Gaijin II: Rewriting the Story/Redefining the Experience

Gaijin II. Ama-me como sou represents a deviation from the first movie. The main narrator is Kazumi, a third-generation Brazilian-Japanese man, who is writing the history of his family. The viewer learns later that Kazumi is the grandson of Titoe Yamada, the protagonist in *Gaijin I*, called "Batyan" throughout the film. *Gaijin II* tells the story of four generations of Brazilian-Japanese, beginning with Titoe and followed by her daughter, Shinobu, who represents the second generation. The third generation is represented by Maria, who is both Shinobu's daughter and Kazumi's sister. Maria's daughter, Yoko, is the one who represents the fourth generation.[7]

Despite the male narrator, the story focuses on a family of women, working within a matriarchal structure, wherein everyone respects Batyan. She is portrayed as wise, the foundation of the family. At the start of the film, the narrator poses the questions that define the narration:

> I was born in this region where people came from all over the world. The natives are the Indians who were expelled by the relentless colonization. My Remington [the typewriter] was the way to find answers. If you didn't like reality, you could invent another one! Who am I? Which country is this? Where did my "Batyan" come from?

In *Gaijin II* the viewer sees this reflection on the rewriting of history, in which Japanese and Brazilians are destined to be part of the same entity. The Brazilian and Japanese flags present in virtually every home shown in the movie help to create the sense of shared destiny and community emphasized in the story. At the same time, the individual's search for his/her roots and a community identity is linked to the larger question of national identity.

As in *Gaijin I*, the film follows the typical structure of immigrants leaving their home country and their arrival to the new Promised Land. However, there are some significant departures from this model in the second film. The scenes set in Japan during the premigration stage are not as dramatic as those in *Gaijin I*. Also, the presence of both Brazilian and Japanese flags suggests that there is a sense of common identity from the start of the migration journey, reinforcing

One of the most significant moments in our understanding of the migratory experience of these communities takes place at a party improvised by the Italians, which depicts a harmonious encounter of cultures and races in which everyone (both men and women) is dancing. This is a foundational moment for the creation of a third group, made up of a mixture of all the immigrants. In other words, to use the term coined by Benedict Anderson, these are the first steps of an imagined community.

The beginning of real integration into a Brazilian national identity is related to Titoe's escape from Santa Rosa, the coffee plantation, and the subsequent move to the city of São Paulo. Following a binary dichotomy, the city is identified with progress and multiculturalism, while the country is a space of oppression.[6] At the end of the film, the romantic encounter between Titoe and Tonho (the accountant of Fazenda Santa Rosa who became a labor activist) in the city of São Paulo states a precise message about the integration of the first communities of Japanese in Brazil. As Jeffrey Lesser pointed out, this conclusion "promoted Brazilianization through interethnic marriage and popular protest" (2007: 65). In doing so, otherness and nationhood seem to find a way to somehow reconcile. Also, this encounter precedes a flashback that summarizes the interactions between Tonho and Titoe throughout the movie. In this last flashback, there are no longer memories of Japan. The homeland has been displaced. Rather than emphasizing the completion of a process, the film highlights the beginning of a new time in which the Japanese will become part of the Brazilian national community.

In summary, *Gaijin I* outlines the struggles of the first generation of Japanese immigrants to Brazil through its portrayal of the initial arrival stage and the problems of integration in a new country. Although the film depicts a clear contrast between the city and the country, it does not treat the relationships between Brazilians and Japanese as binary, but rather shows the complexity of interactions between different social classes as well as that of the migratory phenomenon and the interactions with different groups, such as the Italians. Nationhood among the Japanese is mostly associated with their home country through dreams, hallucinations, and flashbacks. The Japanese are clearly portrayed as the other until the very end of the film. As well, Brazil is not depicted as a welcoming new motherland but rather as a nation that despite existing in a postslavery society is still very hierarchical, a nation only just beginning the process of industrialization that carries a strong association with exploitation. The consciousness of the Japanese, which group would become part of a new nation, is

to Brazil; they had an anarcho-syndicalist background. The Japanese did not have a tradition of struggle in that sense, because they came from a feudal society" (quoted in Simões 2004: 70).

These differences between the Japanese and the Italians are also present in the way the members of the Japanese community constantly reflect on Japan as their homeland. As Stock (2010) points out, "Memories of home are no factual reproductions of a fixed past. Rather they are fluid reconstructions set against the backdrop of remembering subject's current positionings and conceptualizations of home" (24). The moments in which Titoe remembers Japan are, therefore, very significant. They establish a dreamed homeland, which is compared to her present in Brazil. In these flashbacks, Japan is depicted as a longed-for, exotic homeland of bright lights and blurry images. The flashbacks frequently end with a shot of Titoe's smile. She attempts to interpret the present through the lens of her previous experiences, which is always informed by her construction of an imaginary Japan.

The flashback in which Yamada remembers the war between Japan and Russia is particularly significant. It takes place during the scene in which the Japanese are transported by train to the interior of São Paulo. The children are sick and likely will die. The viewer sees how the notion of service and sacrifice is associated with his idea of nationhood. He remembers the suffering of the Japanese, but also their bravery, which informs his view of his homeland as a heroic empire filled with heroic people.

On a different level, otherness also has a political connotation related to the context in which the film was produced and launched. As Maria Lígia Coelho Prado (2001) suggests, 1980 was a crucial year in the fight against the Brazilian dictatorship due to the metal workers' strikes the previous year. The film speaks about the liberation process undergone by the main character when she discovers that she must flee from oppression, but also about the struggle of the working class in general:

> In that context, *Gaijin* was a didactic film, a combat film. Thus, attending *Gaijin* in 1980 had, for those who were struggling against the dictatorship, a very particular meaning. Our political desire for freedom was represented by those characters, establishing an immediate identification between "us," the spectators, and "them." The critique of the power establishment was perceived as a part of "our struggle," and we integrated it into the debate of the opposition to the regime. (103–105)

During the First Republic, the very existence of a workers' movement was always precarious. Few workers' rights were protected by law. Working conditions were bad because of a constant labor surplus, fed by heavy immigration from Europe and Japan and by numerous former slaves, who were relegated to the worst-paid jobs. (72)

The Japanese were, therefore, not accepted as part of the project of this new nation called Brazil. As Teresa Meade (2010) mentions, they were merely a solution in a specific historical moment: "Prompted by planters anxious to recruit low-wage workers in the wake of abolition, politicians from the state of São Paulo prevailed on the Brazilian government to lift an earlier ban on Asian immigration" (137). They are necessary, but must be kept separate. They come from a different place, but are neither Africans nor Europeans (the two main groups that arrived to Brazil at that time). They are not technically slaves, but their working conditions were terrible, a sort of semi-slavery that is illustrated later in the film.

At the same time, the Japanese too did not want to see themselves as part of this new country either. During most of the film, the Japanese insist on calling the people around them "gaijin," or foreigners. Yamada harshly criticizes a young Japanese man for carrying on a relationship with the daughter of Enrico Matarazzo, one of the Italian workers of the coffee plantation. The migrants brought with them a sense of Japanese nationhood that includes respect for tradition, and they state clearly on several occasions that their ultimate goal is to return to Japan.

Their integration proves to be parallel to the story of their exploitation. Little by little, they learn about Brazilian culture while improving their Portuguese language skills. However, it is their own understanding of themselves as a working class, along with their eventual move to the city of São Paulo that ultimately integrates them into the larger national community. The transformation and industrialization of Brazil is, therefore, parallel to the story of the arrival of the Japanese, who are a key element in this long and complex process.

Their otherness is present and emphasized from the very beginning of the film. The Japanese are described as stereotypical; they are educated, disciplined, and extremely formal, in contrast with the Italians who are depicted as loud, problematic, and challenging. The figure of Enrico Matarazzo establishes this contrast in one of the very first scenes, when he demands that the owner of the plantation follow through with his forgotten promises of a raise. As director Yamasaki highlights: "The Italians were the ones who introduced class struggle

However, as discussed later, the immigrants receive very little assistance after this initial welcome. They continue on to the Hospedaria dos Imigrantes (immigrants' hostel) in São Paulo (Lesser 2013: 74)[5] where they are informed about basic rules and regulations: they are told what to do and what not to do. This is a foundational moment that can also be read as a rite of passage, and a crucial one in the creation of an imagined community shaped by common experiences in the confines of the same shared spaces.

This scene in many ways sets the tone of the movie in its foreshadowing of the problems that the Japanese migrants later face. A man's voice off-screen speaks in Japanese to the newly arrived migrants. Explaining the general labor conditions, he emphasizes that they must pay taxes and that they do not have the right to political association. The voice represents the official discourse surrounding immigration and sets expectations for the way they are to be treated and perceived in Brazil.

This scene also shows the filter established by both the Portuguese language itself, and the legal restrictions that dictate its use. As in many movies about immigration, language is a fundamental problem. Mastering both these elements would be the key to integration, as demonstrated in the evolution of the characters. However, as Benedict Anderson points out, language is a very complex issue: "Much the most important thing about language is its capacity for generating imagined communities, building in effect *particular solidarities*" (1991: 133). Anderson here is referring specifically to the context of the creation of modern nations following the independence processes. In Brazil's particular case, its national identity was linked to its metropolis, Portugal, from the very start, since the path to the independence process itself was initiated by the monarchy, when King D. João VI and the Portuguese royalty were forced to flee from Europe to Brazil in 1808 after Napoleon's invasion and was proclaimed by King D. Pedro I in 1822. At the same time, the Portuguese language established Brazil's distinct identity as an entity predominantly surrounded by Spanish-speaking countries. There are many nuances when speaking about immigration, since language can obviously represent a barrier for migrants. However, it can be said that it is not the language itself, but the lack of fluency in a specific language that can help create this sense of community, regardless of whether it results in a third variety of the language or not.

From the very beginning, the Japanese were considered a workforce, but could not partake in political acts as workers. As Paulo Singer (2009) summarizes:

help her brother who is immigrating with his wife. Since only family members are permitted to emigrate from Japan to Brazil, she needs to marry her brother's friend, Yamada. Although the formation of the family structure is somewhat artificial, Titoe stays faithful to it. The four of them join hundreds of other Japanese migrants on the ship that would take them to Brazil.

In terms of structure, before introducing the spectator to Titoe's family story, *Gaijin I* opens with a visual montage of the city of São Paulo in 1980 featuring many shots from *Bairro da Liberdade* (liberty or freedom neighborhood), considered the heart and the soul of the Japanese community in the city. The subsequent intertitles dedicate the film to all immigrants. As Leslie Marsh (2012: 98) points out, despite the fact that the movie focuses mostly on the Japanese community, there is a clear message of inclusion that challenges the notions of cultural identity promoted during the military dictatorship (1964–1985). According to Marsh, this beginning highlights the importance of anonymous migrants as key to the process of development of Brazil over decades, as opposed to stereotyped images of mulattas, samba, and soccer appropriated and misused during the military regime.

The storyline then follows a classic three-stage pattern seen in many films dealing with migrations, diasporas, and displacements. As Thomas Deveny (2012) summarizes regarding films on Hispanic migration: "All migration film narratives have three basic components: the premigration context that triggers the decision to depart one's homeland, the journey or crossing, and the life of the new immigrant in the new land" (ix). This movie's brief premigration component serves as a sort of foreword, focusing on the moment in which the Yamada family decides to leave Japan. The opening credits refer to the journey from Japan to Brazil by sea. The subsequent trip to the interior of São Paulo by train is a brief segment that leads the viewer to the third part of the film, their arrival at the coffee plantation and their new life in Brazil, the primary focus of the film. The story of Titoe and her family can be read as a lengthy flashback, in which the viewer hears an off-screen voice (Titoe) narrating the past from a nonspecific future. However, despite the movie's general lack of a complex structure, there are some flashbacks within this larger flashback that are crucial. As we will see later, this tactic aids in the creation of a dreamy, distant homeland presented in very specific ways, primarily through flashbacks and fantasies.

The Japanese migrants arrive to the city of São Paulo by train, where the official welcome (including a band and a red carpet) highlights the involvement of both governments in this initial part of the process.

Caminhos da Liberdade/Gaijin. A Brazilian Odyssey (1980) and *Gaijin. Ama-me Como Sou/Gaijin 2: Love Me as I Am* (2005).[3] My analysis of select aspects of both films addresses the way in which they characterize the relationship between otherness and nationhood. In doing so, the article contributes to a deeper understanding of the significance of interactions between different generations of Japanese people in Brazil, the challenges they faced and continue to face, and the variety of ways in which they help define a new Brazilian identity and culture.

The term nationhood is being constantly redefined. Authors such as Ernest Gellner (1983) and Eric Hobsbawm (1990) made some of the classic contributions to the understanding of nations and nationalism as concepts mainly linked to the rise of industrial societies, and class-consciousness in the modern world. One of the most widely cited meanings of nationhood was coined by Benedict Anderson (1991 [1983]) in his book *Imagined Communities*, wherein he defines nation in the following terms: "It is an imagined political community—and imagined as both inherently limited and sovereign" (6). According to Anderson's definition, nationhood is, consequently a social construct, a creation. Otherness could be defined as the quality, state, or condition of being different, and is closely tied to the point of view and discourse of the individual(s) who perceives the other(s) as such (Staszak 2009: 43–47). As it is known, many key authors of the Western tradition (such as Jacques Lacan, Jean-Paul Sartre, and Emmanuel Levinas) have deeply studied the self in relation to the other. Also postcolonial theorists such as Frantz Fanon, Edward Said, Homi Bhabha, or Gayatri Spivak, have made key contributions to the analysis of alterity and otherness from diverse perspectives. Otherness is, therefore, a key concept in the definition of national identities and is closely related to experiences of migration, exile, and diaspora. These two components, as we will see later, are key in the context of our analysis of *Gaijin I*, and *Gaijin II*.

Gaijin I: Immigrant Workers in Struggle

Gaijin I tells the story of one of the first groups of Japanese migrants to arrive to Brazil at the beginning of the twentieth century. Once there, they begin working at the Fazenda Santa Rosa, a coffee plantation in the interior of the state of São Paulo. The protagonist, Titoe, is a young Japanese woman who comes to Brazil along with her whole family.[4] As explained by an off-screen voice, Titoe does not want to leave her hometown in Japan. She immigrates to Brazil in order to

8

OTHERNESS AND NATIONHOOD IN TIZUKA YAMASAKI'S *GAIJIN I* AND *GAIJIN II*

Álvaro Baquero-Pecino

Migration is a key component of Brazilian history and society. Over the course of centuries, thousands of individuals and hundreds of groups of migrants from distant places have arrived to this vast land, helping to create one of the most complex countries in the world. Among these migrants, the Japanese community is one of the most relevant additions to the varied population that makes up Brazilian culture, and they currently represent the largest community of Japanese descendants outside of Japan.

Beginning with the arrival of the *Kasato Maru* to the port of Santos in 1908, Japanese migrants and their descendants have been present in Brazil for over a century.[1] This flow to Brazil should be understood also in a broader context of large-scale emigration from Japan to Latin America, including countries such as Peru, Mexico, Bolivia, Paraguay, and Argentina that started to be shaped mostly at the end of the nineteenth century (Endoh 2009: 19). As Takeyuki Tsuda (2003: 56) highlights, most of the first generations of Japanese went to Brazil as *dekasegi* (temporary workers), but the economic reality prevented them from returning to Japan. During the last decades of the twentieth century, a widespread reverse migration, in which Brazilian-Japanese people traveled to Japan to work, added complexity to the equation.[2] As Jeffrey Lesser (1999, 2003, 2010) has underlined, the terms in which these phenomena have been described have been contested, suggesting many questions regarding race, gender, class, and ethnicity.

This article focuses on the portrayal of the Japanese migratory experience in Brazil in two films directed by Tizuka Yamasaki: *Gaijin*.

Mazierska, E., and L. Rascaroli. (2006) *Crossing New Europe. Postmodern Travel and the European Road Movie*. London: Wallflower Press.
Naficy, H. (2001) *An Accented Cinema: Exilic and Diasporic Filmmaking*. Princeton: Princeton University Press.
Nagib, L. (2013) "Back to the Margins in Search of the Core: *Foreign Land*'s Geography of Exclusion," in S. Brandellero (ed.), *The Brazilian Road Movie: Journeys of (Self)Discovery*. Cardiff: University of Wales Press, 162–183.
Orgeron, D. (2008) *Road Movies. From Muybridge and Méliès to Lynch and Kiarostami*. New York, Basingstoke: Palgrave-Macmillan.
Piedras, P. (2010) "La cuestión de la primera persona en el documental latinoamericano contemporáneo. La representación de lo autobiográfico y sus dispositivos," *Cine documental* 1. Online. Available at: http://revista.cinedocumental.com.ar/1/articulos_04.html (accessed January 26, 2014).
Pinazza, N. (2011, Summer). "Transnationality and Transitionality: Sandra Kogut's *The Hungarian Passport* (2001)," *Alphaville. Journal of Film and Screen Media* 1: 1–13.
Pinazza, N., and L. Bayman. (eds.) (2013) *Directory of World Cinema: Brazil*. Bristol: Intellect.
Randel, D. M. (ed.) (2003) *The Harvard Dictionary of Music*. 4th edition. Cambridge MA.: Harvard University Press.
Robertson, P. (1997) "Home and Away. Friends of Dorothy on the road in Oz," in S. Cohan and I. R. Hark (eds.), *The Road Movie Book*. New York: Routledge, 271–286.
Sargeant, J., and S. Watson. (1999) "Introduction," in J. Sargeant and S. Watson (eds.), *Lost Highways. An Illustrated History of Road Movies*. S. L.: Creation Books, 5–20.
Shaw, D. (2013) "Deconstructing and Reconstructing Transnational Cinema," in S. Dennison (ed.), *Contemporary Hispanic Cinema. Interrogating the Transnational in Spanish and Latin-American Film*. London: Tamesis, 47–65.
Signorelli Heise, T. (2012) *Remaking Brazil. Contested National Identities in Contemporary Brazilian Cinema*. Cardiff: University of Wales Press.

Works Cited

Augé, M. (1995) *Non-Places. Introduction to an Anthropology of Super-Modernity*. London, New York: Verso.

Bauman, Z. (2006) "From Pilgrim to Tourist. A Short History of Identity," in S. Hall (ed.), *Questions of Cultural Identity*. London: Sage, 18–36.

Bertelsen, M. (1991) *Road Movies und Western. Ein Vergleich zur Genre-Bestimmung des Road Movies*. Hamburg: LIT Verlag.

Bletz, M. (2010) *Immigration and Acculturation in Brazil and Argentina*. New York: Palgrave MacMillan.

Branderello, S. (2013a) "A Hungarian Passport," in N. Pinazza and L. Bayman (eds.), *Directory of World Cinema: Brazil*. Bristol: Intellect, 263–265.

———. (ed.) (2013b). *The Brazilian Road Movie. Journeys of (Self)Discovery*. Cardiff: University of Wales Press.

Chanan, M. (2007) *The Politics of Documentary*. London: BFI.

Corrigan, T. (1991) *A Cinema without Walls. Movies and Culture after Vietnam*. London, New York: Routledge.

Corrigan, T. and P. White. (2004) *The Film Experience. An Introduction*. Boston, New York: Bedford/St Martins.

Da Cunha, M. (2013) "Framing Landscapes: the Return Journey in *Suely in the Sky*," in S. Brandellero (ed.), *The Brazilian Road Movie. Journeys of (Self)Discovery*. Cardiff: University of Wales Press, 69–92.

Dennison, S. (2013a) (ed.) *Contemporary Hispanic Cinema. Interrogating the Transnation in Spanish and Latin-American Film*. London: Tamesis.

———. (2013b) "Sertão as Post-National Landscape: *Cinema, aspirinas e uruburus*," in S. Brandellero (ed.), *The Brazilian Road Movie. Journeys of (Self)Discovery*. Cardiff: University of Wales Press, 184–198.

Douzian, M. (2012) "Memories without Borders/Mémoires sans frontiers," *Armenian Trends/Mes Arménies*, December 13. Online. Available at: http://armeniantrends.blogspot.be/2012/12/memories-without-borders-armenian.html (accessed January 24, 2014).

Ezra, E., and T. Rowden. (2006) "General Introduction: What is Transnational Cinema?," in E. Ezra and T. Rowden (eds.), *Transnational Cinema: The Film Reader*. London and New York: Routledge, 1–12.

Han, B.-C. (2013) *Im Schwarm. Ansichten des Digitalen*. Berlin: MSB.

Hjort, M. (2010) "On the Plurality of Cinematic Transnationalism," in N. Durovicova and K. Newman (eds.), *World Cinemas, Transnational Perspectives*. London and New York: Routledge, 12–33.

Laderman, D. (2002) *Driving Visions. Exploring the Road Movie*. Austin, Texas: University of Texas Press.

Lie, N. (forthcoming, 2014) "Two Forms of Multidirectional Memory: *Um passaporte húngaro* and *El abrazo partido*," in N. Lie, K. Mahlke, and S. Mandolessi (eds.), *Transnational Memory in the Hispanic World*, special issue of the *European Review*. Cambridge University Press.

Lie, N., and P. Piedras. (forthcoming, Fall 2014) "Identidad y movilidad en el cine documental latinoamericano contemporáneo: *Familia tipo* (Cecilia Priego, 2009) e *Hija* (María Paz González, 2011)," *Confluencia* 30(1).

13. According to Pablo Piedras (2010), Kogut's documentary can be defined through this strategy of "ocultamiento" (hiding), which allows the spectator to take her place and identify with her problems.
14. From Leviathan to Löwinger, from Löwinger to Laita.
15. The grandmother was born Austrian, but lost her nationality by marrying a Hungarian. Later on, she and her husband became Brazilian.
16. I have related this aspect of the documentary to Michael Rothberg's concept of multidirectional memory in Lie (forthcoming).
17. The author wishes to express her sincere thanks to Gary Gananian and his family for the useful information they provided to her on the film by e-mail and in person. She is also indebted to the Fund for Scientific Research—Flanders (FWO), which granted her a travel allowance to São Paulo in preparation of this essay.
18. The documentary was also awarded the British Council Special Award (Yerevan 2012) and the Best Documentary Award at the Pomegranate International Film Festival (Toronto 2012). It was screened at several festivals, for example, the International Film Festival at São Paulo, and the ARPA Film Festival in Hollywood.
19. In fact, the fruit identified with Armenia is the apricot, which is related to the peach.
20. "Accented films encode, embody, and imagine the home, exile, and transitional sites in certain privileged chronotopes that link the inherited space-time of the homeland to the constructed space-time of the exile and diaspora. One typical initial media response to the rupture of displacement is to create a utopian prelapsarian chronotope of the homeland that is uncontaminated by contemporary facts. This is primarily expressed in the homeland's open chronotopes (its nature, landscape, landmarks, and ancient monuments) and in certain privileged renditions of house and home" (Naficy 2001: 152).
21. The wedding provides another intertextual clue with Pelechian's *Seasons*. However, whereas *Rapsódia Armênia* centers on a diasporic couple, *Seasons* focused on local people exchanging vows.
22. At a given moment they are invited to stop filming and join the wedding couple at the dance floor.
23. "Ararat is an enduring emblem of Armenian national identity, to the point that even during the Soviet era—when icons of national consciousness were generally removed from official insignias of the Soviet republics—Ararat remained on the flag of Soviet Armenia" (Naficy 2001: 164).
24. For this distinction between the "swarm" and the "mass" I draw on Byung Chul Han's (2013) essay *Im Schwarm. Ansichten des Digitalen*.
25. This alternation is once again a tribute to Pelechian, who developed a form of "contrapuntual montage" (Naficy 2001: 158).
26. See Nacify (2001: 155) on Pelechian's film-style.
27. Shaw (2013: 56) makes an exception for "economic exile," which affects filmmakers such as Alfonso Cuarón and Fernando Meirelles, who—lured by bigger budgets abroad—make films outside of their homeland.

3. See chapter VII in Naficy (2001).
4. By placing Sandra Kogut's film in this new category and comparing it to *Rapsódia Armênia*, my essay provides a complement to the excellent analysis that Natalia Pinazza (2001) undertakes of *Um passaporte húngaro*.
5. Two other examples of this category in European cinema are *Le Grand Voyage* (2004, dir. Ismaël Ferroukhi) and *Auf der anderen Seite* (2007, dir. Fatih Akin).
6. "The central motif of the road movie is the journey" (Bertelsen 1991: 47).
7. Thus, *Um passaporte húngaro* is included in the section on road movies in the *Directory of World Cinema: Brazil* (Pinazza and Bayman 2013), but it also receives the label 'documentary' under its generic specification (263–265). *Rapsódia Armênia* is alternatively presented as road movie and documentary in a review by Myrna Douzian (2012).
8. Other recent examples of road movie documentaries in Latin American cinema are *Hija* (2011, dir. María Paz González), *Familia Tipo* (2009, dir. Cecilia Priego) *Pancho Villa aquí y allí* (2008, dir. Matías Geilburt y Paco Ignacio Taibo II), *Alicia en el país* (2009. dir. Esteban Larraín), and *Cine al fin* (2011, dir. Meritxel Soler y Julián Vázquez). More early examples of the road movie documentary can be found in *Vakantie van de filmer/Holidays of the Filmmaker* (1974, dir. Johan van der Keuken), *Sherman's March* (1986, dir. Ross McElwee), and *Route One USA* (1989, dir. Robert Kramer).
9. Almost half of Brandellero's volume on Brazilian road movies (2013b) deals with this topic.
10. A clear exception is Walter Salles' *Terra estrangeira/Foreign Land* (1995), but according to Lúcia Nagib (2013: 179), the transnational quality of this film is linked to specific socioeconomic circumstances. Referring to contemporary Brazilian cinema in general, Tatiana Signorelli Heise (2012: 167) also believes that "the focus on subnational or transnational identities is relatively new."
11. This film also has a strong link with the television circuit, particularly Arte, RTBF, and TV5. It gained wide recognition, as can be deduced from some of the awards that it won: Sélection Doc Lisboa 2002 (Lisbon); Etats généraux du documentaire 2002 (Lussas); Rencontres internationales du documentaire de Montréal 2002; Festival Femme totale de Dortmund 2002; Prix du Meilleur Documentaire à la Semaine du film hongrois 2002 (Budapest); Mention spéciale "It's all true" Film Festival 2002 (Rio de Janeiro); Grand Prix de la Compétition vidéo au Festival international de Split 2002 (Croatia).
12. Here, I adopt a somewhat different take on the documentary than Pinazza: whereas she states that Kogut's journey amounts to a "process of transformation as she gradually 'becomes' Hungarian" (2011: 7), my reading underscores the filmmaker's permanent position as an outsider in the film, especially during the visits to relatives of hers in Budapest.

made (Dennison 2013a: 206): whereas Sandra Kogut still needed to look for funding abroad, the filmmakers of *Rapsódia Armênia* found financial support among Brazilian private investors with whom they share their diasporic background. In this sense, the diasporic movement in Brazil is now producing its own films through the children, grandchildren, and great-grandchildren of the original migrants.

However, this essay has also argued that adjustments should be made to Naficy's model in order to include the more recent examples of Latin American accented films, at least as far as they are represented by the two Brazilian documentary films we have discussed. First, the series of journeys related to accented cinema needs to be expanded with the category of the "home-discovering journey," as many filmmakers have not experienced the diaspora themselves. Second, the multisitedness in their work, which Naficy holds to be typical for diasporic cinema, now seems to take other shapes. In Kogut's documentary, we do not find a solidarity with Jewish people in particular—which would be the traditional expression of multisitedness—but with displaced persons in general. Marked by a visual blank, her documentary shows us a world with no clear centers, no clear points of orientation, and no clear grounds for collective identities. I would like to call this form of multisitedness "centrifugal," as it in fact dissolves the specificity of the diasporic experience into a wider, anonymous, mobile web. In *Rapsódia Armênia*, on the contrary, the multisitedness is clearly evoked in the various interviews with Armenians who were born or who lived abroad. However, by linking the scenes of happiness in the documentary with the image of a wedding between two diasporic persons, and having them dance and pronounce their vows on Armenian soil, this documentary indirectly privileges the image of the Armenian returning to his/her country of origin. Multisitedness is acknowledged and preserved, but implicitly geared toward a "centripetal" form of thinking, implying diasporic cultures should return home. In this respect, the image of the guide lost in his landscape, which marks the beginning of the documentary, is fully understandable: only a country filled with its people can become a true homeland.

Notes

1. The use of this word is still contested in the case of Armenia, particularly by the Turkish government, which prefers to consider it as the result of a civil war.
2. Sandra Kogut was born in Rio de Janeiro in 1965. The filmmakers of *Rapsódia Armênia* were all born in São Paulo in the 1980s.

Naficy's observation that in accented cinema, the homeland is not only evoked visually, but orally and musically as well (2001: 24–25). Moreover, the intimate association of image and sound constitutes a tribute to Pelechian, who composed several films and documentaries as musical compositions.[26] Ranging itself under the heading of the rhapsody, the documentary provides an acoustic ending to the film by incorporating a continuation of the fragment with the dhol-players, until their little concert stops. This circular structure is also confirmed by the composition of the final part of the documentary, which first takes the viewer back to the local guide who showed him around in the car, then gives the floor to a very old woman, who recalls the genocide and its impact on women, and then concludes with scenes from the wedding party. Once again, these stand out as a testimony of hope for a country facing so many hardships and adversities. Including these hardships in its portrait of Armenia is the contribution of this documentary, which thereby also displays its use of the journey as a means for critical examination.

While *Rapsódia Arménia* shares this critical dimension with *Um passaporte húngaro*, it departs from Kogut's documentary. Whereas Kogut's work dissociates concepts of territory, culture, and social formation, *Rapsódia Arménia* explicitly unites them. By uniting all Armenians (born and bred as well as diasporic) on the same soil, and focusing on culture as a set of living practices and rituals (the wedding, the dances, the songs) performed on Armenian territory, the documentary itself is instrumental in ensuring the syntactic gesture between culture and territory that was lost in the diasporic experience. This documentary then very much insists upon the homeland, but radically disassociates it from Brazil.

Conclusion

In a recent categorization of transnational filmmaking, Deborah Shaw (2013) explicitly includes accented cinema in her list. However, she also states that the concept has become less useful for Latin American cinema nowadays, because dictatorship and exile are (fortunately) not as prominent as they were in the 1970s and 1980s.[27] Our analysis of *Um passaporte húngaro* and *Rapsódia Arménia* demonstrates the ongoing pertinence of the notion of accented cinema for Latin American cinema, which—thanks to new transnational and national funding mechanisms—is discovering and visualizing parts of its own diasporic constituency. This tendency seems to be particularly strong in Brazil, where a rising economy is rapidly changing the ways in which transnational films are

that put their self-interest above social justice and welfare. Whereas *Um passaporte húngaro* favors movement, this documentary includes long takes and close-ups, suggesting the standstill of a country that "hasn't made any progress in the past twenty years," according to one person. Even the fortune-teller, who deduces "good changes to come" from the leaves of a cup, is not able to believe in her own prophesy, and suddenly bursts out in laughter: "Please do not believe me—it's only a cup."

An important part of the documentary is reserved for people from the diaspora who came back from abroad and deliberately decided to stay in Armenia, because they never really felt "at home" in their Armenian communities abroad. A young Canadian woman testifies to her need to "connect to Armenia as a place, as a land," and a 60-year-old singer praises himself lucky because he can listen to the Armenian language from morning till night. Armenians living abroad cannot find "homely" places, so it seems, and this inevitably affects the image of Brazil as homeland for diasporic Armenians. One of the older interviewees evokes instances of Brazilian-Armenian connectedness (a book donated to him by a Brazilian poet, a Brazilian actress of Armenian descent starring in a Brazilian soap opera on television), and dramatically states: "You, in Brazil, you are so isolated." To the "swarm" of seven million Armenians who left the country, connecting it to different parts of the world, he implicitly opposes the Brazilian population as a "mass" of many citizens, locked up in an immense country and a language hardly spoken elsewhere.[24] These testimonies alternate with the ones of people who were born in Armenia and have more mixed feelings about their homeland.[25] Thus, a young tourist guide affirms that "Armenia has many nice places," but admits she herself would rather live abroad, where there are more jobs. Another old man believes "Living in Armenia is hard," but at the same time feels it is impossible to "leave his motherland." The images of the houses evoke the people's hospitality as much as they evoke their poverty, and besides places of family gathering, they also appear as places where family members (mothers) mourn their loved ones.

This love-hatred relationship with the homeland determines the varied quality of the image of Armenia that this documentary offers. Regularly interrupted by shots of moving trains or other vehicles (taxis, metros), the documentary uses the journey as the framework that keeps the interviews together, suggesting they take place on different locations visited along the road and therefore representative for the whole country. Musical fragments of several Armenian compositions accompany the image and determine its pace, thereby recalling

diasporic experience.[21] The filmmakers inform the audience that the groom was born in Córdoba in Argentina—the country with the largest population of Armenian migrants in Latin America, while the bride was born in Iran, but grew up in Armenia after her parents moved to the country in the 1990s. Their friends are from different parts of the world, including Brazil, where the filmmakers come from. The wedding takes place in the Armenian language but also implies the use of Spanish (a language the groom prefers to his very rudimentary Armenian), English (the second language of the bride, whose Armenian mother was raised in England), and Portuguese (the language of the filmmakers who appear to be close friends of the wedding couple).[22] Contrary to *Um passaporte húngaro*, which insists upon the untranslatability of Hungarian, the multilingual aspect in this documentary is never a problem, and crucial words during the ceremony (such as the approbation of the wedding vow: Ayo—yes-sí) and the party (Snorhakal em—gracias—obrigado) are immediately pronounced in different languages. Of particular importance is the groom's final speech, in which he stresses the notion of "family" (adanik), expanding it to his friends, who he considers "family by choice" (*familia por elección*).

Through similar scenes, *Rapsódia Arménia* stresses the chronotope of the homeland, while also making use of other ingredients listed by Naficy: houses, mountains, and monuments. Besides the house of the bride—with scenes shot in the kitchen, the sleeping room, and the living room—the audience visits the house of an Armenian woman, who together with her husband invites it to a toast, and shows it around. Almost all interviews are shot in domestic interiors, or in front of houses, which are generally filled with pictures and other memories (including a book donated to an Armenian man by Jorge Amado himself). Other important symbols of the Armenian national identity figuring prominently in the documentary are mount Ararat[23]—on which Noah supposedly landed his ark, thus saving the world from the flood (a mythical story recalled by one of the interviewees)—and Khor Virap, a church built in the seventh century and closely identified with Saint Gregory, who converted Armenia into the first Christian country in the world. The church guard of this monument—with an intriguingly long moustache that he considers to be a sign of his Armenian identity—adorns the film poster of the documentary.

However, as mentioned previously, the documentary does not offer a one-sided image of Armenia as homeland. Many interviews evoke the daily hardships of the Armenian people, who feel orphaned by their own children when they emigrate, or betrayed by governments

of two people of the same village. According to Naficy (2001), this idealized portrayal of a rural community corresponds to a desire for a prelapsarian period of unity and harmony of what later on would be scattered and dispersed. In *Rapsódia Armênia*, this opening scene of the Armenian landscape with sheep acknowledges this idealized notion, but it is also partly denied by focusing on the deserted quality of the land. The first question—"Where are the sheep?"—and the image of the guide who is lost in his own landscape (rendered explicit by the motif of the search) are therefore indicative of the new image of the homeland this film provides.

The documentary proceeds with images of a kind of living monument: a 95-year-old man, covered with medals as signs of his patriotism, brings to mind the terrible event of the Armenian genocide at the beginning of the twentieth century. His testimony is followed by a long sequence of close-ups of people who are interviewed by the filmmakers in the course of the film. At the end of this sequence, the title of the documentary appears on screen. This prologue is then indicative of the strategy of the filmmakers: Armenia as homeland will be approached not from the point of view of its prototypical landscape, but from the point of view of the people living on its soil. Introduced after the mention of the genocide, the long series of close-ups even acquires a dimension of resistance, the people in front of the camera appearing as survivors (in spite) of the massacre, but also as people marked by historical trauma and tragedy because of their silence and sad, enigmatic expressions. At the same time, the film alternates between moments of sadness and joy, thereby justifying its self-proclaimed inscription in the musical genre of the rhapsody. A rhapsody—originally a fragment from an epic poem—nowadays refers to a musical composition, marked by a loose, episodic structure—a feature it shares with the road movie—and implying alternation among several moods (Randel 2003: 721). The sad moments evoked by the people interviewed in the documentary—and related to conditions of poverty, unemployment, and post-Soviet diaspora—alternate with moments of strong self-affirmation (Armenians being associated with war heroism, excellence in sports [chess], science, and the arts). The most important provider of happiness in the film, however, is a wedding couple, whose experiences during "one of the happiest days of their lives" (words of the groom) structure the documentary throughout: the film includes scenes from the preparations at the bride's house, from the ceremony at the church, and from the wedding party.

The wedding then occupies a pivotal position in the documentary, all the more so because it unites people who were marked by the

upon this film financed by a Brazilian-Armenian entrepreneur (Andre Kissajikian), and authored by two Brazilian-Armenian nephews and their Brazilian-Armenian friend.[17] The documentary has a strong link with the city of São Paulo, where the entrepreneur and the filmmakers live, and where a considerable community of Brazilian-Armenians is based. Proof of this link is the fact that one of the metro stations of the city is called Armenia, in memory of the genocide. The film gained recognition at various film festivals and received the Apricot award for Best Armenian documentary at the 9th International Film Festival in Yerevan.[18]

Rapsódia Armênia explicitly presents itself as a road movie on the Internet and in the initial shots. After a historical fragment in which two Armenian men beat the dhol—the typical Armenian drum—the spectator sees a car driving through an open landscape on a deserted road. A local guide accompanying them asks an occasional passer-by to take them to a nice place with sheep and peaches, because his clients are preparing a film "to show Armenia to the world." Toward the end of the film, the car and the local guide return, now looking for the borders of the country. The documentary then visually inscribes itself both in the road movie and in a discourse on Armenia as a place to be shown. Moreover the film associates Armenia with the idea of a homeland through reference to two icons of Armenian identity: sheep and peaches.[19] However, the rather poor result yielded by the initial search for the beautiful spot (a poor place in the backyard of a deserted farm with some sheep and peach trees), and the difficulty to locate the borders of the country toward the end of the film point at the director's deliberate departure from previous attempts to show Armenia in film.

More particularly, the opening scene can be read as an ironic comment on *Seasons* (1989), a documentary film by the Armenian filmmaker A. Pelechian, whose name appears in the end credits. Though not immediately related to Lusophone cinema, this intertextual reference is important because it implies a meditation on the general theme of the homeland that influences the framing of this Brazilian-Armenian migration. In *Seasons*, Pelechian offered a utopian vision of Armenia as homeland identified with its landscape and nature. Explicitly discussing it as an example of accented cinema, Naficy points at the presence of "the chronotope of the homeland" in this film. Drawing on Bakhtin, he associates this chronotope with two forms of the idyll in the documentary: the agricultural idyll and the family idyll.[20] Impressive flocks of sheep herded by vigorous men on horseback provide the opening scenes of this documentary, which also depicts the wedding ceremony

under the pressure of any form of nationalism. When the Hungarian couple finally arrived in Recife in 1938, they were originally denied access because of a secret, anti-Semitic circular issued by the Brazilian government. Once they did eventually set foot on shore, they came up against new forms of discrimination set against the background of rising Brazilian nationalism (Bletz 2010: 10). As Jewish-Hungarian immigrants, they were considered to be "the lowest of the low," and taught always to look upward in awe when pronouncing the word "Brazil." The memory of Jewish-Latin American migration then intersects with the history of Brazilian nation-building in revealing the covert anti-Semitism of the Estado Novo (cf. supra, Pinazza 2011: 8). But this memory also expands into other stories of displacement set in contemporary times. This second expansion occurs during Kogut's wanderings through the embassies, which give way to fortuitous encounters with other people requesting passports. There is the testimony of a young Hungarian man, with a Romanian wife, who tells the filmmaker that the couple's ancestors lived in Transylvania, a region once connecting Hungary to Romania and now posing numerous issues of conflicting or multiple nationalities; or the testimony of the Russian man, whose nationality has changed four times in the past ten years under the pressure of continuous reterritorializations. Lacking any reference to Jewish identity, these flashes of other displaced lives inject into the main narrative an element of universality, which ultimately deprives Laitas' story of its specifically Jewish character.[16]

Primarily through the story of her grandparents, but also through the several interviews with other applicants for a passport, Kogut's documentary puts its finger on the discrepancies between culture, territory, and social formations, up to the point of denying the very possibility of grounding an identity in any notion or concept at all. As a "home-discovering journey," the documentary ends up denying the possibility to "locate" a home, and favours movement and displacement, even though it also evokes the tragic dimension of this displacement.

Rapsódia Armênia

This documentary—an opera prima—was funded entirely by a Brazilian private company, AK Realty. As it did not acquire funding through international coproduction, its transnational character is supposedly "weaker" (Hjort 2010) than in the previous case. This might account for the stronger emphasis put on the notions that Kogut diluted: home and homeland. On the other hand, diasporic conditions impact heavily

fragments included in the documentary, the spectator sees people floating in boats, approaching the coastline of Brazil. This shows a predilection for what Naficy, drawing on Edward Soja, has called third-space chronotopes: "The thirdspace chronotope involves transitional and transnational sites, such as borders, airports, and train stations, and transportation vehicles, such as buses, ships, and trains. Border crossing and journeying are narratives that prominently engage these sites and vehicles" (Naficy 2001: 154). Such transitional spaces figure prominently in the documentary. Symptomatic is the location of the last scene referred to earlier: in a moving train with unclear destination, in which Kogut (still out of focus) is probably crossing a border. While a customs officer checks her passport with the local authorities, wondering how a person who cannot speak Hungarian might carry a Hungarian identity card, the spectator hears the voice of her grandmother, who brings to mind a German poem. "When you ask a traveller where he is going to, he will cheerfully say: Home! When you ask him where he is coming from, he will sadly answer: Home." Home, in this documentary, is an empty referent. It is what motivates movement, not what sets it in motion nor provides an end to it.

Home cannot be grounded in the diasporic Jewish community either, even though this community is acoustically evoked through the Jewish folkoric soundtrack, provided by Papir Iz Dorkh Vais and Yah Riboh. When Kogut is brought to the (rather forgotten) grave of her great-great-grandfather in Budapest, she is not able to decipher his name, not only because it is written in Hebrew (a language she does not master), but also because a history of assimilation and persecution has transformed the original family name several times and made it unrecognizable.[14] As for the filmmaker's grandmother, Mathilde Laita, she believes that whatever was left of her cultural identity after the emigration has already been diluted. "Which is good," she adds. Because of the pivotal position of the grandmother in the film as the main interviewee, and because of her own history of ever-changing nationalities,[15] "her testimony, delivered in fluent but accented Portuguese, can be seen to crystallize the question Kogut probes in her documentary" (Branderello 2013a: 264), and therefore also relates to the filmmaker's own "highly fluid identity" (Pinazza 2011: 2). There is, then, no sense of "multisitedness" (Naficy: 14) in this variant of diasporic cinema. Or perhaps it is more correct to say that this notion expands in the documentary into a wider sense of affinity and solidarity with displaced persons in general.

This expansion occurs in two ways. First, the documentary underscores the transnational dimension of the experience of anti-Semitism

a great-granduncle in Budapest explains to her how he escaped from deportation by changing his passport number, which turned him into a Portuguese citizen. When houses do appear, as settings during the interviews with relatives for instance, they provide something that the non-places lack: memory and historical consciousness. Even though Kogut is well received in these houses, her position as an outsider in these domestic environments is also underscored: she is not able to speak Hungarian with her relatives, she is mocked by her aunt because she does not know how to cook Hungarian recipes, and she lacks basic knowledge about Budapest and its inhabitants.[12] Her status as an outsider is visually stressed by the fact that Kogut—who conducts all interviews—is consistently kept out of focus.[13] Hardly any information about her personal life is provided, and when people inquire about deeper motivations to become Hungarian, she eludes the question. In a way, the center of enunciation of this documentary is left blank, so as to allow the inscription of other stories into this particular family-tale.

In parallel fashion, the point of departure of the journey is not rendered explicit, though the "experience of departure" is stressed by opening and closing shots taken from a moving train (Branderello 2013a: 264). As mentioned before, the film is shot in different countries, and the geographical path shown by the montage is determined by the logic of the quest for the passport, beginning with the suggestion to apply for a Hungarian passport, which is briefly recalled during the first interview with the grandmother in Brazil, and proceeding according to the instructions given by legal officials to gather the missing documents in different places. Of special importance are the traveling shots in the film: instead of producing a sensation of free movement through space, these traveling shots—a typical device of road movies— seem to transport the spectator back in time, to the period of the original journey of Kogut's grandparents from Hungary to Brazil. The use of traveling shots as shifters between the actual journey (undertaken by the filmmaker in 2001) and the original one (undertaken by her grandparents in 1938) is achieved by tinting fragments shot by Kogut during her own trip through Hungary, with an aged, yellowed look, and providing them with a melancholic musical score. Moreover, contrary to "normal" traveling shots in road movies, which tend to be directed sideways or forward, the ones in this documentary are filmed backward, thereby stressing the experience of departure once again, rather than of arrival.

In fact, instead of focusing on images of a homeland, this documentary centers on the figure of mobility: people moving, approaching or leaving their homeland, but not living or dwelling in it. In several

which inspired many citizens to request a European passport, availing themselves of their European ancestry. This is also the background of Kogut's own request for a Hungarian passport. Rather than a nostalgic longing for Hungary as a home country, it is this immediate, economic circumstance that motivates Kogut to reclaim Hungarian citizenship, thereby taking to heart a suggestion by her grandmother, Mathilde Laita, who is the only surviving witness of the original journey, and to whom the film is dedicated.

Passport requests produced an intense wave of migration from Brazil to Europe from the 1990s onward, which affected Brazil's traditional position as homeland for foreigners: "Brazil, once the destination of European immigrants, ha[d] now become a country of emigrants" (Pinazza: 6). Rather than centering on this actual emigration, however, *Um passaporte húngaro* focuses on Kogut's journey to obtain the necessary credentials for her application, and this is in the first place an administrative and bureaucratic expedition, leading through a plethora of embassies, consulates, and registration services, and acquiring at times proportions that are nothing short of Kafaesque. The situations described throughout the film imply a strong critique of the concept of national identity as a legal notion. Thus, in the opening scene of *Um passaporte húngaro*, Kogut makes a phone call to two different Hungarian Embassies and asks them the same question: "Can a person of Brazilian nationality, whose grandfather is Hungarian, become Hungarian?" In the first case, the answer is "no." In the second, the answer is "yes." Similar contradictions mark the official discourse on nationality throughout, and when the filmmaker finally receives her passport during an official celebratory ceremony, it turns out to be valid for only one year. However, this administrative journey also implies a journey into the past, which results in the gradual uncovering of a history of anti-Semitism and the impact it had on a family's life. Once again Brazil's image as homeland is at stake: "in revealing the covert anti-Semitism of the Estado Novo and narrating some of her experiences of prejudice in Brazil, Mathilde [the grandmother, NL] destabilises Brazilian national discourses around the myth that the country has always been friendly and open to immigrants" (Pinazza 2011: 8). Houses also occupy a peculiar position in the documentary. First, due to the bureaucratic dimension of the journey, the locations most frequently shot in this documentary are unhomely places or "non-places" (Augé 1995): embassies and consulates, anonymous places of transit. Moreover, houses are remarkably difficult to locate: one of the basic documents lacking in Kogut's file to reclaim Hungarian citizenship is proof of her grandfather's address in Budapest. At another moment,

character, and more particularly their tendency to investigate "the roots of modernity" (Orgeron 2008: 48)—a phenomenon related to problems of displacement, migration, and genocide as caused by the "new" inventions of nationalism and totalitarianism. The relationship between the road movie and contexts of diaspora has already been established by Ewa Mazierska and Laura Rascaroli (2006), who examine a wide body of European road movies against the backdrop of the increased mobility after the fall of the Berlin Wall, with particular attention to the postcommunist diaspora. Their book on European road movies is part of a wider interest in the international dimension of the genre, which has manifested itself recently in scholarship on the genre, and now also includes Brazil (Branderello 2013b). Migration is a privileged topic in Brazilian road movies,[9] but films almost invariably center on migration within national borders, depicting journeys from the countryside to the city, or—in more recent times—in the opposite direction, under the form of the "return journey" (Da Cunha 2013). Our films are related to these journeys of return, but they show an original aspect by approaching migration in a transnational context.[10] Moreover, the intensification of mobility that marks the accelerated stage of globalization we are actually traversing, and a more general crisis of the notions of "home" and "identity" as linked to fixed locations, has led to a remarkable popularity of the road movie worldwide. As Stephanie Dennison (2013b) has recently argued, "A new post-national identity...lies...at the heart of the contemporary road movie" (193), which also shows in the two films we now discuss.

Um passaporte húngaro

As a Brazilian-Belgian-French coproduction,[11] *Um passaporte húngaro* is a typically "transnational" film: a film "produc[ed] on a cross-border basis by multinational organisations" (Dennison 2013a: xv). Dealing with the subject of migration and diaspora, deploying the use of several languages (besides Portuguese and Hungarian she also uses English, French, and Yiddish) and implying location shooting in different countries (France, Hungary, and Brazil), Kogut's film even stands as an example of "strong" transnationalism, a notion proposed by Mette Hjort to indicate films in which "transnationality is operative on several levels at once," including "the cinematic work themselves" (Hjort 2010: 13). Moreover, during the shooting of the documentary, Kogut resided in France, which adds to her accented, interstitial quality as filmmaker (Pinazza 2011: 1–2). The documentary appeared in 2001, during a period of severe economic recession in Latin America,

obsessed with home. Typically, the road takes the traveler away from home. Sometimes, the road leads to a new home, as in frontier narratives or tales of emigration. As often, in various kinds of space or travel narratives, the road just leads away—away from boredom, or anger, or family, or whatever it is that produces the desire or need for something called away as opposed to the place called home. (Robertson 1997: 271)

Our two films then doubly relate to the genre: through the motif of the journey, and through that of home. Nevertheless, the use of the term road movie to refer to these documentaries may come at first sight as a surprise, because we tend to associate road movies with films of fiction, rather than with documentaries. However, specialists argue that "part of the nature of the road movie is its intertextuality and ability to combine with other genres," which turns the genre into a "generic hybrid" (Sargeant and Watson 1999: 6). The truth of this assertion is demonstrated in the fact that the films discussed in this essay have been referred to both as documentary and road movie,[7] though the best way to bring out their combined generic quality is probably by using new, hybrid expressions, such as "documentary on the road" (Branderello 2013a: 264), or "road movie documentary" (Lie and Piedras 2014).[8] In fact, several of the characteristics listed in definitions of road movies suggest a deeper connectedness with the genre of the documentary as such, in particular their tendency to foreground looking and seeing, and their preference for open and episodic modes of story-telling (Laderman 2002: 13). Iconographically and stylistically, road movies are associated with open roads and motorized vehicles, as well as with traveling shots, which tend to convey to the cinema spectator the sensation that s/he is traveling with the character (Corrigan and White 2004: 318). All of these characteristics easily apply to documentaries as well, and the fact that emblematic road movies such as *Easy Rider* (1969, dir. Dennis Hopper) or *Diários de motocicleta/The Motorcycle Diaries* (2004, dir. Walter Salles) occasionally slip into a documentary mode themselves lends credence to the claimed affinity. The director of this last film, Walter Salles, has even argued that "part of the attraction of the road movie genre lies in the blurring of boundaries between fiction and documentary, given that the outside 'real world' is incorporated by definition into the diegesis" (quoted in Branderello 2013b: xxiii).

What makes road movies particularly interesting for our case is their use of the journey as a form of cultural critique, as a tool for critical examination both of the self and of society (Mazierska and Rascaroli 2006: 4). In this critical dimension, they reveal their modern

the journey appears as a theme and narrative structure in accented cinema. More particularly, he distinguishes between three kinds of journeys: the home-seeking journey, meaning the journey of emigration or escape; the home-coming journey, implying the return of the migrants to their original home; and the journey of homelessness, associated with diverse figures, from gypsies to nomads and from vagabonds to refugees.[3]

At first sight, both documentaries fall into the category of the homecoming journey, as they are related to the sociological phenomenon of reverse migration: the filmmakers return diegetically to the homeland of their ancestors. However, upon closer inspection, the documentaries differ from the examples listed by Naficy for this category, because the "return" implies a home that is actually new to them, the original migration or diaspora having occurred long before their birth. In this sense, the homeland is an inherited and imaginary space, rather than a real country, though the journey precisely adds the dimension of reality to what has often become an abstract notion to them. In order to take this difference into account, I would like to propose a new category for these films with a deliberately paradoxical name: "home-discovering journey."[4] Instead of returning to a place that is familiar to them, the filmmakers travel to a country they are invited to adopt as their own, because of their family's past.[5] However, what normally comes naturally—the identification with a homeland—now requires a conscious effort and inevitably unsettles previous perceptions of Brazil as the homeland. In both cases, indeed, Brazil's significance as homeland finds itself reduced and even diluted, a characteristic that I relate to the transnational quality of these Brazilian films. At the same time, both documentaries provide different answers to this dilution: whereas one documentary presents home and homeland as forever unstable notions, the other regrounds them in the original country of emigration. This profound (though differently articulated) meditation on what a home is (or is not) also points to their kinship with the genre of the road movie.

DOCUMENTARIES ON THE ROAD

Though road movies are generally associated with movement and journeys,[6] scholarship has underscored the profound relationship between the genre and the concept of home.

> If the road movie is in some deep sense about the road itself, and the journey taken, more than about any particular destination, it is still a genre

(2001), is the granddaughter of a Hungarian-Jewish couple that emigrated from Hungary to Brazil. Gary Garanian, Cesar Garanian, and Cassiana Der Haroutiounian, who made *Rapsódia Armênia/ Armenian Rhapsody* (2012), are descendants of Armenian refugees to Latin America, currently residing in São Paulo.

DIASPORIC CINEMA

The family background of these filmmakers is then intimately related to the phenomenon of migration, and more particularly to the one of diaspora. As Hamid Naficy (2001) explains:

> Diaspora, like exile, often begins with trauma, rupture, and coercion, and it involves the scattering of populations to places outside their homeland... However, unlike exile, which may be individualistic or collective, diaspora is necessarily collective, in both its origination and its destination. As a result, the nurturing of a collective memory, often of an idealized homeland, is constitutive of the diasporic identity. (14)

In the case of Kogut, her Jewish grandparents left Hungary in 1938, against the backdrop of rising fascism and totalitarianism, which shortly afterward led to the Holocaust. The filmmakers of *Rapsódia Armênia* descend from refugees of the Armenian genocide, which took place in 1915. In both cases, then, migration finds its origin in genocide.[1]

Even though the filmmakers were born long after their ancestors' emigration,[2] the concept of homeland is relevant to both documentaries, as the toponymy in their titles suggest. This feature might be explained by the fact that members of the diaspora, according to Naficy, demonstrate "a long-term sense of ethnic community and distinctiveness" (2001: 14). In their evocations of the country of origin, diasporic filmmakers are said to show a "multisited" awareness, not limiting themselves to the homeland but including in their films references to the other communities that sprung from the diasporic migration (14). More generally, their work belongs to the wider category of "accented cinema," a term proposed by Naficy to refer to the characteristics shared by filmmakers who went through different experiences of displacement (exilic, diasporic, postcolonial). Several of the characteristics mentioned in his book appear in the documentaries of our essay: a multilingual character, an autobiographic dimension, an emphasis on montage, and—as mentioned—an interest in the homeland. In this context, Naficy underscores the frequency with which

7

Reverse Migration in Brazilian Transnational Cinema: *Um passaporte húngaro* and *Rapsódia Armênia*

Nadia Lie

One of the remarkable effects of the current transnationalization of cinema is the success of the documentary (Ezra and Rowden 2006: 10). This success runs parallel to a "subjective turn" in the genre of the documentary itself: instead of showing an objective truth, the new documentary makers render reality from a personal point of view, and tend to permeate this approach with elements of self-discovery and self-investigation (Chanan 2007: 251, Piedras 2010). An increasing amount of Latin American documentaries cast this self-searching dimension in the mold of the journey, thereby infusing into the documentary ingredients of the "road movie," traditionally considered as a fictional genre. However, whereas road movies normally lead away from home, and often have a family crisis as their point of departure (Corrigan 1991: 145), these "road movie documentaries"—made in an era in which home and identity have become increasingly contested (Bauman 2006)—tend to describe the opposite figure, evoking journeys that lead toward a home or a family.

The documentaries at the center of this essay are part of this more general tendency: they belong to or show affinity with the genre of the road movie, and they combine a self-reflexive search with an actual journey. What is specific about them, however, is their association of this "home" with a "homeland." The background of this choice is the fact that the filmmakers' ancestors were migrants to Brazil. Sandra Kogut, the director of *Um passaporte húngaro/A Hungarian Passport*

Kogut, S. (dir.) (2001) *Um passporte húngaro*. Rio de Janeiro: Videofilmes/Riofilme. DVD.

Lins, C. (2004) "*Passaporte húngaro*: cinema político e intimidade," *Galáxia, Revista Transdisciplinar de Comunicação, Semiótica e Cultura* 7: 75–84.

Moriconi, I. (2005) "The PostModern Debate: Brazilian Force Fields—An Introductory Overview," *Journal of Latin American Cultural Studies* 14(3): 355–370.

Nadkarni, M. (2012 [2010]) "'But it's Ours': Nostalgia and the Politics of Authenticity in Post-Socialist Hungary," in M. Todorova and Z. Gille (eds.), *Post-Communist Nostalgia*. New York: Berghahn Books, 190–214.

Podalsky, L. (2011) *The Politics of Affect and Emotion in Contemporary Latin American Cinema: Argentina, Brazil, Cuba, and Mexico*. New York: Palgrave Macmillan.

Probyn, E. (1996) *Outside Belongings*. New York: Routledge.

Salles, W. (dir.) (1999 [1998]) *Central do Brasil*. Culver City, CA: Videofilmes/Sony Pictures/Columbia TriStar Home Video, DVD.

Salles, W., and D. Thomas. (dirs.) (2005 [1995]) *Terra Estrangeira*. Rio de Janeiro: Videofilmes, DVD.

Zambrana, R. D. (2009) "Memoria, sentido trágico y el viaje de aniquilación en *Hotel Atlântico* de João Gilberto Noll," *Romance Quarterly* 56(2): 142–152.

What is taking place in contemporary Brazilian cinema is by no means the death of saudade, but rather its coming to terms with an increasingly volatile, transnational concept of home. Taken together, Walter Carvalho's and Sandra Kogut's films are vivid examples of the emotional experiences common to many contemporary transnational migrants, lending credence to the belief that reflective subjects of saudade and nostalgia "can create a global diasporic solidarity based on the experience of immigration and internal multiculturalism" (Boym 2001: 342). These filmmakers imagine/model psychologically internalized multicultural identities, as well as socially multicultural spaces of solidarity and understanding, that are made more possible through the complex, evolving emotional ties of postmodern saudades.

NOTE

1. It should be noted this term is not in common usage, but rather is used purely for analytical purposes in my discussion of saudade. The term *saudado* indicating the object of saudade was coined by Portuguese philiosopher Pinharanda Gomes (1976).

WORKS CITED

Amaral, S. (dir.) (2009) *Hotel Atlântico*. Rio de Janeiro: Lume Filmes. DVD.
Boym, S. (2001) *The Future of Nostalgia*. New York: Basic Books.
Bradatan, C. P. et al. (2010) "Transnationality as a Fluid Social Identity," *Social Identities: Journal for the Study of Race, Nation and Culture* 16(2): 169–178.
Carvalho, W. (dir.) (2009) *Budapeste*. Rio de Janeiro: Nexus/Imagem/Eurofilm. DVD.
DaMatta, R. (1993) *Conta de mentiroso: sete ensaios de antropologia brasileira*. Rio de Janeiro: Rocco.
Davis, F. (1979) *Yearning for Yesterday: A Sociology of Nostalgia*. New York: Free Press.
Draper, J. (2010) *Forró and Redemptive Regionalism from the Brazilian Northeast: Popular Music in a Culture of Migration*. New York: Peter Lang.
Gomes, P. (1976) "Saudade: ou do mesmo e do outro," in D. L. P. da Costa and P. Gomes (eds.), *Introdução à saudade*. Porto, Portugal: Lello & Irmão Editores, 158–215.
Jameson, F. (2000 [1984]) "Postmodernism, or the Cultural Logic of Late Capitalism," in M. Hardt and K. Weeks (eds.), *The Jameson Reader*. Oxford, UK: Blackwell, 188–232.
Kearney, R. (1992) "Postmodernity and Nationalism: A European Perspective," *Modern Fiction Studies* 38(3): 581–594.

Conclusion

When focusing on the affective register and representations of emotions like saudade in twenty-first-century Brazilian cinema, a general flattening of affect with respect to earlier films is apparent. Saudade, one of the emotions with the most specific and profound connotations in Lusophone cultures, and a related history of thought and literary history going back hundreds of years, has not been reshaped by past filmmakers to nearly the degree to which it is rethought and refelt here in the films of this century. Simply put, it means something quite different when José Costa says "estou com saudades" (I feel saudade) to his answering machine than it did when Dora (Fernanda Montenegro) writes "Eu tenho saudade de meu pai, eu tenho saudade de tudo" (I feel saudade for my father, I feel saudade for everything) in a letter at the end of Salles's *Central do Brasil*. In the context of the latter film, Dora's statement not only ties her saudade to her intimate personal and familial history, but by association to her personal experience of the national geography. Thus, there is a traditional focus on the authenticity of affective interiority/depth and a grounding of this experience within national identity (indeed, within the nation's interior or heartland in the Northeastern *sertão*). This is very much akin to the twentieth-century understanding of saudade expounded by anthropologist Roberto DaMatta, when he writes that saudade is a national "ideological and cultural focus" that "is centered in a temporality of the home" (se centra numa temporalidade da casa) (DaMatta 1993: 21, 32). There is a sense of permanence and self-evidence, of profound intimacy combined with national-popular authenticity, to Dora's saudade that does not hold true for the shifting vectors and intensities of this emotion in *Um passaporte húngaro* and *Budapeste*. This evolution is all the more striking, in that some of the very same filmmakers are involved in the films contrasted here—namely, the director of *Budapeste* (Carvalho) was the cinematographer of *Central do Brasil* and also of *Terra estrangeira/Foreign Land* (1996, dir. Walter Salles and Daniela Thomas), another 1990s film with a more traditional, Lusophone-oriented representation of saudade, even while that story takes place in a transnational context between Brazil and Portugal. On the other hand, the recent flattening of affect in cinema is by no means anti-emotional or rationalist in nature, thus departing from earlier, especially realist eras in Brazilian and Portuguese literature and cinema when affect was repressed or subordinated to rationalism and ideological rigidity (cf. Podalsky 2011 on the framing of affect in New Latin American Cinema of the 1960s).

history that have their own representative statues. Thus, there is a parallel between Costa's attempt to replace his own personal, Brazilian history with Hungary's attempt to replace, or at least establish a distanced relationship to, its socialist history. The example of a postsocialist national monument highlighted in the film is the statue of Anonymous, the anonymous chronicler of the Hungarian king Béla III in the late twelfth century. At one point in the film, in fact in the scene immediately following Costa's phone call in which he expresses his saudade for Brazilian culture and language, he visits the statue of Anonymous in Budapest's City Park. On one level, there is an obvious relationship between the statue itself and the story of Costa since he too writes as an anonymous author. This was a fortuitous coincidence discovered by the filmmakers as they prepared to shoot *Budapeste*, since the author of the original novel, Chico Buarque, was unaware of the existence of this statue in Budapest when he wrote his novel (having never visited the city himself before his novel was adapted to film). The idea that Hungary has a national hero who is an anonymous author made the country seem, ex post facto, to be the perfect place for a man of José Costa's profession to migrate and reshape his identity. Yet in a contemporary political context, this statue takes on another significance in opposition to the statue of Lenin depicted earlier in the film, a return to presocialist folk history, especially the nationalist history of the Magyars to whom Hungarians trace their ethnic roots. This historico-political relationship between the two statues again serves to emphasize the postmodern (and postsocialist) replaceability of saudados or objects of nostalgia.

Costa's visit to the Anonymous statue thus presents us with a complex cross-pollination of Hungarian nostalgia and Brazilian saudade. His rather traditionalist Brazilian saudade, presumably inculcated in him from an early age within the context of Brazilian culture and society, paradoxically inclines him to identify with the national folk history of Hungary and to pursue an intimate knowledge of the literature and language of that people as he seeks to run away from his Brazilian life and the Brazilian Portuguese language and the culture that he associates with it. Thus, we can associate the doubling of the statues with a doubling of Costa's own saudade. This doubling yields another paradoxical effect of making saudade seem more universal and everlasting despite the replaceability of its objects. Through the discarding of one constellation of saudados, just as the Lenin statue was discarded, saudade reveals itself in an abstract, more transnational form that can exist independently of Brazilian culture and then attach itself to new saudados in an entirely distinct, non-Lusophone culture.

first he seems disoriented but then a smile spreads across his face as he starts to enjoy the sound of the new, Hungarian lyrics. This scene can be read as the realization of Costa's earlier expressed desire to replace his native language with Hungarian—the remodeling of his house of language and national identity is complete. Clearly, there is also a parallel with Kogut in the combined transnational and postnational elements of this scene. Costa's shifting back and forth across national borders, identities, languages, and homes inspires director Carvalho's postnational reinterpretation of the Brazilian national tradition of samba.

The replaceability of saudados emphasized in *Budapeste*, which we can connect to the general postmodern phenomenon of the surfacing of affect discussed in the introduction, is represented in the city of Budapest through Costa's observance of two public statues. These public statues in Budapest also serve to address the historical and political context of Hungary in the postsocialist era, as Costa first briefly travels to the country in 1991 and then returns there for an indefinite stay around the turn of the twenty-first century. Further, the fact that the two statues Costa sees have antithetical historico-political associations reiterates the theme of doubling and alienation in the film. The first public statue seen in the film is one of the first things that Costa encounters upon his decision to return to Hungary, just as he arrives in central Budapest by taxi. Driving along the bank of the river Danube that divides the city, Costa tells his driver to stop as he becomes interested in the cargo of a barge that is floating downriver. He proceeds to get out of the taxi and stand on the riverbank as the barge passes by. The camera first emphasizes a bemused expression on Costa's face with an extreme close-up, and then the viewer is shown the barge with an enormous statue of Lenin tied to its deck. The statue has clearly been junked, as it is broken into seven segments and is being hauled away on a rusty barge to an unknown destination (presumably the dustbin of history!). The statue's finger is shown to be pointing in one direction and Costa markedly walks in the opposite direction after seeing the statue, though perhaps his expression has become more wistful than bemused by the time the statue floats away downriver. Costa's bemused then wistful facial expressions immediately establish a political orientation that deems the Soviet past as quaint, kitschy, and irrelevant. This is not so far from the attitude of Hungarians themselves toward their socialist past in the immediate postsocialist period, according to Maya Nadkarni (2012 [2010]).

Costa's saudade is framed within the context of a Hungarian society that tore down its old Lenin statues and then proceeded to privilege other objects of nostalgia, including figures from folk-national

Appropriately, the word that ends this string of associations is a synonym of severity, namely astringency. Onomatopoeically, the word *adstringência* sounds quite severe when spoken in Brazilian Portuguese, especially in contrast with the previous words Costa speaks, words like "saudade" and "Guanabara" which would be much more at home in Brazilian lyrics or poetry. Anatomically speaking, according to the Oxford English Dictionary, something that is "astringent" has the "power to draw together or contract the soft organic tissues." There is a clear association here with a contraction back to Hungary—that is, the end of Costa's attempt to "reach out and touch someone" (to paraphrase the old AT&T ad) as he pulls himself back into his immediate reality of life in a country that is still quite foreign to him. The theme of doubling is emphasized here by a bad phone line that echoes Costa's words back to him, and in the following scene this has an even greater emphasis on alienation when Costa returns home to Rio to find his own message waiting for him, unlistened to, and proceeds to play it back to himself as he walks through his apartment alone and suspects his wife of infidelity. Emphasizing doubling and alienation all the more, Costa finds a copy of the novel that he ghost wrote and that his wife has been reading—the copy is signed by the nominal author, Kaspar Krabbe (Antonie Kamerling), with a warm message to Costa's own wife. With regard to the emotion of saudade itself, there is an abrupt shift here from the scene in the phone booth wherein his wife and Brazil are the objects of an emotion that is very much tied to familiar and beloved people and places that are missed, to the subsequent scene wherein his wife, son, and apartment in Brazil are *made alien* or better yet, *unheimlich* (German for uncanny, but literally unhomely), by his realization that life in Rio has continued on without him as he has pursued his fascination with Hungary. His feeling of saudade has certainly not been reciprocated by anyone else.

Yet the film goes even further than demonstrating the alienation of the protagonist's saudade to emphasize the "replaceability" of the objects of saudade, even those related to national origin and identity like the references Costa makes to places in Rio de Janeiro. It is this aspect of the film that most closely echoes the transnational and postnational vectors of saudade discussed above as represented in *Um passaporte húngaro*. During his final visit to Brazil, we see José Costa walking down the sidewalk next to Leblon beach and passing by a group of street musicians on the beach playing Chico Buarque's samba, "Feijoada completa" (a very nationalist topic since *feijoada*, or black bean stew, is a typically Brazilian dish). Suddenly, instead of the musicians' voices Costa hears a man's voice in Hungarian singing to the same tune. At

Budapeste

The protagonist of Walter Carvalho's *Budapeste* is an entirely fictional Brazilian man named José Costa (Leonardo Medeiros) who travels to Hungary and develops a fascination for the city of Budapest, the Hungarian language, Hungarian literature and poetry, and last but certainly not least, a Hungarian woman named Kriska (Gabriella Hámori). José Costa's profession is that of ghost writer, and associated with this profession in the film's narrative come the key themes of alienation and doubling. Costa quite obviously serves as a secret authorly double (or ghost writer) to several other characters in the film who are the nominal authors of books written in both Portuguese and Hungarian. But not far into the film, Costa also starts to develop a secret, second life in Hungary where he seeks the authentic integration into a family, language, and country that he does not quite seem to have found in his native Rio de Janeiro. Costa clearly feels alienated in Brazil despite all the trappings of a seemingly very successful middle-class lifestyle, with a steady income, a nice apartment, a beautiful newscaster wife, and young son that he lives with there.

Yet the life that Costa builds for himself in Budapest is very much a mirror image of his life in Rio, rather than an escape from it. He becomes involved with a Hungarian woman of about the same age as his wife, who has a young boy about the same age as his own son. As he learns Hungarian, Costa quickly becomes interested in ghost writing for a Hungarian poet. However, Costa does not immediately run away from his life in Brazil. At first he has feelings of saudade for his wife and home country, as evidenced by a scene in which he makes a phone call back home from a telephone booth in Hungary. As usual, Costa's wife Vanda (Giovanna Antonelli) does not answer the phone, but he proceeds to leave a long message in which he says "Vanda...Eu...estou com saudade [I feel saudade]" and then speaks a string of Portuguese words to assuage his feelings of saudade, including the very word saudade itself: "saudade—Pão de Açucar—Maracanã—Guanabara—avenida [avenue]—casa [house/home]—saudade—marimbondo [wasp]—adstringência [astringency]." Aside from evoking the emotion of saudade itself by repeating the word, Costa also says other words which reference home (*casa*) along with specific famous places in his native city of Rio de Janeiro, as well as the African influence in the Brazilian Portuguese language (e.g., the word *marimbondo* derives from the Bantu language of Kimbundo)—an influence that certainly seems far removed from the reality of life in Hungary that he is currently situated in.

pre-World War II Hungary and Brazil. In the process, she not only reinterprets but redefines these memories in the context of her own experiences as a transnational filmmaker in an era of rapidly expanding economic globalization. To a large degree, this redefinition of the significance of Hungarian identity and citizenship comes about very simply through the director's silence—her resolute refusal, despite constantly being asked about them, to clarify her reasons for pursuing Hungarian nationality in terms of nationalist fervor, familial legacy, or the economic and political advantages of potential European citizenship. Her silence is not only a negative refusal to conform to one kind of belonging though, it also an ability to listen to the other across cultures, borders, and even historical time without imposing a nationalist discourse on the other's narrative.

Sandra Kogut has said of *Um passaporte húngaro* that "the story of the film is formed by the stories BETWEEN stories [a estória (do filme) é formada pelas estórias ENTRE estórias]" (quoted in Lins 2004: 3). This comment can be tied to Jameson's description of the replacement of depth with surface in postmodern times: "What replaces...depth models [in the postmodern era] is for the most part a conception of practices, discourses and textual play...depth is replaced by surface, or by multiple surfaces (what is often called intertextuality is in that sense no longer a matter of depth)" (Jameson 2000 [1984]: 198). From Kogut's description of her film's story, one gets the sense of the film being an intertext that she develops through a process of textual play between and along some of the major modern narratives of European and Latin American national identity and citizenship. Kogut's conception of the camera as pen underlines all the more that she thinks of her filmic process as a writing on the margins—or the surfaces—of hegemonic discourses (Kogut 2001: DVD Extras). The impact of such a process upon the affective register of the narrative is largely to uproot the emotion of saudade, traditionally very much focused on a specific place or nation and often not one of the subject's conscious choosing, and to scatter it across a multitude of places and times. There is a related shift in the intensity of the emotion as it is refracted through Jewish folk melodies, Mathilde's memories, and Kogut's own present-day travels, shuttling back and forth across Europe and Brazil. It is difficult to situate saudade clearly within the authentic, passionate interior of any individual in this film due to such a flattening of affect. It should also be noted that her use of the camera as pen adds a personal touch to the film—shaping her production process into one that both represents and reproduces a feeling of diasporic intimacy.

in cultural production consists of "a creative reinterpretation of the diverse traditions of the past, not their liquidation" and a nonlinear vision of history as collage (Kearney 1992: 586, 585). This latter definition of postnationalism, of course, sounds very close to a definition of postmodernism as an artistic style. In any case, by these definitions of transnational and postnational subjects it is safe to say that Kogut would fit fairly easily into either category—while the concept of transnationality describes the framing of space and spatial movement in her film, that of postnationality reflects her representation of temporality.

Um passaporte húngaro reveals the transnationality of Kogut's filmic and directorial persona in various ways. She is shown to converse and maintain relaxed, friendly relations with many different people of different nationalities, who speak different languages, and ranging in roles from family members to officials in various bureaucratic positions in Brazil, France, and Hungary. Kogut seems to be able to move through these different environments with relative ease due to her flexibility in terms of the languages she speaks and her ability to internalize conflicting information from many different bureaucratic sources without expressing hostility, belligerence, exasperation, or really any other aggression or negative affect. The narrative structure of *Um passaporte húngaro*, as well as Kogut's personal affect as filmmaker and first-person subject of the film, serve to produce a sense of diasporic intimacy in the film. The filmic narrative is haunted by overlapping images, sounds, and discourses of home at the same time that the notion of belonging is flattened and scattered across several hemispheres. We discover that one of the "furtive pleasures of exile" (Boym 2001: 6) is precisely the formation of these new affective ties that do not seek complete belonging; instead an outside belonging takes shape that does not forget but historicizes and ultimately undermines earlier exclusive notions of intimacy and home. Kogut's camera evokes a diasporic intimacy whether she is in her Austro-Brazilian grandmother's dining room, in the offices of the Hungarian embassy in Paris, or speaking with a Brazilian archivist. Her ability to film so many scenes suffused with this diasporic intimacy highlights her identity as a flexible social actor, thus matching the definition of transnational subject noted above.

But it is also fair to say that Kogut's filmic style is postnational, in the sense that it reinterprets traditions of the past (such as Yiddish and Hebrew music and German lyrics for example). Further, the film certainly takes a nonlinear view of history, interweaving modern-day footage of Kogut's travels, bureaucratic travails, and conversations seamlessly with her grandmother's and others' recollections of

kind of blended feeling of grief and love mediated through memory. Kogut emphasizes the saudoso tone set by some of her grandmother's musings through a klezmer-influenced score that is centered around two Jewish folk songs evoking the old country. Further, the Yiddish and Hebrew lyrics of the specific folk songs chosen evoke the longing for a distant lover (in "Papir Iz Dokh Vais" [Paper is Really White]) as well as Jewish exile and the desire to return home to Jerusalem (in "Yah Ribon Olam" [God, Master of the Universe]). At certain points in the film during her grandmother's narrative about migration, this music is played as Kogut cuts away to train station scenes and arrivals in ports like Recife, which she shot in Super 8. This departure from the remainder of the film shot with digital camera adds all the more to the saudoso feeling of the music.

In fact, we can further explore Kogut's evocation of her grandmother's memories as an example of how cinema itself is capable of producing saudade. These memories belong neither to the filmmaker nor to her audience, yet using some of the strategies outlined above, Kogut is able to evoke through film a sentiment of saudade for her grandparents' past and her ethno-geographical roots. Kogut's cinematic production of emotion here corresponds to two of Davis's (1979) insights regarding nostalgia, which are equally applicable to saudade in this case. For one, Davis notes that nostalgia is not just a sentiment but an "aesthetic modality in its own right" (73). Kogut's filmic combination of voiceovers of her grandmother's memories, folk melodies, and Super 8 footage as well as digital footage of scenes evoking travel all combine to establish saudade as an important aesthetic modality in her film. A second key point that Davis makes regarding nostalgia is that, as it loses some of its "biographically distinctive moorings," media products "may now serve memory where once houses, streets, and persons did" (129). Through her own filmic media product, Kogut herself and her viewers are able to experience a (mediated, reflective) saudade for a home from which her grandparents were exiled long ago.

Considering that some version of the Jewish exilic subject has existed for millennia, to better establish a contemporary historical context it is also worth considering to what degree Kogut as a filmmaker and the subject of her own film matches up with modern-day theoretical descriptions of the transnational subject and/or postnational subject. According to Cristina Bradatan et al. (2010), a transnational subject "plays different roles in front of different audiences, [he or she is] a flexible social actor that internalized [*sic*] the rules and constraints of different social contexts" (177). On the other hand, postnationalism

the help of some average Hungarians and some members of Kogut's family, especially her grandmother Mathilde, that help her to explore where the line between the outside and inside of Hungarian nationality and citizenship lies. As part of this exploration, the viewer learns that national identity seems to be a far more shifting and ambiguous terrain than citizenship, as was the case even in the 1930s when Kogut's grandparents migrated to Brazil from Hungary. For the immigration officials in Brazilian ports, it appears from the logbooks of the era in Recife—shown on camera as Kogut interviews an archivist—that anyone of possibly Jewish descent/religion was considered an *Israelita* (Israelite) and would typically not be allowed to enter the country, regardless of their citizenship status (which in the case of Kogut's grandparents was Hungarian).

Kogut's efforts to become a Hungarian citizen diegetically represented in her film, as well as her exploration of her Jewish ancestry, in and of themselves position her as a kind of transnational and diasporic subject. In terms of discourses of saudade, diaspora and transnational displacement have been some of the most common factors contributing to the trauma of separation, which in turn causes the grief component of the emotion and the saudoso's (subject of saudade's) typical longing to return to this beloved person, place, or thing that has become distant. Although Hungary itself is not a very common object of saudade, countless Lusophone artists have expressed the sentiment of saudade in contexts that are very much analogous to the historical and contemporary situations of her grandparents and herself posed by Kogut in her film. Thus, it is not surprising that Kogut's grandmother Mathilde, an Austrian migrant to Brazil who lost her Austrian citizenship when she married a Jewish Hungarian, raises the issue of this kind of longing near the end of the film when she offers up to her granddaughter the words of an old German song: "Ask a traveler where are you going and he will say happily, 'Home!' Ask him where he is coming from and he will say sadly, 'Home!'" (Translations from the Portuguese by the author, here and throughout this chapter.) Especially in a Brazilian, Lusophone context, this song epitomizes the traditional, dual affective valence of saudade, which involves both the joyful memories of the distant object of saudade and the grief of having lost that object more or less permanently. Departure from home, the place one loves, is experienced with sadness or grief, while the return is experienced as a kind of joyful redemption. Generally though, these positive and negative affects are not cognitively or even discursively distinguished in the experience and artistic representations of saudade; rather the emotion is experienced and expressed more holistically as a

their belonging in a new culture. One of these furtive pleasures, perhaps bittersweet, is the ability to feel and explore new forms of saudade directed at a widening variety of places, people, and cultures.

In developing her notion of reflective nostalgia, Boym demonstrates a healthy suspicion of the notion of belonging often tied to restorative nostalgia, which can take reactionary and exclusive forms in sundry ethno-nationalist or fundamentalist movements around the world. Yet Probyn (1996) develops a theory of "outside belonging" that allows us to imagine a different kind of relationship to the home sometimes longed for by nostalgic or *saudoso* subjects. Outside belonging reflects the postmodern flattening of affect and imagines what a new notion of home might look like, one that does not depend on the sharp, modern distinction between the private and public spheres, nor on exclusive narratives of authenticity. Desire in the postmodern, postcolonial era is defined as "an intimate relation producing the social as outside, as a plurality of surfaces" (30). The desires to belong to a nation, to return home, or to recover a lost love play out along the surface of the social, the social as surface. Perhaps the biggest transformation indicated by the theory of outside belonging—especially in terms of our discussion of saudade—is that the idea of a hierarchy of emotional objects has been jettisoned. No longer are saudade for a specific territory like one's nation of birth, or saudade for certain individuals like one's lover, parents, or children, or even saudade for the Portuguese language itself, which produced the very word saudade, privileged as the most acceptable and praiseworthy forms of the emotion. Further, a surfacing of affect and identity "presupposes a rendering visible of the forces which constitute the outside and the inside as dichotomous" (Probyn 1996: 12). There is no doubt that such forces are revealed, circumvented, and/or struggled against in the films *Budapeste* and *Um passaporte húngaro*.

Um passaporte húngaro

To begin our film analyses along these lines, we consider Sandra Kogut's film. The forces that produce the dichotomy between inside and outside seem to be alternatively rigid, inconsistent, and permissive and are primarily represented by governments and their bureaucracies in *Um passaporte húngaro*. Kogut makes these bureaucracies visible through a multiplicity of human faces and spaces in the film as she shoots footage from her own point of view to introduce the audience to the polyglot group of bureaucrats she must negotiate to attempt to acquire a Hungarian passport. It is these bureaucrats, along with

Diasporic Intimacy and Outside Belonging

For the purposes of my analysis of these two twenty-first-century Brazilian films featuring saudade, the theoretical frameworks Davis and Boym have developed to analyze nostalgia are helpful in a number of ways. Here at the start, I would emphasize one of the most fundamental insights from these scholars of nostalgia—namely, that it is obvious in the context of both modernity and postmodernity, that the fact that an emotion is critically analyzed, ironized, or questioned in some way by the subject of the emotion herself does not mean that it is not a real emotion or that the emotion is reduced in some way. In the postmodern contexts of the production and narratives of *Um passaporte húngaro* and *Budapeste*, saudade is not usually expressed in an uncritical, first-order, or restorative form. In fact, I argue that a changing, transnational notion of home in the postmodern era makes it all the more likely that the diasporic subjects of these films, and other migrants like them, will demonstrate a more complex, shifting, and reflective saudade. Nevertheless, we should consider this a postmodern form of the emotion rather than a disappearance of the emotion. Thus the concept of a flattening or surfacing of saudade (more on surfacing below) is more appropriate than the idea of a waning of nostalgia or saudade. According to Boym, this flattened, reflective nostalgia is very much associated with diaspora and what she calls "diasporic intimacy." Boym's description of diasporic intimacy characterizes the relationship with the other in exile or diaspora, and could well define many of the relationships of the characters and subjects of Kogut and Carvalho's films:

> [Diasporic intimacy] thrives on the hope of the possibilities of human understanding and survival, of unpredictable chance encounters, but this hope is not utopian. Diasporic intimacy is haunted by the images of home and homeland, yet it also discloses some of the furtive pleasures of exile...The illusion of complete belonging has been shattered [for the exile/migrant]. Yet, one discovers that there is still a lot to share. (Boym 2001: 252, 255)

The importance for the diasporic subjects in these films of unpredictable chance encounters is highlighted by the very structure of the films' narratives, which often feature characters met in a bookstore or on the train as very pivotal in the formation of the migrant's relationship to specific places in the space of diaspora. These same chance encounters yield various furtive pleasures of exile even as the migrant subjects struggle to define for themselves the degree and manner of

fit into a general trend of Brazilian postmodernism. Kogut's *Um passaporte húngaro* certainly fits squarely within this trend as well, since one of the film's main themes is the multiple and fragmentary (not to mention shifting and evolving) nature of transnational identities. Along with these identities, Kogut demonstrates the flattening or surfacing (Probyn 1996) of affective attachments to places and people met in one's home nation as well as in the process of transnational migration and travel. In this way her work fragments the traditional, deep meanings ascribed to nation, family, and home into a multiplicity of potential nations, families, and homes to which the postnational subject might attribute some sort of personal significance or attachment. In my analysis below, I further develop the argument that the styles of both films are informed by transnational conceptions of space on the one hand, and postnational conceptions of memory, time, and history on the other.

Beyond the Luso-Brazilian realm of saudade per se, a few scholars in this global postmodern era have considered contemporary manifestations of nostalgia within art and in a broader societal or international cultural context, most notably Fred Davis (1979) and Svetlana Boym (2001). Though saudade is not identical with nostalgia, especially due to the fact that the affective term saudade has an alternative cultural history that is several centuries longer than that of the term nostalgia, there are many helpful parallels that can be drawn between the evolution of the emotions of nostalgia and saudade in recent decades, along with the corresponding evolution in artistic/cinematic representations of these emotions. First, Davis's study divides nostalgia into three distinct orders, essentially organized by the level of self-consciousness or ambivalence the nostalgic subject feels about his or her own nostalgia. First-order nostalgia is a more or less straightforward experience of longing for the past, while the second- and third-level orders of the emotion add layers of self-consciousness, doubt, and/or irony about the specific context within which one feels nostalgia. Boym later independently developed a related, but perhaps more political schema of two opposing forms of nostalgia, restorative versus reflective. For Boym, restorative nostalgia tends to be more associated with ethno-nationalist and/or exclusive, traditionalist imaginaries of the lost home or homeland. On the other hand, reflective nostalgia is characterized by a more ambivalent longing for the lost home/era that can be critical of its flaws, and focuses more on the potentialities of what this home could have been, rather than imagining it as an actual ideal place that one must return to or reconstruct as restorative nostalgia does.

general. In the broadest sense, the very notion of "home" itself has been more or less gradually displaced and fragmented by the acceleration of transnational flows of people, corporations, labor, capital markets, cultural production, and information in general. As the idea of home splinters, expands, or contracts, it is to be expected that saudade, an emotion that relies so much on a conception of returning home (as does its sister emotion nostalgia), will tend to undergo some transformations and find its affective charge being directed along new vectors with different levels of intensity. In terms of affect more generally, such a transformation has been theorized both as a waning and as a flattening of affect in our postmodern era (Jameson 2000 [1984], Probyn 1996). Fredric Jameson explains that the depth models of modernity that relied so much upon notions of interiority of the subject are being replaced by surface or multiple surfaces. Saudade discourses in particular have—as recently as *Central do Brasil* noted above—depended upon a notion of the subject's affect as a bridge between the private, emotional interior, and the desired element (*saudado*)[1] in the exterior, social world. The depth of this desire in the subject's interior world, psyche, or soul has been considered to largely determine the authenticity of the subject and that of his or her desire—as well as the authenticity of the privileged objects of desire/saudade such as home, nation, lover, family, or childhood.

Budapeste features a character named José Costa who is representative of a certain shifting relationship of identity, space, and memory in postmodern Brazilian novels. Consider, for example, the following description of the narrator and protagonist of João Gilberto Noll's *Hotel Atlântico* (1989): "The narrator of *Hotel Atlântico* precisely exemplifies these new zones of urban experience, always between inertia and migration, the masked desire to escape oneself and egocentrism, amnesiac uprooting and the nostalgic impulse to return to a volatile concept of home" (Zambrana 2009: 151; my translation from the original Spanish). It would be difficult to invent a better description of José Costa himself, and like Chico Buarque's novel *Budapeste* (2003), the novel *Hotel Atlântico* was adapted to film in 2009—though the latter film's notion of migration/displacement is more restricted since the travels of *Hotel Atlântico*'s protagonist are within Brazil's borders (Amaral 2009). Generally speaking, Italo Moriconi (2005) describes the postmodern in Brazil as one that emphasizes "the notion of multiple and fragmentary identities as well as the fragmentation of meaning" (356). Thus, Costa's deconstruction and reconstruction of his national identity and language, as well as the fragmenting and reorientation of his affective attachments to nation, family, and lover,

Station (1998, dir. Walter Salles and Daniela Thomas) took a much more traditionalist perspective on the emotion, framing it as a longing for the rural, idyllic heartland of Brazil. In these more recent films by Sandra Kogut and Walter Carvalho, however, the real and imagined protagonists of the films essentially deconstruct their own nationalities and shift their sentiments of longing in the direction of a country that on first glance has very little in common with Brazil, namely, Hungary. I seek to demonstrate how this reframing of saudade in both a documentary and a fictional film signals an opening to transnational, and at times postnational, subjectivity and affectivity in Brazilian cinema.

Since at least the time of the Renaissance and the works of Luís de Camões, saudade's most privileged object has been the lover left behind in one's home nation. Many of the earliest examples of saudade, such of those of Camões, featured Portuguese colonists longing for their home country during their colonial explorations (this kind of saudade continues to be referenced—somewhat ironically—in recent Portuguese cinema, for instance, in Miguel Gomes's *Tabu/Taboo* [2012], discussed in chapter 1). In Portuguese and Brazilian narratives alike, nation, lover, home, and family have been strongly tied together as part of the affectively charged narratives of memory, love, and loss that characterize the *saudoso* (saudade-feeling) subject's experience. At times in the last century, regional saudades in Brazil such as those expressed in Northeastern as well as Central-Southern Brazilian country music (*forró* and *música sertaneja*) have focused the sentiment primarily on a subnational region, though the object of saudade is still focused in a specific home and territory connected with a lover and family left behind. Also, the saudade that *forrozeiros* (forró musicians) sing about in their songs, for instance, even as it tends to be focused on just one region of Brazil, is still very much tied to Brazilian national history and the large scale internal migration that caused massive displacements of workers from rural regions, along with their related feelings of saudade for the countryside. Thus a song like "Vida do viajante" (Life of the Traveler) sung by Luiz Gonzaga, a famous Northeastern musician who toured far and wide in Brazil, explains that the emotion of saudade serves to tie together all of the places the singer has traveled to in the country, effectively creating a cognitive-affective map of the nation (Draper 2010).

THE VOLATILITY OF HOME IN A POSTMODERN, TRANSNATIONAL CONTEXT

Geopolitical developments as well as economic globalization since the 1960s have doubtless created a new framework for cinema, and art in

6

Two Hungaries and Many *Saudades:* Transnational and Postnational Emotional Vectors in Contemporary Brazilian Cinema

Jack A. Draper III

The emotion of *saudade* has a long and storied history of representations in Brazilian art. Often the emotion has been expressed in a context of diaspora or exile, as in Gonçalves Dias's famous poem, *Canção de Exílio*. As in this poem, the emotion has typically been tied to nationalism in artistic representations, with the beloved object of saudade in large part represented as Brazil itself (whether it be the Brazilian people, climate, culture, or something else perceived as distant from the artist/subject of narration). In a postmodern era characterized by the globalization of national economies and communication systems, one can see signs in cinema of the formation of new identities that are transnational and at times postnational. In concert with the shifting identities of filmic subjects, one finds a shift in the objects toward which their emotions are directed, as well as in the intensity and malleability of those emotions.

In this chapter, I focus on representations of subjects feeling saudade in two twenty-first-century films. The nation continues to be an important point of reference in the films *Budapeste/Budapest* (2009, dir. Walter Carvalho) and *Um passaporte húngaro/A Hungarian Passport* (2001, dir. Sandra Kogut); however the emotions of the films' protagonists with respect to Brazil, and their saudade for their home country in particular, seem to be far more fluid in terms of their object and intensity than past representations in film, literature, or popular music. Just a little more than a decade ago, films such as *Central do Brasil/Central*

Ramos, J. L. (2005) *Dicionário do cinema português, 1989–2003*. Lisbon: Caminho.
Salles, W., and D. Thomas. (dirs.) (1995) *Foreign Land* [DVD]. VideoFilmes.
Sardinha, J. (2009) *Immigrant Associations, Integration and Identity: Angolan, Brazilian and Eastern European Communities in Portugal*. Amsterdam: Amsterdam University Press.
Schrover, M., J. V. D. Leun, L. Lucassen, and C. Quispel. (eds.) (2008) *Illegal Migration and Gender in a Global Perspective*. Amsterdam: Amsterdam University Press.
Teles, L. G. (dir.) (2003) *Fado Blues* [DVD]. Fado Filmes, VideoFilmes, Samsa Film.
Xavier, I. (2003) "Brazilian Cinema in the 1990s: The Unexpected Encounter and the Resentful Character," in L. Nagib (ed.), *The New Brazilian Cinema*. London: I.B. Tauris, 39–63.

to Spain, so too have many immigrants sought to utilize Portugal as a gateway to Europe. For more information on the Agreement's history, see Geddes (2008) and Castles and Miller (2009).
6. Migration films cover three temporal components spanning the premigration context, the border-crossing experience, and the experiences in the target nation after arrival, although individual works rarely extend equal focus to each segment of the migration experience (Deveny 2012). While *Fado Blues* and *Foreign Land* foreground premigration and post-arrival contexts, the experience of border-crossing is by comparison deemphasized. For an examination of European cinema that foreground the challenges of entering Europe in regard to state control, see Loshitzky (2010)

WORKS CITED

Castles, S., and M. Miller. (2009) *The Age of Migration: International Population Movements in the Modern World.* 4th ed. New York: Guilford Press.
Deveny, T. G. (2012) *Migration in Contemporary Hispanic Cinema.* Lanham, MD: Scarecrow Press.
Ferreira, C. O. (2010) "Identities Adrift: Lusophony and Migration in National and Trans-national Lusophone Film," in V. Berger and M. Komori (eds.), *Polyglot Cinema: Migration and Transcultural Narration in France, Italy, Portugal and Spain.* Vienna: Lit Verlag, 173–92.
Freire, J. C. (2009) *Identidade e exílio em* Terra Estrangeira. São Paulo: Annablume.
Geddes, A. (2008) *Immigration and European Integration: Beyond Fortress Europe?* Manchester: Manchester University Press.
Hutnik, N. (1991) *Ethnic Minority Identity: A Social Psychological Perspective.* Oxford: Clarendon Press.
Loshitzky, Y. (2010) *Screening Strangers: Migration and Diaspora in Contemporary European Cinema.* Bloomington, IN: Indiana University Press.
McIlwaine, C. (2011) "Introduction: Theoretical and Empirical Perspectives on Latin American Migration across Borders," in C. McIlwaine (ed.), *Cross-Border Migration among Latin Americans: European Perspectives and Beyond.* New York: Palgrave MacMillan, 1–17.
Nagib, L. (2010) "Back to the margins in search of the core: *Foreign Land*'s geography of exclusion," in D. Iardanova, D. Martin-Jones, and B. Vidal (eds.), *Cinema at the Periphery.* Detroit: Wayne State University Press, 190–210.
Peixoto, J. (2008) "Migrant Smuggling and Trafficking in Portugal: Immigrants, Networks, Policies and Labour Markets since the 1990s," in C. Bonifazi, M. Okólski, J. Schoorl, and P. Simon (eds.), *International Migration in Europe: New Trends and New Methods of Analysis.* Amsterdam: Amsterdam University Press, 65–86.
———. (2012) "Back to the South: Social and Political Aspects of Latin American Migration to Southern Europe," *International Migration* 50(6): 59–82.

negotiating the treatment of migration identity that is not limited to portrayals of criminality or irregular immigration. Despite the apparently contradictory nature of the extremes the two films represent, the coping strategies are not exclusive, for in "envisaging and exploring the relation between integration and identity, acquiring 'the best of both worlds' implies that preservation becomes just as important as assimilation...given the objective of wanting to obtain and to be a part of what both societies have to offer, both personally and collectively" (Sardinha 2009: 23). The films address a number of important conceptions of Brazilian exile or Portuguese paternalism, yet rereading the narratives within the context of identity formation establishes an alternative framework for approaching how cinematic representation engages the complex issues that inform both the present and the future of migration debates.

Notes

1. McIlwaine cites from Robert Meins (March 2009), *Remittances in Times of Financial Instability*. Washington DC: Inter-American Development Bank. Online. Available at http://idbdocs.iadb.org/wsdocs/getdocument.aspx?docnum-1913678 (accessed February 2, 2011).
2. While Xavier (2003) argues that new understandings of nation and displacement emerged in Brazilian cinema of the 1990s, the critic also suggests that the particular relationship between criminality and romance dramatized in *Foreign Land* reflects the influence of successful Hollywood models (50).
3. Ferreira's descriptive overview is a valuable resource not only for drawing attention to the small number of Lusophone films to address issues of migration, but also for its exploration of them within the context of the imagined community of *Lusofonia*. I seek to extend her analysis to more deeply approach questions of integration and exclusion.
4. Teles not only nods to the conventions of pulp fiction and film noir, but he also bases his characters' initiation into crime upon hardboiled detective fiction. Nagib (2010) provides a comprehensive analysis of the intertextual role that Goethe's *Faust* plays in *Foreign Land*. The films additionally utilize musical intertextuality via symbolic allusions to fado music, while Salles incorporates visual intertexts via the stock television images of Collor's public announcements.
5. The Schengen Space, which permits travel without border control within participating European countries, came into force in Spain and Portugal in 1995, the year *Foreign Land* was released, though the film's events take place five years earlier, necessitating clandestine border-crossing for those without proper documentation. Just as the protagonist of *Foreign Land* conceives of Portugal as a liminal space that will provide him access

now imports the labor of African immigrants themselves, and it thus depends upon their integration into its social fabric.

In other words, Teles does not necessarily seek to subjugate Brazil or Angola under a fraternity whose terms are dictated by the colonial center, but rather presents Portugal as an inclusive space in which a set of allegorical characters become mutually dependent, a problematic gesture given that he previously rejects utopian impulses. While walking toward the camera in the film's final shot, Amadeu and Leonardo change positions to either side of Lia, the resulting embrace symbolically locating them on equal terms in relation to Portugal. While the film's conclusion accommodates a convenient understanding of assimilation, a consequence of the romantic comedy code that the film embraces, a greater problem emerges from the two-dimensional allegories the minority characters enact. By making individual characters embodiments of national or cultural traits, the film abandons its earlier dialectical strategy and reinscribes the very totalizing narratives that it has previously sought to destabilize. Additionally, the goal of assimilation is robbed of its significance since the dynamic between majority and minority identity is lost as a consequence of presenting singular cultural representatives. The film fails not because of its lighthearted tone or cultural naivety, but because it does not deliver on the complexity it initially promises. In an attempt to neatly tie together the immigrants' integration via sanitized forms of crime, the film fails to offer an alternative to the most damning stereotype of all, namely that immigrants willingly engage in the above type of informal economy. Despite Teles' self-awareness of the artifice of images, from art's symbolic value to how the mass reproduction of tourist icons empties a space of meaning, the contradictory discourse of equality via criminality that he advocates may signal the film's greatest form of artifice.

Conclusion

As the number of feature films treating Lusophone migration to Portugal increases, so too will the number of interpretations of the "moving target" of integration. The processes and motivations informing immigration are complex issues representing a number of factors, and their cinematic representation is also subject to multiple issues such as budget and market constraints, which influence the aesthetic and ideological choices that directors and their crews make. While the two coproductions this chapter analyzes represent vastly different aesthetic choices, the juxtaposition of their divergent strategies (with respect to integration) creates a set of parameters for

consider a union with her as a means to integrate into Portuguese society. They too begin to perform criminality, treating the theft as a means of impressing Lia as much as an economic strategy. Like Paco, Leonardo is confused by Lia's rejection of him after an initial sexual encounter. In a desperate associative gesture, he passes a series of tests to convince her of his worthiness. In contrast to Alex's rejection of the opportunity to establish via Pedro a union with the dominant culture, Leonardo's union symbolizes acceptance into Portuguese culture.

Carolin O. Ferreira (2010) argues that the film embraces a paternalistic attitude privileging Portugal as the mediator of Lusophone identity, critiquing the problematic racial dynamic that results when Leonardo, who is racially similar to Lia, emerges victorious rather than Amadeu (187). Nonetheless, it should be noted that Amadeu himself ultimately relinquishes his pursuit of Reis' daughter, because he both recognizes Leonardo's greater need for identification and that his personality is too similar to Lia's, an allusion to Lusophone Africa's more recent ties to colonial Portugal. Even in Brazil, Amadeu has demonstrated an acculturative tendency to identify strongly with both Angola and Portugal, rather than identify as marginal or dissociative. Unlike Leonardo, Amadeu's path toward Portuguese assimilation is not dependent upon familial relations, but rather economic ones, demonstrated by his willingness to invest his cut of the illegal profits in saving Salvador's business. Amadeu thus signals his desire to return to legitimate business practices while he figuratively invokes Portugal's new relationship with African immigration. While the imperial power imported its African colonies' resources during its colonial reign, it

Figure 5.6 *Fado Blues.* The final scene reinforces its message of equality.
Source: Screenshot *Fado Blues* (2003, dir. Luís Galvão Teles): Fado Filmes, VideoFilmes, Samsa Film.

the narrow lanes and staircases of Lisbon, and when confronted by the smugglers in a restaurant a mere one hundred meters from the border, he cleverly lures one of them outside and shoots him. For Alex, Paco has served as a replacement for Miguel both in sexual and cultural terms, yet if Alex's subconscious motivations for initially having sex with the young Brazilian are complex, so too are his own. The fact that he reaches his mother's homeland with Alex reinforces his confused perception of her simultaneously as a sexual and a maternal figure. The two migrants thus develop a symbolic familial relation, however short lived, that reacts to their inability to integrate into Portuguese society by dissociating, seeking instead to preserve their own ties to Brazil.

And yet Brazilians are not the only marginalized group. Salles and Thomas bring the issue of minority identity intro greater focus by refusing to create binary oppositions between minority and majority identity via the inclusion of Angolan representatives whose presence underscores racial differences. The hotel owner in Lisbon identifies with Paco's skin color despite his cultural difference, though he evinces prejudice toward his African tenants. The representation of minority discourse, however, does not naively privilege immigrant associations or communities. On the contrary, the dissociative Brazilian and Angolan groups unintentionally alienate each other via unfortunate misunderstandings. A majority of the Angolans reject Paco because of his ethnicity, and Paco's own prejudice emerges when he attacks his lone ally in the group, mistakenly assuming the friend has stolen Igor's violin. Through the question of integration, then, the film seeks to document tensions rather than suggest solutions or diffuse discrimination, and its successful portrayal of the complexity involved in cultural integration lies in its refusal to seek convenient narrative resolution.

If *Foreign Land* demonstrates minority identity through marginal and dissociative characteristics, however, *Fado Blues* explores acculturative and assimilative tendencies, although this identity formation also blurs the line between sexual and criminal union. Like Alex, Lia represents the only female character in the film, and she too becomes the object of desire of multiple males with different ethnocultural backgrounds who seek to establish ties within Portugal. Both Leonardo and Amadeu attempt to seduce Lia, developing a jealous competition that very nearly compromises their friendship as well as the museum robbery. Lia's mysterious character is designed as homage to the sexualized femme fatale of noir film, yet like Paco, Amadeu's and Leonardo's desire transcends mere lust. Both men subconsciously

individual is indifferent to either group, while the dissociative category encompasses those who identify entirely with minority values and reject majority codes. Despite appearing contradistinctive, identity preservation and integration are "both coping mechanisms that permit survival in the new society" (Sardinha 2009: 28), and the narratives' protagonists exhibit these opposing tendencies in their search to (re)establish identity networks.

Within the context of the limited contacts that the protagonists have, however, the need for informal community association becomes bound up with sexual desire and criminal networks, such that the boundaries between the two forms of relations become confused. Nonetheless, since integration and identity are not static variables, the strategies utilized for identity preservation and integration provide radically different outcomes. Applying Hutnik's model of minority identity to *Foreign Land* reveals that the characters demonstrate markedly dissociative tendencies. Initially, Paco appears to be a marginal character who does not identify with any group, whether from Brazil, Portugal, or the Spain that his mother has imagined. It is by virtue of his association with Alex that he begins to reject majority codes, a product of his sexual union with Alex and her own associations with the smuggling group. Pedro, Alex's Portuguese contact in Lisbon who receives Igor's shipments, is in love with Alex. The bookseller is the only Portuguese character to treat her as a human, but this is partially a consequence of his own desire, and when Igor arrives in Lisbon in search of the missing diamonds, Pedro betrays her whereabouts after being tortured.

Alex lures Paco out of Lisbon under the pretext of meeting the smuggling group so that Pedro may steal the violin, but this action has two unintended consequences. First, it means the criminal group will assume Paco has stolen the diamonds, which binds his fate to Alex's. Second, it leads to the Brazilians' sexual union. Free of the city's entrapments, the characters spend the night in the southernmost point of Portugal waiting for a return bus, and Alex, overcome by loneliness, initiates intimacy with Paco. He misunderstands the gesture and is puzzled by her rejection of him the next day, though eventually their union does develop into a "community." With Alex dreaming of a return to Brazil, and Paco intent on reaching Spain, the two figuratively and literally reject Portugal via their race to the border. In fact, after Paco becomes a target of the smugglers, he sheds his previously passive, marginal status and begins to actively protect his relationship with Alex, which occurs through his own performance of criminality. He leads the smugglers on a nighttime chase through

Figure 5.5 *Fado Blues*: Leonardo imitates Rio's Iconic Christ the Redeemer statue.
Source: Screenshot *Fado Blues* (2003, dir. Luís Galvão Teles): Fado Filmes, VideoFilmes, Samsa Film.

Representing Identity: Criminality, Sexuality, and Integration

Portugal's easing of immigration policies at the turn of the twenty-first century signaled an attempt to recognize the importance of migrant labor as well as integrate groups into the fabric of Portuguese society. Nonetheless, the quantity of conflicting studies regarding the implementation of such policies suggests that the complex processes of integration and identification are moving targets that must be constantly reevaluated (Sardinha 2009: 21), and the films address this moving target in opposite fashion. The previous sections show how Teles and Salles utilize the questions of labor and the representation of urban space to reify their characters' alienation from dominant society. Left without any sense of identity, the characters consequently attempt to create communities through their criminal associations and their sexual relationships, both of which reinforce their minority identities.

Nimmi Hutnik (1991) notes that minority identity "is not necessarily a singular, fixed, inflexible given but may be constituted of hyphenated identities that indicate varying degrees of identification with both the ethnic minority group and the majority group" (157), and thus proposes a classification system for minority self-categorization based on four tendencies: assimilative, acculturative, marginal, and dissociative. Assimilative individuals embrace dominant values at the expense of identification with internal minority values, while the acculturative type tends to identify strongly with both dominant and minority groups. On the other end of the spectrum, the marginal

The sequence also calls attention to the disparity in social class between two types of foreigners who frequent this site, namely the tourists who have the means to travel to Brazil and consume its national imagery and Amadeu, an immigrant who is himself consumed by that same utopian imagery. When an undercover policeman exposes Amadeu's fraudulent photography practice, the officer's face is symbolically superimposed over the statue, a blatant comment on the obstacles the law places between immigrants and the dream of prosperity. In the meantime, via alternating shots, the narrative cuts between Amadeu and Leonardo to juxtapose their distinct experiences of urban space and further deconstruct the initially fashionable beauty associated with the city. With windswept hair and stylish sunglasses, Leonardo cruises past gleaming beaches on a scooter, his smile suggesting a carefree existence. Yet at the same moment that Amadeu's deception is revealed by an undercover police officer, the reality of the city below is unmasked when Leonardo leaves the glamorous beachscapes and arrives at the back streets where his shop and crumbling apartment building are located. In a commentary on the city's superficial focus on appearance, when Leonardo attempts to join the city's narrative of success, the jewelry on which he spends his last savings fails to impress his date, who seeks casual relationships rather than stability.

Just as Salles presents urban Brazil and Portugal as reflections of each other, Teles also invites parallel interpretations of the two environments. A deconstructive progression that echoes the film's opening plays out when the friends first arrive in Lisbon. After stealing a scooter outside the airport, they explore the city as tourists until they run out of gas alongside the less picturesque industrial seaport. They then suffer a further setback with the discovery that the entire neighborhood surrounding the house of Amadeu's cousin has been razed, leaving the men without a roof or means of contact. Resembling a war site, the piles of rubble, the collapsed buildings, and the collection of dilapidated furniture form one of the most arresting images of the entire film, for the destruction symbolizes the loss of Portuguese identity that Amadeu has claimed while in Brazil. This is reinforced in visual terms, for Leonardo sarcastically welcomes Amadeu home amidst the rubble with outspread arms, evoking the Christ the Redeemer Statue, and alluding to the same failed economic dream. If Lisbon serves as a locus of shattered expectations for Paco and Alex, then, it also subverts the nostalgia that motivates characters like Amadeu and Paco's mother. In one of the rare emotionally charged moments in the film, the Angolan chooses to sleep inside an abandoned boat he discovers amidst the neighborhood wreckage that, like the two men, has been stranded far from its intended home.

route he and Alex wake up on a beach to discover a gigantic shipwreck beached in shallow waters. Lúcia Nagib (2010) has explored several aspects of the boat's symbolic significance with regard to Brazil and Portugal's historical maritime relationship, arguing that its appearance foreshadows the travelers' own impending shipwreck (195). Indeed, it provides one final monument regarding frustrated historical attempts to enter Portugal, a symbolic testament to the immigrants' ultimate entrapment in-between entry and departure.

In *Fado Blues*, by contrast, Teles does not fragment the city, but nonetheless attempts to subvert stereotypes through strategic juxtaposition of different urban perspectives. The film opens with internationally recognizable tourist images. Accompanied by an up-tempo samba-inspired song, the camera pans over a postcard image of Rio de Janeiro's famous landmarks, circling from Sugarloaf Mountain over the bay to rest upon the Christ the Redeemer Statue. Teles, however, deploys these stereotypes self-consciously, immediately questioning their iconicity. The camera adopts Amadeu's perspective from behind his own camera lens, as a series of virtually identical photographs of smiling tourists posing in front of the statue appears in rapid succession. The mass reproduction of the statue's image not only diminishes its initial aura, but it also establishes the film's preoccupation with copying reality, whether it is Leonardo's desire to imitate the fiction he consumes or the criminal group's replacement of a museum painting with a counterfeit. It is telling that Amadeu requests that tourists say "samba," evoking another stereotypical national association, as he dupes them into believing that he has captured their image.

Figure 5.4 *Fado Blues*: The police officer from Amadeu's point of view.
Source: Screenshot *Fado Blues* (2003, dir. Luís Galvão Teles): Fado Filmes, VideoFilmes, Samsa Film.

Figure 5.3 *Foreign Land*: Lisbon's skyline zooms out to reveal Miguel and Alex at the margins of the frame, reinforcing their marginalization in relation to the city itself.
Source: Screenshot *Foreign Land* (1995, dir. Walter Salles and Daniela Thomas): VideoFilmes.

their conversation about isolation and dislocation. Foreshadowing the film's politics regarding integration, Alex expresses fear of becoming trapped in a place where she does not wish to live: "It's not so much the place. As time goes by, I feel more and more foreign. I'm more conscious of my accent. As if the sound of my voice offended them."

Paco's experience of Lisbon mirrors that of São Paulo through a claustrophobic combination of tight interiors and narrow city streets, and he is once again surrounded by sites of transport that reinforce his immobility as he futilely awaits Miguel's contact for days inside a hotel. When a ship's horn jolts him out of sleep, he discovers his verandah overlooks the central train station and the industrial port, where he heads upon discovering Miguel has been murdered. At once a reflection and a magnification of his solitude in Lisbon, the seated Paco is dwarfed by a ferry that passes in the background across the camera. He encounters other modes of transport, attempting to purchase a bus ticket to Spain, but when he discovers he does not have enough money, he repeatedly attempts to call Igor from a station payphone. The awareness of absolute alienation registering upon his face is juxtaposed against the frenetic pace of arrivals and departures at a taxi stand in the background. In fact, until appropriating a car to flee Lisbon, Paco witnesses, yet is excluded from, virtually all forms of transport. Yet even the freedom of urban escape is fleeting, for en

Figure 5.2 *Foreign Land*: Paco's apartment building seen in relation to the elevated expressway.
Source: Screenshot *Foreign Land* (1995, dir. Walter Salles and Daniela Thomas): VideoFilmes.

level as his mother emerges from underneath the flyover. The building becomes a vehicle for consumerism in much the same way that Paco does when he transports Igor's products, for its presence is virtually erased underneath several enormous billboard advertisements aimed at the passing drivers. Each of the three shots demonstrates how the roadway, along with the accompanying rush of traffic, circumscribes Paco's living space, yet rather than symbolize a physical or economic mobility, the road's presence ironically accentuates the fact that the struggling family is financially unable to take the trip about which the mother fantasizes. The film returns to this initial image near its conclusion via an exchange between Paco and Alex, who harbors a fantasy of return similar to that of Paco's mother. It is no coincidence that Alex claims, as they escape Lisbon via automobile, that in order to return to Brazil she would willingly suffer even the hardship of living under the Minhocão overpass. Unaware that this is precisely the point from which Paco's journey originated, Alex inadvertently points to a cyclical dimension of the processes of migration.

 This cyclicality is also evident in the way visual difference is downplayed in favor of similarity, for, the cityscape of Lisbon is no less fractured than that of São Paulo. The lone establishing shot occurs as Alex and Miguel gaze out from a vantage point from one of its elevated neighborhoods. The two lovers frame the shot as the camera scans the skyline, echoing

by Leonardo's romantic union with Lia and Amadeu's generous offer to pledge his new money to saving Salvador's failing business.

Deconstructing the City

Yosefa Loshitzky (2010) maintains that because contemporary immigration to Europe is motivated primarily by economic necessity, cities become central for the migratory experience (7). She argues, however, that in order to portray the "postmodern alienation" of migration, numerous European films "deconstruct the iconic images of the classical European cities that make for easily consumed picture-postcard views. The famous monuments and landmarks of these cities are either absent from the films or stripped of their traditional cultural capital, assuming the role of post-icons in an impoverished urban fabric" (45). *Foreign Land* and *Fado Blues* also deploy this strategy of recasting utopian images as dystopic environments, suggesting that urban spaces shape social relations and inform their challenges in developing immigrant communities. Yet, in the same way that they present parallel forms of economic hardship in both Brazil and Portugal, they also extend a deconstructive approach toward the urban spaces that the characters experience. São Paulo, Rio de Janeiro, and Lisbon do not merely serve as background settings, but rather become actors that determine the protagonists' alienation. Just as the characters negotiate their shifting identities, the urban centers they inhabit are also strategically represented as fluid spaces rather than sites with stable features. Ironically, however, this emphasis upon physical mobility serves to reinforce the characters' consequent lack of social mobility.

The opening sequence of *Foreign Land* is emblematic of this preoccupation, for rather than establish the film's setting through a long shot that might identify the sprawling metropolis of São Paulo, the city is associated with tight, compact shots that foreground the concept of dislocation. Immediately following the credits, three separate shots of Paco's apartment building, which is bisected by the elevated Minhocão expressway, appear in succession. In the first shot, the road appears in the foreground, literally framing his drab apartment complex at night. In the lone illuminated window, Paco's silhouette appears inconsequential in relation to the concrete masses surrounding him. The camera then cuts to an aerial view of the same space in which the roadway occupies the center of the composition and bisects the frame, running off into the horizon and drawing the eye away from the nondescript tenement, gesturing beyond the city. This image then cuts to a third angle, which represents Paco's building from street

Alex sells her passport to Spanish agents who similarly take advantage of her nationality. The agents' dismissal of her document's value is ironically juxtaposed against the creation of a false passport for Paco. The greatest victim of manipulation, Paco is led to believe he will fly to Spain, though he discovers en route that his passage will take him only as far as Lisbon, where he is instructed to wait for Miguel.

Unaware of Miguel's death, after several days in isolation Paco attempts to track him down, though Alex initially assumes Paco is responsible for the murder. Seeking revenge, Alex helps another of Igor's contacts, Pedro, a local bookseller who houses the false artifacts, steal the violin and diamonds. But when the antique dealer himself arrives in Lisbon and Paco finally understands the plot in which he has become embroiled, both Brazilian immigrants must flee Lisbon for the Spanish border. After a violent encounter leaves the smugglers dead and Paco mortally wounded, the film ends ambiguously with Alex cradling the bleeding Paco in the front seat of their car. In the final shots they burst through the barricade demarcating the frontier, Paco unconscious of the fact that he has fulfilled his mother's wish to return to Spain.

Amadeu and Leonardo also face setbacks upon arriving in Lisbon, discovering similar conditions to those they left in Rio de Janeiro. They have planned to stay with Amadeu's cousin, but they arrive to find the entire neighborhood recently bulldozed in preparation for gentrification. Left without any legitimate contacts, the two men naively embrace the romantic image of crime they have nurtured from the pulp literature in Leonardo's store and set out to meet the Brazilian's favorite mystery writer, known only as Reis, believing that he may also perpetrate crimes. They locate Reis' house, but instead of finding the writer, they are met at gunpoint by a beautiful young woman who, after determining the men are harmless, introduces herself as Lia. Eventually revealed to be Reis' daughter, she agrees to join the project as well as mediate between the two men and the mystery writer. The group is joined by Amadeus' old employer, Salvador, whose local business is about to foreclose. Also a small time crook, Salvador discovers that a painting he previously stole is appearing in a museum exhibit about fake art, its value on the black market having skyrocketed with the painter's death. The group therefore plans to smuggle out the "false" painting, replace it with a "true" counterfeit, and sell the original work on the black market. In contrast to the dire consequences of criminality in *Foreign Land*, however, the criminality in *Fado Blues* ultimately provides a means of forming community bonds and identity within Portugal, a new status symbolized

of losing her savings and all hope of return to Spain. Paco is not only emotionally traumatized, but also destitute; he must forge his mother's signature to pay for her funeral service. He thus becomes an easy target for Igor, a smuggler who conceals diamonds inside antiques that are conveyed to Europe. Igor manipulates Paco's desire to pay homage to his mother's memory, offering him free passage to Spain in exchange for transporting an antique violin, though Paco remains unaware of the real contents hidden inside the relic.

Fado Blues also centers around the question of economic hardship in Brazil. Amadeu is an Angolan immigrant who left Portugal to seek fortunes in Rio de Janeiro, but has failed to find legitimate employment. He resorts to preying upon foreign visitors at the Christ the Redeemer Statue, one of Brazil's most iconic tourist attractions, pretending to be an official photographer despite carrying a camera devoid of film. When an undercover police officer attempts to appropriate Amadeu's money for himself, the immigrant escapes the law but loses the camera, his only form of sustenance. The irony of the Angolan's relationship to the statue becomes evident as he complains bitterly to Leonardo, his Brazilian roommate, "I came to Brazil to make money. Now, not only am I not rich, but I'm poorer than when I arrived...I'm 33 years old. The same age as Jesus when he died." His interlocutor shows little sympathy: "Everyone knows that you don't come to Brazil to get rich...You're in the wrong century!" Nonetheless, because Leonardo's bookstore specializing in detective fiction is failing, Amadeu convinces him to fake a robbery and presumably use the insurance money to travel to Portugal in search of a conventional family and a more stable existence.

Neither film presents Portugal as a promised land of opportunity, however. The second half of *Foreign Land* relates the intersection of two Brazilian immigrant narratives in Lisbon. Unlike Paco, both Alex and her boyfriend, Miguel, are fully aware of the stakes involved in the international smuggling ring. They attempt to survive through legitimate means, yet become entrapped in illegal activities. Alex waitresses in a restaurant, but quits because the prejudiced Portuguese manager both exploits and insults her. While Miguel is a talented musician, there is no market for his skills, leaving him with few options: "You think I like living off of contraband? I want to play music but no one listens...Our life is a heap of shit! I'm leaving." The two are marginalized even when they participate in illegal activities. Miguel acts as a contact for Igor, yet when he assumes agency and endeavors to sell the diamonds directly to Portuguese buyers, they radically underprice the contraband's value because he is Brazilian. After Miguel's murder,

Figure 5.1 *Foreign Land*: Border checkpoint.
Source: Screenshot *Foreign Land* (1995, dir. Walter Salles and Daniela Thomas): VideoFilmes.

identity in an attempt to gain recognition by a female, yet this romantic link serves problematically associative ends in *Fado Blues*, while in *Foreign Land* the resulting identification between cultural outsiders creates dissociative networks.[6]

REPRESENTING LABOR: PARALLEL ECONOMIC HARDSHIPS

While each film traces migratory flow from Brazil to Portugal, neither country is presented as a migration terminus. The use of strategic narrative repetition collapses the difference between the two locations, such that both serve as temporary spaces through which migrants pass, as the protagonists' eventual engagement with crime emerges as a means of escape from the countries' economic instability. In *Foreign Land*, for example, Paco lives in São Paulo, having never seen Spain, the birth country of his mother. Now widowed, her dream consists of saving enough money to revisit her childhood past, one that she clings to through photographs and postcards, even though Paco critiques her plan as quixotic given their financial constraints. The narrative begins in 1990, a time when Brazilian president Fernando Collor de Mello implemented his New Economic Plan, freezing personal assets in an attempt to stabilize skyrocketing inflation. After watching the news via a televised announcement, Paco's mother dies from the shock

intersection around which to view these two films, this chapter seeks to look at them through a distinct critical lens by examining the consequences of this illegality upon their process of integration. The aim of highlighting their contrastive visions, in addition to examining how a comparative view of filmic texts can generate formative debates and interrogate cultural assumptions, is to take a primary step in sketching a methodological framework for understanding what constitutes meaningful contribution to the issues surrounding migration within Lusophone cinema.

Stressing that the concept of "integration" varies depending upon the different contexts and critical approaches it serves, regarding Brazilian and Angolan migration to Portugal, Sardinha (2009) posits that it entails "the learning of, and adjustment to, society's values—processes that bind individuals to society culturally, economically and socially" (33). As he notes, migrants are faced with multiple scenarios when encountering a new social milieu, which may lead them to modify their identities through processes of adaptation or alternately to preserve those characteristics that identify their collective identity (21). *Foreign Land* and *Fado Blues* exemplify these opposing tendencies, for criminality and its performance ultimately serve radically different ends in terms of the formation of identities and communities within the target nation. Approaching questions of assimilation and dissociation, the narratives represent different possibilities for the types of communities their protagonists develop—or fail to develop. Without documentation or sufficient money, the protagonists of *Foreign Land* eventually attempt to use Portugal as a springboard to enter the rest of Europe and escape the conditions of their victimization,[5] while those of *Fado Blues* attempt to assimilate into Portuguese society via the criminal and social associations they forge.

Rather than provide two separate analyses of the films, therefore, this chapter explicates both films around specific sites of comparison related to the representation of irregular immigration. First, the analysis provides a brief overview of the films in relation to shared strategies for representing limited economic opportunities in a pre- and postmigration context, wherein Brazil and Portugal are constructed as unstable spaces characterized by constant processes of entry and departure. This economic instability is further explored in relation to the ways in which the experience of urban space, which is fragmented and deconstructed, determines both the protagonists' movement within criminal groups as well as their ability to form social connections. Finally, I examine the issue of gendered discourse in relation to sexuality, as male protagonists in both films "perform" a criminal

play a definitive role in shaping the identities of those immigrants who attempt to assimilate into Portuguese society.

Reenacting Portugal's historical colonization and exploitation of Brazil, in *Foreign Land* immigrants smuggle historical artifacts and antiques across the Atlantic, though these objects, like the Brazilians who transport them, have value only inasmuch as they are vehicles of transit, for they conceal diamonds to be trafficked in Europe. In *Fado Blues*, a criminal group led by immigrants arriving from Brazil purloins a painting that features at a museum exhibit on fake art, and which the thieves replace with an imitation, a truly fake object. Revealing examples of art in these instances to be empty signifiers highlights the disparity in value accorded to the circulation of objects versus humans, for in both cases the exploitative conditions in the name of informal economy ironically compel the protagonists to take part in illegal activity.

While *Foreign Land* has frequently been applauded by critics for its gritty, layered portrayal of Brazilian exiles (Freire 2009, Nagib 2010),[2] Teles' production has enjoyed considerably less critical treatment. Panned as a narrative "disaster" (Ramos 2005: 591), the film's pan-Lusitanian politics have been criticized as paternalistic in one of the only studies to mention both films in conjunction (Ferreira 2010: 187–188).[3] The difference in the low-budget films' critical reception is partly owing to their distinct genres, for *Foreign Land* is a dramatic thriller, while *Fado Blues* is a comedy that lightheartedly parodies the conventions of film noir. Despite following predictable conventions in order to neatly resolve conflict, however, Teles is not as naïve as some reviews might have it (Ramos 2005: 613). Indeed, he repeatedly demonstrates critical awareness by deconstructing exotic images and cultural stereotypes in both Brazil and Portugal. In fact, in addition to a preoccupation with the illegal economy associated with irregular migration, he shares several structural and thematic strategies with Salles and Thomas that can serve as sites of comparison. Both films place into contact Portuguese, Brazilian, and Angolan characters to explore cultural differences and prejudices. Additionally, the films are not only overtly intertextual, highlighting literary and filmic models,[4] but they also self-consciously interrogate the construction and consumption of national stereotypes while expressing awareness regarding the push-pull dynamic of migration. Thus, they foreground the crisis of Brazil's national project in determining the protagonists' decisions to cross the Atlantic Ocean, yet are also careful to unsettle romanticized notions of Portugal as a promised land of economic opportunities. In conceiving the role of criminal activity as a point of

is this latter group that has been primarily identified with smuggling networks (Peixoto 2008: 73–74, Sardinha 2009: 108). Though the recent influx of irregular migration from Eastern Europe is closely associated with organized trafficking, the informal networks linking Brazil to Portugal are more likely to involve informal smuggling; this is due in part to the already existing, relatively established community of Brazilians as well as the colonial, historical, cultural, and linguistic ties that link the two countries (McIlwaine 2011: 6–7).

Much of the recent academic attention paid to shifting global migratory patterns, however, has focused upon legal migration (Schrover et al. 2008: 9) as well as established directional flows. For example, the fact that three-quarters of the outward flows from Latin America have traveled north toward the United States (until post-9/11 regulations became more restrictive) has led transnational theorizations to privilege this regional phenomenon to the exclusion of increasing European flows (McIlwaine 2011: 2–3, 6, Peixoto 2012: 59). In fact, in terms of remittances sent back by migrant laborers to support Latin American economies, globally Spain is second only to the United States (McIlwaine 2011: 8).[1] While Portugal's population is considerably smaller than that of its neighbor, it now boasts the second largest proportion of Latin American immigrants within Europe (Peixoto 2012: 61–62), and this demographic is comprised predominantly of Brazilians.

Stephen Castles and Mark Miller's (2009) influential characterization of contemporary globalization as an "age of migration" draws attention to the challenges that transnational movement poses to the sovereignty of nations, for while "movements of people across borders have shaped states and societies since time immemorial, what is distinctive in recent years is their global scope, their centrality to domestic and international politics and their enormous economic and social consequences" (3). By highlighting the economic and social consequences that Castle and Miller reference within the context of flows from Latin America to Europe, this chapter comparatively analyzes the representation of irregular forms of migration in two Portuguese-Brazilian coproductions, *Terra estrangeira/Foreign Land* (1995), directed by Walter Salles and Daniela Thomas, and *Tudo isto é Fado/Fado Blues* (2003), directed by Luís Galvão Teles. The immigrant characters in *Fado Blues* voluntarily seek out and cooperate with local agents, while in *Foreign Land* the characters evince varying degrees of awareness regarding the smuggling operation. In both cases, the protagonists' association with criminal networks also metaphorically represents their dehumanization, and I argue that these associations

5

Performing Criminality: Immigration and Integration in *Foreign Land* and *Fado Blues*

Frans Weiser

Introduction

The number of legal foreigners in Portugal doubled between 2000 and 2002 due to a combination of accelerated immigration and the Portuguese government's legalization initiatives that granted "stay" permits to several hundred thousand aliens in the country. The increase in legal migration leading up to the turn of the twenty-first century, however, was accompanied by equally significant increases in irregular immigration, including various forms of trafficking and smuggling (Peixoto 2008: 68). As opposed to trafficking, in which exploitation of human rights is central, smuggling involves a different degree of victimization, as it generally refers to consensual illegal entry. In fact, since smuggling overlaps with regular migration, in numerous cases it is the immigrants themselves who seek out the smugglers' assistance (Peixoto 2008: 66, Schrover et al. 2008: 11).

Portugal and Brazil have historically engaged in mutual exchanges of migrants, and although Brazilian counterflow to Portugal dates back to the turn of the twentieth century, it is only within the last decade that Brazilian immigrants have displaced African communities to comprise Portugal's largest immigrant community (Sardinha 2009: 103). While the first wave of "new" Brazilian immigrants in the 1980s constituted a reaction to economic hardships at home and consisted largely of middle-class and skilled workers, the second inflow beginning in the 1990s has been characterized by a less privileged socioeconomic demographic in response to the need for unskilled labor, and it

Martí, G. M. H. (2006) "The Deterritorialisation of a Cultural Heritage in a Globalized Modernity," *Journal of Contemporary Culture* 1: 92–107.

Oliveira, A. M. C. (2011) *Processos de desterritorialização e filiação ao lugar. O caso da aldeia da Luz*. Masters thesis, University of Coimbra (photocopied).

Oliveira, A. D. B. (2010) "Estado Novo no plateau: luzes, câmara, acção!," *Portuguese Cultural Studies* 3: 73–81.

Rovisco, M. L. (2001) "Panorama histórico da emigração portuguesa," *Janus* 1: 1–5.

Tiago, M. (1994) *Cinco Dias, Cinco Noites*. Lisboa: Edições Avante.

Tuan, Y. F. (2008) *Space and Place. The Perspective of Experience*. 6th ed. Mineapolis: University of Minesota Press.

Velez de Castro, F. (2007/2008) "Lugar e não-lugar em espaços imaginados. Abordagem geográfica a partir do cinema," *Cadernos de Geografia* 26/27: 115–125.

———. (2011) "Emigração, Identidade e Regresso(s) A visão cinematográfica dos percursos e dos territories." *Avanca|Cinema: Proceedings of the 2011 International Conference*. Cineclube Avanca, Estarreja, Portugal, July 20–24, 2011. Avanca: Edições Cineclube de Avanca, 957–965.

and the character is apparently safe. It must be noted that in the final scene, the boatman character is interpreted by a known Portuguese clergyman—Padre António Fontes. The audience's curiosity is piqued. What is the real function of this character? One can extrapolate in several directions. In this context, one might view this as a sort of validation, a divine protection of the act of passage, an approval of the territorial consubstantiation.

In *Duplo exílio*, the resolution is to embrace a multiterritorial experience. The acceptance of the deterritorialization process is more than an inevitability, it is a possibility of choice. The affective bonds become loving in nature for someone who, although deterritorialized in situ, remains there. Yet with the prospective departure, while knowing that he must wait to return to the United States, David does not show evident signs of ontological safety. To a certain degree, he even appears to have a topophilial relationship. In the end, the reterritorialization process is not inevitable under similar circumstances. Achieving it and the degree of effectiveness depends on the positive/negative experiences lived by the individual.

Works Cited

Azevedo, A. F. (2006a) "Geografia e Cinema," in J. Sarmento, A. F. Azevedo, and J. R. Pimenta (eds.), *Ensaios de Geografia Cultural*. Porto: Livraria Editora Figueirinhas, 60–79.

———. (2006b) *Geografia e Cinema. Representações culturais do espaço, lugar e paisagem na cinematografia portuguesa*. University of Minho: Doctoral thesis (photocopied).

Badie, B. (1997) *O fim dos territórios. Ensaio sobre a desordem internacional e sobre a utilidade social do respeito*. Lisbon: Instituto Piaget.

Diogo, H. (2012) "Territórios e paisagens culturais na emigração lusa," *Revista de Geografia e Ordenamento do Território* 1: 41–58.

Fernandes, J. L. J. (2007) "A desterritorialização como factor de insegurança e crise social no mundo contemporâneo," *Proceedings of the I Jornadas Internacionais de Estudos Sobre Questões Sociais*. Universidade Fernando Pessoa, Ponte de Lima, Portugal, May 28, 2007. Ponte de Lima: Universidade Fernando Pessoa, 1–23.

Haesbaert, R. (2004) *O Mito da Desterritorialização. O "fim dos territórios" à multiterritorialidade*. Rio de Janeiro: Bertrand Brazil.

Haesbaert, R., and E. Limonad. (2007) "O território em tempos de globalização," *Espaço, Tempo e Crítica* 2(4): 39–52.

Malheiros, J. (2011) "Portugal 2010: o regresso do país de emigração?," *Janus.Net* 1(2): 133–142.

Marques, J. C. L. (2009) "'E continuam a partir': as migrações portuguesas contemporâneas," *Ler História—Emigração e Imigração* 56: 27–44.

context are however, reversed. He meets Ana who, like himself, confesses to not having a sense of belonging, like a stateless person. He learns that he is not alone in his condition of territorial loss. This leads to his understanding of the importance of the conjugation of the condition of "person and citizen." He chooses to return to his original country, initially unwillingly, but with a strategy to regularize his situation in the territory he feels part of. David's intention to start the legalization process while in S. Miguel, the island where he feels geographically confined, opens the possibility of establishing a relationship of comfort with that place, a reterritorialization that transmits ontological safety and the basis for a state-loving construction with his biological origin. Deep down, David now has dominance over two migration points. His is a multiterritorial perspective of understanding, interpreting and even (a relative) power regarding the territories.

Conclusion: How the Cinematic Solutions Deal with Two Portuguese Emigratory Experiences

Summing up, Ana Francisca Azevedo (2006b: 492) contends that, since an early stage, cinema has held an important geographical and social role in the construction of the idea of place(s), and the process of spatialization of regional/national identities. Her premise is that by accenting the interconnectivity between identity and space, the movie landscape ultimately denounces calling images of place as mediators of power between the individual and place. Likewise, Fátima Velez de Castro (2007/2008: 119) argues that the geography of place is also a result of an imagined reality that is part of everyday life. In this sense, cinema explores the relationship between geography and individuals, using the power of fiction as visual metaphor.

The films analyzed here present cinematic and philosophical solutions by dealing with the representation of these concrete migratory experiences. First they introduce and "fictionally" explore the development of the characters and geographic and social contexts; second, they represent not only the challenges, but also the opportunities provided by the deterritorialization-reterritorialization process, as well as by the possibilities provided by multiterritorial experiences.

In *Cinco dias, cinco noites,* preconization of escape to ontological insecurity, with the consubstantiation of the goal, is materialized through the passage of the river. One does not know what happens next, but the spectator "is relieved" because the film's goal is achieved

difficult and nerve racking, it is a survival strategy that ultimately reunites him with Lambaça, who continued the trip on the bus. André gains an important connection with Lambaça, the one who has cognitive, social, and cultural dominance over that territory, the "expert" at not being caught by the authorities for trafficking individuals. The question of the other side of the border remains in the air, where it seems that André has contacts with the Portuguese community living abroad, possibly in France.

By achieving his goal, by manifesting a great capacity of recovery as mentioned by Tuan (2008) (escape from prison, overcoming difficulties during the journey), André also gains the spatial capital Haesbaert (2004) describes. His resilience to the obstacles imposed by the territorial dynamics results in an access to a complex multiterritoriality composed of several territories in the midst of "his territory" (country of nationality), as well as those encountered in the migration experience.

The same happens to David in *Duplo exílio*. His mandatory exile puts him in face-to-face with a set of unfavorable situations. The 1996 Emigration Act, which repatriated legal but not naturalized emigrants (e.g., in the case of criminals), forces David to return to the country where he was born, but which he left at five months of age, never knowing the language, geography, society, and culture. He contends that Americans do not know where the country is located, and he himself has difficulties in "finding" the Azores Islands in the Atlantic. While his parents wanted to talk to him about Portugal, he acknowledges no interest, pretending to be American by birth, as are his friends from school. His parents never sought naturalization for him because, deep down, they wanted him to keep the Portuguese cultural roots, although acknowledging he always felt American. Thus, there is dissociation between "person" and "citizen" that he considered to be the same individual identity; however, from a legislative point of view, such an understanding never took place. Further, the discordance before the law required that he abandon the country where he had always lived.

When David arrives at S. Miguel as a repatriate, he endures taint by association. Most repatriates are linked to drug trafficking, promoting the construction of a negative stereotype for these "foreigners." For example, because the owner of a bakery was hurt by a repatriate, David suffers from the stigma. His geographical confinement is further evidence of his negative experience. He mentions to Isabel that he feels surrounded by water, whether by sea or by a lagoon, he feels imprisoned. This set of negative situations linked to a deterritorialization

with the ulterior reconstruction of spatial references that end up by reposing the sociability. In other words, despite all, there are inherent advantages to the process. Haesbaert (2004: 250–251) argues that the deterritorialized who had the (relative) option of migrating gains a kind of "spatial capital," given that it furthers access to conditions, even recreation, of different territories.

In the case of *Cinco dias, cinco noites,* André goes through three stages in his migration course until reaching the border: the first, the escape from prison and arrival in Oporto, and meeting the intermediate Lambaça; the second when he visually transfigures and goes by bus to the place where he initiates the clandestine route; the third, when he goes with Lambaça through trails known only to smugglers and the like, until crossing the border. Although he has money to pay the fare, as well as extraneous expenses, the instability of the journey makes him skeptical as to the end. He goes through a set of negative experiences that shape the way he faces his mobility, instigating his own deterritorialization and his emotional proximity to home, belonging and nationality.

At the beginning of the first stage, André admits he was forced to emigrate, and that things are not as simple or easy as he initially thought. Later, in the second stage, when he travels by bus, he is approached by a farmer who recognizes that he is not a local but one just passing through and offers him food. This heightens the sense of the journey through the territory. During the trek on unknown trails, stopping in questionable houses, many times André asks Lambaça where they are and when the "passage" (to Spain) will take place. Often the answer is ambiguous. In the first house where they spend the night, André is uneasy at being the center of attention in an unknown universe—he feels he does not have the necessary information to understand how the migration course is developing. Only Lambaça knows the course well and has the necessary connections to provide the logical and social support to the journey. He operates through an organized network of smugglers, using a "special" language amongst themselves (e.g., signaling danger or its absence through launching flairs, what could be mistaken for celebrations in the villages around).

This set of apparently unfavorable situations for André become positive from multiple points of view. He is compelled to make quick decisions in the face of imminent danger. For example, he has to abandon the bus to avoid being discovered by the authorities. When he is supposed to travel in it again, the vehicle does not stop to catch him and he is alone in the road, in a place that he does not know at all. He weighs his options for moving forward or turning back. Although

The effort and acquired experiences were worth it, contributing to the edification of the migrant as a free person that has the (relative) possibility of choices for his migration destination.

Conversely, David has a setback when reaching the New York airport. His discovered fake documents force him to cooperate with the authorities and return to what he views as "exile." However, he does so with an apparent connivance and positive motivation. This circumstance comes from his affective attachment to Ana and, in a certain way, to the Azores territory, which he already knows and controls. The negative experience allows him to understand the importance of transparency and legality in bureaucratic situations of citizenship and nationality. He contacts Mike and John, the individuals who unjustly incriminated him, and based on a new set of valid arguments, convinces them to tell the truth. Such action enables him to ultimately access North America as a citizen, albeit it is the second time around. He wants to avoid a repetition of the negative experiences of the recent past. In so doing, at the airport he finds the information officer to the Repatriated Support Center of the Azores, who, in turn, alerts him to the danger of being discovered as an illegal immigrant in the United States and the distinct possibility of a definitive return to Portugal. The end result is positive for David and Ana in the context of the deterritorialization-reterritorialization cycle. The importance of a multiterritorial experience in two distinct territories is key for the understanding and (re)construction of the territoriality(ies) and of the individual/collective identity.

Reterritorialization and Multiterritorial Experiences

Haesbaert (2004: 258) synthesizes the idea that deterritorialization is not disassociated from its counterpart—reterritorialization—although it can be experienced in a different way by the subjects. It can either be understood in a positive or negative way, when the need of the individuals to (re)territorialize themselves comes from as extreme indispensability of adapting as a survival processes. Y-Fu Tuan (2008: 149–150) goes further, defending that "human beings have strong recuperative powers. Imaginaries can be adjusted to suit new circumstances. With the destruction of one 'centre of the world,' another can be built next to it, or in other location altogether, and in turn it becomes the 'centre of the world.'" Furthermore, João Luis Fernandes (2007: 9) states that the reterritorialization process can pass to a voluntary or involuntary strategy of ghettoization and spatial isolation,

David is deterritorialized in a country that is not his own, presenting an even more linear and classic vision of the process. By being expelled/deported, this character represents the reality of so many of his countrymen. The United States is the country in which their "identity" occurs, but they are not "citizens." They are legally Portuguese citizens. Thus, territorial domination in migration contexts differentiates very well between the informal (immaterial) belonging (of social, cultural perspective), and formal (material) belonging (power over the territory). The space-loving connection is important from an immaterial point of view (affective), but mostly from a material point of view (regularized citizenship situation).

In both films, the main characters initiate the deterritorialization processes in a negative way. In the case of *Cinco dias, cinco noites*, the exit comes from a need to escape; in *Duplo exílio* the arrival is mandatory, a legislative imposition that results in an involuntary migration. While not evident in the first case, in the second case by the end of the story, this setback in the mobility of the character results in a positive territorial experience. The deterritorialization process and ulterior reterritorialization forces a territorial experience that develops into an affective social-geographical connection to the Azores.

In this regard, Hélder Diogo (2012: 43–45) states that the territories linked to migration movements are simultaneously functional and highly symbolic, especially for the migrants that move in a context of multiterritoriality. This form of spatial comprehension allows a person to live in several territorial dimensions, resulting from past/present mobility experiences, and contributing to the experience of an own cultural essence, for a community and individual identity statement. In this last aspect, the films highlight commercial and restaurant activities, and their associated phenomena as good examples of appropriation and construction of (new) spaces that carry a strong cultural and identity meaning. Such a process leads to individuals with greater mobility, people with both real and symbolic multiterritorial experiences, both from the place of origin, the place of destination, and, eventually, other experienced spaces.

By the end of each movie, each character has experienced a set of negative processes, which, in turn has made possible a reterritorialization that resulted in a positive process. By crossing the physical border (river between Portugal and Spain), André feels he has reached the goal set for him: when Lambaça hands him his passport he gains his "new identity." Lambaça instructs him on how to reach the first Spanish village, where he can catch the train to Madrid or any place he desires, with the freedom he did not have in his country of origin.

retains both the legislative and executive power, while the individual has the eminent need of departure/return.

From the Negativity to the Positive Construction of (Re)territorialities

The apparent negativity of deterritorialization merits discussion. From the point of view of voluntary migrations, negativity results from counterproductive experience, for example, unfulfilled architectural expectations of the migration project (intended job, salary level, difficulties integrating into foster community, etc.), or with situations of mistake and work exploitation. It is possible to minimize the enunciated difficulties. However, they may well arise, marring not so much the reterritorialization itself but the way it is constructed. Thus, despite differences in time and geographical direction, the positive construction of the (re)territorialities brings the two films together.

Both directors' portrayal of the reterritorialization process launches the spectator into the universe of migratory difficulties. Each film presents a negative experience right from the start, and each provokes an interesting discussion about the relationship between home, belonging, and nationality. It must be said that the deterritorialization process is lived in different stages of the migration process. In André's case, it takes place while still in the original territory. Starting with his escape and moving to his arrival at the border, he progressively severs all ties with his native country. This is corroborated by scenes wherein he feels lost; he frequently asks to the intermediary Lambaça where they are. His affective and identity relations are severed at a national/regional scale. The escape takes place in the northeast, the *Trás-os-Montes* region. Although the reference is not evident, it is assumed that André is from Lisbon or another urban area, given how he responds to the profound rural space that surrounds him. His relationship with the landscape translates into an effective topophilial experience, leaving him deterritorialized in his own country.

This form of deterritorialization in situ is also felt in *Duplo exílio* by the character Ana. Despite being born and always having lived in the Azores, in S. Miguel, she feels deterritorialized, neither recognizing nor feeling any affective connection toward "her" territory. Both she and her sister Isabel are in a voluntary geographic confinement, and both manifest interest in leaving that place. Isabel returns to the mainland, where she was studying before her mother became ill, referring to it as the place where she had her first "true friends." Ana intends to go to the United States with David.

dias, cinco noites, the border protects him from the other side because it means freedom; however, it can be a threat because it takes him to an unknown world, a new life, even before departing. One must remember that this young man leaves the country for safety reasons to preserve his physical integrity, to avoid prison. He is a fugitive who has lost the right to study, to work, to be with his family and, at the time of the dictatorship regime (1926–1974), to be a free citizen in his own country.

In the film *Duplo exílio* the situation is different. David is a young man who, in an unexpected situation, is fooled by a fellow countryman and is convicted of a robbery that he did not commit, an incident that happened before the implementation of the 1996 Emigration Act. Consequently, he is forced to serve time in jail, to be sent back to his country of origin—Portugal (Azores)—a territory that is completely alien to him. This case of "classic" deterritorialization serves as a foil against Ana's case, a young woman David meets in S. Miguel and who is deterritorialized in situ because she does not identify with the cultural or social dynamics of the place where she lives. As discussed above, the relationship between territory and cultural identities results from material and immaterial factors. Ana's tangible (material) confinement is self-imposed, whether to the geography of the house or the lagoon. In an apparent opposition, she has no tangible confinement. The stories she reads are her literary geography and lead her to places with which she can relate.

Although representing similar phenomena regarding the space of origin, these two films represent two different experiences, that is, movements in opposite directions: in *Cinco dias, cinco noites*, André leaves Portugal, the country where he was born and with which he has a clear topophilic relation; in *Duplo exílio*, David returns to Portugal, the country where he was born and with which one would expect a natural connection. However, his "affective" geographic relationship with a territory is only with the United States, where he arrived when he was still an infant, and having further lived there during his childhood and his young adult life.

In *Cinco dias, cinco noites*, the territorial identity is Portuguese; in *Duplo exílio* it is North American. Both films have as a common denominator an imposed migratory circulation created by political reasons, but in different times—the beginning of the second half of the twentieth century and final half of the twentieth century, respectively. The competition for dominance that exists between individuals and territories can be precarious for the individual. Both movies state circumstances that directly determine the permanence and the institutional connection of the migrants to the territories. The territory

discussed herein. These two films deal with deterritorialization processes in the Portuguese emigratory context, focusing on the representation of the experience of departure and return. The movie *Cinco dias, cinco noites* portrays the life of André, a 19-year-old man, arrested for communist political activism. He clandestinely leaves Portugal, and reaches Spain (and probably France). Anabela D. Oliveira (2010: 78) considers this character as a representation of escape from the overwhelming geographic and social role of the border. While mainly of political character, André's escape takes on a social and an occupational framework, for it can be generalized to the migration movements from the era portrayed, given that it exposes the great motivation of other Portuguese who emigrated clandestinely at that time. The escape is from miserable living and working conditions, largely agricultural-based with the attendant low levels of household income. Later, many males left clandestinely to escape military conscription and participation in the colonial wars.

José Carlos Marques (2009: 41) refers to the development of a migration culture, based on a system of support values to ways of life with a strong inclination to emigration, that tends to positively frame the migration decisions of its members. Such a fact seems logical, given that the theory of migration networks emphasizes the fact that the maintenance and consolidation of certain migration systems occur because in the arrival territory there are groups of fellow countrymen, and a strong system of organization and solidarity that helps the migration of relatives and friends/acquaintances. Besides perpetuating the flow of individuals to certain destinations, such support systems also help to minimize the risks associated with the costs of the migration process. In the film *Cinco dias, cinco noites*, although not directly evident, this is exactly what happens. André is given the contact of the intermediary Lambaça, who teaches him how to survive in his new territory—the necessary journey taken to clandestinely leave Portugal. Probably he will have other connections abroad, benefiting from the support of someone or some group that takes place in the fostering process.

Haesbaert (2004: 251, 255) explains that many social groups can be deterritorialized in situ even without a clear physical dislocation, without levels of pronounced spatial mobility, experiencing a deterioration in the conditions of their lives. Bertrand Badie (1997: 54) argues that the territory also functions as a mechanism of safety: the border, the territorial scarring, they all become a source of protection. But the border is a two-edged sword. It protects from the enemy, and it creates the enemy, defining safety and creating insecurity. For André, in *Cinco*

Rhode Island, New Jersey, Connecticut, and Hawaii. Therefore, the movie *Duplo Exílio* presents a story that is a leitmotif for discussions of deterritorialization, as well any associated forced return to Portugal and its territories.

In parallel, this essay analyzes filmic representation of other geographic and social realities, including a second migratory cycle in the twentieth century that deeply scarred the Portuguese society from the 1950s onward, namely the European flow. Jorge Malheiros (2011: 141) argues that in the face of present Portuguese economic scenario, Portuguese migration movements may well increase in the next few years, particularly in the framework of European community circulation, wherever there exist social networks with intense socialcultural connections amongst its members and the original Portuguese territory. In this context, the movie *Cinco dias, cinco noites*, based on the homonym work of Manuel Tiago (pseudonym of Álvaro Cunhal), illuminates the movement of an "opposed geography" to the previous film, that is, the forced departure, by political reasons, of a Portuguese young man who is forced to emigrate clandestinely to another European country for his physical safety.

The Influence of the Space-Time Dimension

Rogério Haesbaert (2004: 339–340) defines territorialization as a relationship between domination and appropriation of space. Looking at departure movements, João Luis Fernandes (2007: 3) identifies deterritorialization as a form of "deprival of territory," loss of control, and domination over the personal/collective territorialities, in an evident reduction of access to economic and symbolic places, such as resources and housing, that constitute a structuring axis of a spatial identity of each group or individual. It completes and clarifies Haesbaert's (2004: 127) notion of deterritorialization as the movement through which a territory is abandoned. It becomes reterritorialization, the movement of constructing a territory. Anabela M. Oliveira (2011: 139) emphasizes that deterritorialization almost always implies the process of reterritorialization, gaining of affection, bonding with the territory, and consequently establishing a space-loving relationship. She further argues that deterritorialization is a breach in topophilia. The author concludes therefore that deterritorialization—reterritorialization works as a cycle, and topophilia is an evaluation criteria of this cycle (Martí 2006: 93).

Keeping in mind dynamics of the deterritorialization processes, one's attention is drawn to the notion of time-space in the two films

onward. However, this essay approaches only the twentieth century and the beginning of the twenty-first century, centering on the cinematographic representations of arrival and departure.

The films analyzed in this essay are representative of the twentieth-century Portuguese emigration, but equally important, they reveal migration movements in geographically opposed ways: in one case it is Europe; in the other the destination is North America. They are fictional portrayals of two of the most heavily used migration routes among Lusophone communities; they portray two of the most important and complex Portuguese diasporas. The first case—*Cinco dias, cinco noites*—concerns André, a young Lisbon inhabitant (presumed) who, for political reasons, intends to leave Portugal. He does this through a network of smugglers led by Lambaça, a smuggler famous for knowing the entire Portuguese Northeastern region. In the long border crossing, André comes across territories, paths, and characters of an impoverished rural country, surviving in an extremely repressive political regime. In the end, he clandestinely crosses the border toward Spain and probably France, as thousands of young Portuguese after him have done, escaping colonial war, ideological restraint, and poverty. In the second case, *Duplo Exílio* is the story of David, a North American of Portuguese descent who, by a great injustice, is deported to the region/country from which he came, the place he left as an infant to accompany his parents in migration, that is, the Azores/Portugal. Without knowing the language, completely disintegrated from a territory he does not know, he makes an acquaintance with two American women (sisters) who help him to return, albeit illegally, to the United States. In the end he accomplishes his return, but only after developing a multiterritorial mindset that includes both the society to which he belongs as a citizen, but is only recently aware of—Azorean, and the society he knows best but to which he never truly belonged—North American.

Maria Luis Rovisco (2001: 3) claims that the Portuguese emigration to the United States was very significant in the first two decades of the twentieth century, as well as later in the 1960s and 1970s. Unlike the intense migration flow to Brazil, which normally comprised individuals from the Portuguese mainland, the North American migration flow comprised many individuals from the Azores. This emigration torrent resulted from economic conditions highly unfavorable to a young active population, hence favoring the exit of thousands of Portuguese, many of them from rural settings and with low academic qualifications. The Portuguese communities in the United States concentrate primarily in only a few states: Massachusetts, California,

Within this context, Haesbaert highlights the primary connection between human beings and nature, emphasizing the relative power that the human condition imposes to the surrounding territory. However, it is important to note that despite this capacity of control, the established connection between both parties is not exclusively mechanical and utilitarian. Taking this into account, Rogério Haesbaert and Ester Limonad (2007: 49) argue that the territory can shape and be shaped by cultural identities, having an important role for the constitution and cohesion of social groups. This strong interplay between territory and cultural identities results from material realities, such as jurisprudent, economic and political factors, and from immaterial realities, such as culture and the set of values shared by the group. Migratory movement intensifies deterritorialization, defined as a loss of control over the territory, be it in legal or political matters (material) or symbolic (immaterial). It is a breach of the affective relationship with the everyday space, resulting in limited access to places that constitute the structuring axis of the space identity of each individual or group. This limited access generates instability toward the space, a domino effect, if you will, that may manifest itself in the reduction of the ontological safety of the migrant, of the identity matrix. João Luis Fernandes (2007: 3-4) observes a logic of understanding the process of deterritorialization as a setback, in the spatial optics of loss of access to the territory. He understands that this view implies also a way of "aggressiveness" regarding the feelings of topophilia (*topos* meaning place and *philia* meaning love), given that it has lost the affective connection between individual and space. Therefore, he corroborates the idea that this situation may generate a sentiment of loss, of ontological safety. Thus, the migrant feels the need to reconstruct his/her own identity (individual and collective) in a logic of reterritorialization, regarding the new spatial and social reality in the migration destination.

Deterritorialization as Topophilia Loss in Migration Context

It is pertinent to discuss the processes of deterritorialization in the Portuguese migration context, taking into account different regional and national cinematic views of the phenomenon. The matrix of population departure is a constant in the identity of the Portuguese population, with perhaps its first world projection in the sixteenth century, with the movements of maritime expansion in the American, African, and Asian continents, more specifically from the era of the Portuguese *Descobrimentos* (overseas discoveries and explorations)

processes and geographic and social facts that are not always evident from the perspective of scientific investigation. They do not replace scientific sources. However, they do constitute a great complement to corroborate, confirm, or dissect facts. In the complete absence of scientific sources, they might even be used as support to the construction of qualitative databases.

On the other hand, the approach of the director is important, for it is an individual point of view, a different approach based on a personal/collective interpretation. About this issue, Azevedo (2006a: 64) draws attention to the fact that filmic documents can potentiate or subvert our knowledge of places. For many, the geographical perception of the place, in large measure, is conditioned by the cinema. Many times the strategy of directors seems to be a juxtaposition of both scientific reports/fictional narratives with reality (Velez de Castro 2011: 965). Thus, from a local scale one can extrapolate to territories and individuals with common situations and problems. Consequently, film analysis has validity as a qualitative approach in the social sciences.

Indeed, both films analyzed in this essay reflect more than the drama of a forced arrival/departure. They also reflect the search for a foreign land, based on a deterritorialization process associated to a negative experience. The cinematic solutions are tinged with hope, which brings a new perspective to the discussion, the possible positivity of the reterritorialization process in a migration context. Such possibilities are based on the reconstruction of the migrant's individual identity; on his/her relation with the host society; and with the ability of interpretation, apprehension, and domain of the new territories, in a perspective of multiterritoriality.

Mobility and Territory: The Need to (Re)structure the Identity(ies)

From a geographical and social point of view, mobility is associated with the process of deterritorialization of individuals. This concept derives initially from the perception of territory in its more profound and intimate relation with the human being, which reflects not only visible activities of settlement through housing or work, for example, but seeks to reflect the establishment of affective bonds. Rogério Haesbaert (2004: 243) argues that territory is best defined as a conceived repetition of the movement of physical (environment) and human (society) elements. This repetition is understood as a kind of "controlled movement" and stresses the presence of a process of domination/appropriation that gives the space its function of expressiveness.

works for the analysis and discussion of this phenomena, portraying different times and spaces in the history and geography of emigration in Portugal. Two such examples are the films *Cinco dias, cinco noites/Five Days, Five Nights* (1996) by José Fonseca e Costa, and *Duplo Exílio/Double Exile* (2001) by Artur Ribeiro. The former deals with the clandestine departure of a Portuguese in the European context of the late 1940s; the latter deals with the return of the second generation of Portuguese-American immigrants to the Azores (late twentieth century, beginning of twenty-first century). The two films have common underlying circumstances. The main characters have a connection to Portugal, both are young, and their departure/return is forced.

As common questions regarding Portuguese migratory experiences surface in these films, several topics of discussion necessarily arise, namely, the macro-regional similarities and differences of the migration eras in analysis; the relation between the representations of home/belonging/nationality; and the restructuring of the individual identity based on the deterritorialization process in a context of departure and returning. Taking into account the way these works represent the challenges and opportunities placed by migration flows, our goal is to understand what are the cinematic solutions put forward by these films as they deal with similar/different Portuguese migration experiences.

Cinematic Representations of Departure and Arrival

At the outset, it is pertinent to present overarching ideas about the importance of the filmic documents in analyzing geographical and social phenomena. In her studies about geography and cinema, Ana Francisca Azevedo (2006a: 66–67) argues that any exploration of geography in a cinematic context must take into account the emerging cultural landscapes in contexts mediated by screen environments, shedding light on the incessant dynamics that occur between the individuals and the means they operate, as well as enabling the understanding of the new and complex spacialities. Elsewhere, Azevedo (2006b: 600) further points out that one of the great challenges of contemporary cinema is the way in which space and landscape are represented, stressing the need that many directors feel to break with saturated iconographies of more "commercial" cinema.

In works of fiction in cinema, two aspects should be noted. On the one hand, the storyline can supply a narrative about the dynamics of

4

Deterritorialization Processes in the Portuguese Emigratory Context: Cinematic Representations of Departing and Returning

Fátima Velez de Castro

Introduction

The dislocation of persons in migration is firmly situated in geography, given that there are at stake configurations of new territorialities associated with the migrant's need to rebuild social and spatial identities. Processes of deterritorialization by individuals are inevitable as are the ulterior affective experience with the place (*topophilia*). Deprival of the original territory and the loss of control and dominance of personal/collective territorialities generates this condition, in a clear reduction of the access to the place(s) that constitute the structuring axis of the space identity of each individual or group.

Thus, in many cases the rupture with the "original territory" and the integration in the "new territory"—deterritorialization and reterritorialization, respectively—often imply fractures and strenuous decisions, experiences that involve harmful, disturbing, painful dynamics. However, the foregoing is necessary for one to find his/her relative place within a space, providing the individual with a critical knowledge and the abilities that strengthen and expand it. The individual can thus (re)build his/her identity and understanding of the Other—something that would hardly be acquired any other way. In this sense, contemporary Portuguese cinema has produced important

Rougé, J. L. (2005) "A formação do léxico dos crioulos portugueses da África," *PAPIA: Revista Brasileira de Estudos Crioulos e Similares* 15: 7–17.

Sardinha, J. (2010) "Identity, Integration and Associations: Cape Verdeans in the Metropolitan Area of Lisbon," in C. Weston, J. Bastos, J. Dahinden, and P. Góis (eds.), *Identity Processes and Dynamics in Multi-Ethnic Europe*. Amsterdam: Amsterdam University Press, 233–256.

Siu, L. C. D. (2005) *Memories of a Future Home: Diasporic Citizenship of Chinese in Panama*. Stanford, CA: Stanford University Press.

Straw, W. (1991) "Systems of Articulation, Logics of Change: Scenes and Communities in Popular Music," *Cultural Studies* 5(3): 368–388.

Suárez-Navaz, L. (2004) *Rebordering the Mediterranean: Boundaries and Citizenship in Southern Europe*. New York: Berghahn Books.

Tinhorão, J. R. (1988) *Os Negros em Portugal*. Lisbon: Caminho.

Polyglot Cinema: Migration and Transcultural Narration in France, Italy, Portugal and Spain. Berlin: Lit Vertag, 173–192.

Forman, M. (2004) "Represent: Race, Space, and Place in Rap Music," in M. Forman and M. A. Neal (eds.), *That's the Joint: The Hip-Hop Studies Reader*. New York: Routledge, 201–222.

Forrest, J. (2003) *Lineages of State Fragility: Rural Civil Society in Guinea-Bissau*. Athens, OH: Ohio University Press.

Genova, N. de. (2010) "The Deportation Regime: Sovereignty, Space and the Freedom of Movement," in N. de Genova and N. Peutz (eds.), *The Deportation Regime*. Durham: Duke University Press, 33–65.

Gibau, G. S. (2005) "Contested Identities: Race and Ethnicity in the Cape Verdean Diaspora," *Identities* 12: 405–438.

Holston, J. (1991) "Autoconstruction in Working-class Brazil," *Cultural Anthropology* 6(4): 447–465.

———. (2008) *Insurgent Citizenship: Disjunctions and Democracy and Modernity in Brazil*. Princeton and Oxford: Princeton University Press.

Horta, A. P. B. (2001) *Transnational Networks and the Local Politics of Migrant Grassroots Organizing in Postcolonial Portugal*. ESRC Research Programme/Working Papers Transnational Communications [WPTC-02-03]. Oxford: University of Oxford.

———. (2008) *A Construção da Alteridade: Nacionalidade, Políticas de Imigração e Acção Coletiva Migrante na Sociedade Portuguesa Pós-Colonial*. Lisbon: Fundação Calouste Gulbenkian.

Laguerre, M. S. (1998) *Diasporic Citizenship: Haitian Americans in Transnational America*. New York: St. Martin's.

Lobban Jr., R. A. (1995) *Cape Verde: Crioulo Colony to Independent Nation*. Boulder, CO: Westview Press.

Narayan, K. (2010) "Placing Lives through Stories: Second-Generation South Asian Americans," in D. P. Mines and S. Lamb (eds.), *Everyday Life in South Asia*. Bloomington: Indiana University Press, 472–486.

Pardue, D. (2012a) "Cape Verde Kriolu as an Epistemology of Contact," *Cadernos de Estudos Africanos* 24: 73–94.

———. (2012b) "Cape Verdean Creole and the Politics of Scene-making in Lisbon, Portugal," *Journal of Linguistic Anthropology* 22(2): E42–E60.

———. (2013) "The Role of Creole History and Space in Cape Verdean Migration to Lisbon, Portugal," *Urban Anthropology and Studies of Cultural Systems and World Economic Development* (UAS) Special Issue on African Transnational Migration to Europe and the US 42(1–2): 95–134.

———. (2014) "From 'Improvised' to 'Social' Housing: Struggles over Space and Value in Postcolonial Lisbon, Portugal," in C. C. Yeakey (ed.), *Urban Ills and the Intransigence of Poverty*. Vol. 2. New York: Lexington, 229–252.

Raimundo, J. (1933) *O Elemento Afro-Negro na Língua Portuguesa*. Rio de Janeiro: Renascença Editora.

Rose, T. (1994) *Black Noise: Rap Music and Black Culture in Contemporary America*. Middletown, CT: Wesleyan University Press.

extension, as pondered by one youth in the film, "who is European?") and who is "other"?

NOTES

1. See Narayan (2010) and Siu (2005) for more theoretical exegesis and complementary ethnographic descriptions of emplacement.
2. For example, some scholars cite stories of precolonial occupations of Cape Verde as a refuge by the Jalofo tribe (Baptista 2002, Carreira 1972).
3. See, for example, *Nu Bai*, a 2006 documentary film by Otávio Raposo about rap in Lisbon neighborhoods dominated by Cape Verdean populations.

WORKS CITED

Arenas, F. (2012) "Cinematic and Literary Representations of Africans and Afro-Descendants in Contemporary Portugal: Conviviality and conflict on the margins," *Cadernos de Estudos Africanos* 24: 165–186.
Baptista, M. (2002) *The Syntax of Cape Verdean Creole: The Sotavento Varieties*. Amsterdam and Philadelphia: John Benjamins.
Batalha, L. (2004) *The Cape Verdean Diaspora in Portugal: Colonial Subjects in a Postcolonial World*. New York: Lexington Books.
Bousetta, H. (1997) "Citizenship and Political Participation in France and the Netherlands: Reflections on Two Local Cases," *New Community* 23(2): 215–231.
Brito-Semedo, M. (1995) *Caboverdiamente ensaiando*. Praia: Ilhéu.
Bull, B. P. (1989) *O Crioulo da Guiné-Bissau: Filosofia e Sabedoria*. Lisbon: Instituto de Cultura e Língua Portuguesa (Portugal)/Instituto Nacional de Estudos e Pesquisa (Guinea-Bissau).
Cardoso, A., and H. Perista. (1994) "A Cidade Esquecida: Pobreza em Bairros Degradados de Lisboa," *Sociologia: Problemas e Práticas* 15: 99–111.
Carreira, A. (1972) *Cabo Verde: formação e extinção de uma sociedade escravocrata (1460–1878)*. Lisbon: Centro de estudos da Guiné Portuguesa.
Challinor, E. P. (2008) "Home and Overseas: The Janus Face of Cape Verdean Identity," *Diaspora* 17(1): 84–104.
Connell, J., and C. Gibson. (2003) *Sound Tracks: Popular Music, Identity, and Place*. London: Routledge.
Davidson, B. (1989) *The Fortunate Isles: A Study in African Transformation*. Trenton, NJ: Africa World Press.
Duffy, J. (April 1, 1961) "Portugal in Africa," *Foreign Affairs*. Available at: http://www.foreignaffairs.com/articles/71625/james-duffy/portugal-in-africa (accessed January 3, 2014)
Eaton, M. (1993) "Foreign Residents and Illegal Aliens: Os negros em Portugal," *Ethnic and Racial Studies* 16(3): 536–562.
Ferreira, C. O. (2010) "Identities Adrift: Lusophony and Migration in National and Trans-national Lusophone Films," in V. Berger and M. Komori (eds.),

with strong Cape Verdean presence. However, language has a distinct role in spatial identification (Pardue 2012b), and *Outros Bairros* brings Cape Verdean Creole or Kriolu to the center of attention as both a code of migration and an aesthetic flow of rhythmic barbs.

Local use of Kriolu in Lisbon exemplifies what Nicholas de Genova (2010) has described as the conflict between an "autonomy of migration" and state sovereignty. Cape Verde was born out of an early creole formation involving Portuguese sailors, West African traders, and displaced Muslims and Jews migrating, by force and by choice, out of Iberia. Movement as part of an overall spatial recognition is an essential part of Cape Verdean practices of language and identity. Most recently, the Portuguese state and third-party real estate developers have provided another scenario in the long series of (dis)emplacement dramas for Cape Verdeans as Lisbon administrations have pushed to demolish improvised housing and regroup people into social neighborhoods.

The relationship between urbanization policies and urban experiences is a problem of agency, that life path of connecting self to recognized social structures. *Outros Bairros* shows the heterogeneity of migrant agency. Residents of places like Pedreira enjoy chatting about love, family, and relationships. They are disproportionately young and thus anxious about so many commonplace matters as formative rites of passage. Yet, they can't seem to shake the stigma of being an "other" from an "other" place, whether it is Pedreira or some other improvised place. Hardly complacent, youth have responded through a cultivation of a certain attitude, a sense of self that depends on expressive culture, a performance of self and group. Rap music fits well, and Liberdade and his cinematic partners are smart to include it in a "natural" way. They successfully capture the power of rap as a medium of experience and agency.

Outros Bairros is an artistic attempt to bring together two bodies of knowledge that rarely meet in any systematic way, migrant experiences, and migration policy. An integration of these two spheres of life is essential in understanding the relationship between identity formation and citizenship practices. Ultimately, the film is a representation of dis/emplacement, the process of being dislodged and the challenge to reinscribe oneself in the sociogeographic landscape. In this essay I argue that the creative montage of images and narrative of *Outros Bairros* are effective in conveying the persistent relationship between urbanism and urbanization, the frequently tense links between city experience and state/corporate development. The film is an engaging and beautiful combination of art and politics that asks the viewer to entertain the existential question: who is "Portuguese" (and by

the "spatial partitioning of race and the experiences of being young and black in America" (202). Rappers bolster their claims to authority and legitimacy by transforming vague notions of ghetto into sharp identity tales of the "hood." In popular culture the term used by practitioners and more recently employed by scholars that best characterizes the creative and competitive dimensions of locality is the "scene" (Connell and Gibson 2003, Straw 1991). Kriolu rap as a scene distinct from "Portuguese" rap (*rap tuga*) or Cape Verdean rap (*rap kaubverdianu*) depends on participants' belief and assertion of their identities as essentially linked to inhabited space. It is the popular, in this case rap music, which draws attention through the aesthetics of rhetoric and facilitates circulation in public presentations and information technology.

For Kriolu the efficacy of the scene depends less on commercial spaces of clubs and stores and more on the relative penetration into neighborhood community centers and the social ubiquity of streets. In this respect, Kriolu scenes contribute to the meaning of urbanization processes such as the transformation of improvised into social neighborhoods. *Outros Bairros* allows the viewer to feel the energy of such scenes.

Conclusion

Outros Bairros represents the complexities and contradictions of living experiences in the contemporary periphery of Lisbon by including a number of local voices. Furthermore, the film juxtaposes the condition of abandonment with the driving human force of occupation. Along the way, the viewer sifts through images of disposal, for example, small ceramic statues of Catholic saints, an umbrella, and other broken items on the floor. Demolition is a violent example of abandon and, yet, local residents continue to want to link these precarious and broken places with their identities. As one youth in the film remarks, "They think that when they demolish Pedreira that there will be no neighborhood anymore, but wherever we go (we can go to those *prédios* [set of residential buildings] over there you see in the picture), we will always be Pedreira... I will really miss this place but Pedreira will not disappear from who I am... that is why wherever these photos go, I will be there... so I can keep my memories strong... if they go under the bridge, I will go there."

What occurred in the late 1990s with Pedreira and continues today in places such as Bairro Santo Filomena (Pardue 2012a) is not solely a phenomenon of Luso-Africans or more specifically in neighborhoods

That contemporary European citizenship involves a tense relationship between inclusion and racial differentiation is, of course, not unique to Portugal. As Suárez-Navaz (2004: 7) explains, the rapprochement of Spain with Europe in the 1980s transformed what had been previously a general alliance along class lines between working-class Andalusians and African immigrants into a racialized difference marking the latter as a suspicious group of "foreigners" and "illegals" thereby constituting Andalusia as a "Mediterranean border" between Europe and Africa as well as between democratic modernity and dangerous traditionalism. However, unlike the situation in southern Spain, the move toward a "naturalization of difference" in public practices of hegemony, for example, documentation regulation, and behavior, has been rearticulated to a certain degree by Kriolu negritude and local neighborhood politics. This is despite the fact that xenophobic racism in Portugal carries significant heft in Portuguese politics, as represented in national parties of the right-wing populist CDS-PP (Democratic and Social Center—People's Party) or even more radical in the PNR (National Renovator Party).

Whereas in Spain Senegalese migrants employ the qualifier of "Muslim" to place themselves legitimately in Andalusia as part of regional histories and, indeed, "migrant to take part in the 'Andalusian collective memory'" (Suárez-Navaz: 81), Cape Verdean youth purposefully mark themselves as Kriolu and thus not as part of Luso-tropicalist history of hybridity and quasi-Portuguese status, but as transnational African residents who shape the present Lisbon. In *Outros Bairros*, rapper Praguinha implies as much when he states, "*Nu é pretu. Ka é Tuga. Fuck that*" (original in Kriolu, translation: "We are black [and] that's not Portuguese. Fuck that"; the English phrase is left untranslated).

IDENTITY AS A SPATIAL FORMATION

Space is central to notions of value and power. In her oft-cited ethnography of hip hop culture, Tricia Rose (1994) linked the power of rap music to black youth's response to and reshaping of the "postindustrial city" in the late 1970s. More germane to Kriolu emplacement, anthropologists Laguerre (1998) and Gibau (2005) have made the case that Haitian and Cape Verdean diasporic communities in New York City and Boston, respectively, have forged identity through the "materiality" of the neighborhood exemplified by the corner store.

In his scholarship on rap music and territoriality, Murray Forman (2004) has argued that rappers are experts in analyzing and popularizing

[borrowed]." A jump edit to another Cape Verdean youth. "Angolans began to speak Portuguese [and stopped speaking Kikongo and a host of other Bantu family languages]...I speak Portuguese. I also speak my language, Cape Verdean [*Kauberdianu* or Kriolu], that's it man." Rapper Carlón taps his foot "Cape Verde are our islands...they're ours...see this ground, it may be in Portugal but it is also part of Cape Verde."

The dramatic climax approaches. The viewer sees images of a man packing things, appliances, bed linens. The viewer confronts scenes of abandon. The screen fills with images of demolished corrugated metal, cement structures, and a return to resident profiles, frames of apparent solitude. The film returns to the group of young men in cyphers. The sound consists of trains, traffic, machines, rap music, and cypher chatter. Then the demolition takes over, and the long-expected antagonist shows its face, as men arriving with sledge hammers and machines occupy the screen.

The film does not end here. Youth agency emerges, and history reasserts itself, as struggle marks the final act. A stiff breeze, an ever-present sound in Lisbon, acts as a strong head wind in the face of two former residents. They look across a valley and see their disappearing neighborhood. The sun sets; a young man extends his arms like wings and imagines. Residence once again emerges as a challenge of emplacement.

The viewer is left with the film credits and a return to the graphic design of typography and the contrast of red and white. After the credits are accompanied by a recording of improvised kriolu rap, the final thirty seconds show a black screen, and the viewer hears the sounds of a Lisbon breeze. The end.

Context: Identity and Space

With a sense of the historical context, structure, and content of *Outros Bairros*, I address more substantially the theme of place and emplacement. Certainly, the relationship between space and identification has been a frequent and productive topic of scholarship and public policy. In the European context, scholars have approached the issue of immigration and city space in terms of collective action and sociopolitical agency (Bousetta 1997, Horta 2008, Sardinha 2010, Suárez-Navaz 2004). In Portugal, as Horta explains, such grassroots politics around space and identity are relatively new because terms such as multiculturalism, interculturality, and ethnic minorities (often glossed as *Lusofonia* or Lusophony) emerged only at the end of the twentieth century.

building up their attitude for an *encontro*, a competitive meeting and hangout of rappers and DJs across Lisbon. The viewer visits former Pedreira residents, traveling from south to northside, from Pedreira and Arrentela to the neighborhood of Pontinha.

The filmmakers show that these displaced youth are agile in thought just as they are mobile in transport. They are all looking to stretch a bit, expand their sense of self, and consolidate their position at home. Yet, we/they are not completely free subjects. In this short section of the film, as the viewer returns to Pedreira, the youth discuss the terminal conditions of death and are faced with an impending loss of place, a material change imposed by outside forces. "Everyone here is prepared for death, but that doesn't mean we are consumed by violence... there are, of course, disagreements, family differences, we lack things... but there is not the aimless violence as it is portrayed out there [in the media]." Pedreira is being demolished. The film moves back to still portraits of landscape, accompanied by narration in Kriolu.

Despite it all, youth improvise. Despite it all, people occupy. *Outros Bairros* becomes more performative in its representation of social agency and its connections to emplacement. In the following scene the viewer witnesses Praguinha performing the beatbox with his rapping partner Carlón. Using his mouth and chest in rhythmic patterns and various resonant timbres, Praguinha animates the cinematic frame, ambient straight lines of improvised doorways, set up by Gonçalves, the director of photography. The film transitions quickly to scenes of alleyways, young men sitting around, acting brash swaying back and forth, mouthing the words to a song by Redman, an influential rapper from Newark, New Jersey, emblematic of the so-called East Coast style featuring hard-hitting lyrics with a flair for the funny and ridiculous. Just as Redman often rapped about being from "Brick City," the audacious Lisbon youth construct their identities out of the literal rubble in the Pedreira landscape. The viewer eventually arrives at a party scene. The community comes together to celebrate the final days. They know their days are numbered in Pedreira.

Towards the end of *Outros Bairros*, the directors address the issue of place directly in a documentary style of interview. Metaphors of place and ludic sequences of travel and performance all aside, director Kiluanje Liberdade goes straight to the issue of life as an immigrant in Portugal. He elicits the following from Carlón: "I wish we had never left... in both Cape Verde and Lisbon life is hard... being Black, we get even more stigma." In another scene, Jorginho addresses Liberdade, who is Angolan, "You have no culture, your culture is *emprestada*

viewer can see behind her the modern architecture of late twentieth-century Lisbon urban renewal not too far in the background. The image, however, is not a still. She fidgets, she looks away, she doesn't speak. Her boyfriend (mentioned above in the essay's introduction) approaches. He poses, he whispers in her ear, she gives a look of disapproval. They exchange some inaudible words, and he leaves the scene. She still does not speak to the camera.

The inaudible themes of the previous frame are amplified and move to the center in an extended scene with two teenage girls lying down, side by side, facing each other. They talk about relationships, the wavering responsibility felt by young men toward their partners, pregnancy, often leading to abandonment. "What do I feel? You think he was the ONLY ONE...you learn later what will happen [if you think this way]." The viewer sees Jorginho, a central figure in Lisbon rap, sitting alongside his girlfriend. She dominates the conversation and asserts that men and women have "our own [separate] *business*" (business left untranslated).

What is love? An interesting and perhaps unexpected question, given the film's opening and the tendencies of periphery representations in global cinema. Does love exist for those who live in a "culture of poverty"? What is fidelity? What are the expectations of young migrants? The viewer sees Chullage discussing fidelity with a friend. They sit on the floor, bow their head, and wait for a turn to speak their mind. The sequence shows that marginalized youth faced with residential demolition are, indeed, capable of reflection on the personal philosophies about existential questions of love and relationships. They are not unidimensional waifs who see the world solely in pragmatic terms of survival, territory, and lust. For the most part, the protagonists of *Outros Bairros* enjoy this line of questioning as they can take a short break from the demands of space and place. For better or worse, much of their identity (as it is with anyone) is entangled in the relative values of location. This, of course, is the tension of the film, a demolition of place, a rupture of self and collective imposed from the outside against the will of the community.

At the mid-point of *Outros Bairros* the scene moves away from a survey of youth perspectives on relationships to a ludic sequence that foregrounds place. The viewer takes a ride with Chullage and friends from the southside or *margem sul* on the ferry to Lisbon proper, across the Tagus River. Out of Pedreira and away from the demolition of improvised neighborhoods and away from the stale confines of the social neighborhoods. Surrounded by a mix of rain, windshield wipers, and jazzy French rap, the passengers stare out the window,

and larger than life. Easily read, sans serif type, the words suddenly crowd out the screen, perhaps a gesture to the haphazard intervention of state-sponsored demolition. The title typography foreshadows the dramatic antagonist against which the young protagonists struggle to speak.

In the still photography the boys show the viewer a range of expressions from serious scowls to youthful laughter to confident attitude. At the one-minute mark the viewer sees Praguinha, who would become part of the successful and provocative rap duo Nigga Poison. Praguinha is one of the many protagonists who give testimony to the demolition of their ex-neighborhood Pedreira dos Húngaros. The demolition and precarious life in this neighborhood along with Bairro Santa Filomena, Porto Salvo, Arrentela, Almada, and Pontinha mark the dramatic focus of the film.

By minute three the lens widens and the viewer starts to see the landscape of disappearing neighborhoods. The images remain still photographs but now capture movement as kids play and repurpose the shambles around them. The first moving images are of two uniformed Portuguese police officers shoving the camera to the ground and demanding that the filmmakers explain what they filmed. A debate on rights ensues, and the viewer is left feeling upside-down, looking at a group of legs in denim swinging back and forth.

Bang. It is time for the residents to speak. They speak with their visibility. Everyone is out, walking, riding bikes, zooming past neighborhood rubble on motorcycles. The sunlight, a sharp beam so typical of Lisbon afternoons, overexposes clouds of smoke bellowing out of kids' mouths. Teenagers smoke *pólen*—rolled cigarettes filled with marijuana, hashish, and tobacco. Hardcore rap in English, Portuguese, and Kriolu accompanies the action. Subsequently, the film settles into a few interviews, mostly in Kriolu. The theme is respect or lack thereof in the daily life of a kid from these parts. They struggle to escape the stigma of being gang bangers and in general, the category of the "Other."

The filmmakers, particularly Liberdade, intentionally did not want *Outros Bairros* to be a ghetto flick featuring solely scenes of violence and racism. The idea was to explore as much as possible the heterogeneity and the experience of otherness. PALOP and Cape Verdean migration and emplacement is not just about squalor. For example, approximately at minute ten of the film, the viewer sees a young woman standing next to an improvised shack, a one-room abode made of corrugated metal. What sorts of feminine voices constitute periphery daily life? The young woman's pose is intentional as the

variety of otherness, the directors deploy the tactic of contrast: ludic performance alongside topic-oriented interviews linked by transitional scenes of movement or conduit, for example, shots of alleyways, cars moving across town, machines in demolition mode, and so on. The lessons of this film pertaining to postcolonial living conditions, migration, and youth agency come through in tones and hues. Underlying all of this is a historicity of migration central to what it is to be Portuguese or almost Portuguese.

As mentioned in the introduction to this essay, *Outros Bairros* relies significantly on rap music to achieve its aesthetic and political goals. The director, Kiluanje Liberdade, did not employ sound conventionally as part of a "soundtrack" per se, nor is the film *about* rap in Lisbon or Cape Verdean rap.[3] Rather, the music helps constitute an everyday design of life in the Lisbon periphery. Rap flows from a local setting, from experience, migration, and displacement—it is translocal. For example, the viewer observes Chullage, a contemporary Lisbon rapper, who rose to popularity in the years following *Outros Bairros,* chatting with his buddy as the scene transitions into a listening session. One chair with a boombox, double-tape player, eight young men sitting on a dirt floor in Pedreira dos Húngaros (referred to below as simply "Pedreira"), an improvised neighborhood in the middle of the slow, gradual process of demolition. In the ensuing months they would relocate to state-sponsored project neighborhoods such as Arrentela and Boba. The young men are listening to an early recorded rap song by Chullage. A smooth visual shift and the viewer is inserted into a cypher as young men pass around blunts (tobacco leaves filled with marijuana) and then rhyme about daily life, about surviving in a society where they are not recognized or only seen as thugs, where police hound them, where no one trusts them in the most basic social settings. What is the syntax of these images and sounds? How might we describe daily life in the Lisbon periphery? Let us start from the film's opening.

Annotated Film Synopsis

The film begins with urban noise, street chatter, and a series of black and white stills. The viewer confronts portraits of youth, mostly teenage boys of Cape Verdean descent, posing in front of improvised housing. A color flash, a creative bit of typography with the name of the film company (Tejo Filmes) and the name of the film *Outros Bairros,* constitute this opening segment. An aesthetic exercise in size and sequence, the letters and words appear partially out of the frame

standardized design, featuring clustered apartment buildings around a central square with accessible streets of commerce, which provide basic services of groceries, baked goods, cafés, popular restaurants, clothing, hardware, and household items.

"Social neighborhoods," first established in 1918, essentially are villas on a larger scale. After World War II, migrants from the countryside met significant groups of Cape Verdeans, and to a lesser extent Angolans and Mozambicans, and remade Loures, Seixal, and Amadora, areas adjacent to Lisbon, into large residential suburban cities with significant pockets of "improvised" settlements. In the 1950s the Salazar regime began to address housing through a reinvestment in social neighborhoods to combat the surge of "clandestine neighborhoods" and informality outside of the municipality proper (Eaton 1993, Cardoso and Perista 1994). The implementation of subsequent laws around residential property contributed to a stigma levied against those in autoconstructed communities. The stigma of informality intensified after the implosion of the fascist regime and the concurrent independence movements in Lusophone Africa in 1974 (Horta 2001). *Outros Bairros* focuses on those moments before the ultimate destruction and represents this transitional moment as an opportunity for dramatic performance and thoughtful reflection on dis/emplacement.

The film was made during the early period of PER (Special Program of Relocation), a project initiated in 1993 sponsored by the Portuguese state and European Union agencies to eradicate the *bairro de lata* (corrugated metal neighborhoods) from Portugal's main cities of Lisbon and Oporto by the year 2000. Hardly finished or resolved, the PER project as part of a larger campaign to standardize housing in Lisbon continues until today and remains a presence in the lives of mostly migrant families, as they try to make their way in postcolonial Portugal during a particularly difficult time of economic recession. The turn of the twenty-first century was a high watermark for Lisbon's urban renewal project to eliminate improvised housing as well as a boom period for an emerging local rap scene, especially among Cape Verdean migrant youth who featured a captivating urgency in their Creole or Kriolu speech.

Similar to Costa's representations of Lisbon's periphery, *Outros Bairros* explains very little of this convergence of contemporary migration, urbanization, and expressive culture in Portugal's capital city; instead, it *represents* experience. *Outros Bairros* is a document of the art of life, everyday scenes of youth on the periphery of a city in a peripheral country in contemporary Europe. Intent on showing a

romance, these films treat identity and place as either a memory of what could have been or a temporary hurdle to the true Portuguese spirit of Luso-tropicalism, a set of myths celebrating Portuguese colonialism and postcolonial society as exceptionally "congenial" and "open" to difference regarding particularly black African subjects. As an important aside, *Nha Fala* along with other films depicting Luso-African and Luso-Brazilian multiculturalism were supported by the CPLP (Community of Portuguese-Speaking Countries) in a gesture toward Lusophony.

The most direct cinematic comparison for our understanding of *Outros Bairros* are the films of the critically acclaimed Portuguese director Pedro Costa, discussed in chapter 2. Specifically, in his trilogy of films depicting daily life in the Lisbon periphery during the late 1990s and early 2000s, Costa effectively captured migration, youth, class, and displacement as a struggle for recognition burdened by the stigmas of racism and *machismo*. The viewer takes on a gaze that penetrates the neighborhood of Fontainhas through discourses of personal frustrations and machines ripping gradually at the precarious residential infrastructure. Through long scenes of intimacy, the viewer occupies the perspectives of local perpetrators of sexual violence and masochistic intravenous drug abusers. Costa's representation of the increasingly visible scenes of marginality in the Lisbon metropolitan area unfolds as a depressing and addictive banality through the intense images of sustained stares and the jarring sounds of buses and stray dogs.

Despite his anthropological approach to casting and set production, Costa does not explain otherness or urban renewal in his triptych, which includes *Ossos/Bones* (1998), *No Quarto da Vanda/In Vanda's Room* (2002), and *Juventude em Marcha/Colossal Youth* (2006). Rather, as an aesthete, Costa imposes a sentiment of marginality. The role of Cape Verdeans and Kriolu is fleeting, a few sexual and moral encounters for the main actors to negotiate. In *Colossal Youth* Costa does focus more on movement than squalor and the struggle of internal, intraurban migrants to achieve place. For the most part, Costa privileges class over race and thus holds Kriolu at a distance (Arenas 2012).

Outros Bairros contributes to an understanding of the Lisbon periphery by expanding our notion of social agency produced under extenuating circumstances of forced migration internal to the city. Such a move is common in postcolonial Europe, as millions of people are in transition from an improvised place of autoconstruction (Holston 1991, 2008, Pardue 2013, 2014) to a space of standardization, the housing project or what in Portugal is termed the "social neighborhood" (*bairro social*). The social neighborhood is a

range of established African languages. This presented a special problem and opportunity for the Portuguese as they desperately tried to maintain their colonial ties to Africa in the twentieth century. Jacques Raimundo (1933), a Portuguese scholar of education, writing in the early years of the Salazar-Caetano regime, identified language instruction as an "adept instrument" (*hábil instrumento*) of Portugal's "soft conquest" (*conquista suave*). In his short dissection of what he called "pretuguês," a neologism mixing "*preto*" or "black" with "*Português*" or Portuguese, Raimundo makes a case of Portugal's "vocabulary patrimony" and with it a cultural accompaniment to the "civilizing" process involved in African colonialism (Duffy 1961). In this respect, "black manners" of speaking Portuguese were thoughtful "imitations" of "culture." Cape Verdeans thus became black, semi-acculturated Portuguese and useful as strategic intermediaries between Portugal forces and presumably wholly "other" people, such as the various "tribes" of Bantu speakers (Kimbundu, Kikongo) of modern day Angola, Congo, and Mozambique. In opposition, through the decolonization wars of the 1960s and 1970s leading up to the regime changes of 1974, populist leaders in Cape Verde and Guinea-Bissau significantly highlighted *Kriolu/Kriol* as essential to a resistant cultural nationalism.

CINEMATIC REPRESENTATIONS OF CREOLE AND MIGRATION

This brief historical review shows that Cape Verdean and Portuguese identities developed around migration, encounter, and place, a set of themes made present in relations of interdependency. Moreover, Kriolu became a unique code of mediation that distinguishes Cape Verde from other Luso-Africans. This has remained true in the transition from colonial to postcolonial life. *Outros Bairros* addresses the aesthetics and politics of such a transition and distinguishes itself as unique within the milieu of Portuguese cinematic production.

As discussed by Carolin Overhoff Ferreira (2010: 184), Portuguese cinema has paralleled prevailing histories of migration and has focused on Portuguese emigration to other European locales or the United States rather than immigration and postcolonial realities of the New Europe. The topic of PALOP daily life and the peculiar medium of Kriolu is even rarer. Some exceptions include: *Fintar o Destino/ Dribbling Fate* (1998), *Zona J/J Zone* (1998), *A Esperança está onde menos se espera/Hope Is Where You Least Expect It* (2009), and *Nha Fala/My Voice* (2002). Through the topics of soccer and ill-fated

islands. But in those islands I have discovered a world" (quoted in Davidson 1989: epigraph). What is this "world" of Cape Verde? What could there possibly be in this small scattering of islands off the coast of Dakar, Senegal, that might influence identity, culture, and politics in Portugal?

Part of the world of Cape Verde that over time would constitute the emplacement practices of Cape Verdeans in Lisbon highlighted in *Outros Bairros* is evident in the language-identity term, Creole or *Kriolu*. While there are hypotheses that precolonial culture and society existed on the islands,[2] most scholars and Cape Verdeans purport that Cape Verde and Kriolu resulted from early Portuguese colonialism and creolization, a systematic process of mixture and displacement (Challinor 2008). Interpreting documents from the Catholic church and trade reports, Brazilian scholar Ramos Tinhorão (1988: 47) explains that the early slave trade by the Portuguese went back as far as the fourteenth century with trading locations on Rua Nova in Lisbon. More specifically with regard to Cape Verde, Tinhorão discusses the historical documentation around what many Portuguese children learn in school, the year of 1444 and the first four officially documented slaves to be brought from sub-Saharan Africa, namely Senegal and Cape Verde, to Portugal under the direction of Dinis Dias. Over time, this Creole formation afforded Cape Verde a distinct place in the *imago mundi* (world image) of the Portuguese.

Kriolu as a language and identity originated with migration and dis/emplacement in the fifteenth century of *lançados* in Guinea-Bissau and the parallel process of *ladinização* in Cape Verde (Rougé 2005). The term *lançado* refers to one of the results of the Inquisition in Iberia, that is, a cleansing or throwing out (the Portuguese verb *lançar*) of Jews and Muslims (Forrest 2003, Lobban 1995). In addition, expulsion also took place voluntarily in subsequent generations, as mixed race men, the offspring of white Portuguese tradesmen and black slave women, left Cape Verde and relocated in Guinea (Bull 1989). Subsequently, they became an integral part of the petty bourgeoisie in coastal economies. While occasionally at odds with the Portuguese, these *lançados* actually linked the Portuguese via Cape Verde, their archipelago colony, with a sizable territory of West Africa (Batalha 2004: 22–23). The latter term, *ladinização*, marked the process by which slaves in Cape Verde were inculcated into Catholicism, the Portuguese language, and basic, manual labor skills (Carreira 1972, Brito-Semedo 1995).

Cape Verdeans are unique in the history of European colonialism because their lingua franca was already a hybrid with Portuguese and a

play a particular role in this landscape of postcolonial Europe and the accompanying forms of inclusion and marginalization.

Through a mixture of cinematic and textual deconstruction, Luso-African historiography and an interpretation of contemporary housing politics, I discuss the film *Outros Bairros/Other Neighborhoods* (1999) as a successful representation of tension and transition in Portuguese society. More specifically, I argue that "place," and more actively "emplacement," are effective theoretical positions from which one can appreciate the mixture of social stigma and social agency.[1] The film employs the power of Cape Verdean Creole rap as a sound track and in the process transforms the viewer from a voyeur into a witness. *Outros Bairros* is a robust document of reality as well as a sensitive piece of aesthetics. Coincidentally, as part of my research with Cape Verdean migration and Lisbon rap communities, I have interviewed several of the protagonists of the film since 2007. Their insights on contemporary life in Lisbon and memories of migration through Kriolu complement my interpretation of *Outros Bairros*.

As the title makes explicit, *Outros Bairros*, directed by Kiluanje Liberdade, Vasco Pimentel, and Inês Gonçalves, is a film about the management of "otherness" in urbanization projects. Exploring the dynamics of the improvised residential landscape of Lisbon, the filmmakers mix visual art and ethnographic storytelling in an account of demolition and urban renewal. In the film there is a recurring character who appears suggestively as an enigmatic boyfriend and a disinterested youth. His comments on the Cape Verdean presence in Lisbon hang over the film and frame the basic sociological point of this article. "When Cape Verdeans are in a group, we are perceived as 'danger'...it is natural to them that we have just committed a crime...Look, here [in this neighborhood on the brink of total demolition] we are families. We come together. It's about pleasure." The scene morphs into a series of memories about the *bairro* and people related to it through photos, girls, friends, and family members. "He's in Cape Verde now, she's my sister." Knowing the end is near, the remaining residents invest in activities to remember that which will disappear and those who have left.

Luso-African Historiography

In his poetic and reflective book on Cape Verdean independence, the acclaimed British historian Basil Davidson opens the text with a quote from Nobel Prize Portuguese author José Saramago: "As for the Old Discoverers, I think my name should be added to theirs, and with better reason if modesty allows. For they discovered a handful of deserted

3

OUTROS BAIRROS AND THE CHALLENGES OF PLACE IN POSTCOLONIAL PORTUGAL

Derek Pardue

Standing at the cliffs of Cape Vincent near Sagres, Portugal, the center of navigation studies during the fifteenth and sixteenth centuries, it is easy to imagine that one is at the end of the world. The constant gale above the seas acts as a repository of history recording and archiving the journeys of Iberians, Europeans, and Africans at this westernmost point of Europe: a beacon of modernity on the threshold of discovery. Portuguese history is in great part a narrative about "civilizing" encounters abroad and the cultivation of national character through such meetings in far-flung locales.

By the end of the twentieth century, Portugal became a significant destination of labor and refugee immigration and less of a departure point of emigrant workers and cosmopolitan explorers. Portugal, similar to the rest of Europe, has experienced a complex series of immigrations since the 1960s and has attempted to restructure its policies around urbanization and citizenship. For example, during the 1960s, the Salazar-Caetano regime (1932–1974) gave incentive to companies involved in urban infrastructure development. These companies actively recruited Cape Verdeans to replace Portuguese nationals who had left for Angola and Mozambique in efforts to maintain Portugal's African colonies during the decolonization/independence wars (Batalha 2004). After 1986, when Portugal entered the European Union, a more diverse wave of migrants entered Lisbon with a strong Cape Verdean presence but also including Brazilians and, more recently, various East European nationals. Residents with heritage from the former African colonies or PALOP (African Countries with Portuguese as the Official Language), especially those from Cape Verde, an archipelago 350 miles west of Dakar, Senegal,

RDP—África (September 6, 2013) Henriques, C. (journalist). "Entrevista RDP—África: Pedro Costa." Lisbon: Radio Difusão Portuguesa—África. Available at: http://www.rtp.pt/play/p389/e127883/entrevista-rdp-africa (accessed December 2, 2013).

Rego, M. (2009) "Cape Verdean Tongues: Speaking of 'Nation' at Home and Abroad," in L. Batalha and J. Carling (eds.), *Transnational Archipelago: Perspectives on Cape Verdean Migration and Diaspora*. Amsterdam, NLD: Amsterdam University Press, 145–159.

Suchenski, R. (2010) "'1000,000 Cigarettes': Pedro Costa's *Colossal Youth*," in B. Ildong (ed.), *The Cinema World of Pedro Costa*. Jeonju: Jeonju International Film Festival, 270–283.

countries at the time. This lack of nonskilled workforce was aggravated by the army compulsory draft of young men to fight in the colonial/liberation war(s) until 1974 (Figueirinhas 2011: 10, Arenas 2012: 168).
9. As suggested by the filmmaker during a masterclass organized by the Birkbeck Institute for the Moving Image (London), in January 2014.

Works Cited

Arenas, F. (2010) *Lusophone Africa: Beyond Independence*. Minneapolis, MN: University of Minnesota Press.

———. (2012) "Cinematic and Literary Representations of Africans and Afro-Descendents in Contemporary Portugal: Conviviality and Conflict on the Margins," in *Cadernos de Estudos Africanos*, 24. Lisbon: Centro de Estudos Africanos—IUL, 165–186.

Berger, P. (1949) *Robert Desnos*. Paris: Seghers.

Cabo, R.M. (2009) *Cem Mil Cigarros, Os Filmes de Pedro Costa*. Lisbon: Orfeu Negro.

Câmara, V. (1995) "Convalescer na Ilha dos Mortos," *Público* (supplement *Zoom*) Issue no. 1799: 2–4.

Corless, K. (2008) "Ace Ventura: King of the Quarter," *Sight & Sound* 18(5): 12.

Costa, P. (July 2, 2012) Personal interview, Lisbon.

Elsaesser, T. (2005) *European Cinema: Face to Face with Hollywood*. Amsterdam: Amsterdam University Press.

Ferreira, F. (2006) "Guarda a minha fala para sempre," *Expresso* Issue No. 1778:14–17.

Figueirinhas, R. (2011) *Bairro, identidade, interacção: Um olhar etnográfico sobre o Centro Social do Bairro 6 de Maio*. Unpublished master's thesis, ISCTE—Instituto Universitário de Lisboa.

Guimarães, R. (1995) "Entrevista com Pedro Costa e Inês de Medeiros," *A Grande Ilusão—Revista de Cinema* Issue no. 18–19: 66–75.

Hall, S. (1999) "Cultural Identity and Cinematic Representation," in T. Miller and R. Stam (eds.), *Film and Theory: An Anthology*. Malden, MA: Blackwell Publishing, 704–714.

Lemière, J. (2009) "Terra a Terra: O Portugal e o Cabo Verde de Pedro Costa," in R. M. Cabo (ed.), *Cem mil cigarros: os filmes de Pedro Costa*. Lisbon: Orfeu Negro, 99–111.

Luz, N. (1994) "Estou desgostado com Portugal," *Diário de Notícias* Issue no. 45715:29.

Meintel, D. (1984) *Race, Culture, and Portuguese colonialism in Cabo Verde*. Syracuse, NY: Maxwell School of Citizenship and Public Affairs, Syracuse University.

Neyrat, C. (2012) "Conversa com Pedro Costa," in P. Costa, C. Neyrat, and A. Rector (eds.), *Um Melro Dourado, um Ramo de Flores, uma Colher de Prata: No Quarto de Vanda, Conversa com Pedro Costa*. Lisbon: Midas Filmes and Orfeu Negro, 9–21.

I would also like to acknowledge the assistance of the Portuguese Cinematheque, which granted me access to documentation related to *Casa de Lava*.

Notes

1. Pedro Costa's first feature film, *O Sangue/Blood*, was released in 1989.
2. This essay uses the title *Casa de Lava*, adopting the title of the most recent international DVD release of the film (by Second Run in 2012). All other titles appear in English.
3. As the other citations from Portuguese articles used in this essay, this is a translation made by the author.
4. Cape Verde was not the first location of the film. In a personal interview with the author, Pedro Costa points out that an initial idea for the project was to film it in the Atlantic islands of the Azores, with a volcano in the island of Pico. This location indicated by Costa was in fact preceded by another, which is specified in an early script treatment of the film, titled "Quando ninguém olhar por mim" (When no one looks after me) (1991). In this document, while the adaptation to Tourneur's film is evident, the film's narrative is placed in continental Portugal, in a location far more connected to the scenery of *Blood*.
5. The 1990s in Lisbon were particularly demanding in terms of construction workforce, with the long process of rebuilding part of the city's downtown, destroyed in 1988 by a massive fire. Moreover, and partially due to the infrastructures of the 1998 Lisbon World's Fair (Expo '98), major construction projects were underway throughout the city, with the subway expansion, the construction of the Vasco da Gama Bridge, and the urban expansion to the east-end of the city, where the Expo '98 grounds were to be located.
6. "Lettre a Youki," reproduced in Pierre Berger's *Robert Desnos* (1949). The version used in *Casa de Lava* and later in *Colossal Youth* is partially reproduced on the cover of R. M. Cabo's *Cem mil cigarros: os filmes de Pedro Costa* (2009). An English translation is presented in the catalogue of the retrospective of Pedro Costa's work at the Jeonju International Film Festival in 2010 (Jeonju: JIFF, 2010).
7. Despite the fact that the film is commonly classified as a documentary (a format particularly disdained by Costa), it needs to be pointed out that many of the scenes of *In Vanda's Room* were acted during several takes, as explained by the filmmaker in some interviews. As Costa describes, some of these scenes were filmed several times until these became fluidly represented and detached of any melodramatic tone (Neyrat 2012: 65–69).
8. The active recruitment of nonskilled workers in the Portuguese colonies offered a solution to the shortage of a nonqualified workforce overall, due to the migratory waves of Portuguese citizens to other European

these two films depict the full cycle of immigration. *Casa de Lava* depicts the postcolonial condition of Cape Verdeans, a result of the underdevelopment and repression of the former colonial rule and the reclusive situation of these islands. It documents the efforts of part of the population to immigrate to Portugal, against a backdrop of the risks taken on the constructions sites in Lisbon. Complementary to this, *Colossal Youth* describes the aftermath of this immigration process, by presenting the transition between the slum of the Fontainhas and the government-sponsored estate of Casal da Boba, where many of these immigrants were being relocated in the early 2000s.

These representations of Cape Verdeans participate in a broader depiction of marginal characters. Sharing a common cultural and social victimization, these immigrants are also part of the abject heroes that constitute part of the postcolonial and postrevolution social fringes. One can easily form a critical stance concerning the social issues depicted. But Costa films' idiosyncratic tone presents a more observational nature, concerned with problematizing poverty in a slow and contemplative emotional texture, which translates the characters' displacement in an individualist form. In those terms, *Colossal Youth* translates, perhaps, the depuration of Costa's minimal and slow style, with Ventura's laconic presence becoming the embodiment of an historical process that is revealed in a contemplative format.

While *Colossal Youth* can be understood as closing a cycle initiated in *Casa de Lava*, simultaneously, it also starts a new phase in Pedro Costa's work. The relationship between the filmmaker and Ventura remained after this film and in the related subsequent short films, such as *Tarrafal* (2007) and *The Rabbit Hunters* (2007), *O Nosso Homem/Our Man* (2010), and more recently *Sweet Exorcism* (2012). These shorts develop further Ventura's story and his constant imaginary dialogues between his past in Cape Verde and his presence in Portugal, with the latter serving as part of a feature film announced to be released during 2014.[9] Further developing the representations of migrants as individuals scared by the oppressive death chain, these recent works link Ventura to both contemporary Portugal and a limbo where ghosts of the past, in both a figurative and literal sense, constantly emerge.

Acknowledgments

I would like to thank Pedro Manuel Sobral Pombo and Francisco Ferreira for their help in providing two of the articles used, and to Pedro Costa for the extensive interview conducted in July 2012.

Relating with these two dimensions, Ventura's wanderings between the Fontainhas ruins and the new buildings at Casal da Boba become physical and also chronological. The film shows numerous unexplained flashbacks of Ventura and his friend Lento (played by Alberto Barros), revealing the fragmented, traumatized memories of Ventura. These subjective representations of Ventura's memories span his arrival with Lento to Lisbon and the immediate aftermath of the 1974 revolution, tracing the ordeals and problems involved in adapting to the city, as well as the hard toil of back breaking work and Ventura's accident at the construction site. Toward the end of the film, the confusion caused by the events following the revolution is also made apparent. Contrasting with the commonly reported happiness and euphoria connected to the revolution, these flashbacks show Ventura and Lento barricaded in their shack in Fontainhas, fearing the violent acts inflicted on the African population at the time.

In *Colossal Youth* the theme of the political death chain became exemplified further by the use of the Robert Desnos' reworked letter. This powerful text reemerges once again in Costa's work, connecting historical contingencies with oppression, serving as a powerful reminder of the dire immigrant condition. The letter is recited by Ventura in an almost mantra-like fashion, marking a persistent form of recollection of the loved one left behind in Cape Verde. The letter is constantly repeated in these flashbacks, with illiterate Ventura dictating it to Lento, so he can send it to his wife. This form of oral recollection becomes a central piece in Ventura's loneliness and displacement—a desperate mode of communication in his attempts to reconnect with Cape Verde roots, which became definitively lost in suburban Lisbon. As pointed out by Lento, while they take shelter in their shack at the Fontainhas, Ventura's letter became useless as soon as the revolution of April 25, 1974, took place, since all communications with Cape Verde were interrupted. While Ventura and Lento lose contact with their past lives in Cape Verde, they also find themselves trapped in Lisbon, and excluded due to the political and social turmoil. They are who are displaced from every place they situate themselves in; they are "other" in every way.

Colossal Youth closes a cycle of representations of Cape Verdeans that began with *Casa de Lava*, exposing a constant oppressive death chain that links contemporary Portugal to its former colonies, showing the links between colonial rule and the contemporary displacement of immigrants from Cape Verde. This link with the past is renegotiated in the marginalized space of Fontainhas and later in Casal da Boba, in which a new sense of community was formed. One can argue that

Focusing particularly in representation, the film presents a studied stillness marked by long shots, which sustains the monotone acting of the film. The characters are framed in almost-still studied compositions that recall tonality, light dramatics, and composition values of painted still-life style, that translate an artistic and studied contemplative realism.

One can argue that this monotone style enhances the narrative being depicted. The film is centered in biographical details of Ventura, a former construction worker who came from Cape Verde to Lisbon, as part of the workforce needed to build the city infrastructures during Portugal's economic growth during the 1960s and early 1970s.[8] According to Pedro Costa, Ventura was 19 years old when he arrived in Lisbon in the early 1970s, "alone, leaving his wife in Cape Verde" (RDP África 2013). Ventura is presented by Costa as "one of the pioneers, who built the first shacks" at Fontainhas, and soon after "was involved in a terrible accident at work," which left him handicapped "when still very young" (Corless 2008: 12, Ferreira 2006: 15). The film's monotone style suits this biographical aspects of the narrative, revealing the contours of the repressive death chain. It illustrates an individual and idiosyncratic process of the main character, presented in a contemplative manner, neutralizing possible abrupt political emotions.

In the film, Ventura wanders between the Fontainhas as it is being demolished and the new estate of Casal da Boba (in the municipality of Amadora), where some of the Fontainhas former residents are being relocated. Abandoned by his wife, he seems to be making a final effort to gather all his "sons and daughters," so they can join him in a new apartment situated in that estate. Throughout the film, Ventura visits several of his "children," many of them characters that also populated *In Vanda's Room*. These visits reveal that Ventura's offspring are not his direct family kin, but the whole of Fontainhas, reflecting the relations of an inclusive multicultural family. As the film's Portuguese title *Juventude em Marcha* (marching youth) bitterly and ironically points out, this was a multicultural family that once, animated by promises of freedom, tried to get out of the historical ties imposed by the political death chain, only to get stopped by the social inequity of the country's recent historical process.

Colossal Youth documents this historical process by maintaining a narrative line that constantly shifts between past and present. As pointed out by Costa, "there are two parts in this film, a past and a present at Fontainhas, [two parts that] coincide with the before and after the 25th of April [Revolution]" (quoted in Ferreira 2006: 16).

these two local-social places, marking further the differences between recognizable Lisbon streets and a territory strikingly secretive and sinuous.

Costa's following feature film, *In Vanda's Room*, presents an even more disconnected relation with Lisbon. Casting exclusively nonprofessional actors and filmed while the neighborhood was being demolished, the film reveals an extreme sense of displacement representing the isolation and cultural adaptation "which entails a hybrid and insular state of being localized in a shifting multicultural urban landscape" (Arenas 2010: 58). Not as acutely obvious as in the previous films, the question of cultural identity (particularly Cape Verdean) is only dormant, while the film accommodates other issues. *In Vanda's Room* presents the everyday routines of heroin addicts and other abject heroes, living in this degraded neighborhood during its gradual demolition and the inhabitants' relocation to a social housing estate. With an (apparently) loose narrative, the film depicts the life of Vanda Duarte's steady daily routines (who played the character of Clotilde in *Bones*), marked by heroin consumption (alone or with her sister Zita Duarte) and by interactions with several characters passing by her dwelling. This narrative is marked by a structure in which Vanda's family household (and particularly her room) becomes the unifying and pivotal point. Parallel to the depiction of these routines, another (at times overlapping) narrative line follows the life of a group of male characters, also with drug dependency issues, living in a squatted house nearby. These two groups of interior scenes are complemented by others set in the public areas surrounding these houses, representing the neighbors in their street daily habits, occasionally affected by the visible and audible demolition works in the background.

Being Costa's first feature film produced in a nonindustrial framework and using the potentialities of affordable digital video technology, *In Vanda's Room* expresses a form of realist representation that was made possible by the use of unobtrusive equipment. The adoption of this artisanal working process allowed Costa to refine further his cinematic realism style that, as Richard Suchenski points out, is a "powerfully realized fusion of sustained observation and stylistic austerity" (2010: 271). One can observe a contemplative emotional texture that emerges from the minimalist style of the film, which captures the social dynamics of the neighborhood in an almost documental format, while presenting nonprofessional actors performing in a slow and neutral acting mode.[7] Deploying a similar minimal format and slow-pace realistic representation, *Colossal Youth* takes the (fabricated) *cinéma vérité* (truth cinema) observed in *In Vanda's Room* further.

marked by an alterity that expresses a less optimistic side of multicultural cinematic representations found in contemporary European cinema (2005: 124). As Elsaesser explains (drawing on Manuel Castells' vision of Europe as a network society), these are individuals who cannot or do not want to "participate in any of the circuits of redistribution and networks of [producers/consumers] exchange—of goods, services, affective labor or needs," and who take the risk of dropping "out of the human race" (Ibid). Not conforming to what is commonly understood as the European social façade, these characters are portrayed as keeping precarious temporary jobs or involved in illegal activities. Some of them, while feeding the necessary menial working force that makes economic development possible, are left outside the core of social organization. *Bones* documents the lives of these characters (some of them migrants), portraying the reality of non-contract, low-paid employees (cleaners, construction builders, cooks), social dropouts, drug addicts, and prostitutes; paradoxically, these are participants in the urban everyday routine but are commonly cast out of the social fabric. As with Costa's previous film, *Bones* presents a mixed cast of professional actors (Mariya Lipkina, Isabel Ruth, and Inês de Medeiros) and nonprofessional actors, recruited mostly at Fontainhas and surrounding neighborhoods (i.e., Nuno Vaz, Vanda Duarte, Zita Duarte). Most of these nonprofessional actors lived in the midst of these complex social issues and dependency problems depicted throughout the film.

The foreignness and inaccessibility of these characters match, as already pointed out, the detached neighborhoods where they live: attached to Lisbon theoretically, but portrayed as outside any recognizable area of the city. This relation to space takes a form of "double occupancy," placed outside a homogenized social context and with different overlapping social and national constituencies (Elsaesser 2005: 109). In terms of cultural representation, this concept of double occupancy problematizes the common perceptions of what may be recognizable as "national" identity. As pointed out by Arenas, one can experience "a sense of the uncanny...combined with claustrophobia, spatial disorientation and cultural and linguistic deterritorialization" (2010: 57). In *Bones*, Costa depicts this spatial ambiguity by making his characters travel in and out of these local/social delimitations and filming their actions and reactions in relation to their location at any given moment. For instance, Clotilde (Vanda Duarte) and Tina (Mariya Lipkina) are seen traveling from the derelict suburbs to the city center by bus, in order to do their jobs as cleaners in a middle-class apartment. The character of Nuno Vaz wanders in and out of

reflecting the "illusions" created by the consumerist culture that were also related to previous historical issues (quoted in Lemière 2009: 104). Reflecting the idea of the political death chain visible in Costa's films, Lemière points out that the filmmaker's criticism toward his society expresses a reaction to a falsely benign official discourse that tried to present itself as "tolerant" to the figure of the once-colonized "other," invoking "togetherness," while candidly ignoring "slavery" and the "colonial brutality rule" (Ibid).

Costa's subsequent films develop further the notion of political death chain, placing this postcolonial relation in the carefully crafted portrait of the Fontainhas, as observed in *Bones* and particularly in *In Vanda's Room*. These films consolidate Costa's search for a representation rooted in cinematic realism, reenforcing the connection between the camera and the subjects portrayed. As in *Casa de Lava*, this further step into realist representation reenforces the relation between space and its inhabitants, this time portraying Lisbon's urban fringes. Placed along the boundaries that divide Lisbon and Amadora municipalities, neighborhoods such as Fontainhas, Estrela d'África (also referenced in *Bones*), and Bairro 6 de Maio were at the time out-of-bounds socially, marked by drug-related economies and commonly associated with some of Lisbon's violent crime. Like the surrounding low-income neighborhoods, Fontainhas rose clandestinely by successive waves of work migrants coming to Lisbon (including migrants from the interior of Portugal), and often housing immigrants mostly originated from former colonies (Figueirinhas 2011: 15).

Pedro Costa's close relationship with Fontainhas started after the shooting of *Casa de Lava*. Returning from Cape Verde with several bags full of letters and gifts from family members and friends to their countrymen and women who migrated to Lisbon and surrounding urban areas, the filmmaker acted as a "mail carrier," bringing them news from home (Costa 2012). Costa recalls that most of the addresses of these letters were located in "Fontainhas, Benfica, Damaia, Estrela d'África, Cova da Moura...[In 1995] these neighborhoods were tough [but] we went there and we were [very well received]...Since then...I've never left [the Fontainhas]" (Ibid). These contacts allowed a proximity to this normally restricted neighborhood, and Costa spent most of his days in Fontainhas, mixing with the inhabitants and observing its realities. This observation contributed to the screen-writing process of *Bones*, filmed in 1997.

While Cape Verdean cultural manifestations are still visible in *Bones*, the film portrays a far more multicultural and fragmented social milieu. *Bones* portrays what Thomas Elsaesser called abject heroes, characters

becomes even more marked. The film reflects the connection to Portugal (and particularly Lisbon), observed in the representative presence of characters that, like Leão, try to reach Lisbon hoping to find better living conditions. Further links in the postcolonial death chain, these migrants constitute part of the third wave that moved to Lisbon to work in the ongoing development of the city during the late 1980s and throughout the 1990s (Figueirinhas 2011: 11).[5] In the film, the character of Edite (Edith Scob) is central to these aspirations. A former nurse and widow of a political prisoner who died in the Tarrafal camp, Edite helps inhabitants (particularly male) to escape their insular condition by commonly providing financial backing to the process, using her late husband's pension, provided by Portuguese state. Illustrating further the analogy between the political condition of the inhabitants of Cape Verde, before and after the colonial rule, this second part of the film connects Tarrafal and the condition of the immigrant workers. Central in this link is a letter appropriated by Mariana, which is an adaptation of the well-known letter-poem that Robert Desnos wrote to his lover soon after his arrest by the Nazis in 1944. This letter, assumed to be from an immigrant in Lisbon who left his loved one in Cape Verde, invokes a sense of imprisonment and loss, while making a (make-believe) list of presents that the payment of the hard work in Lisbon could (eventually) make possible.[6] As Costa observes, this is a letter born from the same "feelings" and the same (metaphorical) "prison," marked by isolation and loss of hope (quoted in Ferreira 2006: 17).

Even if transmitting a clear fascination with Cape Verde, *Casa de Lava* problematizes the postcolonial condition by deploying a realistic style contrasting with the "dominant regimes of representation" that normally veil "critical points of deep and significant difference" (Hall 1999: 706). What is observable in this style is that it represents an earlier stage of the realistic depiction of alienated human beings in adverse conditions, which project dissociation with assumed concepts of harmonious postcolonial relations. When interviewed about the film in 1994, Pedro Costa was resolute in manifesting his dissatisfaction concerning the paternalistic views of Portuguese society in relation to the former colonies. According to the filmmaker, *Casa de Lava* became a vehicle of "disgust" against the early-1990s political climate felt in Portugal, a system ignorant of the realities lived in its former colonies, and far more obsessed by "blind" economic optimism (quoted in Luz 1994: 29). In an interview with Jacques Lemière, Costa expanded his criticism of Portuguese society at the time, by pointing out the new social values that the European Community expounded, mainly

of opposition to the dictatorship. During the colonial/independence war(s) (1961–1974), the camp was reactivated (renamed Campo de Trabalho do Chão Bom), serving for the imprisonment and torture of African freedom fighters and liberation movement supporters.

This historical context is problematically reflected in *Casa de Lava*. A European coproduction and the first collaboration with influential producer Paulo Branco, the film was initially planned as an adaptation of Jacques Tourneur's classic *I Walked with a Zombie* (1943), continuing Costa's cinephilia attachments of this filmmaker, so expressively displayed in his monochromatic first feature film, *O Sangue/ Blood* (1989). Costa seemed to have found an ideal location for this project in the remote and desolate landscape islands of Cape Verde.[4] However, the filmmaker's perception of the place and his increasing familiarity with the local participants in the film (during the location scouting and shooting), considerably changed the initially planned project. While the film still reveals the influence of Tourneur's work, Costa became increasingly fascinated by the location and its inhabitants. Soon after the shooting started, the script was abandoned (Costa 2012), giving way to more documental representation; "the fictional [side of the film] was lost, but the location wins, as [the] relation with those people, which remains until today" (RDP África 2013).

Without a script, the narrative of the film becomes unattached to a rigid structure when observing narrative-unrelated scenes that serve to document the culture of the inhabitants, rather than a cohesive storyline. The film's fragmented narrative is divided into two main parts. The first one introduces what can still be perceived as the original idea of the storyline, centered on a Portuguese nurse, Mariana (played by Inês de Medeiros), who takes home a comatose Cape Verdean construction worker (Leão, played by Ivory Coast-French actor Isaac De Bankolé), after he suffers a fall at a construction site in Lisbon. Arriving in Cape Verde, Mariana tries to find Leão's family, a task that becomes difficult considering the distance and reserved nature of the local residents toward her. The second part of the film's narrative expresses more deeply the disuse of the script, reflecting a far more fragmented and subjective narrative, centered on the island's inhabitants, while revealing issues concerning the location and its past. Though not explicitly, Pedro Costa introduces in this narrative segment elements of (historical) reality, revealed through details that invoke the memories of the Tarrafal prison camp and human rights abuses perpetrated by colonial rule.

In the second part of the film the extreme isolation and underdevelopment of Cape Verde, consistently visible thorough the film,

irremediably linked through "politics" (Guimarães 1995: 67–68). Thus, one can argue that Costa's analogy serves to illustrate a broader expression, related to (individual) human conditions under repression, reclusion, and social neglect, which Costa's work illustrates in a particularly persuasive way by mixing fiction and documentary through a strong cinematic realist representation.

Relating this death chain analogy with the representation of Cape Verde immigrants and latent contemporary Portuguese identities, one needs to look into the relation between the two countries. Perhaps one of the first Creole societies developed by the European Atlantic slave trade, Cape Verde hosted a cosmopolitan population constituted by several European and African constituencies (Meintel 1984: 23–25). Its multicultural strata were shaped by the conditions of the Portuguese sea expansion started in the fifteenth century, which culminated in a colonial, or commercial, presence in several parts of the world. The archipelago was uninhabited until 1460, when the Portuguese tried to turn it into an agrarian colony, an unsuccessful task that soon gave way to the busy and profitable marketing of slaves (Rego 2009: 146). As described by Fernando Arenas, the approximation between Portugal and Cape Verde was the result of "colonialism, widespread miscegenation," and the "special legal and ontological status of Cape Verde within the African colonial empire and the Portuguese imaginary, in addition to mass Cape Verdean migration to Portugal and economic dependence" (2010: 57). During the twentieth century, Cape Verde became a symbolic representation of the ambiguities of a cultural identity under colonial rule. Portuguese propaganda kept a discourse of colonial unity, claiming that all territories under colonial presence were part of the same country, allowing for administrative differences.

Serving as one of the examples for defending its colonial position, which became politically awkward after World War II, Cape Verde was ascribed an ideological significance, as a "showcase of Luso-African racial harmony," while its inhabitants enjoyed more rights than the ones allowed in mainland colonies of Angola, Mozambique, and Guinea-Bissau (Meintel 1984: 3). While Portuguese propaganda maintained this ideological relation, the islands' remote location, separated from Africa and distant from Europe, made it a particular destination for those in forced exile and, simultaneously, for those escaping it via immigration to the American continent and to Portugal. As already mentioned, this destination for exiles was further reinforced in the early twentieth century with the presence of the Tarrafal prison camp, used until the 1950s for the imprisonment of the fiercest elements

documents various aspects of these communities, both in their inborn country and later in Lisbon, in a multifaceted form. However, Costa's films do not represent the social aspirations latent in mainstream narratives such as *Zona J*, neither do they reflect any identity formations commonly observed in many of the recent Portuguese documentaries focused on migrant communities (for instance, in *Outros Bairros*). Instead, Costa's films are inherently more concerned with the idiosyncratic trajectories of individuals' lives that are marked by historical processes and political repression.

As expressed above, Costa associates the living conditions of the immigrants from the former colony of Cape Verde in democratic 1990s Portugal to the underdevelopment and oppression under the former dictatorial regime. In an interview given during the domestic release of *Casa de Lava* in 1995, Costa explained this idea of a chain that connects the two stages, declaring that:

> [you just need] to connect the cemetery crosses at the Tarrafal [prison camp] to the hospital bed in Lisbon to see the chain that [links] death in the concentration camp to the death of the Cape Verdeans [falling from] scaffoldings [at construction sites in Portugal]. This is the work of any filmmaker, trying to be the most complete [in showing] that political death chain. For me it was the most accurate way to see Portugal. (quoted in Câmara 1995: 4)

Retrospectively, Costa argues that *Casa de Lava* is his most explicitly political film, and that his positions became less explicitly represented in his following works (as declared during an interview to RDP África in September 2013). However, it is still evident that this oppressive element remained visible in Costa's following films as well, discernable in the lives of people who are considered outside the limits of (any) homogenous social context (either because of their social practices or because they are seen as foreigners or without any defined nationality, even if legally and officially they do not fit any of these categories). Even if indirectly, what Costa understands as a political death chain demonstrates the inequities of the Portuguese colonial regime, forcing the inhabitants of the remote islands of Cape Verde to live in restricted conditions, isolation, and making constant efforts to break away (through immigration). Although this association may seem forceful, Pedro Costa, in another interview, considers the direct relation of repression between the dictatorship symbolized by the prison camp situated in Cape Verde's island of Santiago, with the hard toil and hostile environment toward immigrants in democratic Portugal,

Villaverde) or later *Costa dos Murmúrios/Murmuring Coast* (2004, dir. Margarida Cardoso), as films with a political stance that engage in the inequities of the colonial rule and with related loss of family ties. Other contemporary Portuguese films seem to focus on cultural differences and discontinuities, as opposed to colonial rule. *Paraíso Perdido/Lost Paradise* (1995, dir. Alberto Seixas Santos) still maintains a critical vision concerning the Portuguese presence in Africa but also engages in the memories of cultural links that the previous colonial presence offered. This tendency becomes even more marked in films such as *Tabu/Taboo* (2012, dir. Miguel Gomes), discussed in chapter 1, or the television series *Depois do Adeus/After the Goodbye* (2013, RTP [Rádio e Televisão de Portugal/Portuguese public broadcasting corporation]), which engage with an almost dreamlike colonial living or with the displacement of the 1970s Portuguese *returnados* (people who return to Portugal after the African colonies' independence).

The other side of this fragmented cultural identity is noticeable in the cinematic representations of the immigrants that choose Portugal, and particularly Lisbon, as their destination. *Zona J/Zone J* (1998, dir. Leonel Vieira) depicts the multifaceted and broken cultural links of the sons of Angolan immigrants in Lisbon; *Os Mutantes/The Mutants* (1998, dir. Teresa Villaverde), shows with gritty realism the difficult lives of disfranchised and neglected Portuguese youths, some of mixed-culture background. Other works, particularly documentaries, deal with the complexities of multifaceted cultural identities in Lisbon in, perhaps, a more unequivocal way: *Outros Bairros/Other Neighborhoods* (1999, dir. Vasco Pimentel, Inês Gonçalves, and Kiluanje Liberdade), discussed in chapter 3, presents the "new identitarian formations emerging among" Afro-Portuguese youths, and the cultural negotiations to "forge a new, autonomous, and proud culture in the heart of Portugal" (Arenas 2010: 58). Similarly, *Lisboetas/Lisbonners* (2011, dir. Serge Treffaut) and Rui Simões' *Ilha da Cova da Moura/Cova da Moura Island* (2010), focus on the adaptation of migrants, portraying the constant cultural dialogue between their cultural origins and the new site.

In the cinematic context outlined above, and considering the ambiguous and multiple qualities of a contemporary cultural identity that oscillates between unity and fragmentation, the work of Pedro Costa reveals a unique form of thinking about Portugal while looking at the conditions to which migrants from former colonies, particularly from Cape Verde, are subjected. While most of the films above show a facet of the problematic relation of Portugal with its former colonies and the negotiations presented in its contemporary culture, the work of Pedro Costa problematizes further nuances of these realities. It

of immigration. As argued by Fernando Arenas, "the relationship between Portugal and Africa is absolutely crucial for understanding the Portuguese national imaginary and the construction if its identity" (2012: 165). This relationship is part of a broader (and complex) context of immigration. Being simultaneously a country with a strong diaspora itself, with a migrant population spread around Europe (e.g., in France, United Kingdom, and Germany) or in countries with connection to the Atlantic (Brazil, Canada, United States), Portugal is also the destination of several migration waves, mostly (but not exclusively) related with its former African colonies. While this relation animates a multiple and fluid cultural expression, it can also be observed that Portugal's national identity is (ambiguously) marked by ideological notions (Arenas 2012: 165). As argued by Stuart Hall (1999), the ambiguity latent in the concept of cultural identity is animated by two paradoxical, and yet somehow complementary, notions. In the first instance, there is an effort to identify the "idea of one, shared culture" that forms a collective unity, even if there are other fragmented cultural identities beneath the surface (704–705). Second,, another notion of cultural identity recognizes "critical points of deep and significant difference" shaped by historical circumstances, which generate differences and discontinuities (706). Both notions seem to be latent in the nature of European postcolonialism cultural representations: while the former dominant culture tries to adapt to the cultural changes originated by colonial presence, it is also observed that the cultural differences are frequently difficult to register as a unified national identity. This ambiguity is reenforced by the representations of a common historical past, constructed through a (subjective) relation formed by "memory, fantasy, narrative and myth" (707).

As a national cinema of a country that is marked by issues that are, in part, the products of its colonial past, contemporary Portuguese cinema seems to reflect ambiguous notions of cultural identity. The historical reminiscences of films such as Paulo Rocha's *A Ilha dos Amores/The Island of Love* (1978–1982) or Manoel de Oliveira's *Non, ou a Vã Glória de Mandar/ No, or the Vain Glory of Command* (1990) present a highly problematic collective unity, formed in a mythical way and almost heedless of historical constraints. The issues related to the colonial war and the subsequent decolonization operated after the April Revolution are also central to the negotiations between Portuguese identity (as a postcolonial and democratic country) and its cinematic representations. Even if distinct from one another, one can point out examples such as *Um Adeus Português/ Portuguese Farewell* (1985, dir. João Botelho), *A Idade Maior* aka *Alex* (1991, dir. Teresa

films are, particularly and inherently, related with individual trajectories that share similar displacement—even if not originated directly by the colonial process or postcolonial issues. As observed in *Bones* or *In Vanda's Room*, this representation of Cape Verdeans is integrated in a larger multicultural community of Fontainhas, a former shantytown near central Lisbon, composed of both Portuguese and migrants from former Portuguese colonies and their descendants. The lives of these disenfranchised characters are presented in a cinematic realism style, in consonance with representations of other "abject heroes" observed in contemporary European cinema (Elsaesser 2005: 124). United by a common social and cultural victimization condition, these characters share solidarity links, in order to deal with the circumstances that oppress them.

In an interview given during the domestic release of *Casa de Lava* in 1995, Costa expressed concerns about how the oppression implicit in the lives of the characters of his films is essentially rooted in the political climate generated by Portugal's postcolonial condition. Costa draws a direct correlation between the dictatorship rule and the precarious conditions of the immigrants working at Lisbon construction sites, a "subterranean" form of oppression that Costa defines as a "political death chain" (quoted in Câmara 1995: 4).[3] According to Costa, this relation emerges from Portugal's former colonial position, but it is also a result of the democratic process that followed the April 25, 1974, Carnation Revolution, which terminated 48 years of dictatorship. In order to reveal some of the characteristics of this oppressive "death chain" identified by Pedro Costa, this essay, first, briefly looks into other cinematic postcolonial identity representations, understanding these as a constantly involving process, a never-completed "production" that reveals a fragmentary identity (Hall 1999: 704). Second, looking at the distinct features of Costa's films, this essay analyses *Casa de Lava*, particularly centering the arguments in the way the representation of Cape Verdean migrants reflects the issues raised by Portuguese postcolonial condition. This essay proceeds by looking into modes of representation and cinematic style in *Bones* and *In Vanda's Room*, and how these films express an idiosyncratic view of Fontainhas and its inhabitants. Last, it concludes with the analysis of *Colossal Youth*, as the culmination of a representation process, not only as a cinematic language but also as an exemplification of the displacement, difficulties of adaptation, and social injustice implicit in the migration process.

Further historical context is necessary in order to develop Costa's concept of political death chain and interrelated representations

2

Thinking of Portugal, Looking at Cape Verde: Notes on Representation of Immigrants in the Films of Pedro Costa

Nuno Barradas Jorge

The work of internationally acclaimed filmmaker Pedro Costa (Lisbon, 1959–) uniquely expresses Portugal's postcolonial condition. Costa's second feature film,[1] *Casa de Lava/Down to Earth* (1995),[2] as well as his following films *Ossos/Bones* (1997), *No Quarto de Vanda/In Vanda's Room* (2000), and *Juventude em Marcha/ Colossal Youth* (2006), reflect issues of immigration, urban displacement, and the uneven social and economic development of Portugal within the last few decades. The latter also reflects the consequences of the historical transition between the dictatorial regime and democracy and its effects on immigrants from Cape Verde as well as their descendants—as embodied by the film's main character and nonprofessional actor, Ventura, a former Cape Verde construction worker whose real life story is unequivocally and brutally marked by such historical circumstances.

The lives of some of these individuals, like Ventura or the characters in *Casa de Lava*, participate in an "ensuing emergence and growth of African-diasporic populations and identities, where marginalization, discrimination and lack of citizenship prevailed" (Arenas 2012: 165). However, while Cape Verdean cultural identity is present in Costa's films, it is not explicitly referred, as neither is any structured form of representation of the Cape Verdean diaspora and its cultural distinctiveness. Rooted in more than specific cultural identity settings, Costa's

Gil, J. (2004) *Portugal, Hoje—O Medo de Existir*. Lisbon: Relógio D'Agua.
Gomes, M. (dir.) (2012) *Tabu* [DVD]. O Som e a Fúria, Komplizen Film, Gullane, and Shellac Sud.
Hanich, J. (2002) "Jenseits der Stille. F.W. Murnaus *Tabu* zwischen Hollywood und Südsee, Moderne und Primitivismus und dem Ende des Stummfilm-Kinos," *Amerikastudien/American Studies* 47(4): 503–524.
Lourenço, E. (1999a) *Portugal como Destino seguido de Mitologia da Saudade*. Lisbon: Gradiva.
———. (1999b) *A Nau de Ícaro seguido de Imagem e Miragem da Lusofonia*. Lisbon: Gradiva.
Matos-Cruz, J., and J. M. Abrantes. (2002) *Cinema em Angola*. Luanda: Caxinde Editora.
Ribeiro, M. C. (2004) *Uma História de Regressos. Império, Guerra Colonial e Pós-colonialismo*. Porto: Edições Afrontamento.
Naficy, H. (2001) *An Accented Cinema: Exilic and Diasporic Filmmaking*. Princeton: Princeton University Press.
———. (2007) "On the Global Inter-, Multi-, and Trans-Foreword," in A. Grossman and A. O'Brien (eds.), *Projecting Migration: Transcultural Documentary Practice*. London: Wallflower, XIII–XV.
Peixoto, J. (2008) "Imigração e Mercado de trabalho em Portugal: investigação e tendências recentes," *Revista Migrações* 2: 19–46.
Rowland, R. (2002) "A cultura brasileira e os portugueses," in C. Bastos, M. V. Almeida, and B. Feldman-Bianco (eds.), *Trânsitos coloniais: diálogos críticos luso-brasileiros*. Lisbon: Imprensa de Ciências Sociais, 373–384.
Santos, B. S. (2001) "Entre Prospero e Caliban," in M. I. Ramalho and A. S. Ribeiro (eds.), *Entre Ser e Estar—Raízes, percursos e discursos de identidade*. Porto: Edições Afrontamento, 23–85.
Ukadike, F. N. (1994) *Black African Cinema*. Berkely: The University of California Press, Berkeley.

"a structurally imperial ideology without empire. Militant, hagiographic, ultra-nationalist, openly and innocently hostile to democratic inspirations, it was not possible to overcome half a century of 'single thinking.'"

6. This feeling has been latent but never acknowledged in films on the period, as, for example, in *Non ou a Vã Glória de Mandar/No or the Vain Glory of Command* (1990) by Manoel de Oliveira; *Um Adeus Português/A Portuguese Farewell* (1985) by João Botelho (Ferreira 2005).

7. David Flaherty (1959: 16) explains: "It is not without significance that *Tabu* was made as a silent in the beginning of the era of talkies. This was a deliberate choice, dictated not by economic but by aesthetic considerations. If *Tabu* enjoys a certain universality and timelessness, credit this (for that time) bold decision."

Works Cited

Ancine [Agência Nacional do Cinema] (1996) "Protocolo luso-brasileiro de co-produção cinematográfica, 1996." Online. Available at: http://www.ica-ip.pt/Admin/Files/Documents/contendoc727.pdf (accessed March 30, 2006).

Andrade-Watkins, C. (1995) "Portuguese African Cinema: Historical and Contemporary Perspectives—1969 to 1993," *Research in African Literature* 26(3): 134–150.

———. (2003) "Le Cinema et la Culture au Cap Verte et en Guinée-Bissau"/"Cinema and Culture in Cape Verde and Guinea Bissau," *CinemAction* 106: 148–155.

Diawara, M. (1992) *African Cinema: Politics and Culture*. Bloomington: Indiana University Press.

Ferreira, C. O. (2005) "Decolonizing the Mind? The Representation of the African Colonial War in Portuguese Cinema," *Studies in European Cinema* 2(3): 227–240.

———. (2007) "No Future—The Luso-African Generation in Portuguese Cinema," *Studies in European Cinema* 4: 49–60.

———. (2011a) "Brothers or Strangers—The Construction of Identity Discourses in Contemporary Luso-Brazilian Co-productions with Portuguese Migrating Characters," in I. Blayer et al. (eds.), *Narrating the Portuguese Diaspora*. New York: Peter Lang, 111–125.

———. (2011b) "Guiné-Bissau, Portugal, Brazil: Contemporary Discourses on National Identity Formation in Lusophone films," Universidade de Aveiro. Aveiro, Portugal. *A Europa das Nacionalidades—Mitos de Origem: Discursos Modernos e Pós-Modernos*. May 9–11. Conference Presentation.

———. (2012) *Identity and Difference—Postcoloniality and Transnationality in Lusophone Films*. Vienna, Berlin: LIT Verlag.

Flaherty, D. (1959) "A Few Reminiscences," *Film Culture* 20(12): 14–16.

Freyre, G. (n.d.) *Aventura e Rotina: Sugestões de uma Viagem à Procura das Constantes Portuguesas de Caráter e Ação*. Lisbon: Livros do Brasil.

While these latter films, mainly *Bocage* and *In Vanda's Room*, do not simply tell a story but also reveal the construction of fictions on colonialism and postcolonialism, *Tabu* offers an approach that not only parts from the existing imaginary but distinguishes itself by associating both periods, and does so with understated humor. Divided into two main parts and a prologue, the spectator literally discovers the strong liaison between past and present step-by-step. In the prologue, the farcical explorer, and the way in which his extravagant and absurd story is told, acted, and framed reveals Gomes's witty take on exploration as quintessential colonialism. Whereas contemporary Lisbon's civilizational malady has no palpable explication at the start of the film, it can already be sensed that the central myths of Lusophony and Luso-tropicalism have endured. The filming techniques give this stiff world a grotesque appearance. The love-story of the last part is rendered comprehensible by means of the separation of the cinematographic elements—sound, music, images. The general lack of dialogue reinforces that colonialism was no paradise and that nostalgia is a fictitious utopia of mainstream cinema, responsible for the perpetuation of colonial power relationships. Gomes thus uses the storytelling of an Italian migrant in an invented African colony to make perceptible the self-indulgence of colonial society that still makes life difficult for present-day migrants from the PALOP. After watching this film, especially the second part, which contains no dialogue, inspired in the aesthetics of silent cinema, the idea of a humanist, and above all, Christian colonialism, and even postcolonialism, practiced by Portugal becomes distinguishable as pure fiction.

Notes

1. I do not take into consideration the Asian colonies Timor, Goa, and Macau, even though the film, *A última vez que vi Macau/The Last Time I Saw Macau* (2012), by João Pedro Rodrigues and João Rui Guerra da Mata would certainly deserve attention here.
2. For a more detailed analysis of these films and the context of their production mode, see Ferreira (2012: 175–204).
3. For a more detailed analysis of these films and the context of their production mode, see Ferreira (2012: 143–174).
4. I am not taking into consideration films on the colonial war, since the characters could not be considered migrants. Nonetheless, they are not completely alien to the universe discussed. For further information see Ferreira (2005).
5. Eduardo Lourenço (1999a: 79–80) observes that Portugal did not have a cultural revolution during the redemocratization and that it remained

coproductions in which they are featured most often. Brazilian national films still focus primarily on the encounter during colonial times but tend to be less critical than they used to be. Luso-Brazilian productions equally take a deeper interest in stories from the past. But the perspectives on migrating, set in different epochs, depend strongly on the precedence of the filmmaker. Brazilians usually investigate Lusophony and Luso-tropicalim critically by means of their migrants (*Foreign Land, The Jew, Bocage, Desmundo*), while Portuguese directors are more often than not affirmative about the possibility of Portuguese immigrants becoming influential in Brazil (*Word and Utopia, The Forest*) or find a better life in Portugal (*Fado Blues*). When there are exceptions to this rule, the films in question are usually somewhat stereotypical (*A Shot in the Dark* and *New World Diary*).

None of the coproductions from the PALOP are free of mythical perspectives on the pleasures of living in a harmonious Lusophone world. Migrants or travelers are welcomed (*Dribbling Fate* and *Fado Blues*), colonialists will become Luso-tropicalists (*A Drop of Light*), Africans will gain international stardom in Europe (*My Voice*), and Portuguese will always be welcomed and have a home in Africa (*Miradouro*).

Portuguese national cinema is much more pessimistic. After briefly flirting with Luso-tropicalism in *Down to Earth* (but not with Lusophony since he is much more interested in the divide that Creole and Portuguese could bring about), Pedro Costa soon realized and engaged with the marginalization of migrants in his trilogy on Fontainhas. His portrayals are dignified but sometimes, as in *Colossal Youth*, tend to monumentalize the migrant by resorting to canonical Western iconography, as I have argued elsewhere (Ferreira 2012: 233). Teresa Villaverde shares his concerns with the lack of integration in *The Mutants*, and Luso-tropicalism survives only in commercial cinema, namely in *J Zone*.

Whereas national cinemas either look at the comic aspects of the colonial encounter that result from emigrational fluxes (Brazil), or develop aesthetics that try to dignify relegated immigrants (Portugal, especially Pedro Costa), a significant number of coproductions still look for an all-embracing culture and identity, and—one might guess—box-office success. Some are aware of diversity, tensions, or conflicts, but they also reaffirm stereotypes. Only a rather small number of films, namely *Desmundo, The Jew*, and *Bocage*—set during colonial times—and *Foreign Land, The Mutants*, and *In Vanda's Room*—set in contemporaneity—construct migrating characters trying to come to terms with the burden of Lusophony and Luso-tropicalism.

by the Spaniards at the time (Ferreira 2012). Gomes visibly does not share Oliveira's religious stance. Secular, his characters and spectators do not gain such insight. And he takes no rescue in an omniscient godly perspective but challenges the fictions told about colonialism.

Given his aesthetic strategies that follow Murnau's silent film closely, there is no conventional melodramatic structure. We are not invited to identify with the characters or to indulge in their love story. This is the result of the lack of dialogue, the odd environment sounds, and the nostalgic love songs. In fact, the use of music is an important instrument to create a nonjudgmental ambivalence and to foreground human desire. The love songs are emotionally charged and highly popular hits from the 1960s that have not lost their romantic power. "Be My Baby" (Jeff Barry, Ellie Greenwich, Phil Specter), sung in Spanish, is introduced in the first part of the film to underline Pilar's loneliness. When Gianluca speaks of his easy life, Mario's band performs "Cosi Come Viene" (Remo Germani). And while Aurora chats with her girlfriends, we hear "Lonely Wine" (Roy Orbison), followed by "Baby I Love You" (Ramones) at a party. Whereas the songs make us understand the mood of the characters, they do not lull us into their feelings. Rather, the materiality of the music and the feelings they raise become distinguishable and their sweet but inadequate sentimental flair perceivable.

As we watch Aurora and Gianluca and listen to their story, the lack of dialogue adds a layer of documentation. Not being able to hear what they utter, we have a reduced idea of them. Just as conventional ethnographic film would do in relation to the depicted "Other." But portraying the colonialists in such a manner does not reduce them to objects. On the contrary, with the help of the nostalgic music, they are neither essentialized nor demonized. It is possible to perceive them in a heterogeneous way: we can recognize their desires for romance and adventure but also grasp their capriciousness. Whereas Murnau made a statement against colonialism and sound film, Gomes returns to his topic and the aesthetic strategies of silent film in order to make us see and feel the persistence of an absurd longing for exotic adventure and love in postcolonial times perpetuated in the talkies. Together with Christian love, this nostalgia masquerades the master-and-servant power play that is still being practiced in postcolonialism and thus affects contemporary African migrants.

Conclusion

Generally, migrating characters are not a central issue in Lusophone cinema, neither in national films of the CPLP countries, nor in the

Figure 1.7 *Tabu*: Aurora, the hunter.
Source: Screenshot *Tabu* (2012, dir. Miguel Gomes): O Som e a Fúria, Komplizen Film, Gullane, and Shellac Sud.

an ambivalent character. Even though he tries to prevent Aurora from running away, the former seminarian and Gianluca's bandleader is a womanizer and a liar.

After the murder, Aurora, who is pregnant, gives birth to a girl. Gianluca calls her husband, and he and Aurora never see each other again. Thus, at the end of the film "Paradise Lost," which seemed to be associated with contemporary Portugal, discloses itself as a punishment of the illicit affair and the foolish acts of the couple that lived in the colony. While Gomes does not judge the characters or denounce colonialism directly, he shows how each of the characters is entangled in his or her desires.

By concentrating on the question of Christian sin in the colonial context, the filmmaker posits himself in the tradition of Portuguese film history, dialoging as well with Manoel de Oliveira's *Le Soulier de Satin/The Satin Slipper* (1985). Whereas Oliveira sustains in his adaptation of Paul Claudel's play that the European desire for material wealth and power during colonialism is in vain and submitted to God's higher plans, he does not blame Portugal, which was occupied

unhappy neighbor, but mainly because the whole action seems pointless in its staged lifelessness.

As the young democratic society reveals itself as merely fiction—civic action is ineffective, people are deceitful, and postcolonial power structures remain—the curtains to the second part open to show us that the idea of a former colonial paradise survived only in the imagination. This is especially demonstrated in Pilar's attraction to Aurora and love for period films, which does not deserve the nostalgia invested into it.

Sounds, Songs, and Sins

In "Paradise," a non-Portuguese migrant, Gianluca Ventura, who Aurora calls to her deathbed but who arrives too late, tells their illicit love story in a nonexisting African country, where Aurora lived on her husband's tea plantation at the foot of a mountain named Tabu. Gianluca's voice takes us back to the 1960s and remains as commentary until the end of the film. There is, in fact, no dialogue. In an uncanny reference to Murnau's critique[7] toward sound film and his employment of synchronized music, we can only hear Gianluca's voice, environment sounds—for example, a stone dropping into a pond, nostalgic pop songs, or the chants of the natives. This has several effects: it exposes again the fictionality, enhances the idealized utopia associated with the pop songs, makes "Paradise Lost" appear like an ethnographic study of a very restricted part of colonial society, and calls attention to the materiality of images and sounds.

In a more obvious take on Hollywood movies, the second part depicts colonialism as a situation that allows for self-centered activity. Since Gomes is not interested in denouncing imperialism but its imaginary, Gianluca presents the characters as self-indulgent adventurers. Aurora is introduced not only as a spoiled young woman but also as a renowned hunter. And Gianluca presents himself as someone attracted to escapades that involve women, gambling, and unknown, preferably exotic, places.

Whereas the original silent movie shows a native couple whose downfall is caused by authoritarianism, this couple is characterized from the start as irresponsible and extravagant. As part of the colonial society, they are no victims but perpetrators. In contrast to Reri and Mathai and within the context of Christian dogma, Aurora and Gianluca factually commit sins that result in their expulsion of paradise: they are not only adulterous, but Aurora, the skilled shooter, kills her husband's and Gianluca's best friend Mario. Developing on the double standards of Christian morality as presented by Pilar, Mario is

Figure 1.5 *Tabu*: Maya and Pilar at the airport.

Source: Screenshot *Tabu* (2012, dir. Miguel Gomes): O Som e a Fúria, Komplizen Film, Gullane, and Shellac Sud.

Figure 1.6 *Tabu*: Pilar and her NGO.

Source: Screenshot *Tabu* (2012, dir. Miguel Gomes): O Som e a Fúria, Komplizen Film, Gullane, and Shellac Sud.

(1719) by Daniel Dafoe. As is well known, Crusoe established a master-servant relationship, which is subtly associated not only with Aurora, but also with Pilar.

Contemporary Portugal is obviously at odds with its colonial past. Fixed static shots and mechanically delivered dialogues aesthetically translate the rigidness and seclusion of this world. After Pilar is seen in the cinema, we cut to her driving through the streets. Lisbon is not at all picturesque, only modern and functional buildings fly by the window. And human relationships are cordial but corrupted. When Pilar reaches the airport to pick up the nun, what turns out to be a young woman who isn't a nun lies to her again, telling her that the expected guest did not come because she wants to stay with friends.

The artificiality of the framing enhances the inflexibility and dullness of this society, but preserves the sense of humor from the prologue. A demonstration of Pilar's NGO (nongovernmental organization) against the United Nations, for example, is rendered ridiculous. Not only because she breaks the moment of silence in order to pray for her

Figure 1.4 *Tabu*: Santa reading *Robinson Crusoe*.

Source: Screenshot *Tabu* (2012, dir. Miguel Gomes): O Som e a Fúria, Komplizen Film, Gullane, and Shellac Sud.

Gomes's situation is dissimilar but not completely different. His postcolonial context makes him equally skeptical toward contemporary society, but he adopts a caustic change. Instead of focusing on natives, he uses a romantic couple from the colonial period, which he calls ironically "Paradise." The postcolonial moment, on the other hand, is entitled, paradoxically but coherently, "Paradise Lost." The spectators only understand the full meaning of the titles at the end of the film, and I will return to them after discussing each part.

The lost paradise part establishes a sense of loneliness, hollowness, and a latent sense of lack.[6] And it introduces issues related to colonial times and African migration with great understatement in present-day Portugal. The story of Pilar, a common and lonely middle-aged Portuguese woman who tries to be a good Christian and an engaged citizen, is told in short sequences that extend over a week. She is politically active in an NGO, helps her demented neighbor Aurora out, offers to host a nun who comes to Lisbon for a meeting of the ecumenical Taizé, and spends time with an elderly painter friend with a crush on her. Her fascination with Aurora, who, in a pun on the novel *Out of Africa* by Karen Blixen and its cinematographic adaptation, once had a farm in Africa, testifies to her longing for exciting stories that she tries to satisfy by frequently going to the movies, as we have already seen. Aurora is an already senile gambler who constantly loses her money at the casino. Pilar therefore censures Aurora's black housekeeper Santa for not taking action, even though she is only a poor immigrant from some unspecified country of the PALOP, paid for by Aurora's daughter who lives in Canada.

Santa's character reveals the limits of Pilar's Christian values and also demonstrates that Luso-tropicalism and Lusophony survived in Portugal's postcolonial society, covert under pseudo-democratic actions. Aurora's demonization of her—she says she was sent by the devil—clearly testifies against a happy coexistence between ex-colonizer and former colonized. And while Pilar is friendly, she also frequently assumes an intimidating and superior position.

When it comes to Lusophony, Gomes takes care to sustain its factual inexistence since Santa is just learning how to read and write in Portuguese. Ironically, even the Polynesians in Murnau's film knew how to read and write, though this was not to their advantage. And Santa's way out of illiteracy is rather thorny. The teacher displays a paternalistic arrogance when she praises the fact that Santa is ahead of her class because she is reading a book, and the literature she has chosen only reaffirms her subordinate place. It is the most famous and widely published book on the colonial encounter: *Robinson Crusoe*

the explorer recalls Buster Keaton, his wife looks like a ghost from a B-movie. One of the favorite genre mixes of Hollywood—adventure and love stories in exotic landscapes—is dismantled with dry humor. Thus, the introductory part makes us perceive two kinds of fiction: colonialism camouflaged as exploration and the cinematographic love story set in a tropical environment.

Anthropology, Postcolonialism, and Aesthetics
In order to underline both points, a cut takes us to Pilar, the main character of the first part, sitting in the cinema and, presumably, watching this movie. The blending in of the title "Paradise Lost" is obviously ironic. If this was paradise, how can it have been lost? But there is more to it. Fritz Murnau's film on a love story in the South Sea is equally divided in two parts. A native couple, Reri and Mathai, defies the religious authorities and end tragically since they have to flee from their Garden of Eden. Therefore the first part, set in Bora-Bora, the island of the natives, is called "Paradise" and the second, set in a colonized island, "Paradise Lost." As I will show, Gomes not only inverts this logic but also radicalizes the lack of rigidity of this binary opposition.

As Julian Hanich (2002: 517) notes, the native society has already been corrupted in "Paradise." When Reri, the daughter of the chieftain, is claimed by the Polynesian king to become the virgin of their gods, a priest arrives on a French ship and presents his demand in writing, which proves that the once oral and flexible society has already become rigorous and authoritarian. Threatened by their own society, in "Paradise Lost" the couple becomes victims of capitalist colonialism. Unfamiliar with the monetary system, Mathai, who earns money diving for pearls, becomes indebted to Chinese merchants. Even though he defies imposed taboos twice, he and Reri cannot get away from the exploitation institutionalized in modern civilization.

Murnau thus not only engages with the critique of Western civilization brought forward by his contemporary anthropologists, such as Franz Boas, Margaret Mead, and Ruth Benedict (Hanich: 512), the film also discusses the triumph of the written word and law, imposed by religion and colonialism: "writing in *Tabu* is a means of power and authority" (515). The focus on the act of writing and its implications thus associates the loss of the natives' world with the end of silent film. The silent film considers the spoken word as threatening to the art of filmmaking as the written word is to precolonial society since. It is worth mentioning that both—written law and sound film—build the basis for capitalism.

IMAGINING MIGRATION 29

second part: the love story. This occurs in a fashion that is reminiscent more of ethnographic filmmaking than of Hollywood movies set in the African jungle.

An omniscient voiceover explains that the anonymous explorer is not propelled by scientific longing for knowledge, but by grief for his deceased spouse. We see the explorer walking through the Savanna, having an encounter with his dead wife who tells him he will not be able to run away from his feelings, stand in front of a river in which he throws himself, as we are being told, to be eaten by a crocodile. In a generic twist that emphasizes the ridiculousness of his love suicide, his African servants then perform a dance. Some of the dancers establish eye contact with the camera, as though we were now watching an ethnographic documentary.

Returning to the love story, the voiceover tells us that according to legend, the melancholic crocodile was often seen in the company of a lady, which is then illustrated by a shot of both of them. Due to the estranging ethnographic approach and the deadpan acting, the sequence is rather comic. In travelling or static shots, the characters perform mechanically their supposedly deep feelings, and while

Figure 1.3 *Tabu*: Citation of ethnographic documentaries.

Source: Screenshot *Tabu* (2012, dir. Miguel Gomes): O Som e a Fúria, Komplizen Film, Gullane, and Shellac Sud.

Figure 1.1 *Tabu*: The explorer.
Source: Screenshot *Tabu* (2012, dir. Miguel Gomes): O Som e a Fúria, Komplizen Film, Gullane, and Shellac Sud.

Figure 1.2 *Tabu*: The explorer and his servants.
Source: Screenshot *Tabu* (2012, dir. Miguel Gomes): O Som e a Fúria, Komplizen Film, Gullane, and Shellac Sud.

colonialism and its legacy. But Miguel Gomes takes a further step by engaging with spectator expectations. Divided into two parts—one set in modern day Portugal and one during colonial times—the film not only challenges Lusophony and Luso-tropicalism, it works against the colonial imaginary put forward in photography and films by foregrounding its construction.

With his title, his topic, and aesthetics, Gomes sets up an intense dialogue with one of the first truly significant films on colonialism from the end of the silent era, Fritz Murnau's film *Tabu—A Story from the South Seas* (1931). He follows the German filmmaker's discussion of colonialism from an anthropological point of view, his defiance of categories such as ethnographic documentary and fiction film, and his highlighting of the materiality of the cinematographic image and of its sound, but deals with the feeling of loss from a changed perspective.

History, Love Stories, and Identity

Before the first part of the film, entitled "Paradise Lost," begins, there is a prologue that sets the tone, the subject, and the aesthetics of the film. Challenging postcolonial perspectives still popular in Portugal, *Tabu*, shot entirely in black and white, introduces colonialism not as exploitation but as migration fuelled by scientific exploration. The first image we see is that of an explorer of the nineteenth century, equipped with a tropical helmet and a water pouch. He stands still in a pose reminiscent of photography, a frozen image in time of a prototype traveler in the African bush. The iconographic image comes to life when his African carriers appear in the picture. The explorer remains motionless in his pose while the titles blend in.

Already in this first shot, Gomes puts at stake a historical self-image that Portugal has developed over centuries: that its colonization was a humanistic and scientific project and not one of economic interest.[5] At the same time, he comments on the image production that this idea entailed. In order to do so, the filmmaker re-creates the existing imagery with regard to the colonialist explorer and then exposes its construction by revealing his pose when the Africans move at his service. The moving image, so to speak, can say more about colonialism than the photographic image, since it is capable of revealing the subordination that was factually at its (colonialism's) base. This capacity of film to disclose fictionality is employed throughout *Tabu*.

The photographic images that have participated in structuring discourses on Africa and its landscape are as much revisited as the romantic adventure stories that have been told by mainstream cinema. The prologue deals, therefore, with a central theme that is also vital in the

Verdean Fogo Island and establishes an analogy with the repression during the dictatorship. Thus, the concentration camp on the island and the fate of another nurse extend the problem of contemporary migration.

In the Fontainhas trilogy—*Ossos/Bones* (1997), *No Quarto da Vanda/In Vanda's Room* (2000), *Juventude em Marcha/Colossal Youth* (2006)—Costa's preoccupation is centered exclusively on the destinies of Cape Verdeans in the Portuguese capital. *Colossal Youth* is a tale of a striking beauty that attributes to its protagonist Ventura, an immigrant worker, an unquestionable dignity. It goes beyond the belief in cultural harmony that can be encountered at the end of *Down to Earth*, which is—as *Bones* and *In Vanda's Room* equally suggest— only possible on African soil. In contrast to *Bones*, wherein two young women reject equally the help of a Portuguese woman and the men from their own community, the film accepts ambivalence and does not try to resolve Ventura's paradoxical situation as migrant. It also points linguistically at the main character's difficulties to integrate and visually at the contribution of the first generation of immigrants to the construction of Portuguese society.

Os Mutantes/The Mutants (1998) by Teresa Villaverde and *Zona J/J Zone* (1998) by Leonel Vieira are equally concerned with the integration of African descendants. Since their immigrants face no linguistic barriers or have vivid memories of the countries from which their parents migrated, the filmmakers' concern is to encounter ways to express aesthetically their rejection in Portugal's society. However, the approaches of Villaverde, an acclaimed auteur like Costa, and Vieira, a producer of blockbusters, could not be more different. Similar to *Bones*, *The Mutants* presents no affirmation whatsoever of Lusophony's mythic idea of a shared place, apart from the fact that all share the same language. The film clearly indicates that within Portugal's postcoloniality, racism endangers Luso-Africans even more than the already predisposed adolescents who live in foster homes. *J Zone* offers a similar discourse in terms of the impossibility of integration of an adolescent of African descent who not only speaks Portuguese as his mother tongue but also holds Portuguese citizenship. Nonetheless, the film believes naively in another myth: that Luso-tropicalist racial mixture is the only solution to racism.

Tabu by Miguel Gomes

As mentioned earlier, *Tabu* distinguishes itself from most of the already cited Portuguese films, with the exception of Pedro Costa's trilogy and Teresa Villaverde's film that present an equally heterogeneous view of

film by Fernando Vendrell, engages with conflict but uses the coming of age of an adolescent boy, the son of a colonial administrator in the 1950s, to forward cultural relativism, insinuating that both cultures, the African and the European, are in fact cruel. The film equally aims to liberate Portugal from five hundred years of oppression, genocide, slave trade, and abuse in its Luso-tropicalist stance.

Portugal

Apart from its colonial history, Portugal is still better known as a country of emigrants whose experiences have often been reflected in its national cinema. As I have suggested elsewhere (Ferreira 2007: 49), at least 20 films have narrated emigrants' stories since the reestablishment of democracy. These stories depict migrants who move to or return from richer countries, mainly France, and also the United States. Immigration from the PALOP only became relevant after the Revolution in 1974, and following Portugal's adhesion to the European Community in 1986, which made the country economically more attractive.

While the decolonization process is usually interpreted as the main reason for the explosion of immigration, rather, it led to an inverted migration process, since Portuguese citizens who had moved to the African colonies now returned in large numbers. In fact, the amount of non-Portuguese citizens remained insignificant after the PALOP and East Timor gained independence. Only in the late 1990s and early 2000s did a foreign workforce represent more than 5 percent of the working population (Peixoto 2008: 27). The growth of immigration was as much a consequence of the economic boom that followed Portugal's entry into the European market, which created a demand for mainly unskilled workers, for the most part in the construction industry, as a result of the political situation of the former colonies. The civil wars in Angola (1975–2002) and Mozambique (1975–1991), the constant political instability in Guinea-Bissau, and the severe economic crisis that affected Brazil in the early 1990s were all responsible for the influx of migrants.

Portuguese National Films

Still, few Portuguese filmmakers have dedicated national feature films to immigrant main characters from the CPLP.[4] Pedro Costa stands out since he has made a number of features on the lives of Cape Verdean immigrants and their descendants in the Lisbon slum Fontainhas. *Casa de Lava/Down to Earth* (1994) follows the story of a nurse that brings home a migrant who tried to commit suicide. It is set mostly on the Cape

in local and international audiences. These initiatives and the films have been regarded as key factors for opening up a new and important chapter within the history of African and world cinema.

Aware of the importance of films, the socialist governments in Angola, Cape Verde, Guinea-Bissau, and Mozambique established film institutes in the first years of independence. Civil wars, economic crises, corruption, the end of the cold war, and the general lack of funding, infrastructure, equipment, and qualified technicians soon brought an end to these promising beginnings. In the 1990s and early 2000s civil wars came to an end and so did most of the monoparty regimes. The PALOP opened up politically and economically to an ambivalent future. In the wake of this paradigm shift, democratic elections became possible, as also the introduction of neoliberal economic rules and other shortcomings of globalization.

Official regulations for the funding of transnational films with Cape Verde were established in 1989, with Mozambique in 1990, Angola in 1992, and São Tomé and Principe in 1994 (Matos-Cruz and Abrantes 2002: 17–20). The treaties on cinematographic coproduction established with Portugal and the fact that these productions account for 74 percent of all films produced (Ferreira 2012: 146) are part of the ambivalent new situation, since they encourage technical and financial dependency.

There are, in fact, no national productions on the subject of migration. However, a small number of Luso-African productions tell stories of the encounters and dis-encounters of Africans in Europe. *Fintar o Destino/Dribbling Fate* (1998) by Portuguese Fernando Vendrell celebrates openly Luso-tropicalism and Lusophony by drawing a picture of Portuguese receptivity and easy assimilation when a Cape Verdean bartender who loses his chance to become a Portuguese soccer player in the 1950s, visits the country in order to open this perspective to a young athlete he coaches. France is even more important for the identitarian and professional prospects of a beautiful young woman who leaves Guinea Bissau for Paris to study in *Nha Fala/My Voice* (2002) by Guinean Flora Gomes. Even though made from an African perspective and by a highly respected filmmaker, the colorful musical ignores differences, just as its Portuguese counterpart *Fado Blues* did. The same is true for *O Miradouro da Lua/The Belvedere of the Moon* (1993) by Jorge António. It is, however, much more simplistic and eager to not only wipe out cultural differences between a young Portuguese migrant and the Angolan youth who guides his integration with delight, but, more importantly, to forget about possible tensions or unpleasant legacies of the colonial period. *Gotejar da Luz/A Drop of Light* (2002), another

PALOP

The film histories of the PALOP begin, comparable to their colonial history, significantly later than their Brazilian counterpart. Even though Vasco da Gama reached the Island of Mozambique a little earlier than Pedro Alvares Cabral did Brazil, in 1498, it would take much longer before Portugal factually occupied and settled in its African colonies. Only after the Berlin Conference in 1885, when the European empires divided the continent, did the country start setting up a colonial administration system. And while the other European nations began withdrawing from their African colonies shortly after World War II, Portugal engaged in a long colonial war that lasted from 1961 until the dictatorship and empire finally ended with the "peaceful" revolution on April 25, 1974. Unimpressed by the decolonization processes in the French, Belgian, and British colonies, the nationalistic regime clung to Angola, Cape Verde, Guinea-Bissau, Mozambique, and São Tomé and Principe, euphemistically declared "ultramarine provinces" and defended in a long colonial war.

Luso-African Coproductions[3]

As I have discussed in another place (Ferreira 2012:144–145), the PALOP share with many other sub-Saharan cinemas technical and financial deficiencies and face profound problems in terms of distribution and exhibition. Nonetheless, their cinemas' histories—told by Claire Andrade-Watkins (1995, 2003), Manthia Diawara (1992), and Frank Ukadike (1994), to name but the most relevant—had a dissimilar start when compared to the Anglophone or Francophone African nations. The authors' accounts underline that in contrast to the British, French, or Belgian colonizers, the Portuguese only set up a very restricted infrastructure for documentary production during the colonial period, which was of little help after the overdue independences in 1975.

But unlike other colonies, the PALOP were active in filmmaking during the armed fight against Portuguese colonialism. According to Diawara (1992: 89–91), the organizations involved in the liberation struggles—MPLA (Movement for the Liberation of Angola), PAIGC (African Party for the Independence in Guinea and Cape Verde), and FRELIMO (Liberation Front of Mozambique)—invited international filmmakers to accompany their wars of independence. Most of the films were documentaries that informed about the wars' atrocities and the desire for self-governance, and their aim was to raise consciousness

Silva, a Brazilian-born Jew who became Portugal's most celebrated playwright of the eighteenth century and was then sentenced to death by the Inquisition in *O Judeu/The Jew* (1995), by Brazilian filmmaker Jom Tob Azulay, is the only example set during colonialism.

Symptomatically, Luso-Brazilian coproductions all deal with crimes, echoing either playfully or with a somber tone the shared colonial history and its abuses. Only once, in *Fado Blues*, are the different cultures and languages portrayed as being compatible and the migrant characters successful in striving for a better life in Portugal. Linguistic and cultural differences are mentioned in *A Shot in the Dark* and explored in *Foreign Land* and *The Jew*, but shatter Lusophony's dream of a shared cultural history by indicating a deep divide between Brazil and Portugal.

A slightly larger number of coproductions, five to be precise, focus on the inverted route, that is, on Portuguese main characters migrating for diverse reasons from Europe to Brazil. There is the famous priest António Vieira in *Palavra e Utopia/Word and Utopia* (2000) by Manoel de Oliveira; young women to be wed to settlers in the sixteenth century in *Desmundo* (2003) by Alain Fresnot; a clerk in the early twentieth century in *A Selva/The Forest* (2000) by Leonel Vieira; Manuel Maria Barbosa du Bocage—the most important Portuguese poet and enfant terrible of the eighteenth century—in *Bocage—O Triunfo do Amor/Bocage—Triumph of Love* (1997) by Brazilian filmmaker Djalma Limongi Batista; and settlers who move from the Azores to the south of Brazil in the same century in *Diário de um Novo Mundo/New World Diary* (2005) by Paulo Nascimento.

The Forest and *Word and Utopia* perpetuate the existing celebratory and hybrid identity discourses, no matter if directed by an *auteur* such as Manoel de Oliveira or a market-oriented filmmaker like Leonel Vieira. *Desmundo* and *New World Diary*, directed by Brazilian filmmakers, both suggest the autonomy of a specific Brazilian identity that the Portuguese immigrants assume once they arrive on Brazilian soil. *Desmundo*, then again, not only develops a more sophisticated cinematographic style, but is also more interested in exploring where the insubordinate mentality of its settler Francisco comes from than the clichéd characters Paulo Nascimento drafts in his superficial love story *New World Diary*. Aesthetically stunning and politically daring, *Bocage* proves Lusophony wrong by declaring that Portuguese is in fact a plurality of languages that are related but autonomous from its matrix. It offers a transnational universe in all its ambivalence.

Anchieta, José do Brasil (1977) by Paulo Cesar Saraceni, which reconstructs the life-story of the famous Jesuit priest José Anchieta and turns him into a "true" Brazilian.

Contemporary films still engage with the colonial past and the encounter between natives and Portuguese characters that cross the Atlantic, but not with the same intensity or investigative outlook. Nonetheless, the first film of the so-called *Retomada*, the film Renaissance in the 1990s that followed years of production crisis, was a piece on colonial history, *Carlota Joaquina* (1995), by Carla Camurati. Interpreted as a satire on the Portuguese colonialists by most critics, it is rather an interrogation of present-day politics and the role of corrupt politicians, who are allegorized by means of the former Portuguese monarchs (Ferreira 2011b). Movies on the encounter of colonialists and the native population now tend to recycle Lusotropicalism. This might come in the form of weak literary adaptations of a classic—for example, *O Guarani* (1996), based on the famous love story between a native and the daughter of a rich settler, written by José Alencar and directed by Norma Bengell—or as harmless comedy with an inverted love story between a Portuguese and a lovely native girl, such as *Caramuru—A Invenção do Brasil/Caramuru— The Invention of Brazil* (2001) by Guel Arraes.

Luso-Brazilian Coproductions[2]

The interest in Luso-Brazilian cinematographic collaboration has a long history but needed a kick start. This changed when the two governments formalized a protocol in 1981, and following the Brazilian financial crisis in the early 1990s that turned coproductions into a necessity. Nonetheless, Luso-Brazilian films on the subject of migration are still rare, although the protocol foresees narratives on the common cultural heritage (Ancine 1996).

There are in fact only four films that tell stories on migration to Europe: *Terra Estrangeira/Foreign Land* (1995), by Walter Salles and Daniela Thomas, in which three Brazilian main characters feel alienated in the Portuguese capital and thus challenge the idea of brotherhood; *Tudo isto é Fado/Fado Blues* (2003), by Portuguese Luís Galvão Teles, in which a Brazilian and an Angolan immigrant have a merry encounter with a writer of police novels and his daughter in Lisbon and celebrate not only Lusophony but also Luso-tropicalism; and *Um Tiro no Escuro/A Shot in the Dark* (2005), by Portuguese Leonel Vieira, in which a Brazilian woman has to become a criminal in order to reencounter her kidnapped daughter. The case of Antônio José da

Lusophone Migrational Flows and Imaginaries in National and Transnational Films

Brazil

Colonial enterprise sits at the beginning of the Lusophone migrational flows, triggering off sea voyages from the "metropolis" Portugal to new places around the globe. Brazil stands out in this context because of its profuse resources and the comparably little resistance of the native population. As I have cited elsewhere (Ferreira 2011a), the migration of adventurers, colonizers, settlers, and missionaries from Portugal to the lands of "Vera Cruz" (the true cross) has been divided into three main events: First, during the formation of the patriarchal slave society in the sixteenth and seventeenth centuries; second, the emigrational flow between 1700 and 1760 when the gold and diamond mines were discovered and the country's south received a vast amount of settlers; and third, the migration of young clerks who moved temporarily to Brazil at the end of the eighteenth and the beginning of the nineteenth century—even after Brazil's independence in 1822—in order to make money in the commercial establishments and then return well-off to Portugal (Rowland 2002: 375–376).

Part of the first and second events was the exploration of the interior of the country in search of areas to settle and precious gem stones and metals. Even though, as the third occasion proves, Brazil never ceased to be attractive for Portuguese migrants (another significant event occurred at the end of the African wars of independence in 1974), it is worth noting that nowadays Brazil's developing economy is appealing for Portuguese professionals with university degrees in what might be called a fourth—if not fifth—wave.

Brazilian National Films

Brazilian national cinema already looks back on a tradition of critically examining colonial history, first established during the *Cinema Novo* in the 1960s and 1970s. Especially after the military coup in 1964, this "modern cinema" looked at historical episodes and characters, reread famous texts of the period, or used colonialism as an allegory of current political affairs. The most notorious movies in this context are *Terra em Transe/Land in Anguish* (1967) by Glauber Rocha, which discusses populism and the failure of left-wing intellectuals in the context of the military coup, *Como era gostoso o meu francês/How Tasty Was My Little Frenchman* (1971) by Nelson Pereira dos Santos, an anthropophagic reading of sixteenth-century travel literature, and

empire was under threat from the decolonization processes in the Anglophone and Francophone colonies.

Lusophony, on the other hand, is a product of the same moment but entered the Lusophone stage permanently as a concept after Portugal finally let go of its colonies in Africa in the early 1970s, which brought a feeling of severe loss to the Portuguese nation. It also advocates the belief of a harmonious transnational community in the colonies and aims to guarantee its survival after the end of the empire by identifying the Portuguese language as a metaphor for a shared culture. To do so, it ignores regional and national linguistic, cultural, and historical differences and uses Portuguese as the cornerstone of a common cultural identity, which—due to its transnational dimension—is considered superior to any national identity. Both concepts are powerful tools that convert the colonial history into a collective cultural history.

Only in the last decade or so have Portuguese literary critics and social scientists started to translate the insights from postcolonialism and the awareness of a postcolonial national identity crisis into the critical assessment of these and other concepts and ideas associated with Portugal's supposedly humanistic colonialism. As I have noted in a different place (Ferreira 2012:19), scholars such as Eduardo Lourenço (1999a, 1999b), Boaventura Sousa Santos (2001), Margarida Calafate Ribeiro (2004), and José Gil (2004), among others, question the national predisposition for transnationality and the celebration of its postcolonial cultural legacy and thus help to lay bare Luso-tropicalism's and Lusophony's intent to camouflage difference by acknowledging that they were designed to maintain the imaginary of Portugal as a great nation.

In contemporary films, as I argue later on, it is still common to take this mythical imaginary at face value and construct narratives around it. Even though it has been challenged before, *Tabu* is a particularly interesting example, since it engages with the construction of ideas regarding colonialism and postcolonialism, while also dealing with the existing visual and audiovisual imaginary. Accordingly, I discuss Gomes' film in the second step, demonstrating how it reconnects in an innovative manner to the past and its places. The filmmaker shows as much the longing for the colonial past, as postcolonialism's insistence in its most negative side: the master-servant relationship. *Tabu* explicitly does not shy away from the nostalgia that involves remembrance of Portugal's recent colonial history, but stands out in present film production by confronting viewer expectations usually aroused in European films that express nostalgia for lost empires.

transportation generally take us away to other lands, the communication media reconnect us to earlier places and times, connect us to new places and times, and help us re-imagine new possibilities. (Naficy 2007: xiv)

This intriguing liaison between the fluctuation from one country or region to another— during colonialism and in its aftermath—and the construction of cinematic imaginaries within the Lusophone world are the focus of this chapter. I argue that the mythical imaginary around the concepts of Lusophony and Luso-tropicalism has persisted so far in films on migration, and that a recent film, the much-praised *Tabu/Taboo* (2012) by Miguel Gomes, finally points toward a necessary shift in the mediated depiction of migration in Portuguese-speaking cinema. I make this apparent in two steps. First, I draw a historical panorama of the migrational flows that involved Portugal, the PALOP, and Brazil[1] and sketch how they have been portrayed in national and transnational contemporary films. My main interest in this first part is to present my earlier research findings on the insistence in the key myths just mentioned.

Lusophony and Luso-tropicalism deserve special attention since they have been substantial in the development of an imaginary of the Lusophone world that advocates a "soft" colonialism, and which distinguishes itself strongly from the aggressive Spanish, the brutal Belgian, the segregationist British and Dutch, and the paternalistic French forms of European expansionism. As I have stated elsewhere (Ferreira 2012: 19–20), Luso-tropicalism can be defined as propagating Portugal's outstanding accomplishments—the discoveries of sea routes, islands, and continents—as a consequence of the country's desire to convert the world to Christianity in a peaceful manner.

Trying to distinguishing itself from the Spanish conquerors, Portugal's colonialization process has been interpreted as guided by religious instead of material interests and understood to have been nonviolent by engaging, living, and mixing with the most diverse cultures and ethnicities from the Southern Hemisphere. Luso-tropicalism is, in fact, based on the idea that the Portuguese people, due to their own cultural miscegenation that suffered influences from Europe and the North of Africa, are transnational in their essence. The Brazilian sociologist, Gilberto Freyre (n.d.), is considered the concept's spiritual father in an attempt to tighten and pacify the Luso-Brazilian bonds. This concept regained importance in the 1950s when the Portuguese

1

Imagining Migration: A Panoramic View of Lusophone Films and *Tabu* (2012) as a Case Study

Carolin Overhoff Ferreira

Introduction

Intricate reasons have motivated movements, resettlements, and relocations between Portugal and its former colonies—Brazil, African Countries with Portuguese as Official Language (PALOP), Timor, Goa, and Macao—over a little more than five centuries and established a dense network of historical, cultural, and sociopolitical relationships. After decolonization, the ongoing emigrational fluxes between the members of what is now the supranational Community of Portuguese-Speaking Countries (CPLP) keep changing according to the needs and opportunities of our globalized world.

Hamid Naficy (2007: xiii) calls attention to the fact that today "globalization and displacement are the Janus faces of our contemporary late-modern condition; one necessitates the other. We are living in an interrelated world that increasingly favours horizontality over verticality, multiplicity over singularity, routes over roots, and network over nation." Interrelations that the author pays special attention to are traceable in the works of diasporic and exilic filmmakers from previous colonies, which he denominates "accented" cinemas (Naficy 2001). The author also foregrounds the connection between the question of migration in the real world and the possibility of traveling in the imaginary by means of the diverse media that we now have at our disposal:

> Globalization and mediation are another Janus-faced feature of our contemporary times, one necessitating the other. While the means of

Rêgo, C., M. Brasileiro, and C. Rocha. (2013) "Diapora," in N. Pinazza and L. Bayman (eds.), *Directory of World Cinema: Brazil*. Bristol: Intellect, 168–186.

Rueschmann, E. (2003) *Moving Pictures, Migrating Identities*. Jackson, MS: University Press of Mississippi.

Vieira, E. R. P. (2013a) "Lusophone Cinemas," *Hispanic Research Journal* 14(1): 2–8.

———. (2013b) "Mozambique's Post-Independence Kuxa Kanema: O Nascimento do Cinema/Kuxa Kanema: The Birth of Cinema: An Interview with Margarida Cardoso," *Hispanic Research Journal* 14(1): 86–93.

Wilson, F., and J. R. Correia. (eds.) (2011) *Intermingled Fascinations: Migrations, Displacement, and Translation in World Cinema*. Newcastle Upon Tyne: Cambridge Scholars Publishing.

World Migration 2003: Managing Migration—Challenges and Responses for People on the Move. (2003) Vol. 2 of World Migration Report Series. Geneva, Switzerland: International Organization for Migration (IOM), 4–21.

———. (2010b) "Locating Migrant and Diasporic Cinema in Contemporary Europe," in D. Berghahn and C. Sternberg (eds.), *European Cinema in Motion: Migrant and Diasporic Film in Contemporary Europe*. New York: Palgrave McMillan, 12–49.
Bernd, Z. (2003[1992]) *Literatura e Identidade Nacional*. 2nd ed. Porto Alegre: UFRGS.
Bertellini, G. (2013) "Film, National Cinema, and Migration," in N. Immanuel (ed.), *The Encyclopedia of Global Human Migration*. New York: Blackwell Publishing, 1–6.
Beumers, B. (2010) "Nostalgic Journeys into Post-Soviet Cinema: Towards a Lost Cinema?," in D. Berghahn and C. Sternberg (eds.), *European Cinema in Motion: Migrant and Diasporic Film in Contemporary Europe*. New York: Palgrave McMillan, 96–113.
Boym, S. (2001) *The Future of Nostalgia*. New York: Basic Books.
Brah, A. (1996) *Cartographies of Diaspora: Contesting Identities*. London, New York: Routledge.
Branderello, S. (2013) "A Hungarian Passport," in N. Pinazza and L. Bayman (eds.), *Directory of World Cinema: Brazil*. Bristol: Intellect, 263–265.
Deveny, T. G. (2012) *Migration in Contemporary Hispanic Cinema*. Toronto: The Scarecrow Press.
Durovicová, N., and K. E. Newman. (eds.) (2009) *World Cinemas, Transnational Perspectives*. London, New York: Routledge.
Ezra, Elizabeth, and T. Rowden. (eds.) (2006) *Transnational Cinema: The Film Reader*. London, New York: Routlege.
Ferreira, C. O. (2010) "Identities Adrift: Lusophony and Migration in National and Trans-national Lusophone Films," in V. Berger and M. Komori (eds.), *Polyglot Cinema: Migration and Transcultural Narration in France, Italy, Portugal and Spain*. Vienna/Berlin: LIT Verlag, 173–191.
———. (2012) *Identity and Difference: Postcoloniality and Transnationality in Lusophone Films*. Zurich, Berlin: LIT Verlag.
Gergely, G. (2012) *Foreign Devils: Exile and Host Nation in Hollywood's Golden Age*. New York: Peter Lang.
Kazecki, J., K. A. Ritzenhoff, and C. J. Miller. (eds.) (2013) *Border Visions: Identity and Diaspora in Film*. Toronto: The Scarecrow Press.
Loshitzky, Y. (2010) *Screening Strangers: Migration and Diaspora in Contemporary European Cinema*. Bloomington, IN: Indiana University Press.
Marsella, A. J., and E. Ring. (2003) "Human Migration and Immigration: An Overview," in L. L. Adler and U. P. Gielen (eds.), *Migration: Immigration and Emmigration in International Perspective*. Westport, CT: Praeger, 3–22.
Nacify, H. (1999) *Home, Exile, Homeland: Film, Media and the Politics of Place*. London, New York: Routlege.
———. (2001) *An Accented Cinema: Exilic and Diasporic Filmmaking*. Princeton: Princeton University Press.
Pinazza, N., and L. Bayman. (eds.) (2013) *Directory of World Cinema: Brazil*. Bristol: Intellect.

Félix explores issues of cultural mobility/crossover appeal, displacement and belonging, subjectivity and agency, gender and sexuality/sexualized body of the foreigner, and the quest for self-affirmation (as an iconic star) in the face of personal crisis and suffering.

The editors hope that this volume will appeal to both academic and nonacademic readers interested in contemporary cultural (including cinematic) trends within and among the Portuguese-speaking countries—in short, precisely the kind of multi- and interdisciplinary scholarly work featured in this volume.

NOTES

1. This volumes builds on the assumption that "just as filmmakers with a migrant and diasporic background do not necessarily engage with migration and diaspora in their work, a considerable number of non-migrant and non-diasporic screenwriters and directors have produced films that are centrally concerned with questions of migratory and diasporic existence" (Berghahn and Sternberg 2010a: 16–7).
2. Ferreira (2010) further highlights the fact that "the concept of *Lusofonia* (Lusophony) suggests cultural homogeneity and harmony among the Portuguese-speaking world [which] is based...on an imaginary brotherhood." And yet, "[b]y constantly invoking a common language and memory it thus turns a blind eye to colonial and post-colonial conflicts" (174).
3. Portugal was the last European colonial empire to give up its overseas territories; in 1999 it turned Macau over to China, and in 2002 it granted sovereignty to East Timor.
4. Also known as Community of Countries with Portuguese Language (CPLP).

WORKS CITED

Appadurai, A. (2005 [1996]) *Modernity at Large: Cultural Dimensions of Globalization*. Minneapolis, London: University of Minnesota Press.

Atkinson, M. (ed.) (2008) *Exile Cinema: Filmmakers at Work beyond Hollywood*. Albany, NY: State University of New York Press.

Barrios, N. B. (ed.) (2011) *Latin American Cinemas: Local Views and Transnational Connections*. Calgary, Alberta: University of Calgary Press.

Berger, V., and M. Komori. (eds.) (2010) *Polyglot Cinema: Migration and Transcultural Narration in France, Italy, Portugal and Spain*. Vienna, Berlin: LIT Verlag.

Berghahn, D., and C. Sternberg. (eds.) (2010a) *European Cinema in Motion: Migrant and Diasporic Film in Contemporary Europe*. New York: Palgrave Mcmillan.

Baquero-Pecino's analysis of Yamasaka's films highlights some recurrent themes of migration films portraying that particular period in Brazilian history. One such film is *Cinema, Aspirinas e Urubus*, the subject of analysis of Ursula Prutsch's chapter, "*Cinema, Aspirins, and Vultures:* A Double Escape from a Global Conflict." Tackling the issue of trans/national migration in the context of World War II, the film focuses on the journey of two migrant characters (one German and one Brazilian) across the sertão in their journeys of quest for a home away from home. Although the film represents a cinematic return to the sertão, which allegorized the nation in the 1960s, and was nostalgically revised in several films made in the 1990s, Prutsch is less concerned with the cinematic representation of the sertão than with the historical references and symbols (such as the German Bayer aspirins) repeatedly made/shown in Gomes' film. In so doing, Prutsch notes, the film gives insights into both the phenomenon of trans/national migration and the history of modern Brazil. In her words: "That Ranulpho, like all Brazilians, would also be menaced by aggressive Nazi-Germany, was spread through the radio, as the Brazilian war propaganda (not mentioned in the movie) made people believe that Germany was going to include Brazil in its growing empire of evil. Johann's enemies were the same. Germany made him a traitor; Brazil made him a political enemy."

With narratives also set during World War II, the films *Olga*—the life story of Olga Benário, the German-Jewish political activist who participated in the communist plot against Getúlio Vargas led by her husband, the leader of Brazil's Communist Party, Luís Carlos Prestes, until her imprisonment and deportation to Germany, where she died in a concentration camp— and *Tempo de Paz*—the story of a (fictitious) Polish character who immigrates to Brazil at the end of World War II—are the subject of analysis of Carolina Rocha's "European Immigrants and the Estado Novo in Contemporary Brazilian Cinema." While it may be disputed whether *Olga* and *Tempo de Paz* are films on the Polish- and German-Jewish diasporas, they certainly allow for a critical discussion about nation, history, memory, belonging, and exclusion, and the retelling of a historical moment in which immigrants were looked upon with suspicion and prejudice.

Concluding the volume, Regina R. Félix's "The Migrant in Helena Solberg's *Carmen Miranda: Bananas Is My Business*" offers a critical reading of Solberg's 1995 documentary about Portuguese-born (and Brazilian-naturalized) singer and actress Carmen Miranda, made known by Hollywood's war time musicals as the Brazilian Bombshell. Contesting Solberg's rendition of Miranda's life as an U.S. émigré,

In "Otherness and Nationhood in Tizuka Yamasaki's *Gaijin I* and *Gaijin II*," Álvaro Baquero-Pecino explores issues of national and ethnic identity, generation, and memory, and the implications they have had for the first wave of Japanese (im)migrants to Brazil as portrayed in *Gaijin I*, as well as the problems of reverse culture shock and reintegration when Japanese emigrants return to their country of origin as portrayed in *Gaijin II* as per the "diasporic optic" of Tizuka Yamasaki, a Japanese-Brazilian director. In so doing, Baquero-Pecino's chapter reminds us that "[m]igrant cinema does not always deal with the Other…Sometimes filmmakers want to trace their own family's roots to come to terms with their own heritage. In this case the 'Other' is the director's family or community as an 'Other' because they represent a religious or ethnic minority" (Deveny 2012: 350). As Baquero-Pecino himself contends, by viewing and analyzing these two films one can come to a better "understanding of the significance of interactions between different generations of Japanese people in Brazil, the challenges they faced and continue to face, and the variety of ways in which they help define a new Brazilian identity and culture."

Although Brazil has become a haven for huge waves of immigrants throughout its history, especially during the modern period, Brazilian society has not always being exactly the happy, unprejudiced melting pot that some would like to believe. As Baquero-Pecino points out, *Gaijin I* reflects a concerted effort on the part of the director to bring to the fore the experiences of an earlier generation: that of her grandmother as a migrant in Brazil. But as Baquero-Pecino argues, "Brazil is not depicted as a welcoming new motherland but rather as a nation that despite existing in a postslavery society is still very hierarchical, a nation only just beginning the process of industrialization that carries a strong association with exploitation." This, in conjunction with closed borders policies meant to keep out the feared "Other" during the 1930s and 1940s, contributed to an antagonistic and patronizing portrayal of Japanese and other ethnic groups who, as Baquero-Pecino notes, became targets of Getúlio Vargas' Estado Novo's (1937–1945) anticommunist propaganda and repressive policies. As Baquero-Pecino observes, "World War II brought external tensions, causing many immigrant groups to be perceived as enemies within the Brazilian territory. Through this event, the film reflects the repression of Japanese and Germans by the Estado Novo, which intended to promote a Brazilian national identity, focusing on the period beginning in 1938 with the April 18th Decree Number 383, which prohibited foreigners' participation in public affairs."

include a new and purposely paradoxical category: home-discovering journey. In this regard, she asserts that the designation home-coming journey (which implies the return of the migrants to their original home), as used by Nacify to designate reverse migration, does not neatly fit these documentaries because, for these filmmakers, "the 'return' implies a home which is actually new to them, the original migration or diaspora having occurred long before their birth. In this sense, the homeland is an inherited and imaginary space, rather than a real country, though the journey precisely adds the dimension of reality to what has often become an abstract notion to them."

Even though Brazilians have traveled to, lived, and/or worked abroad since at the least the nineteenth century, the Brazilian diaspora is a fairly recent phenomenon driven mainly by the economic crisis afflicting the country during the 1980s, and which was aggravated in the 1990s following President Fernando Collor de Mello's (1990–1992) implementation of two disastrous neoliberal plans (Collor Plan I and II) to modernize the country's economy. "This not only deeply affected the cinema industry but also resulted in mass emigration" (Ferreira 2010: 22). The fact that Brazil has traditionally been a country of immigration may explain why the national cinematic production dealing with the issue of emigration is comparatively less developed than that of Portugal; a country which, as noted above, has a relatively long tradition of emigration. In fact, in view of the relatively small number of emigration films produced since the 1980s, it is very apparent that Brazilian cinematic production has traditionally engaged with the question of (im)migration. As noted elsewhere (Rêgo, Brasileiro, and Rocha 2013), Brazilian films have tended to either focus on internal migration, which occurs mostly from the poorest regions of Brazil, especially from the drought-stricken Northeastern *sertão* (backland), to the cosmopolitan centers of the South, or on immigrants from different parts of the world who have moved to Brazil seeking work and a better life. In contrast to the other articles on Brazilian films that focus on Brazilian emigrants, the next three chapters, then, offer an insight into the immigrant experience in Brazil. Coincidentally, four of the films discussed below—*Gaijin I* (1980, dir. Tisuka Yamasaka), *Cinema, Aspirinas e Urubus/Cinema, Aspirins and Vultures* (2005, dir. Marcelo Gomes), *Olga* (2004, dir. Jayme Monjardim), and *Tempos de Paz/Peacetime* (2009, dir. Daniel Filho) are set during the Vargas era (1930–1945) when Brazil implemented immigration policies detrimental to migrants in general, and European Jews in particular, who chose Brazil as a migration destiny in the 1930s and 1940s.

Nostalgia has thus become a key operative concept to discuss migration, exile, and diaspora in today's modern global context. As Svetlana Boym (2001) reminds us,

> Nostalgia (from *nostos*—return home, and *algia*—longing) is a longing for a home that no longer exists or has never existed. Nostalgia is a sentiment of loss and displacement, but it is also a romance with one's own fantasy...nostalgia is a longing for a place, but actually it is yearning for a different time—the time of our childhood, the slower rhythms of our dreams. (xiii)

Working with the categories of restorative and reflective nostalgia developed by Boym, in his chapter "Two Hungaries and Many *Saudades*: Transnational and Postnational Emotional Vectors in Contemporary Brazilian Cinema," Jack A. Draper III explores how two Brazilian productions—Sandra Kogut's documentary *Um passaporte húngaro/A Hungarian Passport* (2001) and Walter Carvalho's fiction feature *Budapeste/Budapest* (2009)—depict migration through their émigré characters' nostalgic feelings (or *saudades*) for a long-lost past. As Draper illustrates, the notion of national identity (and national cinema) has become ever more contested and fluid in both symbolic (and/or imaginary) and cinematic terms in the context of trans- and postnationalism. Taking both films as representative examples of transnational film narratives, he suggests that, no more exclusively linked to the longing of one's home nation (as traditionally portrayed in Brazilian literature and cinema), the feelings of saudade may be regarded as a constitutive feature of trans- and postnational (and postmodern) subjectivity, typically experienced by those living and working in contemporary (globalized) migrant and diaspora cultures.

Conversing with Draper's chapter, Nadia Lie's "Reverse Migration in Brazilian Transnational Cinema: *Um passaporte húngaro* and *Rapsódia Armênia*" takes issue with the concept of "road movie" as it does not adequately reflect the specificities of migrant and diasporic documentary films such as *Um passaporte húngaro* and *Rapsódia Armênia/Armenian Rhapsody* (2012, dir. Gary Garanian, Cesar Garanian, and Cassiana Der Haroutiounian). On account that both films "belong to or show affinity with the genre of road movie, and they combine a reflexive search with an actual journal" away from home/land, she proposes an alternative category, "road movie documentary" or, as suggested by Sara Branderello (2013), "documentary on the road," to cover a terrain very similar to that of road movie genre. Lie also engages with Nacify's concept of accented cinema, extending it to

migrant characters), displacement (deterritorialization), and emplacement (reterritorialization) at different historical times. As she argues, both films depict migration as an emotionally ambiguous (and often traumatic) experience: in short, a life-changing event that offers both the possibility and impossibility of affective bonds with host countries, or new geographic territories, on the part of migrant groups and individuals, thus playing a crucial role in the negotiation of migrant and diasporic identities as well as in the creation of a sense of belonging.

In its turn, Frans Weiser's "Performing Criminality: Immigration and Integration in *Foreign Land* and *Fado Blues*" discusses two Luso-Brazilian coproductions that deal with ("illegal") migration. Coincidentally, both films were released in the midst of a diplomatic crisis between Brazil and Portugal, a crisis triggered by Portugal's blocking the entrance of Brazilians and PALOP citizens at its airports after signing the Schengen Treaty in 1995 (Ferreira 2010: 184). As Weiser recalls, "Portugal and Brazil have historically engaged in mutual exchanges of migrants, and although Brazilian counterflow to Portugal dates back to the turn of the twentieth century, it is only within the last decade that Brazilian immigrants have displaced African communities to comprise Portugal's largest immigrant community." On account of the themes they address (illegal immigration, crime, and the problem of Lusophony), the aesthetic choices of the directors (two Brazilians and one Portuguese), and the divergent ways they reflect on inclusiveness—or integration—of migrants of different origins (and of different linguistic and cultural backgrounds) in modern Portuguese society, Weiser concludes that while "both films represent vastly different aesthetic choices, the juxtaposition of their divergent strategies (with respect to integration) creates a set of parameters for negotiating the treatment of migration identity that is not limited to portrayals of criminality or irregular immigration." As such, not only do they address a number of important conceptions of Brazilian exile or Portuguese paternalism but also inaugurate "an alternative framework for approaching how cinematic representation engages the complex issues that inform both the present and the future of migration debates."

One particular phenomenon of interest to scholars writing about migrant and diasporic cinema is the representation of migratory characters who nostalgically long for a home/land of the past, be it real or imaginary (Beumers 2010). According to Brazilian cultural historian Zilá Bernd (2003 [1992]), in a postmodern context, displacement is a euphoric concept, charged with feelings of nostalgia and/or rebirth that are instrumental for the subjectivity of displaced subjects (90).

so-called undocumented ("illegal") and disenfranchised African immigrants in Portuguese society. Examining how these filmic narratives of migration depict issues of space, belonging, place, and displacement vis-à-vis other Lusophone films portraying migration, Jorge concludes that "Costa's films are inherently more concerned with the idiosyncratic trajectories of individuals' lives that are marked by historical processes and political repression."

Conversely, Derek Pardue's "*Outros Bairros* and the Challenges of Place in Postcolonial Portugal" offers a close reading of *Outros Bairros/Other Neighborhoods* (1999, dir. Kiluanje Liberdade, Vasco Pimentel, and Inês Gonçalves), a film that explores the disjunctures between displacement and emplacement (or relocation) and belonging and otherness as experienced by Cape Verdean (and to a lesser extent Angolan and Mozambican) immigrants living on the fringe of Portugal's main cities of Lisbon and Oporto's neighborhoods. Established in 1918, these neighborhoods exemplify what Avtar Brah calls "diaspora space," that is, a site of transformation, intersection, and intermingling where, contrary to that of diaspora, "the native is as much as diasporian as the diasporian is a native" (Brah 1996: 209). As Pardue concludes, therefore, "The film is an engaging and beautiful combination of art and politics that asks the viewer to entertain the existential question: who is 'Portuguese' (and by extension, as pondered by one youth in the film, 'who is European?') and who is 'other'?"

A useful framework that accommodates the approach taken by Fátima Velez de Castro in "Deterritorialization Processes in the Portuguese Emigratory Context: Cinematic Representations of Departing and Returning" is Thomas G. Deveny's (2012) notion of migrant films as it relates to the Hispanic world.

> All migration film narratives have three basic components: the premigration context that triggers the decision to depart one's homeland; the journey or crossing; and the life of the immigrant in the new land. Some films show all three segments of the migrant experience; others focus on one or two. But the three components, whether explicit or implicit, constitute the common threads to all of the films of Hispanic migration, no matter what the country of origin or of destination. (ix)

Taking *Cinco dias, cinco noites/Five Days, Five Nights* (1996, dir. José Fonseca e Costa) and *Duplo Exílio/Double Exile* (2001, dir. Artur Ribeiro) as examples, Velez de Castro discusses how recent Portuguese filmography portrays migration (through the journeys of

territories. Its inhabitants were thought of as assimilated Africans and were allowed to work in the mainland's construction and manufacturing industries. As a result of its colonial history, the influx of migrants since the mid-1980s until today originates largely from the PALOP (*Países de Língua Oficial Portuguesa*[4]) [African Countries with Portuguese as Official Language] that became independent in 1975 and suffered the consequences of brutal civil wars for a long period. The largest group of migrants now derives from Brazil with which Portugal retained strong emigrational ties after independence in 1822. (173–174)

In "Imagining Migration: A Panoramic View of Lusophone Films and *Tabu* (2012) as a Case Study," Ferreira goes on to offer an insightful overview of the rapidly expanding corpus of Lusophone migration and diasporic films in order to show how they deal with the questions of Lusophony and Luso-tropicalism, here understood as an expression for the commonly held myth of racial harmony resultant from the Portuguese capacity to adopt and adapt to tropical cultures, as well as the ability of African and Brazilian immigrants to integrate to Portuguese society. For Ferreira, contrary to national and transnational Lusophone productions portraying migration, such as *Casa de Lava/Down to Earth* (1994, dir. Pedro Costa) and *Tudo isto é Fado* (already mentioned), *Tabu/Taboo* (2012, dir. Miguel Gomes) "explicitly does not shy away from the nostalgia that involves remembrance of Portugal's recent colonial history, but stands out in present film production by confronting viewer expectations usually aroused in European films that express nostalgia for lost empires." By adopting a comparative, transnational, and dialogic perspective, which recognizes the cultural diverse traditions of film cultures of Portugal, Brazil, and the PALOP countries, Ferreira establishes a critical framework that underpins the more specific issues addressed in the volume's subsequent chapters.

Dialoguing with Ferreira's chapter, Nuno Barradas Jorge's "Thinking of Portugal, Looking at Cape Verde: Notes on Representation of Immigrants in the Films of Pedro Costa" offers a critical appraisal of the representation of the Cape Verdean diaspora in the films of Pedro Costa, one of the most internationally known Portuguese film directors of his generation, and one of the few to have dedicated several feature films to the subject: *Casa de Lava*, which was set mostly on the Cape Verdean Ilha de Fogo, and the so-called Fontainhas trilogy (*Ossos/Bones*, 1997; *No Quarto de Vanda/In Vanda's Room*, 2000; *Juventude em Marcha/Colossal Youth*, 2006) focusing on the lives of Cape Verdean immigrants who arrived and settled in the Lisbon slum Fontainhas from the 1960s on, and thus giving visibility to the

the notions of Lusophony and Luso-tropicalism highly problematic. Still, according to Ferreira, immigrant cinema has yet to have a transformative impact on Portuguese film culture. In her words:

> Due to its journeys of discoveries and its many colonies spanning Brazil to Macau, but even more because of its weak socio-political and economic situation from the eighteenth century onwards, Portugal has always been a country of massive emigration. Accordingly, its cinema has been more interested in this subject than in portraying the relatively recent impact of migration into the country. While the decolonisation process after 1974 was an important factor for movements to Portugal, it was only when the country joined the European Community in 1986 that it become more attractive for immigrants. Since it remained distant from the social and economic standards of the first world nations, Portuguese emigration to Brazil, richer European countries or the Unites States of America did not cease. (173)

Located on the Iberian Peninsula on the western edge of Europe, Portugal rose to become a hegemonic power in the fifteenth century as the result of pioneering the so-called Age of Discovery, when it began expanding its influence onto a vast number of territories in Africa, Asia, and what would be its largest and most important colony, Brazil. Emigration, thus, was part and parcel of conquest as the Portuguese established prosperous settlements in the new overseas territories, becoming one of the world's major colonial powers, and ultimately dividing the world with Spain. Beginning in the late nineteenth century, the Portuguese ultramarine empire started seeing a marked declined, following the independence of Brazil in 1822 and, more recently, of other Portuguese colonies, among them Mozambique and Angola in 1975.[3]

With a long history of emigration, Portugal has since become a country of immigrants; a situation brought about by waves of Portuguese returning to the country in the aftermath of independence of the African colonies in the 1970s, as well as of immigrants from other (African and European) countries as early as the 1960s. Beginning in the early 1990s, with the boom in construction and, consequently, the increasing need for immigrant labor, new waves of immigrants, especially Brazilians and Africans from former colonies, settled in the country. In her assessment of Lusophone films portraying migration, Ferreira (2010) explains that,

> [t]he first migrants to Portugal came mainly from the Cape Verde islands in the 1960s when they were still considered Portuguese ultramarine

cultural encounters between characters with various Lusophone backgrounds" (ibid.).[2]

The core questions and issues raised by the volume, while manifold, are grouped together by a shared concern with key questions about cinema and representation as broached in films about migration of the Portuguese-speaking countries: how do films, filmmakers, producers, studios, and government/funding bodies relay narratives of migration within the Portuguese-speaking world? How is the nation (home/land) imagined, narrated, constructed, and disseminated within single films? Answering these questions led to a series of further questions and qualifications, which were posed for potential contributors to the volume in the Call for Papers: What are the main questions that come to the surface when we deal with films that represent the migratory experience from the perspective of the Portuguese-speaking countries? How do these films represent the challenges and opportunities of displaced subjects? How do these films discuss the relationship between home/land, belonging, and nationality? How is the debate about the implications of the migratory experience framed from a postcolonial perspective? What are the cinematic and philosophical solutions put forward by Lusophone films when dealing with the representation of migratory experience (i.e., deterritorialization, reterritorialization, loss, memory, cultural ambivalence, home/land, and identity)? What are the regional or national differences among the different cinematic traditions in Lusophone cinema? Along with national productions, how have transnational productions (most resulting from Ibermedia and other agreements between Portugal and the former colonies) contributed to the notions of identity and difference, as well as cultural unity, such as Lusophony and Luso-tropicalism?

In this line of thinking, contributors have formulated a number of responses to the above questions. Incorporating the tools of cultural studies, film studies, literary analysis, alongside those of history, geography, cultural anthropology, as well as diaspora and area studies, they throw light on what the editors consider a blind spot in current film scholarship: the representation of migration in Lusophone cinema.

As Carolin Overhoff Ferreira (2010) and Else R. P. Vieira (2013a) note, Portugal's colonial and postcolonial history impregnates both its film culture and those of the former colonies. But as Ferreira explains, in the Portuguese context immigrant characters were a novelty until at least the 1990s, when national productions began to explore the theme of immigration. Ever since then, there have been an increasing number of Portuguese films focusing on the everyday experience of (mainly African) immigrant and diasporic characters. As such, they have made

representations of migration in Lusophone cinema from multiple positions of enquiry. This analysis includes both national and transnational feature-length fiction films as well as documentaries that have been released either in movie theaters or film festivals, either at home or abroad. It does not, however, offer a representative survey of migrant cinema in all of Portuguese-speaking countries, neglecting, for instance a number of the lesser-known cinemas such as those of Angola, Mozambique, Cape Verde, and Guinea-Bissau (formerly Portuguese Guinea). The volume builds upon the assumption that "each cinema deals with migration at different times and in different ways" (Deveny 2012: 7). As a consequence, the editors have roughly divided the chapters (and the films they discuss) both chronologically and geographically. In so doing, our goal is to establish a sense of migration movements (immigration/emigration) within, into, and out of the Lusophone world in the context of cinematic representations.

In this analysis of Lusophone films portraying migration, the emphasis is on productions from two countries with relative strong cinematic traditions: Portugal and Brazil, including coproductions between the two countries such as, for instance, *Terra Estrangeira/ Foreign Land* (1995, dir. Walter Salles and Daniela Thomas) and *Tudo isto é Fado/Fado Blues* (2003, dir. Luís Galvão Teles). Moreover, while migrant and diasporic film scholarship has tended to focus almost exclusively on the production of filmmakers of migrant origin or a refugee background, this volume moves on to examine representations of migration in Lusophone films, regardless of the filmmakers' place of origin and/or residence[1]; a topic that is underexplored in studies of Portuguese-speaking cinemas across continents. The volume, then, seeks to fill this gap and to be a catalyst for multi- or interdisciplinary debates on the subject. Furthermore, it does not attempt to erase, ignore, or "harmonize the differences in Lusophone Cinemas within and across three continents through this label" (Vieira 2013a: 7). As the Portuguese director Margarida Cardoso reminds us, "One cannot talk about Lusophone cinema as such because each national cinema is so different...There is a great difference in perspectives and the whole Lusophone issue is complicated. Angolan Cinema is not the same as Mozambican, Brazilian, or Cape Verdean Cinema. Each Lusophone country is different" (quoted in Vieira 2013b: 91). As well as, Carolin Overhoff Ferreira (2010) notes "One should not speak of one Portuguese language but of a plurality of countries, peoples and languages" (175). Understandably, therefore, "the few Portuguese films that do deal with immigrants structure their narratives around

of issues related to immigration and transnationalism. In the wake of postmodernist and postcolonialist cultural critiques, scholars such as Edward Said, Homi Bhabha, Arjun Appadurai, Gloria Anzaldúa, Avtar Brah, Nestor García-Canclini, and Silviano Santiago have conceived a notion of culture and identity as a nonessentialist notion or, as Salman Rushdie has put it, as "always plural and partial" (quoted in Ruchsman: 181). Continuing his reflection on this phenomenon, Rushdie also states that migration is responsible for creating people "who root themselves in ideas rather than places, in memories as much as material things...people in whose deepest selves strange fusions occur, unprecedented unions between what they were and where they find themselves" (quoted in Ruchsman: 181).

While drawing upon the wide theoretical framework of migrant cinema, the intention of this volume, the first to look at Lusophone film cultures through the lens of migration, is to open a space for further critical enquiry and debate on the topic by fostering an intellectual dialogue that bypasses disciplinary borders, and by engaging with other (inter)national, institutional, and discursive contexts. Precisely for this reason this volume moves emphatically beyond the current restrictive frameworks of the field of film studies by opening it up to a wider spectrum of texts, contexts, and approaches to the subject. In so doing, it offers a collage of a series of heterogeneous chapters written by researchers from diverse disciplinary, cultural, and linguistic backgrounds as well as continents.

Aware of the need for a forum that would bring together scholars working across the humanities, the editors set about organizing two conference panels: *Latin American Cinemas after the Year 2000* for the 54th International Congress of Americanists (ICA), which took place in Vienna, Austria, in July of 2012, and *Diasporas and Brazilian Cinema* for the 11th Brazilian Studies Association (BRASA) International Meeting, which took place in Urbana-Champaign, Illinois, in September of 2012. The panels offered us ideal settings for discussing the question of migrant narratives in contemporary Brazilian cinema, and we are grateful to all participants, including Carolina Rocha, Regina R. Félix, Jack A. Draper III, and Ursula Prutsch, who are also contributors to this volume. Our interest and focus on the ways cinema chooses to represent the experience of migration, as both lived experience and imagined community, remains. More recently, we explored the topic in our chapter on "diaspora," which appeared in the *Directory of World Cinema: Brazil* (Pinazza and Bayman 2013).

In contrast to studies on specific migration and diasporic cinema, therefore, the editors set out to understand and critique cinematic

Fascinations: Migrations, Displacement, and Translation in World Cinema (Wilson and Correia 2011); *Latin American Cinemas: Local Views and Transnational Connections* (Barrios 2011); *Foreign Devils: Exile and Host Nation in Hollywood's Golden Age* (Gergely 2012); *Migration in Contemporary Hispanic Cinema* (Deveny 2012); *Identity and Difference: Postcoloniality and Transnationality in Lusophone Films* (Ferreira 2012); *Border Visions: Identity and Diaspora in Film* (Kazecki et al. 2013), among many others.

While this is not the place to survey the large body of literature on migration cinema, it is nonetheless necessary to note, as Bertellini does, that "the world's film cultures, when read through the lens of migration, reveal overlooked historical junctures and inform fruitful revisionist takes, particularly with regard to national cinemas' past and future significance" (2013: 1). Further, although different trends may be noted with regard to individual national film cultures, themes depicted in migrant cinema are constant. Referring to migrant narratives in Hispanic films, Deveny maintains that,

> The combination of push and pull factors that lead to migration, the difficulties of the journey, or the border crossing, the difficulties of adjusting and integrating into the new country, the physical and emotional problems of immigrants, the manner in which the residents of the receiving country deal with immigrants, and the questions of identity for both the migrant and the society as a whole are evident in all of the films. (2012: 345)

Given all of this, it comes as no surprise that scholars interested in cinematic representations of migration tend to see the gestures of displacement (deterritorialization) and emplacement (reterritorialization) as movements that can resignify cultural (and geographical) territories, as well as enable new transcultural experiences. Despite the possibility of enrichment of the migrant journey, scholars have also called attention to the uncertainty of this "journey of hope." In *Screening Strangers: Migration and Diaspora in Contemporary European Cinema* (2010), for example, Yosefa Loshitzky reflects on the profile of the archetypical poor immigrants, leaving their country to improve their lives. For her, the metaphor of the "suitcase" translates the irretrievable loss of the familiar environment in search for an uncertain future.

In *Moving Pictures, Migrating Identities* (2003), Eva Ruchsman maintains that the concern about the diasporic experience has increased during the 1990s with artistic and theoretical explorations

INTRODUCTION

Cacilda Rêgo and Marcus Brasileiro

"Hardly a new feature of human history" (Appadurai 2005 [1996]: 4), migration (from Latin *migrare*, the process or act of migrating) entails "population movements either within nation states or across borders" (Berghahn and Sternberg 2010a: 12). According to Anthony Marsella and Erin Ring, "The impulse to migrate is inherent in human nature—an instinctual and inborn disposition and inclination to wonder and wander in search of new opportunities and new horizons" (2003: 3). But if "[m]igration movements were long confined to relatively straightforward and linear relations between closely linked poles" (*World Migration*: 4), new migration patterns, as Giorgio Bertellini maintains, "have followed ever more complicate geographical routes" over the past half century. "As such," he argues, "they have more broadly and radically affected contemporary media geography and film poetics even though migrations per se have not had a comparably transformative impact on all national film cultures" (2013: 1). And yet, migrant cinema and its various incarnations—that is, accented, polyglot, postcolonial, transnational, exilic, and diasporic cinema—constitute an area of growing interest in film studies since the 1990s, as attested by the number of critical publications bearing the term(s) on their titles and/or subtitles: *Home, Exile, Homeland: Film, Media and the Politics of Place* (Nacify 1999); *An Accented Cinema: Exilic and Diasporic Filmmaking* (Nacify 2001); *Moving Pictures, Migrating Identities* (Rueschmann 2003); *Transnational Cinema: The Film Reader* (Ezra and Rowden 2006); *Exile Cinema: Filmmakers at Work beyond Hollywood* (Atkinson 2008); *World Cinemas, Transnational Perspectives* (Durovicová and Newman 2009); *Polyglot Cinema: Migration and Transcultural Narration in France, Italy, Portugal and Spain* (Berger and Komori 2010); *European Cinema in Motion: Migrant and Diasporic Film in Contemporary Europe* (Berghahn and Sternberg 2010); *Screening Strangers: Migration and Diaspora in Contemporary European Cinema* (Loshitzky 2010); *Intermingled*

Acknowledgments

We would like to thank a number of people who have helped in the preparation of this book. We are very much indebted to the contributors for the various drafts they supplied and the many deadlines they met. Fernando Arenas, Piers Armstrong, and Anne Gibson provided valuable suggestions at different stages of the project. Thanks also to the anonymous reviewer for the invaluable time and insightful comments on the manuscript. Special appreciation goes to Myra Cook Brown for her generosity, for the lively conversations and meticulously copyediting many of the articles of this book. We would like to thank everyone at Palgrave—particularly Erica Buchman (editorial assistant), Robyn Curtis (editor), and Abimbola Oladipo (production assistant), as well as Deepa John (project manager) at Newgen Knowledge Works—for helping bring this book to fruition.

Figures

1.1	*Tabu*: The explorer	28
1.2	*Tabu*: The explorer and his servants	28
1.3	*Tabu*: Citation of ethnographic documentaries	29
1.4	*Tabu*: Santa reading *Robinson Crusoe*	32
1.5	*Tabu*: Maya and Pilar at the airport	33
1.6	*Tabu:* Pilar and her NGO	33
1.7	*Tabu*: Aurora, the hunter	35
5.1	*Foreign Land*: Border checkpoint	97
5.2	*Foreign Land*: Paco's apartment building seen in relation to the elevated expressway	101
5.3	*Foreign Land*: Lisbon's skyline	102
5.4	*Fado Blues*: The police officer from Amadeu's point of view	103
5.5	*Fado Blues*: Leonardo imitates Rio's Iconic Christ the Redeemer Statue	105
5.6	*Fado Blues*: The final scene reinforces its message of equality	108

8	Otherness and Nationhood in Tizuka Yamasaki's *Gaijin I* and *Gaijin II* Álvaro Baquero-Pecino	151
9	*Cinema, Aspirins, and Vultures*: A Double Escape from a Global Conflict Ursula Prutsch	167
10	European Immigrants and the Estado Novo in Contemporary Brazilian Cinema Carolina Rocha	187
11	The Migrant in Helena Solberg's *Carmen Miranda: Bananas Is My Business* Regina R. Félix	203

Filmography	221
Notes on Contributors	223
Index	227

Contents

List of Figures ix

Acknowledgments xi

Introduction 1
Cacilda Rêgo and Marcus Brasileiro

1 Imagining Migration: A Panoramic View of Lusophone Films and *Tabu* (2012) as a Case Study 17
Carolin Overhoff Ferreira

2 Thinking of Portugal, Looking at Cape Verde: Notes on Representation of Immigrants in the Films of Pedro Costa 41
Nuno Barradas Jorge

3 *Outros Bairros* and the Challenges of Place in Postcolonial Portugal 59
Derek Pardue

4 Deterritorialization Processes in the Portuguese Emigratory Context: Cinematic Representations of Departing and Returning 77
Fátima Velez de Castro

5 Performing Criminality: Immigration and Integration in *Foreign Land* and *Fado Blues* 93
Frans Weiser

6 Two Hungaries and Many *Saudades*: Transnational and Postnational Emotional Vectors in Contemporary Brazilian Cinema 113
Jack A. Draper III

7 Reverse Migration in Brazilian Transnational Cinema: *Um passaporte húngaro* and *Rapsódia Armênia* 131
Nadia Lie

To Byron Burmester, my best reason to migrate. And to my parents, friends, and relatives who stay so close in the distance.
M.B.

To my parents, Raul (in memoriam) and Gicélia, with gratitude and "many saudades"
C.R.

MIGRATION IN LUSOPHONE CINEMA
Copyright © Cacilda Rêgo and Marcus Brasileiro, 2014.

All rights reserved.

First published in 2014 by
PALGRAVE MACMILLAN®
in the United States—a division of St. Martin's Press LLC,
175 Fifth Avenue, New York, NY 10010.

Where this book is distributed in the UK, Europe and the rest of the world, this is by Palgrave Macmillan, a division of Macmillan Publishers Limited, registered in England, company number 785998, of Houndmills, Basingstoke, Hampshire RG21 6XS.

Palgrave Macmillan is the global academic imprint of the above companies and has companies and representatives throughout the world.

Palgrave® and Macmillan® are registered trademarks in the United States, the United Kingdom, Europe and other countries.

ISBN: 978–1–137–40891–4

Library of Congress Cataloging-in-Publication Data

 Migration in Lusophone cinema / edited by Cacilda Rego and Marcus Brasileiro.
 pages cm
 Includes bibliographical references and index.
 1. Emigration and immigration in motion pictures. 2. Immigrants in motion pictures. 3. Aliens in motion pictures. 4. Motion pictures—Portugal—History. 5. Motion pictures—Brazil—History. 6. Motion pictures—Africa, Portuguese-speaking—History. I. Rêgo, Cacilda, editor. II. Brasileiro, Marcus, 1969– editor.

PN1995.9.E44M55 2014
791.43′6552—dc23 2014022174

A catalogue record of the book is available from the British Library.

Design by Newgen Knowledge Works (P) Ltd., Chennai, India.

First edition: November 2014

10 9 8 7 6 5 4 3 2 1

Transferred to Digital Printing in 2015

Migration in Lusophone Cinema

Edited by
Cacilda Rêgo
and
Marcus Brasileiro

palgrave
macmillan

Migration in Lusophone Cinema